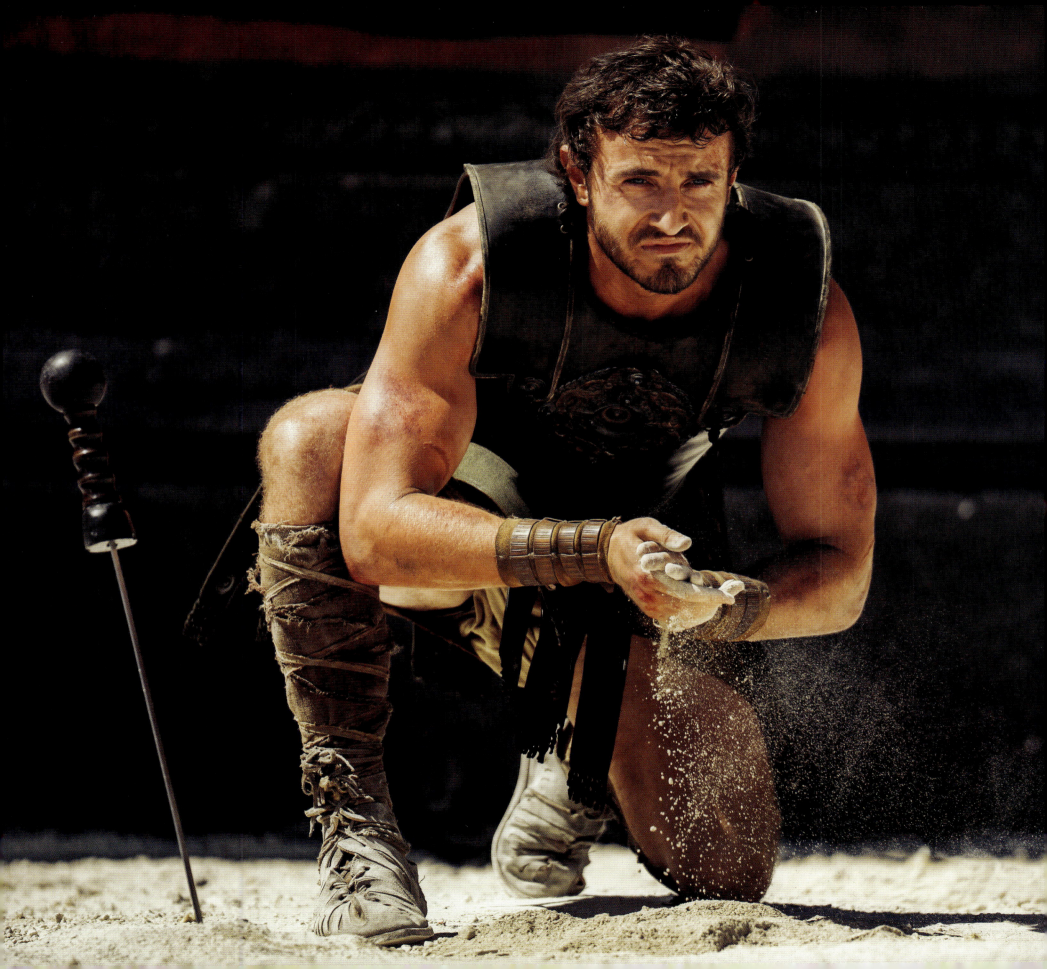

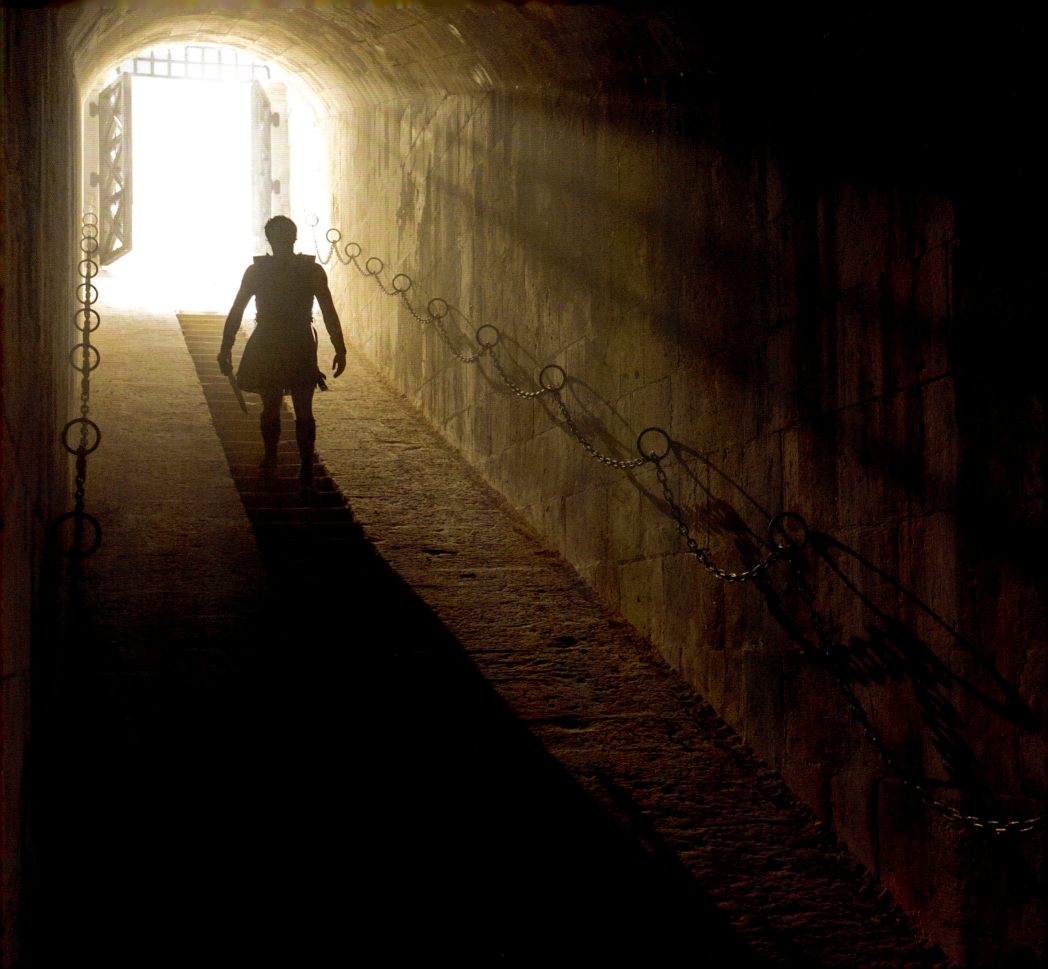

GLADIATOR II

THE ART AND MAKING OF THE RIDLEY SCOTT FILM

JOHN WALSH · FOREWORD BY SIR RIDLEY SCOTT

ABRAMS · EBORVACUM NOVUM

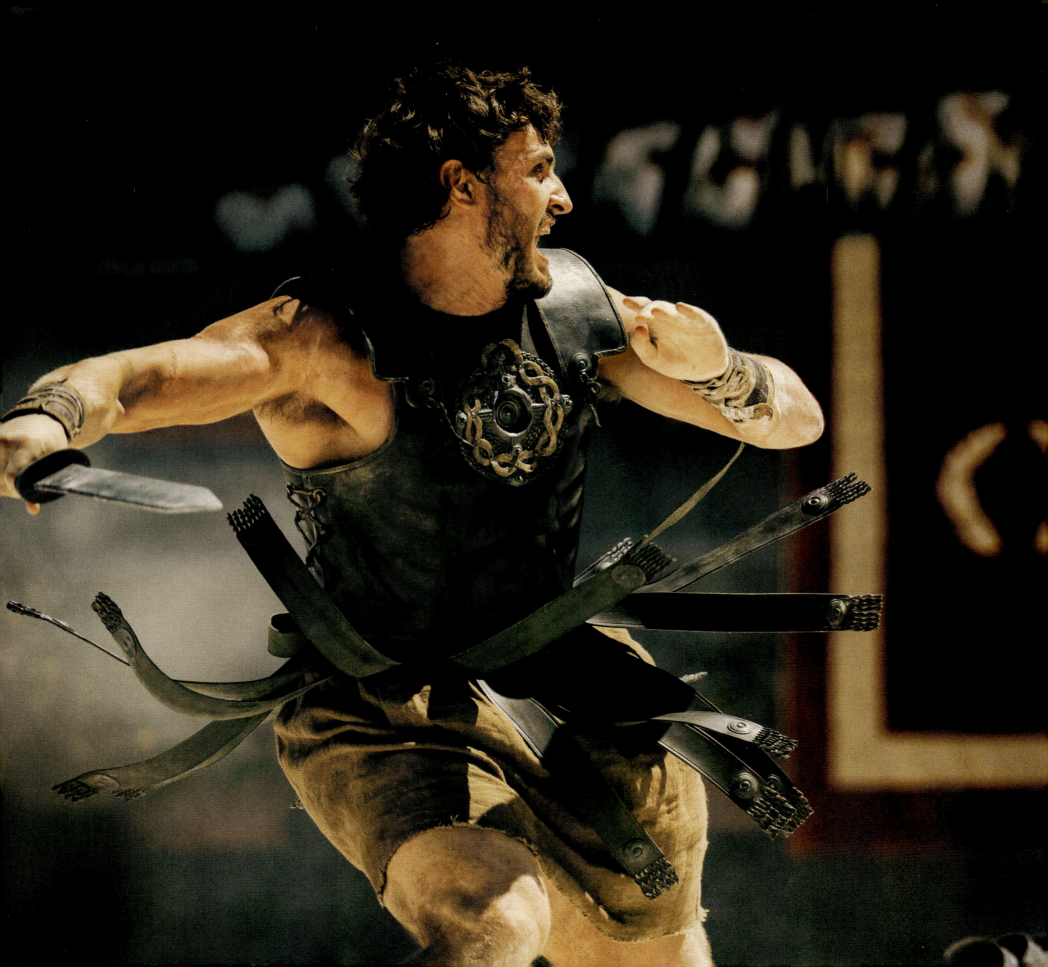

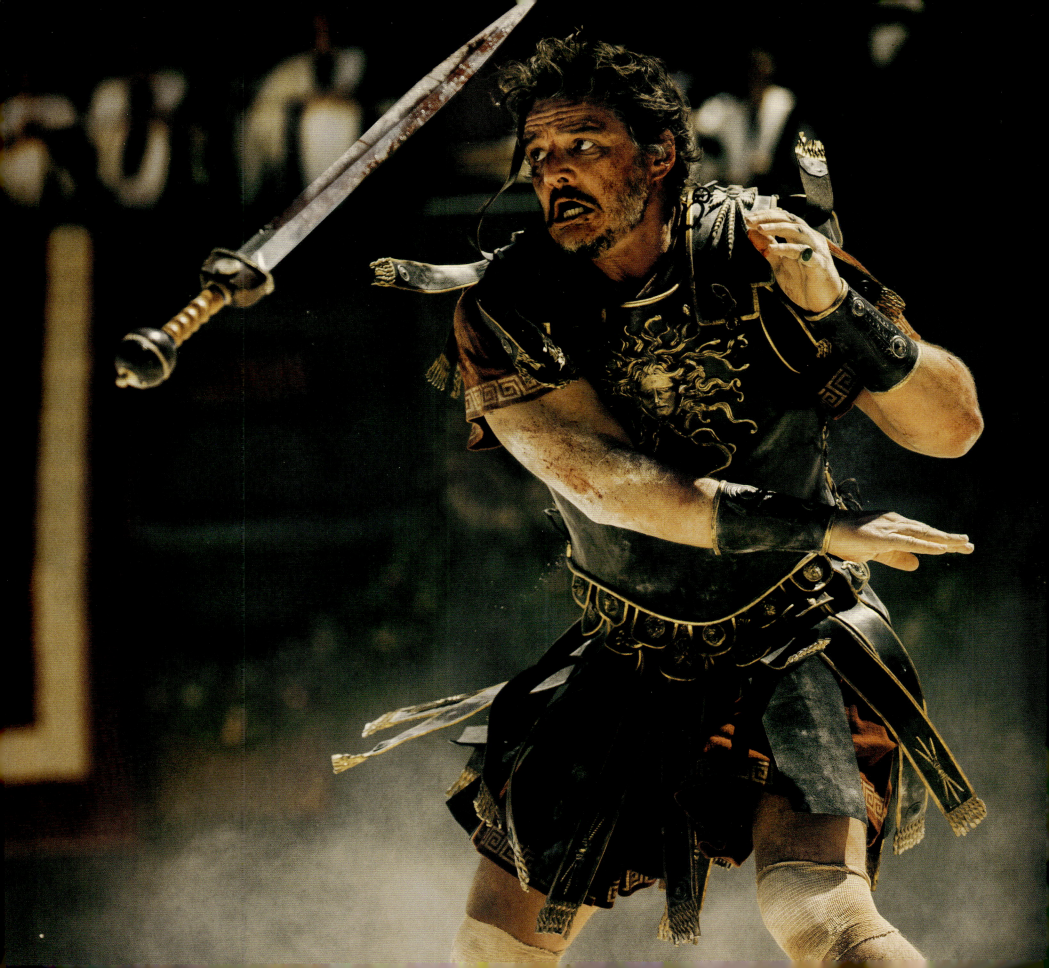

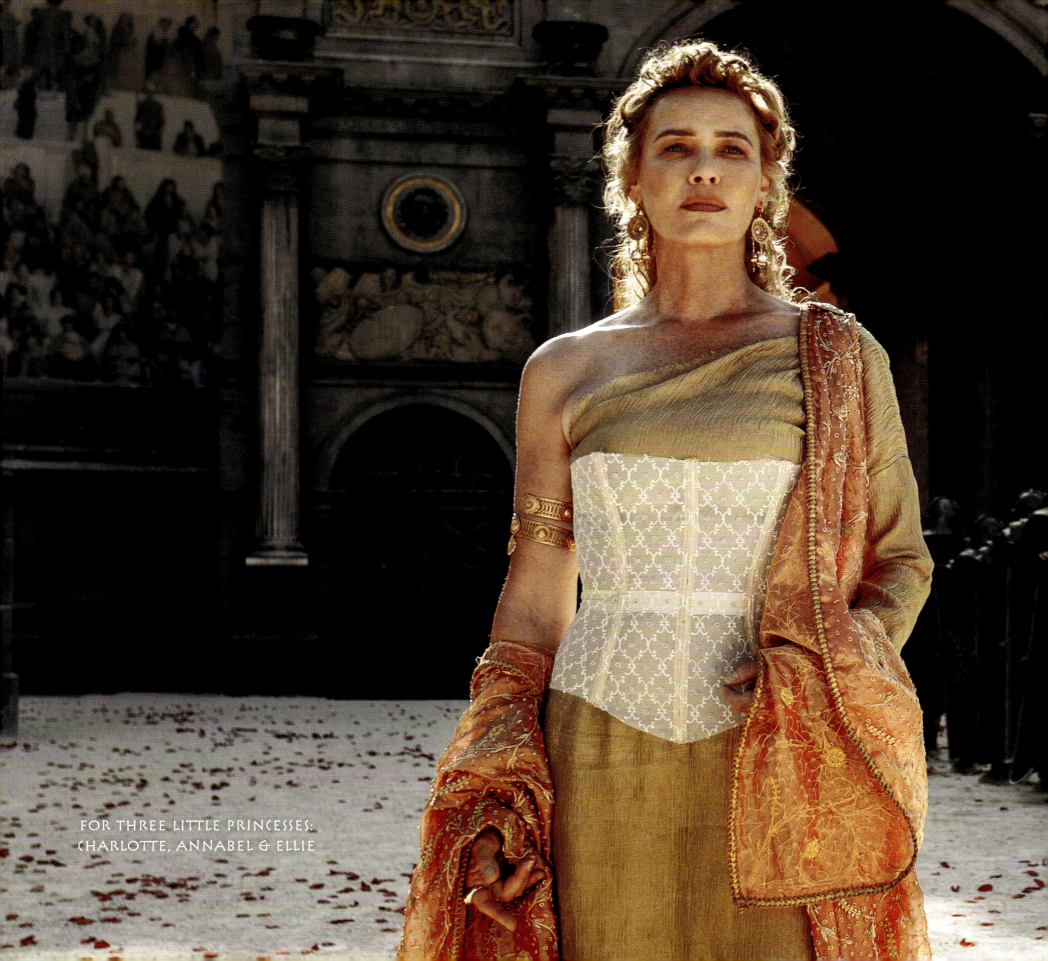

FOR THREE LITTLE PRINCESSES:
CHARLOTTE, ANNABEL & ELLIE

FOREWORD · 9
INTRODUCTION · 11
DIRECTOR'S · CHAIR · 13
THE · ROAD · TO · ROME · 17

I
THE · CAST
23

II
DESIGN
49

III
COMBAT
213

IV
SPECIAL · AND
VISUAL · EFFECTS
223

LEAVING · ROME · 237
ACKNOWLEDGMENTS · AND · NOTES · 238

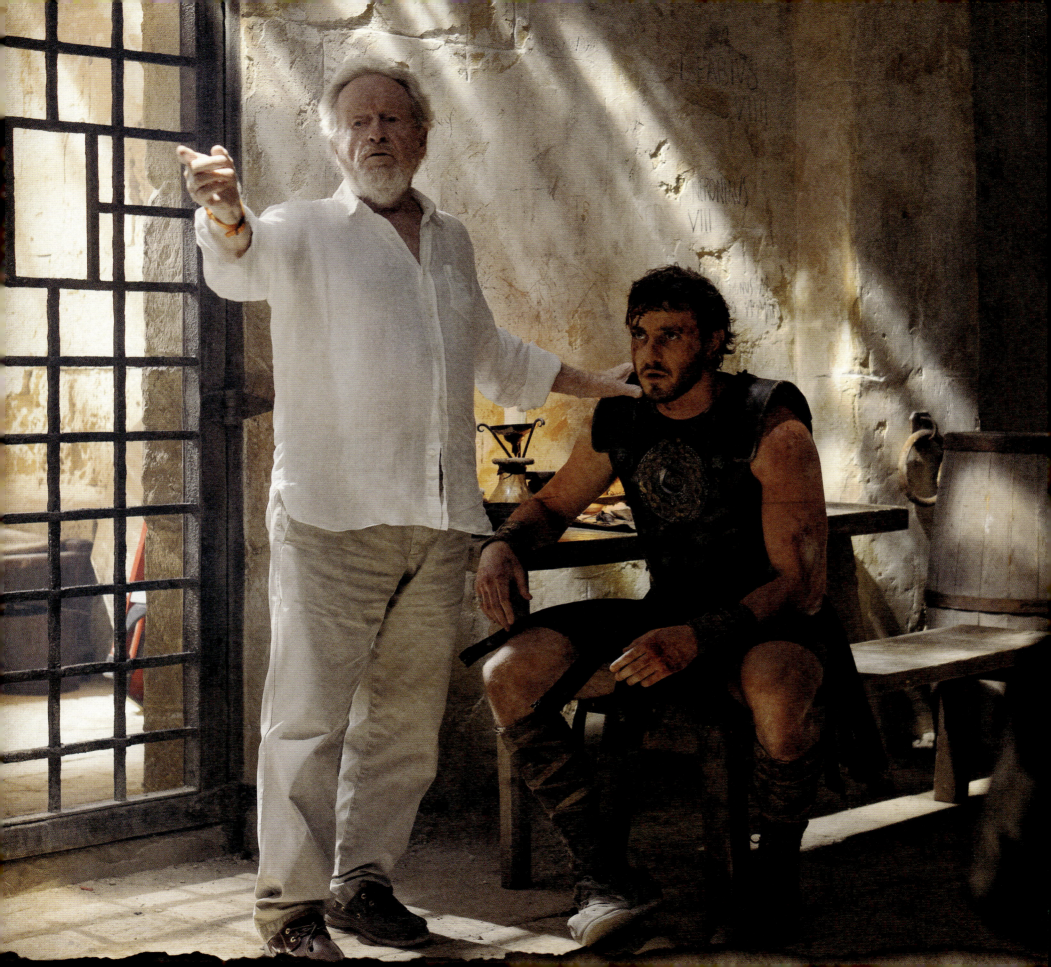

FOREWORD

A SEQUEL FOR A VERY SUCCESSFUL FILM WILL ALWAYS BE A CHALLENGE AND WILL ALWAYS BE COMPARED WITH THE ORIGINAL.

Who survived? How and why did they survive? And where did they go in the years that have passed?

The most important survivors were Lucilla, her son, Lucius, and Senator Gracchus.

These parts of a jigsaw puzzle were enlarged by trial and error and endless discussion, until a footprint was found in the dust of Rome. And the script was then written by David Scarpa . . .

In *Gladiator* I discovered immortality as a powerful thread that ran through the story. "Afterlife" would have to be considered as part of *Gladiator II*.

Rome would still be the unbalanced universe of ingenuity, art, architecture, and brutality, the most important architectural artifact for centuries being the temple of death, the Colosseum, where events took place as a form of entertainment . . . Death and blood on the sand were the highlights. Religious figures and prisoners of war were all fodder for the insatiable Roman mob, matching anything that can be seen today in all of its oppression and bloodshed.

Russell Crowe was the marvelous Maximus, and I needed another persona to fill that role. I happened to see a TV series called *Normal People* and was intrigued by the actor Paul Mescal, who certainly had the Roman profile—or was it his likeness to Richard Harris? Or was it simply just his great, assertive performances? Paul became Lucius.

My key creative artists from the first film returned, including Janty Yates, costume designer; John Mathieson, director of photography; special effects supervisor Neil Corbould; and production designer Arthur Max. They built and dressed the world of Rome, letting it breathe new life into the golden city once again.

I hope we successfully transport you to Roman times . . . Rome was not built in seven days, but in fact fifty-one.

Sir Ridley Scott,
August 2024

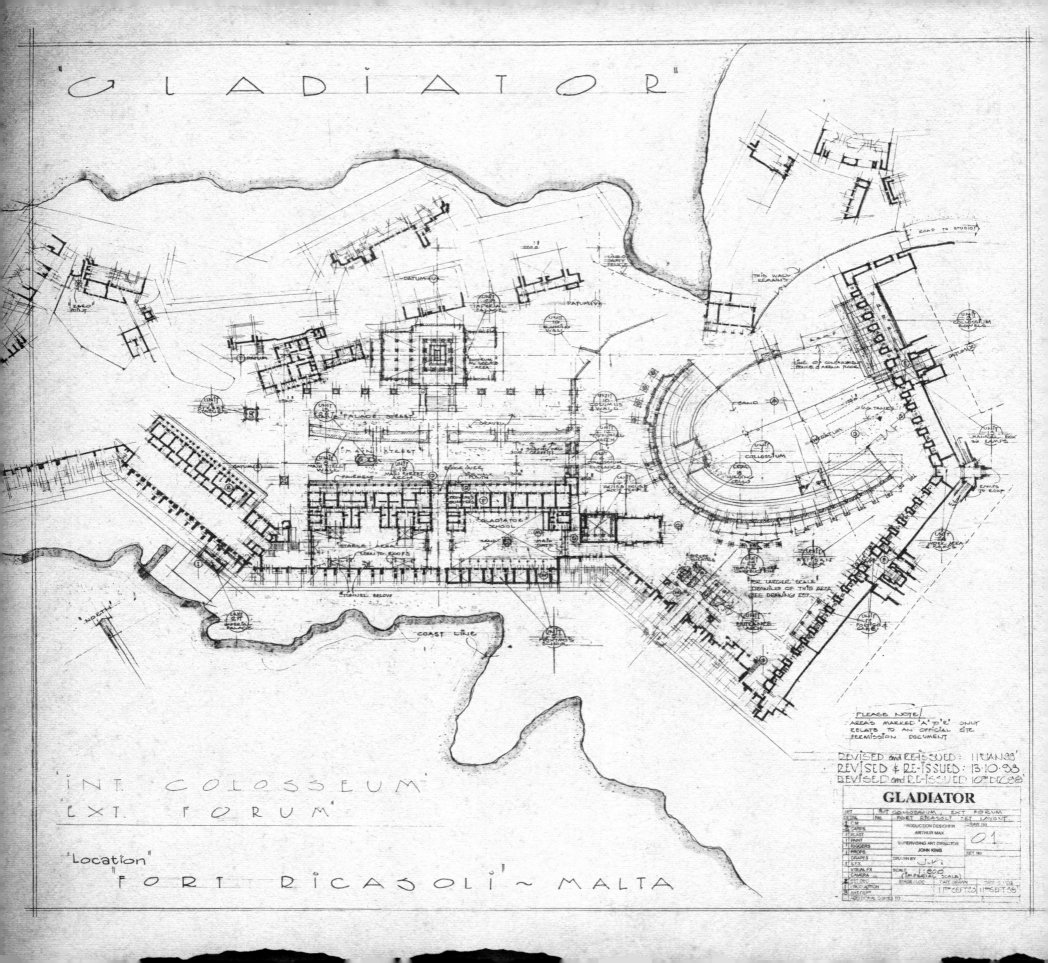

INTRODUCTION

"FATHER OF A MURDERED SON, HUSBAND TO A MURDERED WIFE, AND I SHALL HAVE MY VENGEANCE IN THIS LIFE OR THE NEXT."

Sir Ridley Scott's eleventh feature film, *Gladiator*, opened in 2000 and found him once again redefining a cinema genre. The British director's landmark films *Alien* (1979) and *Blade Runner* (1982) reinvented science fiction for a generation. Today, his 1985 fantasy *Legend* is considered a cult classic, and *Thelma & Louise* (1991) is a significant milestone in feminist film.

Before *Gladiator*, the success of Roman "sword and sandal" epics was firmly locked in the past with biblical epics *The Ten Commandments* (1956) and *Ben-Hur* (1959). Stanley Kubrick's *Spartacus* (1960) portrayed the life of the enslaved Spartacus, played by Kirk Douglas, as he heads a rebellion against Rome and the events of the Third Servile War. It would remain the benchmark other filmmakers needed to meet to offer discerning audiences a new perspective on an old tale, winning four Oscars and an acting award for costar Peter Ustinov.

No filmmaker would come close to Kubrick's classic in the ensuing years, and attempts at Roman epics made throughout the 1970s, '80s, and '90s failed to capture the public's imagination. By 1999, Scott decided he wanted to take on the challenge.

Australian actor Russell Crowe was cast in the lead as Roman general Maximus Decimus Meridius. Maximus was a strong and fearsome warrior whose body had borne witness to a life of battle and a life of service to the emperor. He is betrayed by Commodus, played by Joaquin Phoenix, the dangerously ambitious son of Emperor Marcus Aurelius (Richard Harris), whom he kills to take the throne. Under the new regime, Maximus is enslaved and sold into gladiation, where he returns to avenge his slain family and the emperor he viewed as a father figure.

Gladiator became Scott's most significant critical and commercial success, winning five Oscars, including Best Picture and Best Actor for Crowe, and a nomination for Best Director for Scott. The universally lauded computer-generated imagery in the film re-created Rome in a time of splendor and brought actor Oliver Reed, who died during filming, back to life. British visual effects company The Mill created a stunningly lifelike digital re-creation of him for his final scenes. Scott once again reinvented the genre that many thought was no longer viable.

Ahead of *Gladiator*'s release in 2000, Scott was pragmatic about the scale of the process of making the film when asked if he was daunted by re-creating Rome: "You get used to it. Every project has a new set of problems. I knew it would be a large-scale process, but you get so practiced at knowing how to put all the pieces in place and with the right people. It's all to do with hiring. Getting the right people to do things for you and having a relationship with those people. On a film like this, it is a real team thing."[1]

Scott kept an open mind regarding the casting of the film; he had an instinct for what would work almost immediately after meeting prospective actors. "I tend to cast somebody when they walk in the room during the casting session. I have no idea who they are. Usually, I'm interested immediately or not by the first appearance; then it's down to how they do it. And then you can always be totally surprised and have a 180-degree turnaround. That's what's fun about casting."[1]

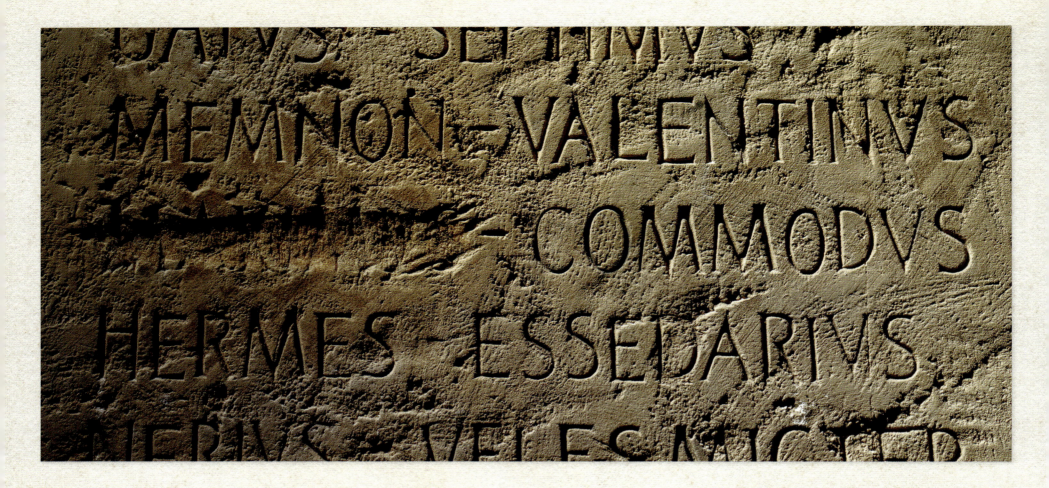

Scott was determined the film would not be an epic battle film that only worked on surface visuals. "I didn't want to go into a film where we just made a film about rock and roll with armor and swords. That was one of the hardest things to get nailed to the wall regarding our film. The character and story stuff stood up as well as the action. And I think that's what I'm happiest about."[1]

In the following years, Scott has been incredibly prolific, making another seventeen feature films, including a return to the worlds of *Alien*, with *Prometheus* (2012) and *Alien: Covenant* (2017), and *Blade Runner*, as executive producer on *Blade Runner 2049* (2017). Until now, though, *Gladiator* has not been revisited. The script for a follow-up to his greatest commercial and critical success had to be just right.

A sequel to *Gladiator* was first suggested in 2001 with returning co-screenwriters John Logan (who later wrote the screenplay for *Alien: Covenant*) and David Franzoni. Many ideas were developed, including Russell Crowe's return to a more contemporary setting or a perspective on the afterlife from Nick Cave. Scott, busy with other films, wondered if the right story would be found after almost twenty-five years had passed. *Gladiator II* was written by regular Scott collaborator David Scarpa, who also penned *All the Money in the World* (2017) and *Napoleon* (2023). The film has a mostly all-new cast headed by Paul Mescal, Denzel Washington, and Pedro Pascal, along with Joseph Quinn and Fred Hechinger. Reprising their roles from the first film as Lucilla and Senator Gracchus, respectively, are Connie Nielsen and Sir Derek Jacobi.

I have had exclusive access to the cast and crew—and thousands of stills, designs, and pieces of conceptual artwork—to give you the ultimate guide to how this epic film was brought to the screen. Since the original *Gladiator*, the cinematic floodgates have opened, with numerous historical action films triumphing at the box office. Now, the king is back to claim the crown.

"A hero will rise . . . again."

PREVIOUS SPREAD

The vast scale of the first film, seen in the plans for the Colosseum and Forum outdoor sets, is matched and surpassed by this ambitious sequel.

ABOVE

Previous battles in the Colosseum are documented in carved rock within the undercroft. The fatal clash between Maximus (Russell Crowe) and Commodus (Joaquin Phoenix) has been defaced.

DIRECTOR'S CHAIR

Sir Ridley Scott, GBE, was born in England on November 30, 1937. He studied at the Royal College of Art, worked at the BBC, and then founded Ridley Scott Associates with his younger brother Tony.

His high-concept visual style of artistic expression was honed in the world of advertising, where he worked on an estimated two thousand commercials. He told *Variety*, "I was out of the era of *Mad Men*."[4]

Scott's first feature film, *The Duellists* (1977), led the way to *Alien* in 1979, and his career has bristled with successes through half a century of filmmaking, but he's always kept active in commercials and recognizes their potency on viewers beyond selling a product. "We were really inventing modern advertising and modern communications. The big question I always ask when making a movie now is, 'Am I communicating?' And if you're not communicating, you won't have a film do business, and our business is about commerce, not art. People at that time said TV commercial breaks were better than the programs. In doing that, I learned to address the most basic question: 'Am I communicating, or am I going over your head?' And that's what all filmmakers face."[4]

Scott's eye for a good film is so finely focused that a single image can propel him to a project. This was the case for the original *Gladiator*. He revealed it was a striking depiction in a Jean-Léon Gérôme painting, which lit the creative light bulb for him, saying it portrayed the Roman Empire "in all its glory and wickedness."[5]

The innovations of the Roman era are not lost on Scott himself, a fellow innovator. "The Roman Empire has interested storytellers from Shakespeare to Stanley Kubrick. The Romans brought us literature, engineering, art and architecture, law, and government. They built everywhere they went. Their armies were stonemasons and warriors; their physical presence is still there to see all over Europe and throughout the Mediterranean."[5]

Many of Scott's films have brought a raw, visceral history to the screen. "First of all, I love doing period films. I love the research. I love to create smells of the period. I think what we did with the first *Gladiator* . . . I don't like being critical of other things that have happened before, but I wasn't the biggest fan of Hollywood Roman epics, honestly. They felt artificial, so it was not very good when I was asked to consider a script. But the person [*Gladiator* producer Doug Wick] who gave it to me said, 'I want to show you one thing,' and he picked up an illustration; this is true; it's called *Pollice Verso*, by Gérôme. He holds it up. It's a picture of this big painting of the Colosseum, and in the corner, there is this guy about to tuna fork this poor bastard. He's got this thing in his neck, and he's looking up for permission to kill. I went, bloody hell, that's never been done properly before. Never. I said, 'I'll do it.' He said, 'You will?' I said, 'Yes.' 'Did you want to read the script?' I said, 'No,' and we went off and hit the ground running around the table and evolved the new material."[3]

The pitch to Scott for the screenplay was perfectly handled. "It's one image that got me. It was the smartest thing to do for them to show me an image, because I'm an image man. I went, 'Oh my God. Yeah. What a good idea. I'll do it.' That was it. To be fair to the writer at that moment, there was a lot of work to be done on that script, and we reworked it."[3]

GREAT SCOTT

Scott has won or been nominated for numerous awards, including three Oscar nominations and, along with his film director brother Tony, received the BAFTA Outstanding British Contribution to Cinema Award. The National Film Registry—and the U.S. Library of Congress—selected *Alien* and *Thelma & Louise* for preservation as "culturally, historically, or aesthetically significant" works.

With an exceptional body of work, Sir Ridley Scott is one of the most prolific, imaginative, and hardworking filmmakers in the business. He was knighted by Queen Elizabeth II in 2003 and appointed Knight Grand Cross of the Most Excellent Order of the British Empire by King Charles III in 2024.

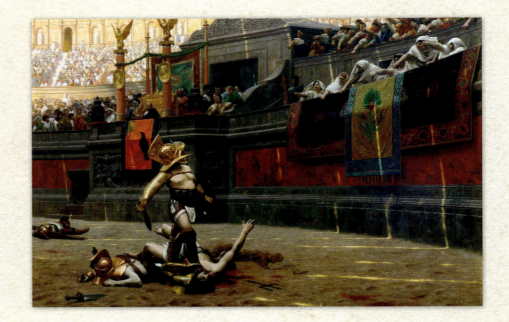

FILMOGRAPHY

The Duellists (1977) Paramount Pictures
Alien (1979) 20th Century Fox
Blade Runner (1982) Warner Bros. Pictures
Legend (1985) Universal Pictures / 20th Century Fox
Someone to Watch Over Me (1987) Columbia Pictures
Black Rain (1989) Paramount Pictures
Thelma & Louise (1991) Metro-Goldwyn-Mayer
1492: Conquest of Paradise (1992) Paramount Pictures
White Squall (1996) Buena Vista Pictures
G.I. Jane (1997) Buena Vista Pictures
Gladiator (2000) DreamWorks Pictures / Universal Pictures
Hannibal (2001) Metro-Goldwyn-Mayer / Universal Pictures
Black Hawk Down (2001) Sony Pictures Releasing
Matchstick Men (2003) Warner Bros. Pictures
Kingdom of Heaven (2005) 20th Century Fox
A Good Year (2006) 20th Century Fox

American Gangster (2007) Universal Pictures
Body of Lies (2008) Warner Bros. Pictures
Robin Hood (2010) Universal Pictures
Prometheus (2012) 20th Century Fox
The Counselor (2013) 20th Century Fox
Exodus: Gods and Kings (2014) 20th Century Fox
The Martian (2015) 20th Century Fox
Alien: Covenant (2017) 20th Century Fox
All the Money in the World (2017)
 Sony Pictures Releasing / STX Entertainment
The Last Duel (2021) 20th Century Studios
House of Gucci (2021) United Artists Releasing /
 Universal Pictures
Napoleon (2023) Sony Pictures Releasing / Apple TV+
Gladiator II (2024) Paramount Pictures / Universal Pictures

ABOVE
Pollice Verso, 1872, by Jean-Léon Gérôme

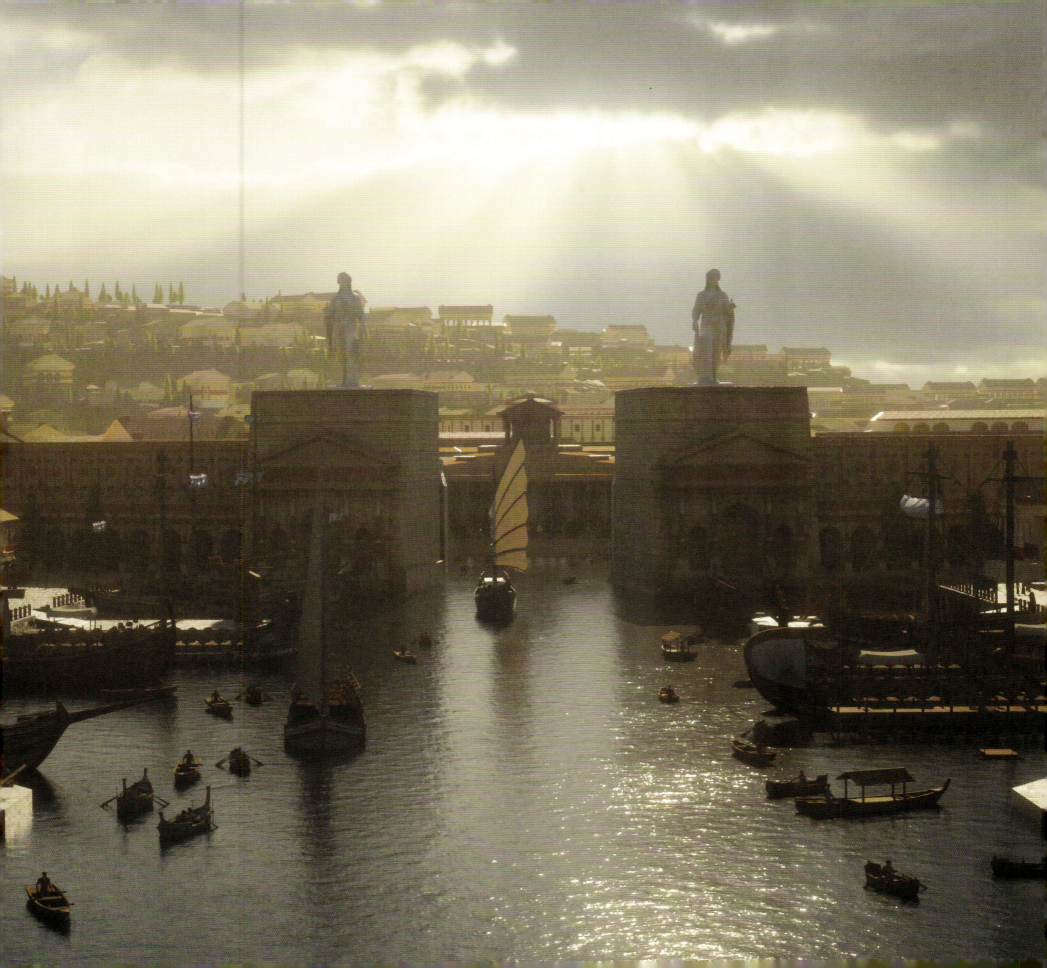

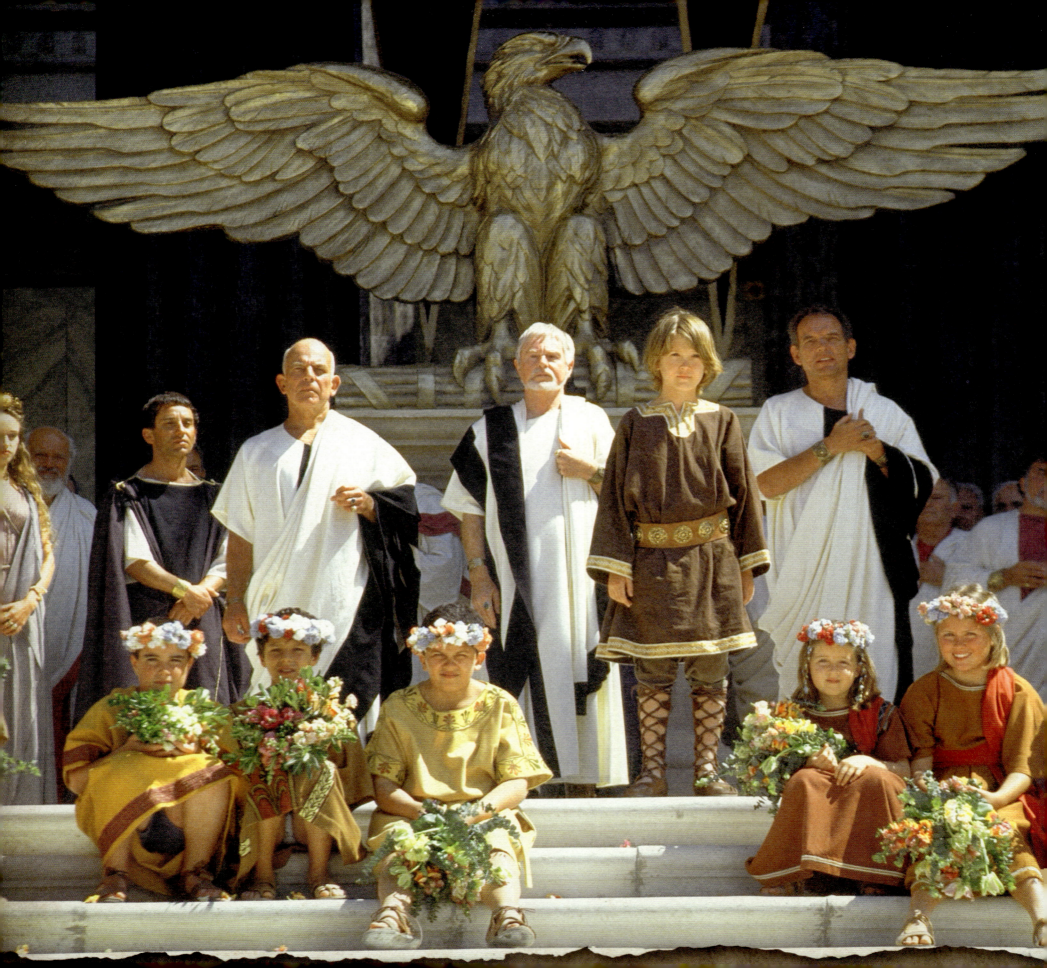

THE ROAD TO ROME

IN THE WAKE OF THE ORIGINAL FILM'S BLAZING TRIUMPH AT THE 2001 OSCARS, TALK OF A SEQUEL BEGAN, WITH PLANS THAT IT WOULD BE SET A DECADE AFTER THE FIRST FILM.

A now-adult Lucius embarks on a journey to uncover the truth about his biological father, set against the backdrop of the Praetorian Guards' reign over Rome.

Plot details emerged in 2002 and featured plans to once again star Russell Crowe as Maximus, whose resurrection was based on extensive research into the afterlife beliefs of the Romans. However, it would be another four years before the next update on the proposed sequel was revealed. This time, the narrative continued the story of the original film's timeline. Crowe supported a fantasy element that would bring Maximus back, but Scott firmly believed that any sequel needed to be grounded in historical accuracy and realism. Scott confirmed plans to reveal Lucius as the son of Maximus and Lucilla at the time, but a more complex parallel narrative of political corruption in Rome was needed.

Many talented people, including Australian musician, writer, and actor Nick Cave, sought to bring a new perspective to the film. Cave's alternative take imagined a story in which Maximus returned to earth after a time in purgatory as an immortal warrior. His return to the realm of the living would see him fighting in the major wars of history, from the Crusades to World War I and II to the Vietnam War. The story would have continued to the present day with Maximus working in the Pentagon. The idea was ultimately passed on by the studios.

The return of cinema's most iconic Roman hero faced numerous hurdles, including the corporate restructuring of DreamWorks Pictures, the film's rights holder, and the subsequent sale of the rights to Paramount Pictures. Plans for the sequel were again put on hold in 2006. It wasn't until more than a decade later, in 2017, that Scott announced the resolution of the issue of resurrecting a deceased character.

Paramount Pictures officially announced in November 2018 that the sequel was in development. The project gained significant momentum with Scott's full support and a fresh script by Oscar-nominated screenwriter Peter Craig. The involvement of these key personnel underscored the sequel's importance and potential, reigniting excitement among fans.

This time, Scott would co-produce with Douglas Wick and Lucy Fisher and bring together Paramount Pictures and Scott Free Productions.

Scott asked screenwriter David Scarpa, who worked with him on *All the Money in the World* and *Napoleon*, to take on *Gladiator II*. A completed script was announced in September 2023, with Maximus's secret son, Lucius, as the protagonist. The story of *Gladiator II* takes place twenty-five years after the original film, centering on the story of Lucius Verus, played by Irish actor Paul Mescal. "Lucius had isolated himself for fifteen years and was in the wilderness," according to Scott, who added, "making no contact even with his mother, who believes he may now be dead."

Scott provided details about the new storyline during the shoot for *Gladiator II*. "The story is based on Lucius as a child sent away to protect him, and he disappeared into North Africa. We now start the story when Lucius is about twenty-eight, and we meet a young man; we've no idea who he is, except he's taken his home, his friends, and even maybe his wife or his lady in a Numidian sea town. We start in the sea town, and the Roman invasion would come and take Numidia easily; they're so dominant. He was taken as prisoner and ironically taken back to Rome, which he hates, and no one in Rome knows who he is."

Scott continued, "We are in the seven hills of Rome, where you're five miles from the Colosseum, and he's been brought here, ironically, to qualify as a kind of athlete gladiator because he was a soldier. He may be bought by a man who buys such fighters. And that man is Macrinus, played by Denzel Washington, who then watches Lucius face a troop of baboons who haven't been fed for two weeks. They're carnivores. They come in, attack eight men, and we see Lucius's survival because of his wild leadership; he's also a natural warrior."

Scott reveals how Lucius connects with the animal instincts of the baboons. "He does something very unusual. In the short time confronted by them, he figures out the components of a baboon's emotions, emulates, bites a baboon, and removes flesh from its arm. A baboon leaps back, and they stand up. All of them suddenly realize it was one-on-one, that their leader, a silverback, is now staring at another man whose opponent he is unafraid of."

SPIRITUAL THREADS

Scott knew the first film's spiritual path struck a chord with audiences and critics alike and wanted to recapture some of that mystery for *Gladiator II*.

"In the spiritual thread in the first *Gladiator*, Russell Crowe actually said on paper that he goes home to his wife and child in heaven, so that's difficult. It's not just shooting the slow motion with dry ice. [We] pulled off a very good view of what heaven might be for him. Heaven is simply a place you want to be forever. Therefore, we saw his home, saw his wife, and saw his child welcome him back into the afterlife. So that was, I think, a real strength that ran through *Gladiator*. I'm not trying to find that thread putting those components together for this.

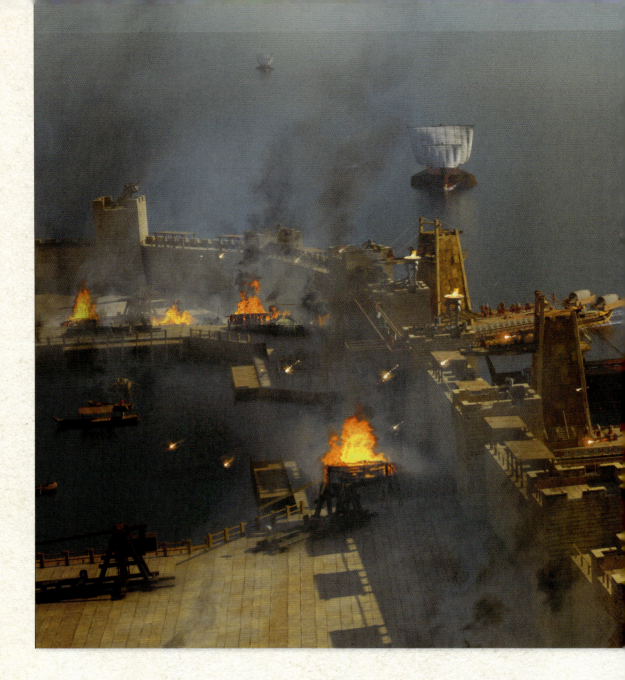

"Back then there were gods, plural, as there were around the world, but I think the Roman Empire at this point had several gods, which shows the fragility of the idea of God in the hereafter. But at this moment, we're already way into the time of Christ, the birth of Christ. But Christ has not yet been a significant threat to other religions.

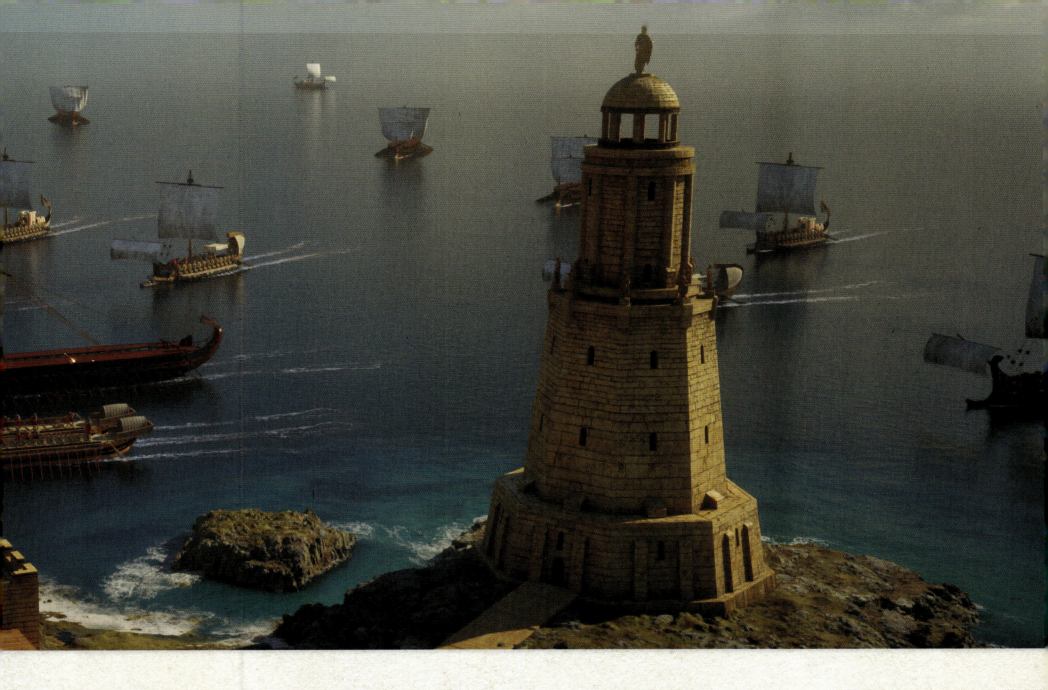

"Lucius, in the battle and the defeat of Namibia, is hit and struck down, and he falls off the wall, which is fifty feet high. He goes into the sea. He goes underneath the ships, we go down with him into blackness, and we find [that] he wakes up moments later on a black sand beach. This is a dark world, almost like Iceland in midwinter, where you get two hours of light and no sunlight. It's just a gray, rather beautiful gloom. And we're going to see him nearly die and then come back. And he nearly passes out and then doesn't, and he comes back. He's washed up on the beach, so we experience him nearly dying, and he sees his loved one was struck in the back because she's an archer and a soldier. We see her go and get on the raft to Styx, where he knows he's lost her forever. Then he's brought back out of that on the beach, captured by Romans. He now finds himself here. So that's the beginning of the possibility of a spiritual story."

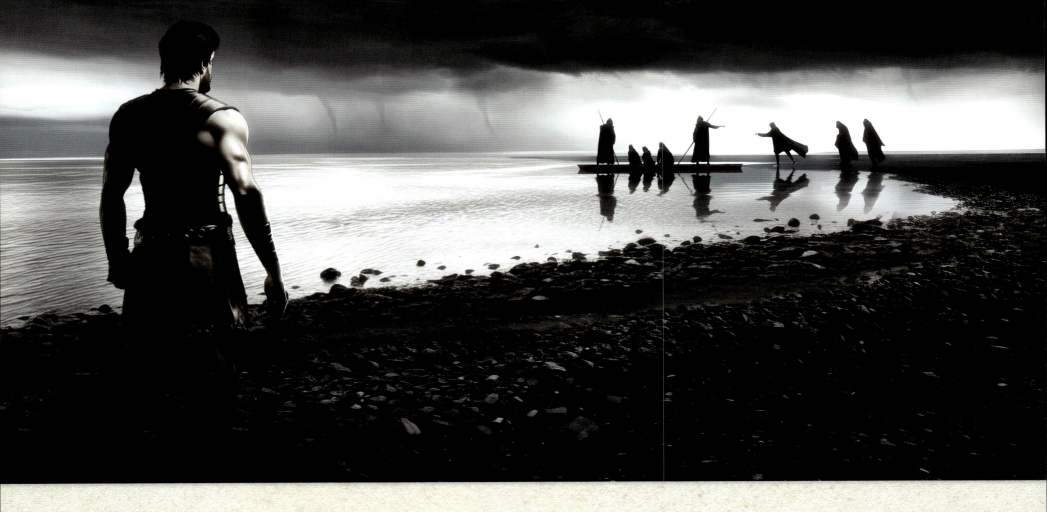

THE PRODUCERS

Douglas Wick, a producer on *Gladiator*, came back for the sequel. With high expectations for a follow-up to the Oscar-winning original, Wick wanted to bring something new to audiences but knew this would be challenging and took a pragmatic approach when the SAG (Screen Actors Guild) and WGA (Writers Guild of America) strikes in 2023 affected the shooting schedule of *Gladiator II*. "Getting a body blow and focusing on the work is difficult. I mean, it's hard. We're making a movie about the fall of Rome, and now we look around at all of our colleagues. All the people who helped build the empire are leaving or coming back, but we all worked for years to get here. And there's a sadness about everyone saying goodbye. So the best attitude you can have is to take the challenge and look for a silver lining."

That silver lining came in the form of an opportunity not usually afforded to an active production and reflected one of Hollywood's most influential founding figures. "Charlie Chaplin always used to schedule reshoots because it was such a luxury. Once you've seen a bunch of footage, pick up something, and say, 'If I only had this shot.' We had that opportunity and made the best of the wait. But it was hard. I mean, it's a real sadness. We're a family. I'm one of the people who was here twenty-five years ago on the first movie, and here we are back in this space. Now we found ourselves in a position where people were leaving in the midst of it. So, I'd say it was a tough time."

After years of working on major motion pictures, starting as a producer on Mike Nichols's classic *Working Girl* (1988), Wick spoke contemplatively about his role as producer and how he deals with a crisis. "The formula is to pause amid the chaos and the noise and try and center yourself. Suddenly, you look up, and you can't see any of the stars, and you're on a little sailboat, and it's storming, and you're trying to figure out what direction to go. And the only really sensible thing is to pause and try and figure out how to navigate. And that starts by looking for a North Star."

Wick was joined on *Gladiator II* by his wife, producer Lucy Fisher, cohead of their production company, Red Wagon Entertainment, where together they've produced a series of acclaimed feature films, including *Stuart Little 2* (2002), *Peter Pan* (2003), *Jarhead* (2005), *RV* (2006), and *The Great Gatsby* (2013). As the crew awaited updates on the pending SAG strike that was materializing at the time, Fisher said, "The fall of Rome, which happened several times throughout history, appeared to be happening as we awaited news from SAG. It was their time after midnight, and yet we still hadn't heard. We had a lot of people, from lepers to senators to our main cast, waiting for our potential last day."

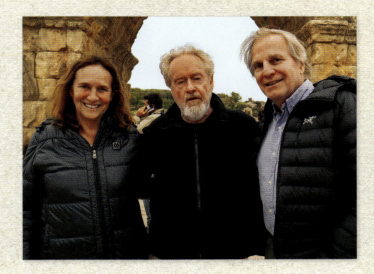

Producer Michael Pruss, president of film production at Scott Free, worked with Sir Ridley Scott on his Napoleon biopic in 2023. Dealing with unknowns is part and parcel of a producer's role. Their success depends on both the situation and their reaction to it. Pruss gave some sage advice on the set of *Gladiator II*. "One of the fundamentals of producing is that you're always trying to anticipate unknowns and problems. And we had known about the strike. What it does is force us to have plan B, plan C, and plan D. It's not just about actors; it's about your crew, it's about your gear, it's about your security, it's about schedules, it's the knock-on effect of not being able to finish the job we'd started. So, as a practical matter, we were thinking about how long the strike would last and if we could stay here and wait this out, enjoy the beaches of Malta, and plan for when we return. A longer strike put us into another unknown territory. And then: Are we sending people back? Are we sending [crew] home and not just cast and our equipment and everything else? There are plans for all of this that have big financial ramifications. It's a stressful time, like every day on a movie set, but this is why we love it. It's like a military operation. It's about executing a

meticulous plan, and sometimes reinventing the plan as you go along. Chaos and magic live side by side."

Only 50 percent of the film had been shot when the SAG strike led to production being suspended. A sequence was being filmed with leading cast members and hundreds of extras inside a replica of the Colosseum when filming was halted on Thursday, July 13, 2023, as actors officially took to striking. It would be nearly four months before the strike was resolved and production could begin again.

TOP
Producers Lucy Fisher and Douglas Wick with Ridley Scott (center)

BOTTOM
Actor Fred Hechinger with producer Michael Pruss

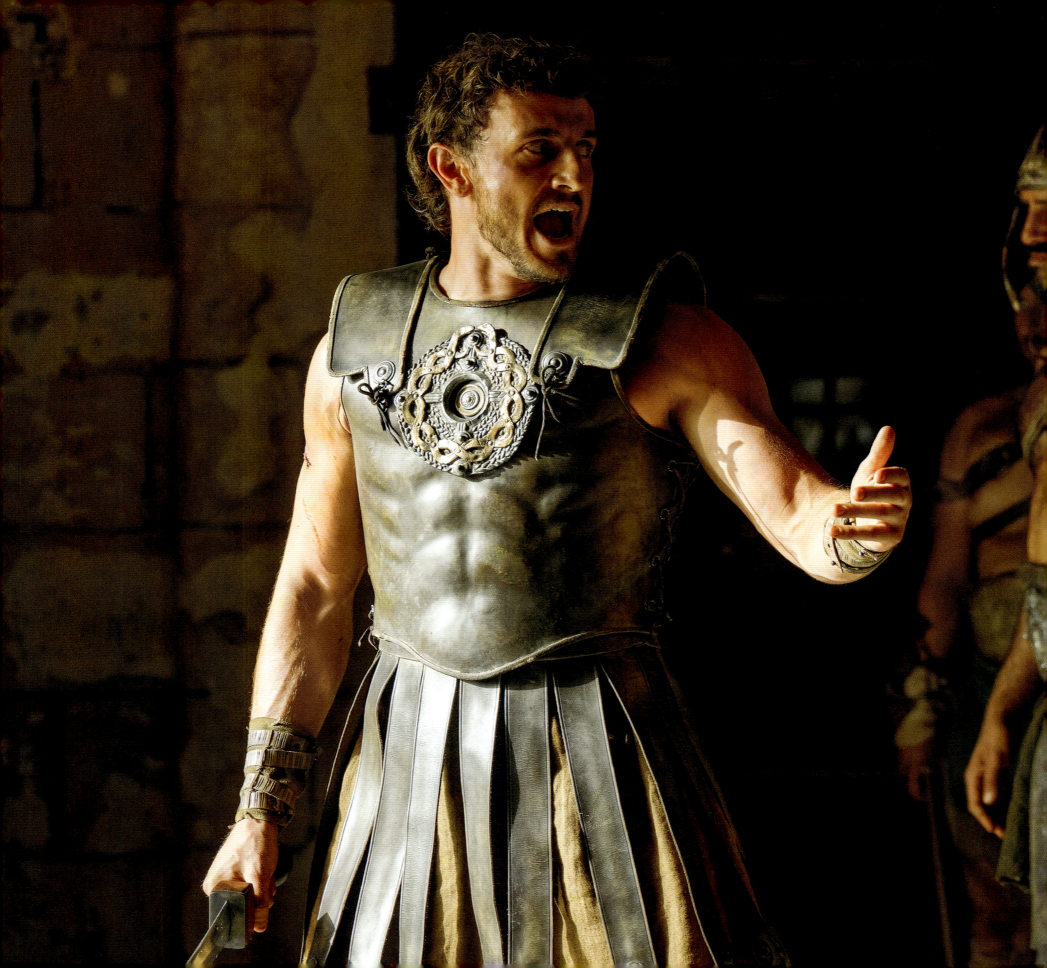

I

THE CAST

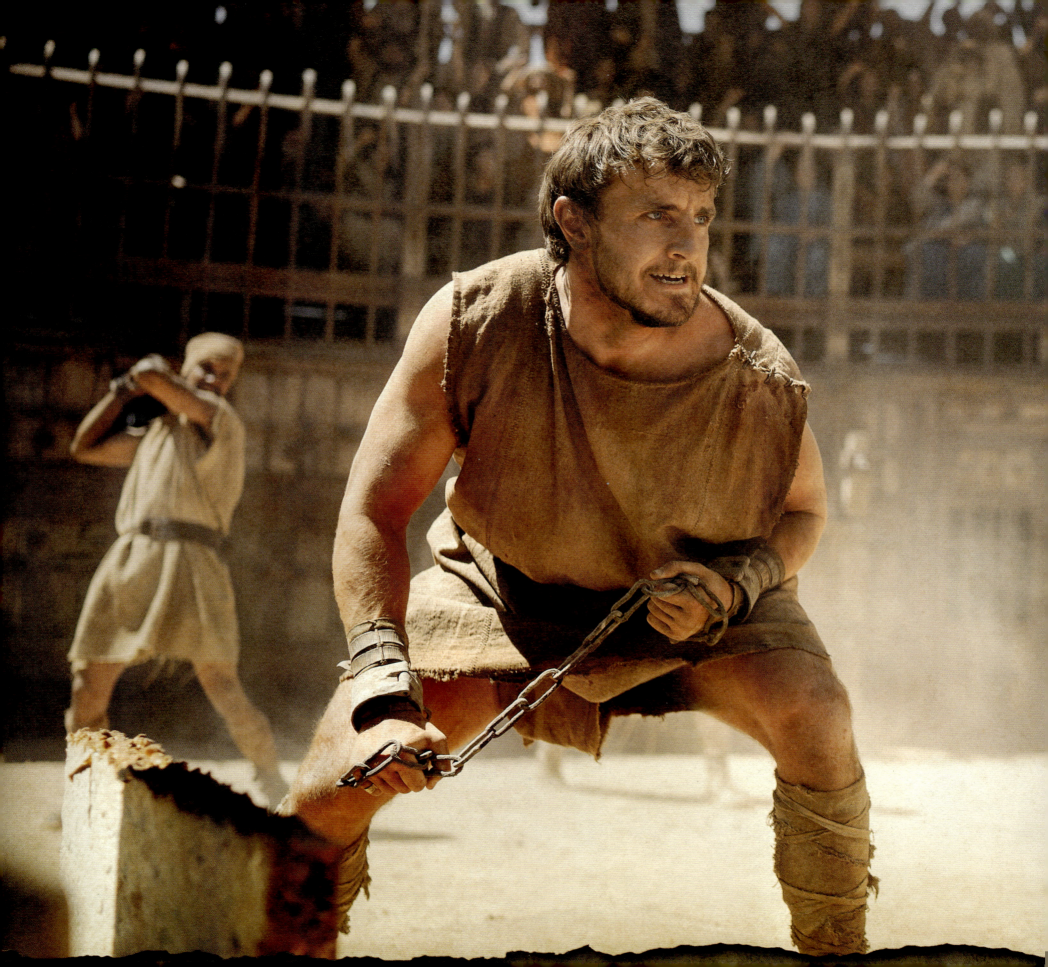

PAUL MESCAL AS LUCIUS

Paul Mescal, in his first period drama, is new to the world of *Gladiator*. On set, he discussed the challenges and rewards of his scenes with his on-screen mother, Lucilla, played by Connie Nielsen. "The obvious version of the scene is that it's a rekindling of a mother-and-son relationship, but I don't think it's as simple as that. I think he feels somewhat deserted. And that distance is an important or useful tool and kind of establishes tension. I think it's always more interesting when things are less sentimental—and Ridley's good at that. And I like working that way."

The intricate relationship between Lucius and his mother forms the crux of the film's drama. "My mother's grief is feeling like she's deserted her son, and the son feels somewhat deserted but also wanting. That's why . . . what they plan to do to you in that scene is very important because it's him reaching out to her in a repressed way. Even though [Lucius] talks about betrayal, he's hurt. I think [when] somebody is around violence all the time and is used to it, it's much easier to exist in an arena of pain, hurt, and betrayal. But, actually, what he's feeling is wanting to forgive and relieve."

THE ARENA

Mescal appreciated the vast scale and scope of the arena in the film. When asked "How does it feel?" he responded briefly but with passion: "Ominous. Exciting. Hot. Epic." To keep his energy up in the high temperatures, he was drinking electrolytes "because it's hot as fuck." His character does not always triumph, but Mescal is pragmatic about that. "I feel like it's a futile battle that I'm gonna lose today. But, yeah, it's good."

Pedro Pascal costars in the role of Acacius. In a scene of confrontation between the two leads, Pascal revealed, "The moral complexity between Lucius and Acacius is one that I find motivates [Lucius's] thirst for revenge, [Acacius's] existence, and, ultimately, forgiveness."

Pascal explained that the complexities of family and loyalty are key to the relationship between the two. "[Lucius's] mother is my love. And his father was my mentor. I became the general of Rome under his father, Maximus. So it's like fighting my son in a way. It's the ultimate failure from my end. I was meant to protect Lucius, and I didn't. We must compress our entire history into a fight in the arena, which is interesting."

For Mescal, the role of Lucius made him reevaluate everything he believed up until that moment on set. "To go from the person that I want to kill most in the world to then turning around and calling him a hero of Rome dramatically is quite difficult to get to. But it was fun to play."

KNEEL

In one of the film's standout moments of drama, Lucius kneels in front of Acacius, which was not in the final shooting script. Mescal explained his motivation here. "I wanted to

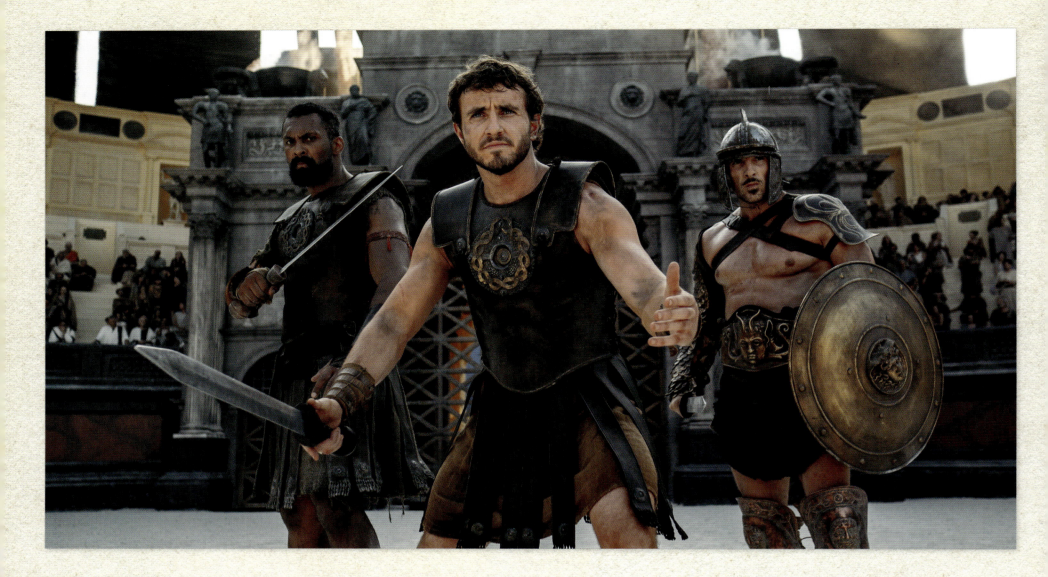

kneel because it's such a big pivot that I felt like it needed a big gesture. I feel it's dangerously overplaying potentially being cheesy, but it didn't feel cheesy doing it . . . I indulged the sentimental bone that I have in me that when I asked Ridley if he liked it or not, he said he was afraid that he did."

THE CROWD

These scenes of intimacy are played out to a Roman crowd of thousands. "The crowd is everything," explained Pascal. "The way that the crowd plays into this scene is what informs us. It's about everything being on a specific kind of stage, which is meant to be played for a crowd, what the emperor's intentions are, and the backstories [that lead] up to this." Mescal sees the larger societal backdrop to the scene. "It's not like the crowd is invested in both. It becomes political. And it's all theater—political theater."

> "ROME. THE ENSLAVER. THE DESTROYER. THEY HAVE NO LANDS BUT THE ONES THEY HAVE STOLEN."
> —LUCIUS

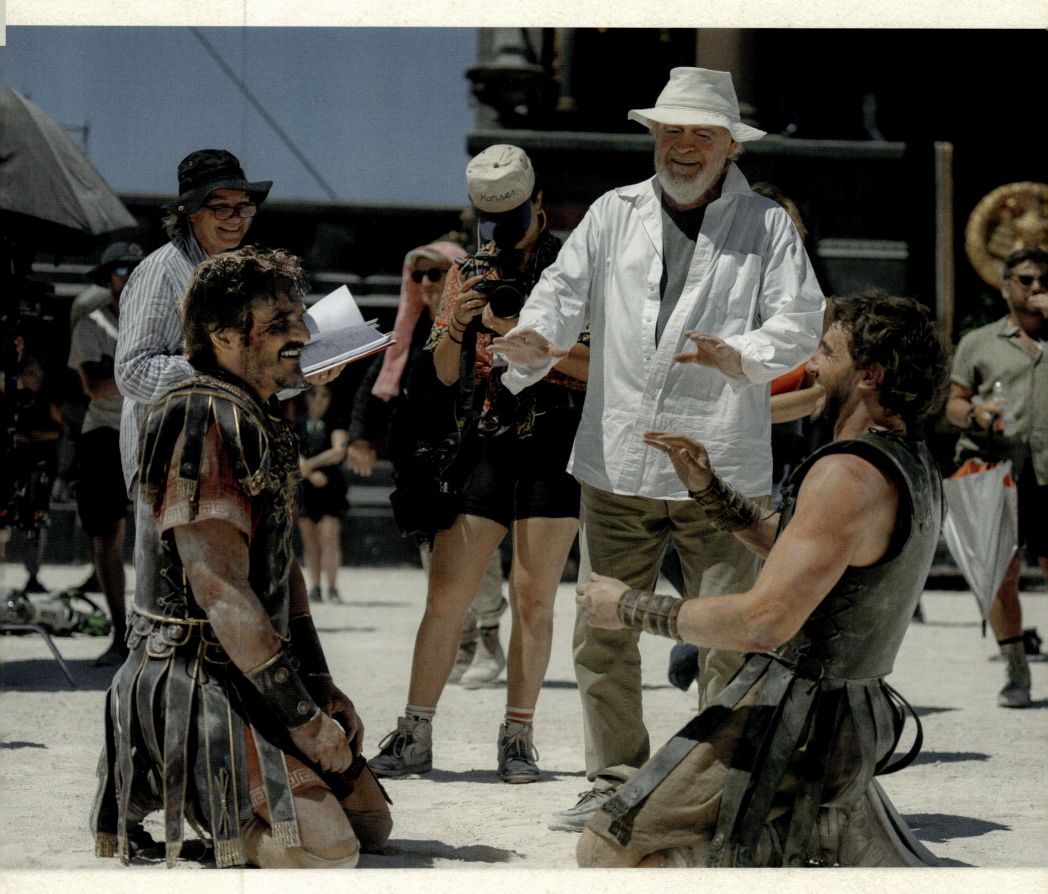

CHAPTER I: THE CAST 27

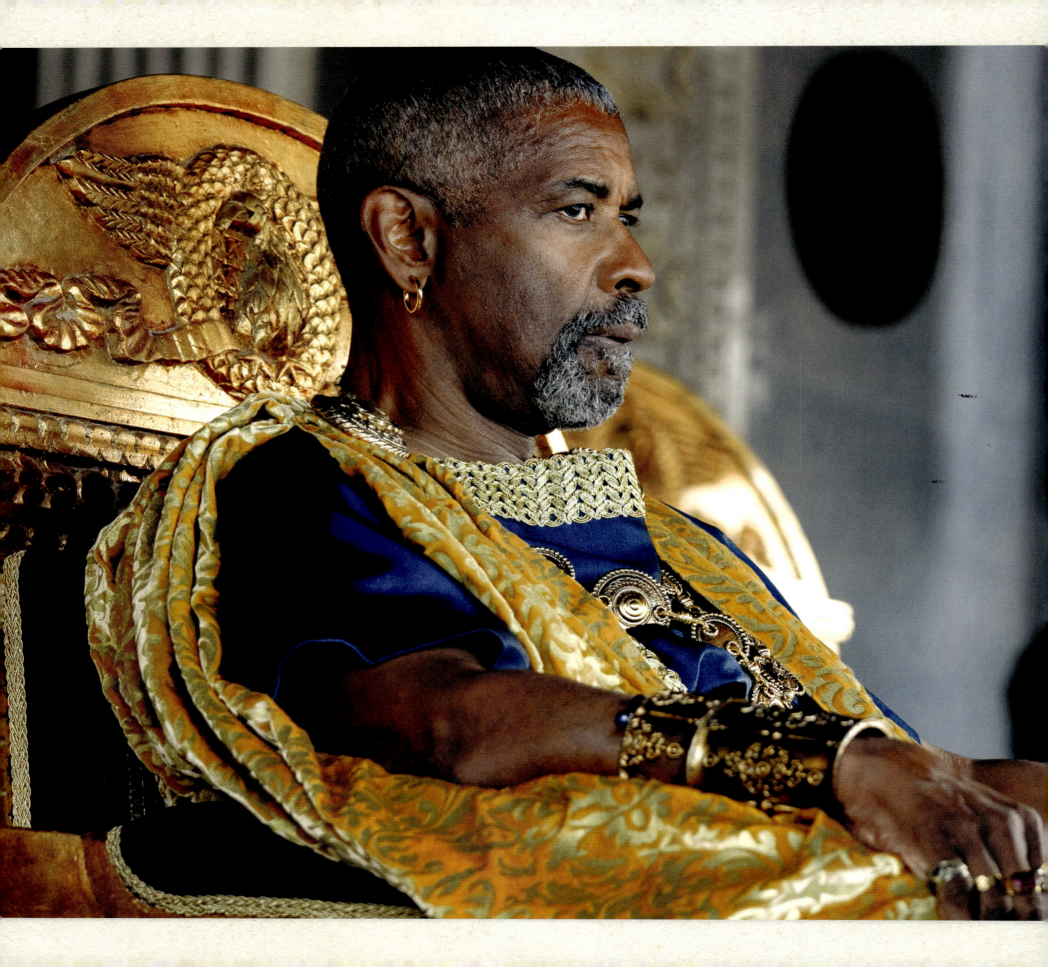

DENZEL WASHINGTON AS MACRINUS

Gladiator II marked the second collaboration between two-time Oscar winner Denzel Washington and Sir Ridley Scott (the first being their 2007 film *American Gangster*). Scott revealed the motivation behind Washington's character in the film. "As for Denzel's character, there were businesses for gladiators who could indeed earn their freedom if they stayed alive. That was the deal, so we went right into that in-depth. Where did he come from? How was he taken? He was branded with marks and registered with a brand on his chest as an enslaved person. So that's how he comes into the story."[6]

The theme of slavery is a visceral motivator in *Gladiator*, and the road to a man winning back his freedom was the central theme of the first film. When we meet Washington's character, we see his road to freedom has already been walked. "He's a rich guy who's still carrying a grudge," says Scott, which drives his narrative. Scott was delighted to work with one of the world's great actors for a second time. "I respect Denzel Washington tremendously. I shouldn't call Denzel a golden oldie—he'd fucking kill me—but he's gold dust."[6]

Washington's decision to take the part was a simple one. "Ridley Scott called and said, 'Are you interested?' And that was enough. It's a fascinating time, period." For Washington, he relished playing the part of Macrinus, whose villainy is a far cry from his usual on-screen personas. "Power. I don't know if he's evil. The power behind the throne is kept by any means necessary. I don't know if he had his eye on the throne. But I think he preferred to manipulate, where he could be the puppet master. He was bitter about his past, overcame it, thrived, and was well taught. He uses everyone. He doesn't love anyone. If they're not a part of what can make him better or more powerful, he has no use for them." When Macrinus first sees Lucius, he makes an impression. "He sees his ability. He sees himself in him. He's a natural-born leader. He's a great fighter. And he's useful."

Washington recognized Scott's exceptional ability for world-building on a vast scale while also paying attention to the details and casting choices. "All credit to Ridley. He put a wonderful cast together. He painted the canvas. There are all types of people and talents, and I think it seemed like the whole was bigger than any of us individuals. It helps so much with the clothes and the environment where we are. Everywhere you look feels like history.

"Ridley's a genius, like his late, great brother." [Washington worked with director Tony Scott on five films: *Crimson Tide* (1995), *Man on Fire* (2004), *Déjà Vu* (2006), *The Taking of Pelham 123* (2009), and *Unstoppable* (2010).] Washington felt a strong bond with Tony. "Creatively, we're soulmates." But working with Ridley for a second time excited him. "It's more than an opportunity; it's a pleasure. He's a national treasure. I know he'd hate me saying those kinds of things." On *Gladiator II*, Washington felt secure in Scott's hands. "He's a visionary. I don't have to think or worry about anything. Just put on the costume and do my part."

COSTUME

Costume designer Janty Yates, who won an Oscar for her work on the first film, came back for the sequel, and Washington was thrilled with her design for his character. "She is a genius and just the sweetest. She looks worried about whether I'll be pleased. But she's so talented, and I told her I hope we get to work together again, because she's one of the great ones." Yates is a frequent collaborator with Scott, having worked on fifteen feature films with him, and the same is true of many of the other creatives working on this film, which Washington recognized in their styles of communication. "There's a shorthand to it. They get on with it. They know what they're doing. They're extremely talented."

EPIC CINEMA

This film's colossal scale and cost are not lost on Washington, a producer and director in his own right. "This is the biggest film I've been on. It's the biggest budget. It's huge. It's Cecil B. DeMille on steroids. Ridley's not going to have a hundred guys; he's going to have a thousand of them. He won't have twenty horses; he will have twenty *scores* of horses. It makes my job easy. Everywhere you turn, you feel like you're in that world." Washington recalled the epic films from his youth. "I was looking at all those Roman soldiers coming down the hill and thinking about all those old movies, [like] *King of Kings* [1961] and *The Ten Commandments*. It just feels like those big movies. It makes it easier for me as an actor to slip into. It's a reflection of Ridley. His crews make it easy to get on with it. Everybody's pitching in; that's how I like it."

SWORD PLAY

Washington had horse riding and sword fighting to contend with as Macrinus, but he took this in stride. "I have a great stunt double, Clay. He's been with me for a while, and Clay is a brilliant horseman and a gentleman and can fight. That was fun, too, going in every morning. We were practicing swordplay, and you put the gear on and stood there. Even my horse looked at me like, 'Hey, I know what I'm doing.' I was trying to get him to go one way. He turned. He almost looked at me like, 'You think this is my first film or something?' It was all fun. And they pay me. [LAUGHS] Shhh! Don't tell anybody."

COLOSSEUM

Despite being a film industry veteran, Washington admitted to being amazed by the production's scale. "It was all a spectacle, just the size of the damn Colosseum. I was like, 'They built the Colosseum!' [LAUGHS] I'm like, 'Man, can they use that for another film? Will it stay up?' I won't say this grand scale is an intimate film, but it is all about the relationships. We have wonderful players and a great script. Let's not forget

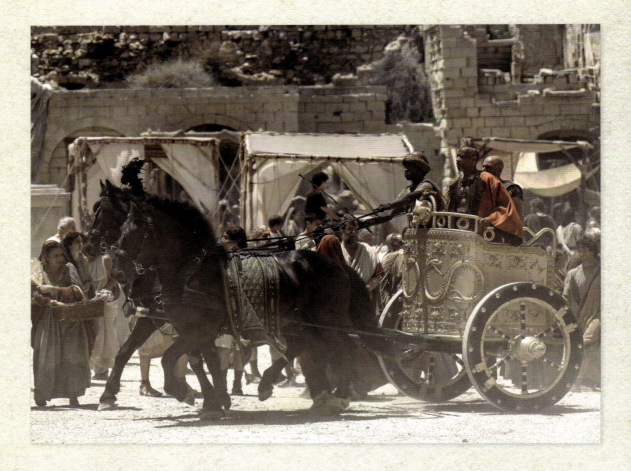

we had a great jumping-off point. And to the writer's credit, he was flexible. I changed a line or two, but everybody was in it for what's best for the film, as it should be."

PLAYING THE VILLAIN

Heroes may dominate in terms of screen time, but actors often feel that more layers and pleasure can be derived from playing the bad guy. Washington had a unique take on approaching a villainous persona, saying he does so "by not playing one." He went on, "I don't know what a villain is. [Macrinus] thinks he knows he's right, even if everybody else is wrong. I don't know what a villain is because nobody's born a villain. It's a life experience. Maybe some people are. Perhaps some people are just bad right out of the womb. They come out and slap their mother. But we're products, if clichéd to say, of our environment. A slave doesn't dream of freedom but of having a slave of his own. That's how he

> "THE GODS WANT ROME REBORN. THEY SENT ME TO FULFILL THAT TASK."
> —MACRINUS

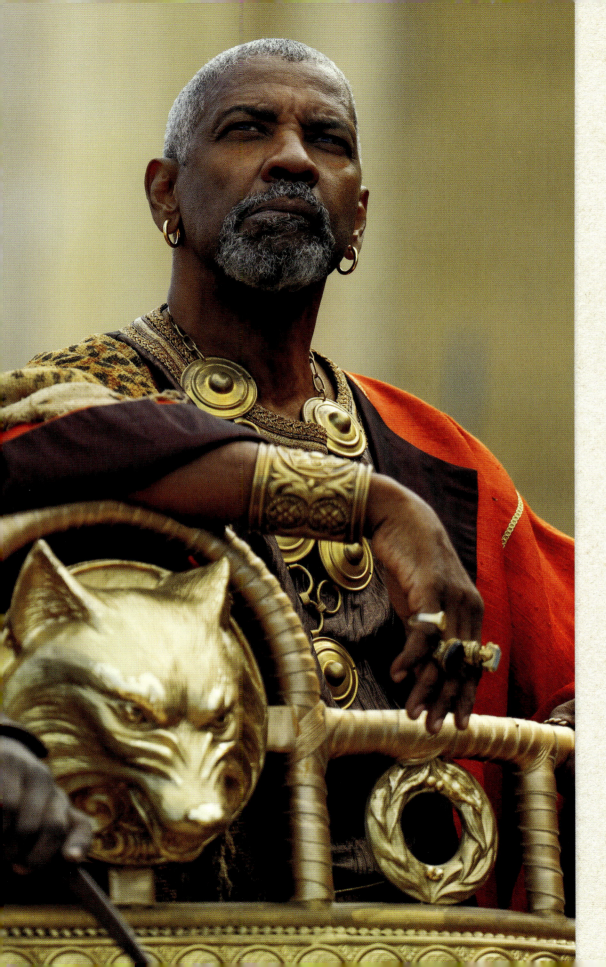

was raised. First, he, Macrinus, is an ex-slave who graduated from gladiator. He did pretty well, and I don't think he did it through evil or villainy, but he got drunk with power. And it became easier to take. It is an addictive drug. Taking and getting away with it, or taking and intimidating and creating fear and dominating, and all those kinds of things are almost like a drug that you then need—can't live without. I don't think an evil man is satisfied until he's dead. And in his heart of hearts, that's really what he wants. But he'll take advantage of anyone afraid of that or [who] doesn't recognize that they're scared of it. So I wonder if that's evil. But we see it every day. Not to this degree, hopefully, but you know that's in us, every one of us. That balance with Spike Lee's movie *Do the Right Thing* [1989]. We can choose to do right or wrong. It feels good once we go over to the other side, and [Macrinus] needs more of it. The happiest moment in Macrinus's life is his last breath."

DREAMS

Marcus Aurelius spoke of dreams in *Gladiator*, and they're a crucial part of the franchise's visual narrative. According to Washington, Macrinus takes a pragmatic approach. "He had no time for dreams. It was a brutal life. You waste your time. First, you must be asleep to dream or in a daydream. And in this world, you can get your head chopped off dreaming. He's just a taker. He takes advantage of every situation. Even that can start as a good thing, such as taking education. But once he had a taste for it—I don't want to say evil, but once he had a taste for taking, he became addicted. He had to have more.

"He wants to control the situation. He didn't want to be the emperor; he wanted to control the emperors. That's more power for him to control, manipulate, and dominate in that sense, and he's quite the actor. He's always bad. He's 'I'm not worthy.' There's a little Uriah Heep in there [a character in Charles Dickens's novel *David Copperfield*, Heep is Copperfield's clerk who pretends to be humble to disguise his attempt to cheat him]. But don't turn your back on me."

PEDRO PASCAL AS ACACIUS AURELIUS

Chilean American actor Pedro Pascal is best known to millions as Din Djarin—the titular character in the Disney+ Star Wars series *The Mandalorian*—and as Joel in HBO's groundbreaking drama series *The Last of Us*. In *Gladiator II*, he stepped into the role of a noble and proud Roman general, and he was keen to share his character Acacius's story arc. "The movie starts with the Roman Empire, led by General Acacius, invading Numidia [in North Africa], where our lead, played by Paul Mescal, is hiding out. It's just a perfect way to start the movie and, in my eyes, an incredible homage to how the first movie starts. It was a ground invasion with the barbarians on horses. And this time, we're on ships [with] fireballs, waves, rowing men, arrows, bells, and whistles. And Acacius is the general of Rome. He's leading the army into the invasion."

RIDLEY SCOTT

Pascal was keen to work with one of cinema's great filmmakers. "What got me interested in the movie are such big and obvious things, one being Ridley Scott and two being the first movie. I saw the first movie multiple times in the movie theater when it was released in 2000. I grew up watching Ridley's movies. He might be the only director that I can say has multiple films in my top ten. I'd be in anything under his lens.

"I find Ridley to be the hardest-working man in Hollywood and the most direct, challenging, [and] charming. I think he is this incredible contradiction of having such specificity in terms of the visual setup, where the cameras are and what the lighting is. The smoke, the production pieces, and the entire composition of it are practically compulsive. And yet he delights utterly at the spontaneity that an actor will develop something that he would never have thought of himself. It has to be such a controlled environment to be as big as it is. And yet, somehow, he finds a way to keep it completely organic and spontaneous in the moment, which is why the performances are always so good."

Pascal reveled in the unique experience and complexity of a Scott production. "Something about Ridley, which you will not find on another set, is that [he leaves nothing] to the imagination. I will probably not experience something like this again. There isn't going to be another time where I'm at the back of a Roman ship—and all the rowers are there and all the archers are there—and I can see the wall, all the soldiers, and all the people that were invading. There are just hundreds of extras, and it's all like start to finish once he says, 'Action!' All these moving parts are playing out right before you, and you're not making any of it up in your head. It's all there. That's never happened to me before, and it's not likely to happen to me again."

SCRIPT

The original film's impact was imprinted on Pascal, and any association with it interested him. "What makes the original so memorable and the reason behind its major impact, I think, is that it's classic Hollywood cinema with emotionally rich characters, performances, and storytelling. There's something grand in its scope; [it's] elegant, sophisticated, bloody, and sexy. Instead of being long and expensive, it's incredibly profoundly entertaining, thrilling, and moving."

STORYBOARDS

The detailed screenplay offered Pascal all the research he needed, but he found the visual imagery of the storyboard enlightening. "I found everything I needed was on the page, including what I knew about the first movie and how much we think about the Roman Empire. I was allowed to look at storyboards that Ridley illustrated to get [further] inside the vision he had for the movie."

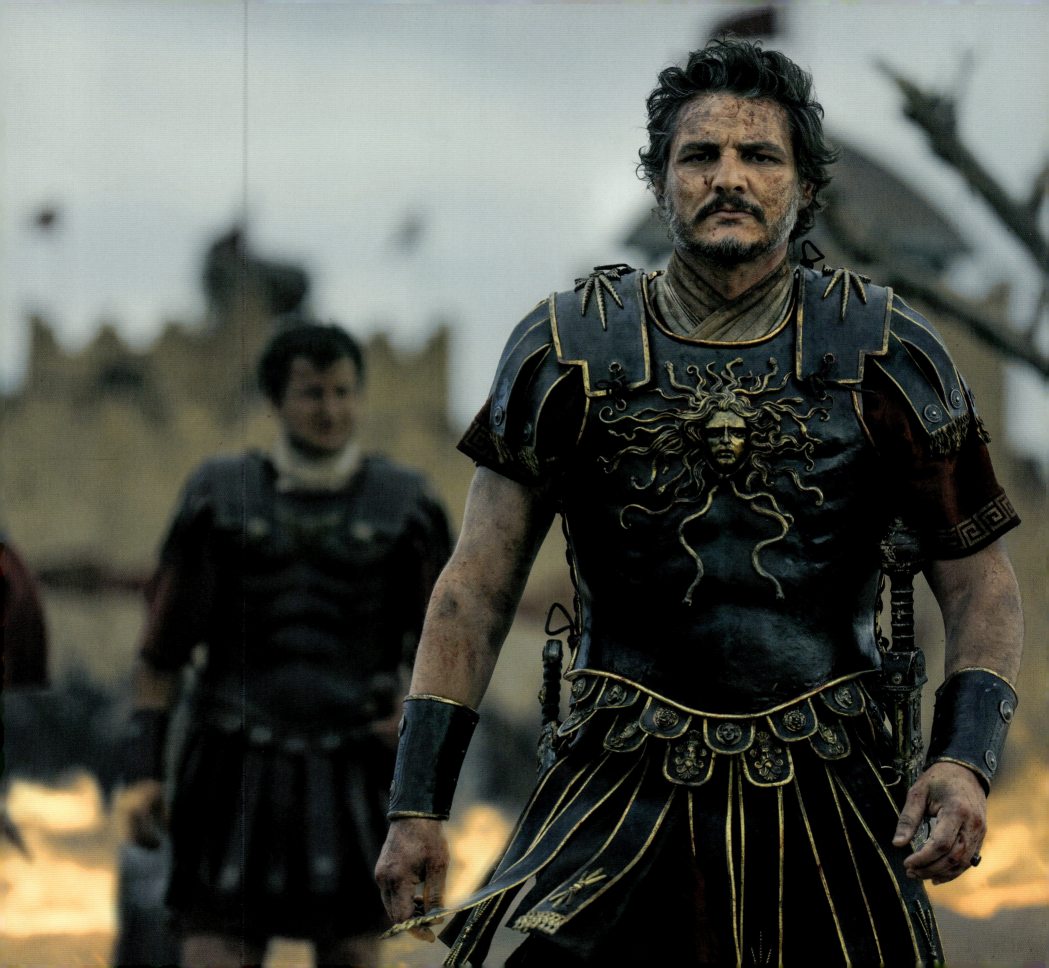

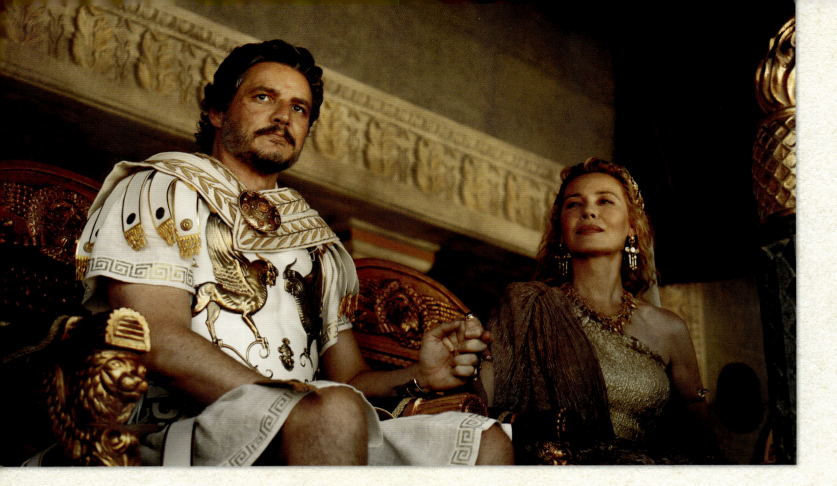

GENERAL ACACIUS'S MOTIVES

Finding the heart and soul of the character is what drives Pascal in all his roles, and he especially enjoyed the duplicity of Acacius. "One of the things that I love about the movie and about the character that you have to pay attention to is where his alliances are and why he has those alliances. In the movie's introduction, [we see] the Roman army and this character leading them. You are wondering whose side [he's] on. Pascal realizes the audience will pick sides once they know the character's motivation. We are the enemy, and once you realize that, we are starting the movie. So this man is a villain, but we follow him into Rome, meet the two emperors, and realize that Acacius is our key to Lucilla to bring back a beloved character from the first movie. Oh, no, wait a minute. He's a good guy. He protects her. He loves her. The emperors are evil. And [the story] continues playing those tricks with us, which I love. And I love playing a character that is an instrument, misleading people."

LUCILLA

Pascal's scenes with the film's leading lady were among his most enjoyable. "Connie Nielsen, to me, is iconic in the role of Lucilla in the first movie and, if I'm being honest, totally my favorite character. I find her to be the most complex, and I've been having conversations with her from the perspective of Acacius and my personal opinions. She's the smartest person in the room and has found complex ways to navigate her existence in a world of men and to survive. There isn't anybody like her who can fill those shoes within this world."

COSTUME

The clothes maketh the man, as far as Pascal is concerned. "In movies like this one, I think that the important departments of costume design, hair, and makeup tell as much of the story as do the words on the page. I wouldn't have a

"THE BALLISTA IS MY FIST. THE CATAPULT MY ELBOW."
—ACACIUS

character if it weren't for my clothing and appearance. It is the best I've ever looked. These are the highest talents out there, yet they still give the space to collaborate and fit the design to each character. Everybody looks wonderful. But I look particularly good. I got the best costumes in the movie."

PRODUCTION DESIGN

Having worked on many expansive, big-budget films, Pascal knows the extent to which behind-the-scenes skills are involved in world-building. "Arthur Max's production design is essential. There are so many moving parts that if you remove one of them, the whole thing falls apart, and Ridley knows that. That's why he's so confident placing so many cameras in different places to catch the action from start to finish. The production design is unmatched, and so are the costumes, hair, and makeup. Because of everyone who goes into creating this world, very little is left to the imagination as you're doing it. You're not looking at a tennis ball at the end of a pole. You're seeing it all play out, and it's epic!"

SWORD FIGHTING

Although stunt performers handled the most dangerous moments, members of the main cast did have to get physically in shape and work closely with the stunt teams for close-up work and play-fighting. "I was sword fighting. And to be frank, I'm getting a little old for this level of sword fighting and hand-to-hand combat and one-on-one combat, especially if [my opponents] happen to be more than twenty years younger than [me] and a hell of a lot stronger. I'm too old to get my ass kicked like this. But there's lots and lots of sword fighting. It's a very physical role and likely to be the last one I do."

The level of training was comprehensive to keep performers as safe as possible in potentially risky scenarios. "There's an incredible stunt team—the most talented I've seen, and I've been around such incredible stunt teams and a lot of fight choreography. I, as the general of Rome, [play] somebody who enmeshes himself physically in these battles, unfortunately. [It would] be nicer if he just sort of, like, hung back and gave orders. But he gets into the shit, and that meant a lot of physical fighting, some of it specifically rehearsed, and some of it created spontaneously on the fly and in the moment because of how brilliant our stuntmen are and how quickly they can teach you something."

THE EMPEROR'S GAMES

Acacius attends the gladiator games, but Pascal felt that it wasn't something his character particularly enjoyed. "I think there's an irony that Rome celebrates General Acacius for conquering another region and then holds games in the Colosseum in his honor. But General Acacius is not one for games. He's one for battle. And he doesn't like the demonstration, especially if it's in his name and he's fighting for people he doesn't believe in. So it's not his style, but he can't look away."

Acacius and Lucius battle each other in the arena, with Pascal candid about the outcome from his younger and stronger opponent. "I got my ass kicked! I call [Paul Mescal] Brick Wall Paul. It was like throwing myself up against a brick wall. It's a very exciting moment in the story [when] Lucius finally gets to his goal of fighting and hopefully killing General Acacius for the murder of his wife and the conquering of his people and land. The part of the world that he's integrated himself into and built his life into. It was particularly challenging to see scenes with hundreds of people battling one another, [but it was] even more challenging to see a one-on-one fight for me. At the same time, it is particularly fun because it's like a violent kind of dance or a dramatic scene with a wonderful scene partner. Paul and I didn't have a lot of words; we had a lot of punches and tackles. That was our language. Again, I want to emphasize the age difference here."

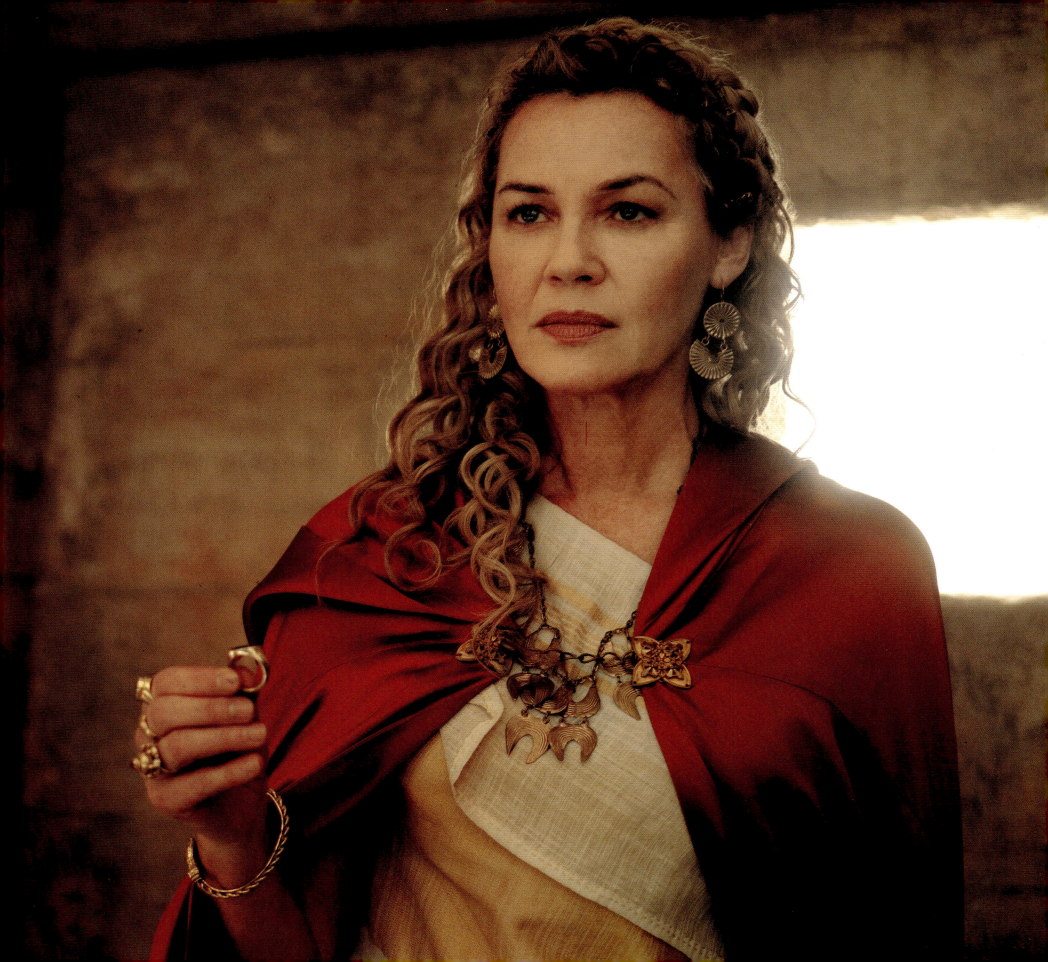

CONNIE NIELSEN AS LUCILLA

Danish actor Connie Nielsen, known for her compelling performances, is one of two performers returning from the original film, the other being British actor Sir Derek Jacobi. In the sequel, Nielsen reprises her role as Lucilla, daughter of Marcus Aurelius and former lover of Maximus. With her complex motivations and unique journey, Nielsen's character is a crucial element that draws audiences back to this world. "It speaks to a deep yearning in people that goes through history for an equitable and fair society and the willingness of people to sacrifice for that equitable, fair society. The love story was something that was out of their hands, out of their control. I think a lot of people have felt that. I've had many women come up to me and say when you said that line, it was like you spoke about my life. So there were lines in there that people felt seen by."

RETURNING TO ROME

The challenge in returning to the character was finding something new to say. "I was worried about how they would build a story now that Commodus and Maximus are dead. I could not believe what they came up with. It was so brilliant, and I thought it would be a fantastic situation for me as a character. And it's also something that . . . really, really speaks to a kind of deep human experience—in my case, motherhood—and, again, sacrifice. And this extraordinary thing of having to sacrifice something that is the most important thing in your life. I felt that that was a compelling story to be a part of and play."

Lucilla's story during the twenty years between films has not been without turmoil. "Lucilla and Rome have been through twenty years of upheaval. From the moment Commodus died, there have been pretenders to the throne. She immediately understood that this upheaval could cost the life of her son, who is a true heir to the throne. She yearns for a benevolent democracy, a *real* democracy. Instead, she has been through the madness of several power-hungry people who have just bought power and put their sons in charge. You continue to see these people who have realized that if they can buy the Praetorian Guards, they can buy the emperorship. And this is Rome, which is chaotic at the film's start. It is also a historical fact that after Commodus died, that was the end. After the death of Marcus Aurelius, five decades of a golden period of Rome with benevolent emperors was [over] like that. They call it the Five Good Emperors. Now we have jumped into this abyss of chaos, and we are almost seeing Rome become a sewer, where any good values that underpin a fair and equitable society have given way to corruption, selfishness, and a total lack of values."

LUCILLA AND ACACIUS

A woman navigating the corridors of power in a male-dominated Rome brings drama and tension to the scenes involving Lucilla and Acacius. "I have found myself, as the daughter of a former Caesar, [to be a] kind of political pawn that can be trotted out and used. And at the same time, Lucilla is fully aware that this is how she can survive. She has found a love that she never expected to feel. Acacius, a former comrade of Maximus's, has not only become her champion but is the leading general and leader of the army in this quest to continue to expand the empire and to get more money by taking over more colonies. Acacius is forced to operate as a general and champion of an empire he no longer believes in. But he does it for one reason only. He hopes that, together, he and I can bring back the republic, that we can topple these horrible people who have usurped a power they have no legitimacy for."

NEW EMPERORS

Rome's leadership is pivotal to the narrative in *Gladiator II*, and the new controllers of power bring the story to new heights of drama. "Rome had its share of crazy leaders. Despite the many poisonings and assassinations we hear of today, the people during this time were especially insane. And they subjected not just the people but anyone close to power to extraordinary abuses. We see what happens in societies where these abuses are allowed; the only thing it begets is more abuse. There is no appeasing a tyrant. You see how Caracalla and Geta are these unbelievably corrupt people, one of whom is truly unhinged. You've given them this absolute power. And we all know that is probably the worst thing you can do. It's like taking a person and creating an evil child. And that's what you have. You have these two emperors who are like evil children, and you have to survive but also somehow create a coherent state under these crazy people."

LUCILLA AND MACRINUS

Nielsen recognized Lucilla and Macrinus have a solid on-screen dynamic early into filming. "Lucilla and Macrinus are two animals of power. They both immediately see each other's capacity for statesmanship. They both immediately recognize the other person's danger, and they are never going to be friends. They both know that and have opposite ideas about what power is. Is this how power is supposed to be wielded? To Lucilla, power is something that you can only use in the name of the people and only if the people have given that action legitimacy. However, to Macrinus, power has something to do with his ego . . . with how to feel powerful over everyone, and [it is] something that, therefore, is consumed only by him and not in the name of the collective. And those two feelings, those two positions are vying for power.

Denzel Washington's Macrinus is a charlatan figure who is far more complex than he first appears to Lucilla. "Macrinus is another pretender. He's one of those people in history that did exist. Macrinus is someone who has found a way to ingratiate himself into power. The Praetorian Guards can be bought. So it's easy to undermine and turn Caracalla and Geta's inner circle against each other, making them vulnerable to being removed from power. Macrinus is one of those people who has figured out how to use the Colosseum and the gladiators to ingratiate himself first with the emperors and, once he is in, to start turning people against each other and isolating these two kids to the point where they become vulnerable themselves."

Nielsen discussed her professional admiration for Washington. "I am, of course, like everyone else, an incredible fan and have been in awe of Denzel Washington since I saw him in *Glory* [1989]. And I also saw him [perform] in Shakespeare in the Park back in the day. This man, just as he comes on to set, you can sense that the air around him is being moved with him as he approaches. And I was stunned when he entered Lucilla's house that first day on set. This man has this natural power."

> "ROME KILLED MAXIMUS, AND THAT FATE IS NOT FOR YOU."
> —LUCILLA

LUCILLA AND LUCIUS

The closeness of mother and son in the first film is under stress here with fears that he may be lost or dead after leaving Rome fifteen years prior. "Those scenes between myself and my son are heartrending. I weep for Lucilla because she has tried to save her son by sending him away with soldiers who were supposed to protect him and keep him away from the inevitable assassins of the Praetorian Guard that would come after him so that they could quell or remove his pretension to the throne. What I did not bargain for is that they would lose him, and they lost him. The search parties that I sent out for him have never found him. They keep bringing me clues that he may or may not have survived. Lucilla is living this nightmare where she does not know if her child is still alive, and she, just like any mother would, yearns for that one thing that she loves more than

overarching love for her son. So when she does find her son or realizes that he is alive, she is then met with this awful, awful realization that he hates her. And I don't think any mother could imagine any worse fate than finding a child and then realizing that that child now hates them."

SON OF MAXIMUS

The biggest revelation in the film is that Lucius is Maximus's son, but Nielsen had a 'mother's instinct' about this twenty-five years ago. "I think that Russell and I, when we were shooting *Gladiator*, often talked about what that relationship was back when they were kids, when they were fifteen, sixteen years old. At that time, Lucilla was about to get married. As a political pawn, she was betrothed to her uncle or adoptive uncle, Lucius Verus. Her father used her to cement the co-emperorship with her, his brother, and her adopted brother. These were normal things at the time to cement an equitable coregency. She was used as a pawn for that. That one moment of love came courtesy of a time with Maximus. In reality, in history, there were so many rumors about what it looked like: political expediency. And I think it was straightforward to imagine that Lucius was Maximus's child and not Lucius Verus's son."

MAXIMUS AND MARCUS AURELIUS

Maximus, played by Russell Crowe, and Roman Emperor Marcus Aurelius, played by the late great Irish actor Richard Harris, still cast long shadows over the new film. "As the sole surviving parent of my son—one of the things I brought into Lucilla this time was that sense of how you cement the burden and gifts from your heritage in that child. What is the thing that makes our family so special? What about your father, mother, grandfather, and grandmother? What is it about them that you are carrying inside you right now? A young man, especially Lucius, is confused and enraged and has lost everything he loves several times. He is a traumatized young man. He needs to be grounded in his heritage, which is what Lucilla is trying to ground him in . . . that he is the continuity of this line."

anything else in the whole world. But she has to, out of duty, choose to let go of him so that she could stay behind and try to fight to save Rome."

Nielsen liked the tension this brought to her new portrayal of Lucilla. "Instead of following her heart and going with her child to keep him safe, she makes an impossible choice. And I feel like one of the things that's so emotionally wrought for Lucilla is that fine balance between the values of stoicism and duty she has been brought up with. And then this natural,

TWENTY-FIVE YEARS LATER

Since she'd witnessed the world-building powers of Sir Ridley Scott twenty-five years ago, Nielsen was in a unique position to compare the two experiences. "Getting back, working with Ridley, and experiencing much more technology he had to work with was fascinating. I've always admired how Ridley uses these very classical storytelling devices and, at the same time, incorporates whatever technology is available. Technology has evolved a lot in filmmaking. On *Gladiator*, I saw him commandeering like a general with his cigar and five cameras. Now I see him commandeering eight cameras. He has amped up the spectacle. He has an extraordinary team, as always, with him. He builds these great machines. He can make an epic in a few months, which would take far longer for other people."

Scott became the film's producer, giving him more control over the time it took to make it. However, this didn't slow down the production. "We've consistently been ahead of schedule because he is that fast. It just rolls right off. It is extraordinary to see scenes that are both huge and very personal. You need to use and benefit from this incredibly well-oiled machine that goes to work around you. Hundreds of fighters are in a scene, each with their own meticulously prepared tableau and outcome. You see all these people rehearsing with utter seriousness and commitment between takes. Walking out in that arena for the second time in twenty years was amazing. I'm sorry that Joaquin and Russell didn't get to have that feeling of being here again and experiencing this magical room he's built up at the top of this fort in Malta."

A NEW LOOK FOR LUCILLA

Nielsen worked with Scott and costume designer Janty Yates on her look for the sequel. "When I saw Ridley in preparation for starting to shoot, he saw that I had more blond hair than before. I was darker in the original, but he liked this for this Lucilla. And I think he's right. It suits this Lucilla. Janty was interested in giving both a nod to Lucilla from *Gladiator* and a nod to the evolving fashions at the time. [She wanted to bring] in a modern approach to those fashions and the majesty of Lucilla, [which] is really what's keeping her alive—the one value that she has that she can barter with."

BUILDING A NEW ROME

The new set construction is complemented by returning *Gladiator* director of photography John Mathieson, whom Nielsen fondly remembered working with on the first film. "John Mathieson is amazing. I still remember to this day how he realized in *Gladiator* that the camera was so close that it could see the lights in my eyes, so he put bars on the lights so it looked like it was the window of the cell. I was impressed by how Arthur Max [production designer] reinvented the Colosseum twenty years later and showed a Rome that had fallen into excess and poverty. The extremes of haves and have-nots. That signifies a sick society where people are living in sewers. Ridley is bringing these themes to life with the help of this fantastic crew. Nothing Ridley does is by chance. He has me walking through a scene that says I'm escaping my house through a corridor that takes me underground. But, of course, because it's Ridley, you have a statue of Remus and Romulus, two brothers whose rivalry and tragedy are at the core of the Renaissance of Rome. That's a typical Ridley moment, where he constantly puts context into every scene. It makes it attractive for an actor to do even the simple things, such as running through an underground passage."

THE FINAL BATTLE

Despite the cinematic spectacle, the intimate and personal stories are what really drive the dramatic themes in *Gladiator II*. "One of the things that is just so heartbreaking in this story is that this mother and son find themselves being used and tortured by these emperors. First, the son is forced to fight against what would be his stepfather. Then he is forced to try to save his mother from being killed in the arena herself. And there is just something so incredible about these setups. Of course, it is classically Colosseum. These were the fates and how the fates decided the living or dying of the people who entered those halls."

"I AM THE EMPEROR!
I HAVE BEEN
CONCEIVED FIRST."
—EMPEROR CARACALLA

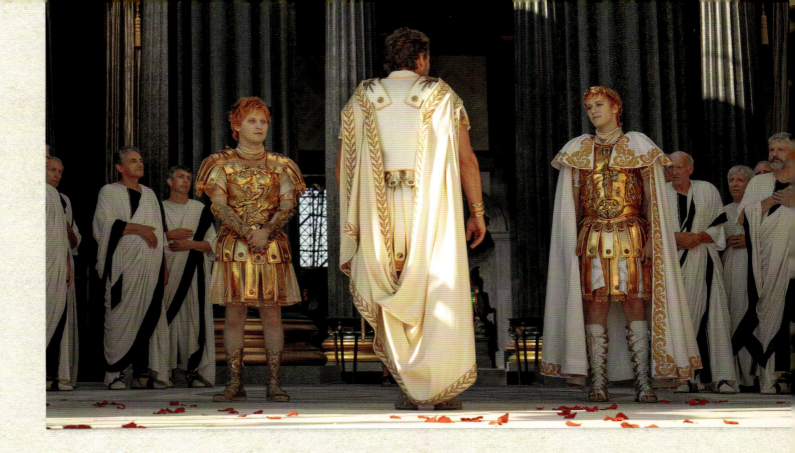

JOSEPH QUINN as EMPEROR GETA and FRED HECHINGER as EMPEROR CARACALLA

English actor Joseph Quinn is best known for his standout role as Eddie Munson in the fourth season of *Stranger Things*. On this film, he had to come to grips with the scale and anticipation of the production, including his own hopes and fears. "I think the breathing is coming from a place of a genuine internal panic." On top of the professional anxiety that any young performer would have was the large number of cameras on set. "There were lots of cameras on all the time. Nowhere is safe, which lends itself to this very unsafe world. It's an exciting experience that is very new. This allows Ridley to cut between many different angles and gives him much freedom. So to be in that is both very thrilling but fucking terrifying."

Quinn clearly understood the shared desperation and mania that inhabits his character of Geta. "It's a loss of power and control. It's frightening to have everything—more money, more problems, as the phrase goes. I think it's the fear of losing a significant and abundant life and feeling like that's being ripped away from you. It's kind of how I feel about my career and this job."

Geta is a ruling twin with brother Caracalla, played by American actor Fred Hechinger. Their on-screen chemistry is a large part of the pair's success in the film. "Fred is to die for. He's a lovely, lovely man and very talented. There's genuine care for each other on this job. And so, hopefully, it translated on screen. Caracalla's mind is slowly being eroded by syphilis, and that plays into Geta's awareness that he needs him. But these two boys need each other to maintain power and balance. When his mind starts going, everything starts falling apart. There's this codependency that is fun to play."

ALEXANDER KARIM AS RAVI

Swedish-born actor and writer Alexander Karim is best known as Dr. Sigur Johanson in the science fiction television series *The Swarm* (2023) and from the political drama series *Tyrant* (2015–16). In *Gladiator II*, he plays gladiator physician Ravi. Karim expressed his deep gratitude for the opportunity to be part of cinema history: "If you're from my generation, the original film had an extreme impact on your life. I was a young man in the late nineties, and looking at Maximus, that's how you view yourself. You see yourself as this little person going out into this big world, fighting this evil empire, and hopefully winning against all odds. It was a relatable story I've carried throughout the years. It's just a beautiful opportunity to be part of something historic."

RAVI'S ROLE

Karim plays a key role for new fighters in the film. "I'm introduced when the character of Lucius arrives in Rome. I'm a former gladiator turned cutman and physician for the gladiators. I take care of all the wounds after the battles and introduce Lucius to the world of the undercroft and the world of the gladiators in the arena. Ultimately, I help him try to fulfil his destiny. I am Lucius's friend and his ally, and I am trying to fulfill his destiny. But Ravi sees more to Lucius's character than meets the eye. I also realized that he has a history here, and I tried to get him to see more of the history, including who Maximus was and what happened twenty years earlier."

Karim did extensive research on the period. "The script is dense. It just has a lot of color, flavor, and texture. You want to find out more, and you want to see what else is in there. I did a lot of research. After my first meeting with Ridley, I said, 'I see Ravi as a sort of Dickensian character.' And that gave me my biggest clue to the character's path, seeing who he was and what kind of function he had, and giving me tons of physicality as far as the character goes and the look and the feel."

PAUL MESCAL

Karim worked well with leading man Paul Mescal. "Paul is unbelievable. You see someone who has this enormous responsibility of carrying this whole film on his shoulders. And he does it. You can tell he's ultra-prepared but does it with ease and grace. That's what makes him perfect for the part of Lucius. If you were to have someone who just came in as a barbarian roughneck, then it would have been not easy. The character needs to be someone who has that real broad palette of emotions and the strength and physicality of Lucius." That said, Mescal brought many sides to his character, which involved the complexities of Lucius's childhood and fractured upbringing. "He also has to draw you in as someone you feel for because he's a little kid abandoned by his parents. It's fantastic working with him. He's generous. He'll give you a lot in every scene, even with the smallest moments. He takes every moment seriously."

INTO THE ARENA

The entire team on *Gladiator II* was awestruck by the enormity of the production; Karim was no exception. "It's the biggest thing I've ever seen in my life. I've been on some huge sets, but this is just beyond. I had this one scene where you're walking into the undercroft, and Ridley has seven cameras rolling, and you don't know where they are. You've got three hundred extras, and you're walking through this whole thing. Then you land over by Paul and have this little intimate scene, and that's it. And he does that in three takes because everything's already covered. Obviously, as an actor, you're not pretending. There are no big green screens covering you, [and you're not] trying to imagine that there's this big spaceship there or there's this or there's that. Everything happens in the moment. If you find something, you can go to Ridley and say, 'Can I try this,

> "THERE'S PLENTY OF PAIN WAITING FOR YOU IN THE NEXT LIFE, FRIEND. YOU DON'T HAVE TO BE SO GREEDY FOR IT IN THIS ONE."
> —RAVI

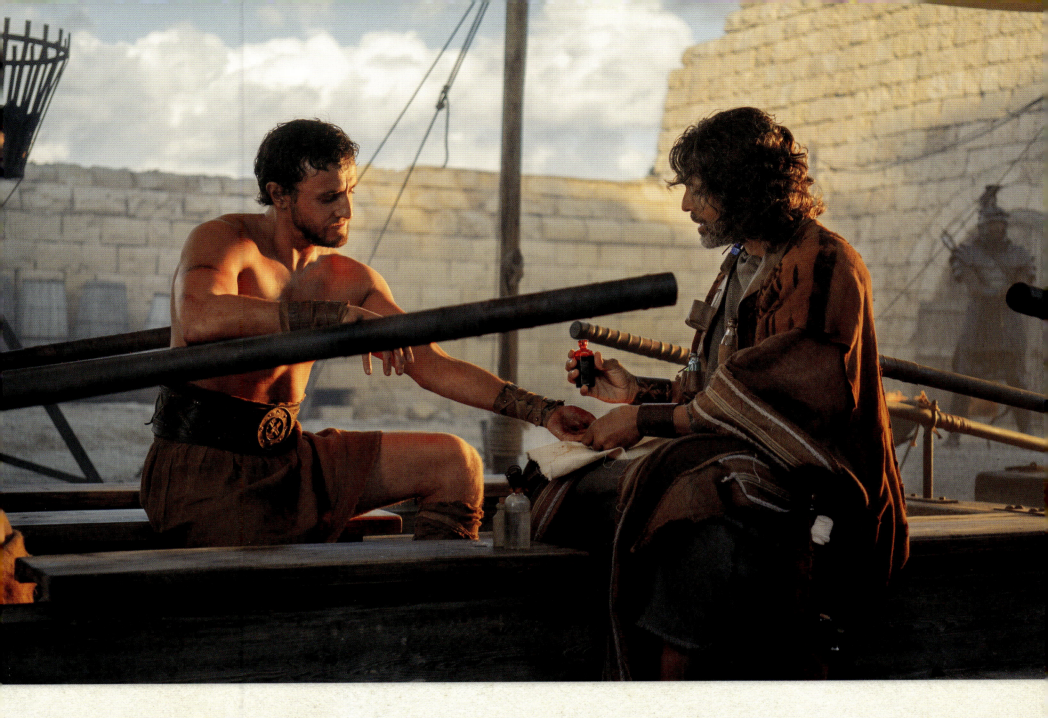

or can I try that?' And everything is fine because you'll still be within the realm of continuity. It's fantastic." The extensive world-building for *Gladiator II* hugely benefited actors like Karim. "It's hard not to be in awe when everything is accurate. I rode into a village, and there was an actual village with food being cooked over there in one of the tents, and you've got actual guards standing around. Everything is so real you are thrust into the reality of the story. If you look at any of Ridley's films, they are all larger than life, huge, and massive, but you always see the best acting in them because you don't have to pretend once you know your character. Just do it."

LIOR RAZ AS VIGGO

Israeli-born Lior Raz, an actor and writer best known for *Fauda* (2015), *Hit & Run* (2021), and *6 Underground* (2019), said it was a "dream come true" to work with "a legend like Ridley Scott." Raz plays the brutal and physically demanding role of gladiator trainer Viggo.

FIGHTING THE FIGHTERS

Raz was aware of the initial lack of sympathy of his character when he is seen on-screen. "Viggo is the trainer of gladiators on Macrinus's farm. So I'm the trainer. I'm not a kind person. I'm taking them to the fights, talking about what it is to be a gladiator, and escorting them all the way, and this is Viggo. He's a very tough guy. He was a gladiator himself. He was a slave in the beginning, and then he became a gladiator because he won. So he got his freedom like all the gladiators who won the fight, the tournaments."

There is no love lost between Paul Mescal's Lucius and Viggo. "Both of us were not loving or liking each other at all. In the first minute I saw him, we had a huge fight. Then I understood that he was an amazing fighter who could fight with me, better than me. I'm the older guy who sees a younger guy who is better than him, so there is jealousy. In the beginning, a gladiator is just a piece of meat."

WEAPON OF CHOICE

As the most experienced cast member using weapons, Raz was the right casting choice for Sir Ridley Scott. "I used to be in the special forces in the Israeli army. I know how to fight, and I know how to deal with weapons. The kind of fighting we have here is a combination of Filipino martial arts that I didn't practice. I had to practice here with amazing stunt directors, and we trained a lot for the fights as long as possible. It wasn't easy for me, but it was really fun. My weapons were my fists. I never used [swords] before. When I was in acting school, I studied fencing; it is so different."

RIDLEY THE LEADER

Raz's military experience gave him a unique perspective on leadership, and seeing Ridley Scott on set in full command was eye-opening. "How he deals with eight cameras in a scene, amazing. It's the first time in my life that I've seen it and how he controls this huge [set]. It's a master class of directing, leading, and commanding. And to see him was an inspiration for me. It was a huge honor to work with this amazing director—one of the best directors in the world ever."

DRESSING LIKE A GLADIATOR

The costumes gladiators wore had to spark fear in the hearts of their opponents. "My costume had the fur of a leopard and a sword. He's different from the other gladiators. We started to shoot in the summer, so putting the leopard on wasn't easy. When we are in the winter, I'm happy I have a leopard on me; it's a beautiful costume."

> "THE ARENA TURNS SLAVES INTO GLADIATORS AND GLADIATORS INTO FREE MEN."
> —VIGGO

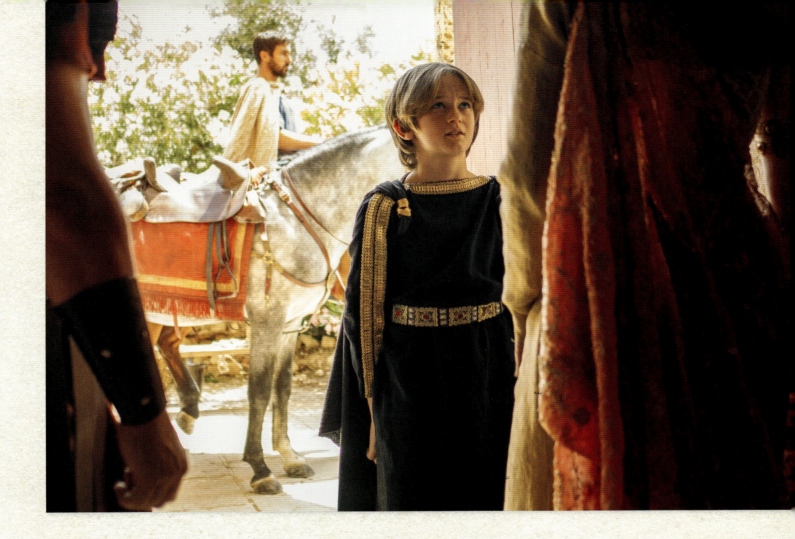

ALFIE TEMPEST AS YOUNG LUCIUS

The cast's youngest member, British-born Alfie Tempest, had already earned significant credits, including Guillermo del Toro's *Pinocchio* (2022), and *Masters of the Air* (2024) on Apple TV+. His acting growth was evident in his preparation for *Gladiator II*, where he learned new skills. "I learned how to ride a horse, and I just trot. That's the highest I can get. I don't know how to gallop, though. I'm pretty good."

Tempest was understandably excited about the film's release, eager to see how his portrayal of Young Lucius worked in the final edit. "I'm looking forward to seeing the film, as I'm old enough to see it now. And it's probably going to be fun. I can imagine this being a really good film."

Tempest was clearly a focused young man who hoped to continue in his chosen path. "My goal would probably be just to be a decent actor and, you know, continue acting. I do want to continue this, because I want to see what happens. Because you can do some fun stuff and do acting." Tempest had a great time working on the film. "You get to do lots of different things. If you want to be like a mechanic, you could get a role when you're a mechanic, and you can do stuff that you wouldn't get to do in other jobs."

CHAPTER I: THE CAST 45

PETER MENSAH AS JUGURTHA

Peter Mensah, a Ghanaian British actor, captivated viewers with his portrayal of Oenomaus in the television drama series *Spartacus* (2010–13). His talent extends beyond the small screen, with notable roles in films like *Tears of the Sun* (2003), *Avatar* (2009), *The Incredible Hulk* (2008), and *300* (2006).

A LEADER OF NATIONS

Of his character, Jugurtha, Mensah noted the everyman quality of his role and Jugurtha's ability to work and talk with many races. "The interesting thing about Jugurtha's story is that he was a leader of a mixed nation [with] Arabs, Numidians, all sorts of people. He took in our hero without question. In a time when war was a matter of course, he was good at it. They had repelled the Romans a few times. He had learned how to live with everyone and, in his defeat, chose to leave as he had done as much as he could. To die in an arena after you have achieved peace seems a bit odd, but I guess that's the gladiator story. The only way to find peace is to die. It's a strange way to end, but it seemed appropriate."

For Jugurtha, giving a home to Lucius would have been controversial at the time. "Jugurtha lived his life [in] a sort of multiracial, diverse society, so to take in a stranger seemed the thing he would do, right? He might not have known who the kid was, but for as fierce of a warrior as he was, he clearly had a kind heart that had the capacity to nurture."

THE AFTERLIFE

Jugurtha's religious beliefs help guide him in his decision-making. "Religion and the system that comes with that help structure a society and navigate a pretty difficult world. His conversation around death and what happens after shows he uses faith to guide him through some difficult times. We probably won't end well, but you could go through those things because you believed in what would happen after. That structure is part of what informs Jugurtha and allows him to lead."

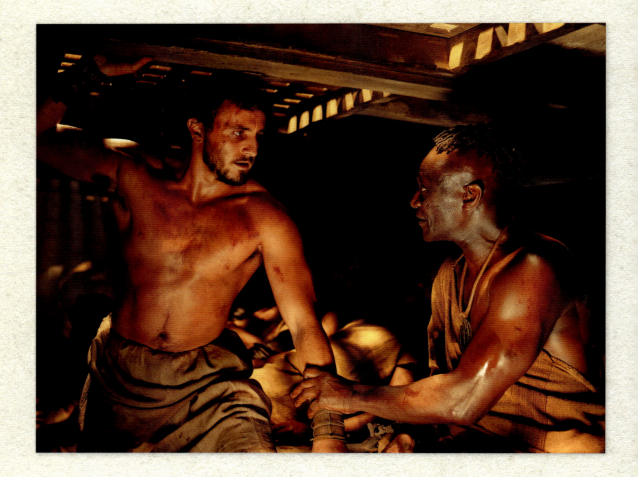

"WHEN I GO INTO BATTLE, MY ANCESTORS BATTLE BESIDE ME."
—JUGURTHA

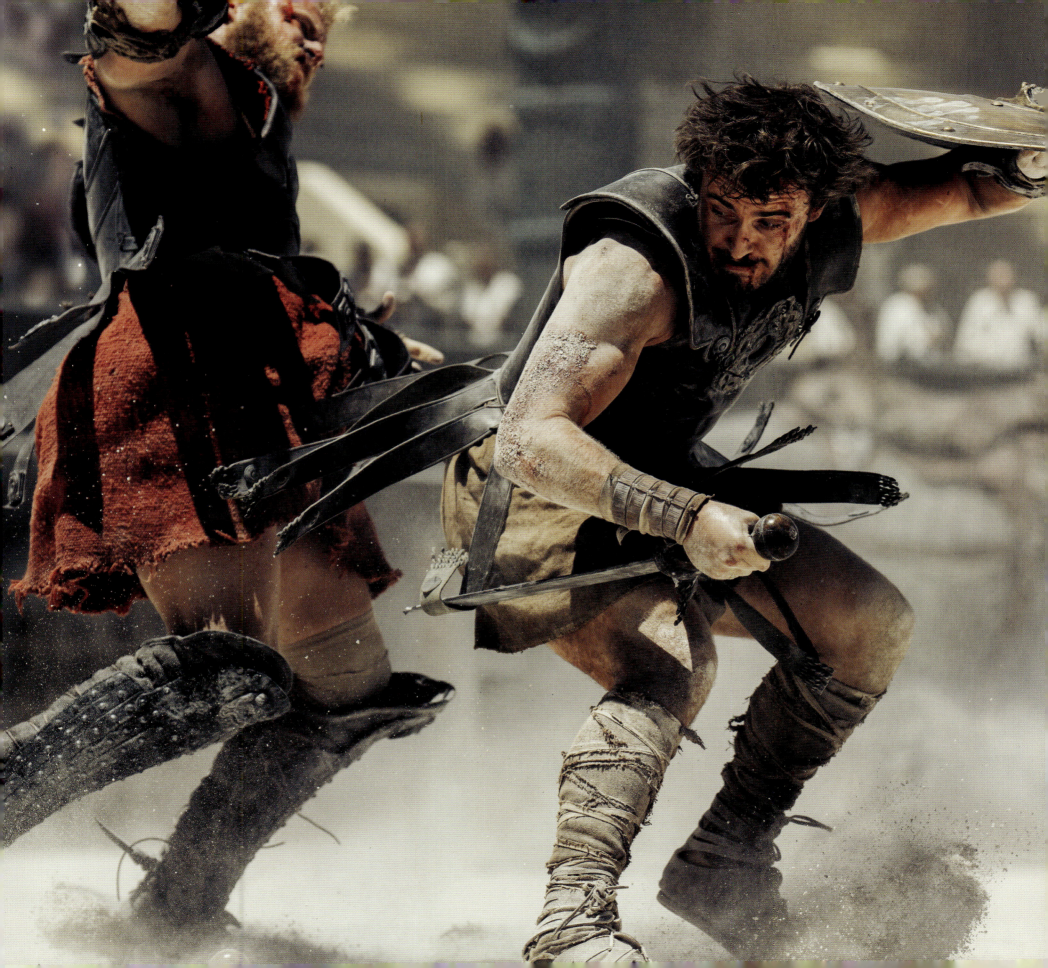

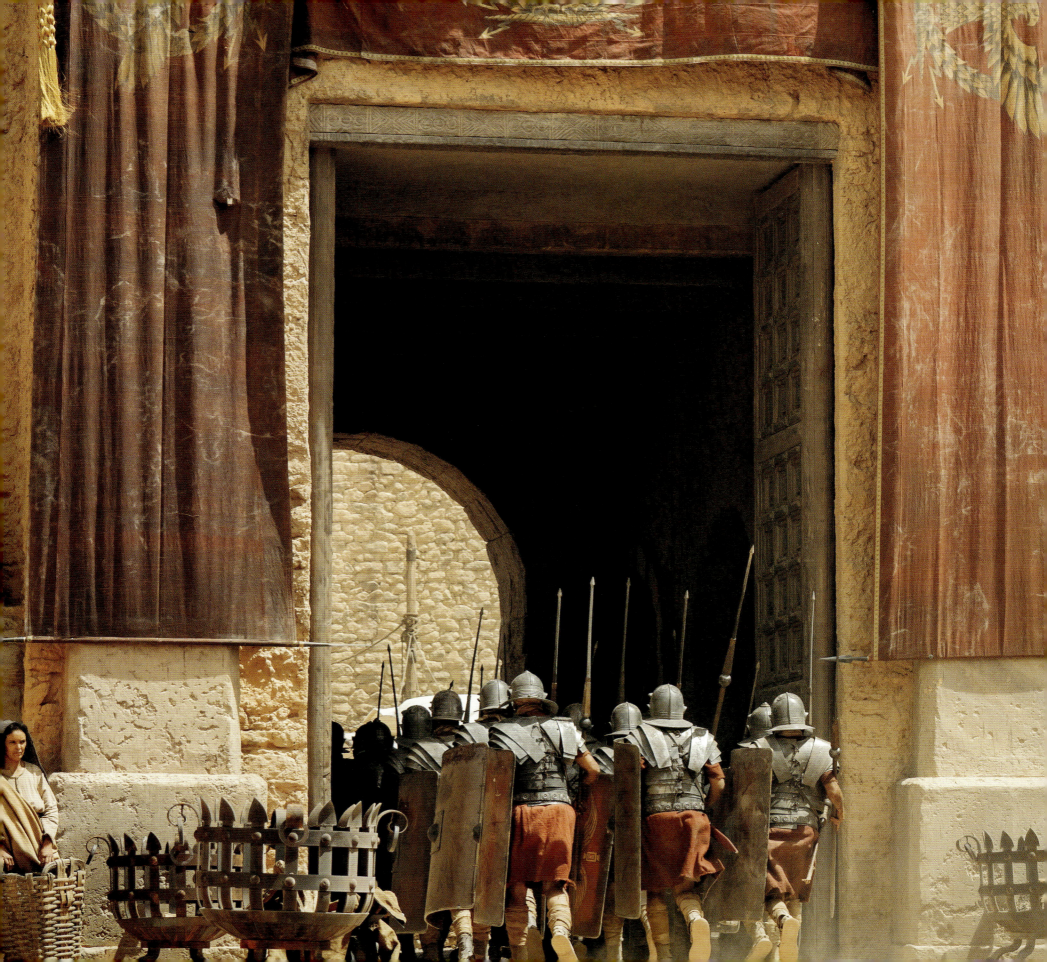

II

DESIGN

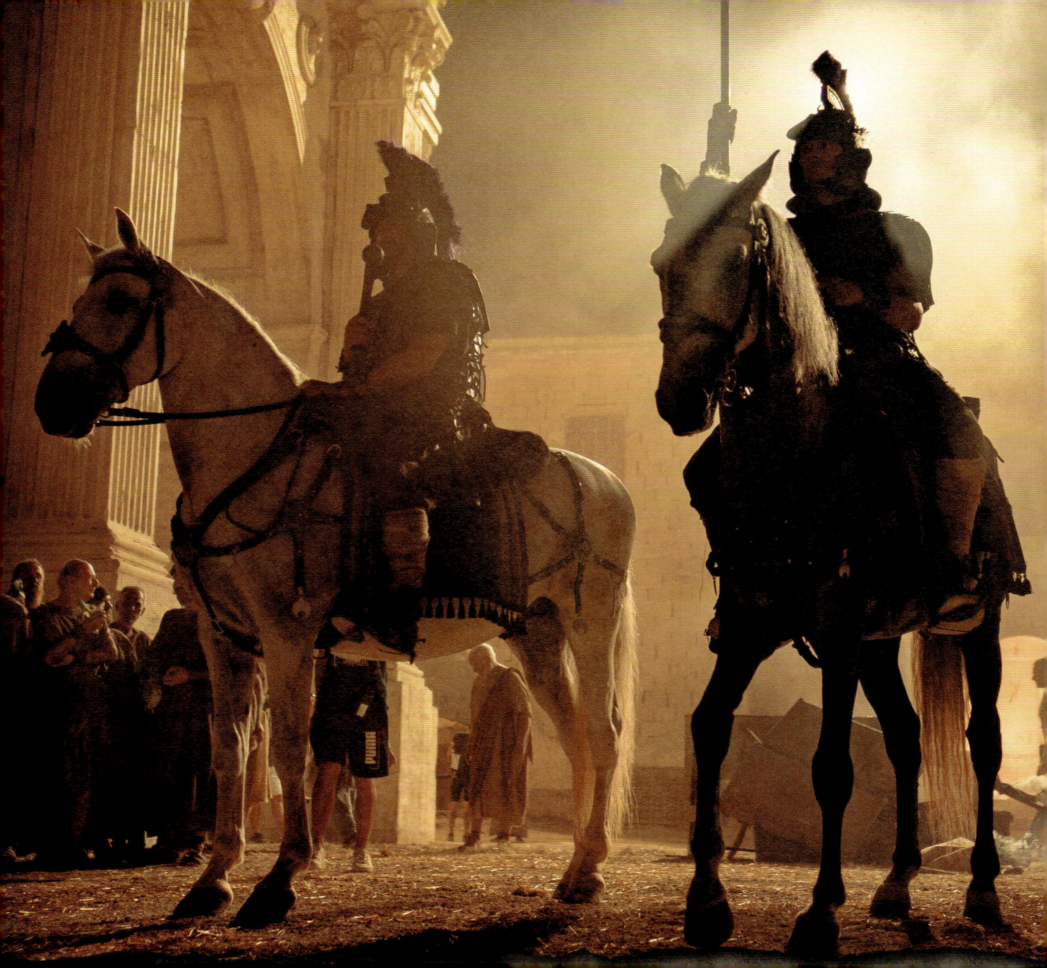

PRODUCTION DESIGN

PRODUCTION DESIGNER ARTHUR MAX HAS BEEN NOMINATED FOR FOUR OSCARS: FOR GLADIATOR (2000), AMERICAN GANGSTER (2007), THE MARTIAN (2015), AND NAPOLEON (2023). SIR RIDLEY SCOTT DIRECTED ALL FOUR FILMS. MAX HAS WORKED WITH SCOTT ON SIXTEEN FEATURE FILMS AS PRODUCTION DESIGNER.

His professional start was as a stage lighting designer in the music industry in the late 1960s and early 1970s. He studied architecture in Italy, England, and the UK, where he worked on architectural design projects in London. His entry into feature film design was as an assistant on Hugh Hudson's *Greystoke: The Legend of Tarzan, Lord of the Apes* (1984). His first production design credits were in the world of commercials, where he met Scott.

After twenty-five years, Max tried to decode the first film's success. "There was a certain magic in the creation of the ancient world. A certain level of myth and an acknowledgment of the ancient Romans' polytheistic culture gave it a spiritual aspect to what was an action-adventure movie. And I think that brought a lot of unscripted stuff. It was spur-of-the-moment on-location ideas that injected a certain spirituality into what might have been just a journey or a way of interpreting how he gets involved with the afterlife, for instance. And I think that raised the level of what we're used to seeing in so-called sword-and-sandal movies."

Max saw the challenge of returning to the world of *Gladiator*, but there was also some unfinished business while using new computer-generated imagery (CGI) technology sparingly. "We got a chance to get right what we didn't on the first one and embellish things that we wanted to do but couldn't do technically the first time because the media has changed, and the techniques have changed on many different levels. We still use the same old-school craftsmanship to a large degree for architectural re-creations, sculpture, frescoes, and painting techniques. But these days, there's a lot of digital media we haven't accessed, and things take much longer. So we haven't done as much as we can these days. So that was exciting to be able to apply the new media to the old stories."

GO BIG

Max knew Scott wanted to be more expansive for the sequel. "I've been working with Ridley a long time, so there's not a lot of long-winded discussions. There's a shorthand. He said to me, 'We're going to go for scale on this one.' I took that to mean we're going to build everything bigger than we did on *Gladiator*, which was very big to start with. For example, we are now in Malta, the Rome set in Fort Ricasoli, where we built the original set with the Colosseum, the palace, and the Roman Forum. We used the whole site this time, whereas we only used half of it previously. We built the Colosseum the same, except it's a bit higher. It has a more impressive entry arch for various reasons."

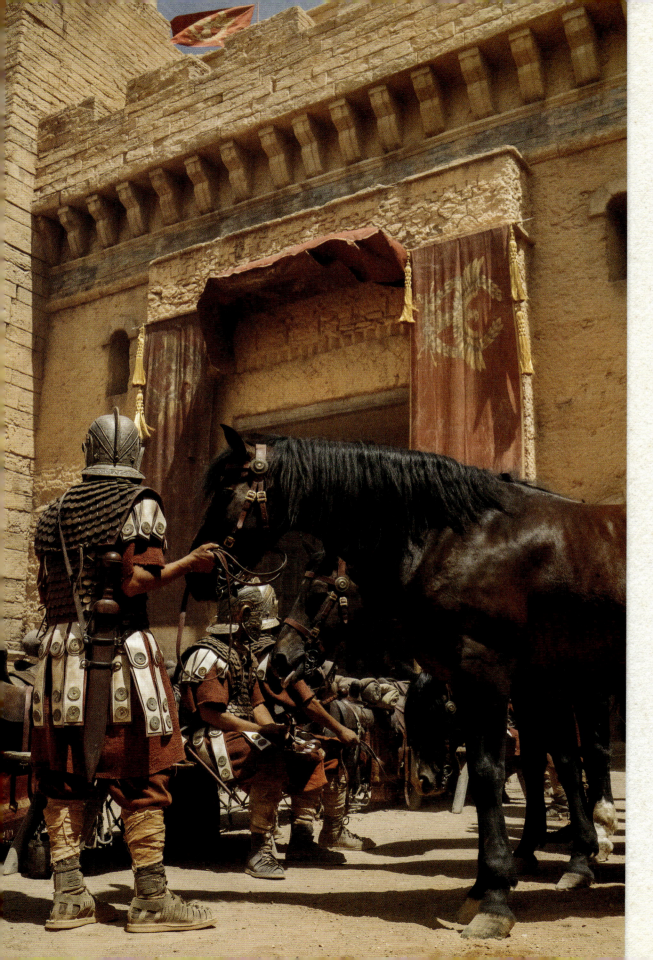

RIDLEY SCOTT'S DESIGN

Scott has a strong design background, which makes him almost unique among film directors. Max elaborated, "He's involved in every phase, every department, yet he's a collaborator. He's kept up-to-date with all the technologies as they evolve. I think that comes from his background in commercials—which is where I first encountered him—because that's an area where you can experiment with new techniques and learn as you go. Because a commercial is a compressed version of a film, shot in a short period, it has to be very elegant. That's one of his gifts.

"He's a stylist. He's a visualist. He has a background in fine art. He was a production designer himself. He knows all of our tricks and is interested in every department to a level of natural sophistication. So I'm always learning from him. He's usually got something to offer on every kind of level, so it's a challenge working with Ridley because he expects a bit more. When you think you've done as much as possible, he wants you to raise the level to an even higher standard. The schedule is compressed for the scale of what we're doing, which is challenging and always exciting. You're constantly being called upon to produce something special, which also keeps your attention. What else can I say? In a way, he's a film institution."

SEQUELS

For Max, new ground was broken with a return to the world of *Gladiator*. "Every film with Ridley is a prototype. They're never the same. Ridley allows you to work on different genres because he likes reinventing different film styles. He never, up until this point, has made a sequel to one of his own films. The challenge of doing a sequel is making it unique and exciting, where the point of departure is from the previous film, and still retaining a sense of the root material. Where do you take it, and where do you go with it? I think that was the challenge on this one. It's like *Gladiator* on steroids in terms of scale. It's ambitious. It was very challenging on that practical level. Can we finish the sets in time? Because they were so much bigger and more elaborate with naval battles."

MOROCCO

Gladiator II returned to Morocco, one of the original film's most iconic filming locations. "Ridley likes shooting in Morocco because of the light," said special effects supervisor Neil Corbould. "The light is amazing out there. I'm not sure of anywhere else in the world, apart from maybe Jordan, where the light is so special. Revisiting the old sets from the first film, [with] slight tweaks on the old sets for the new film and different visual effects in the background, takes you to a different place. The first film was a rehearsal for this one because we knew where the unit base would go. We knew where the set was going to go. We knew how to get in there. We knew where the restaurants were!"

RETURN TO OLD LOCATIONS

Scott's affinity with Morocco also meant a return trip for Max. "We returned to the location we shot for Jerusalem in *Kingdom of Heaven* (2005), but we completely transformed it into Numidia, a North African province of the Roman Empire with a completely different style of architecture. Plus, we put on an enormous extension. We made a port and harbor, which seems ironic because we were in the desert without sea, but the evolution of water software and film has become so sophisticated. It's so much easier to work on dry [land] than on water, so we decided to go down that road where we would put the water in afterward and have the convenience of working on land. We built an enormous harbor extension onto the old Jerusalem set. It was like visiting old friends but giving them a new lease on life and a new haircut. And the same in Malta. We returned to [Fort] Ricasoli, where we did the first Rome and Colosseum sets, and our approach was much the same but much larger. We went out to other locations we hadn't used before, like an eighteenth- and nineteenth-century fortification underground tunnel complex used for the bowels of the Colosseum. We returned to the same beach we used on *Napoleon* to extend the Numidian battle, the sea battle for the climax of that, because we needed a real ocean. So that's an old location that we used before. We shot in the harbor for the return to Ostia, which we had visited for *Napoleon*. But we never shot the original *Gladiator* there. There were various locations, new territories, and new frontiers to conquer—but some old friends as well."

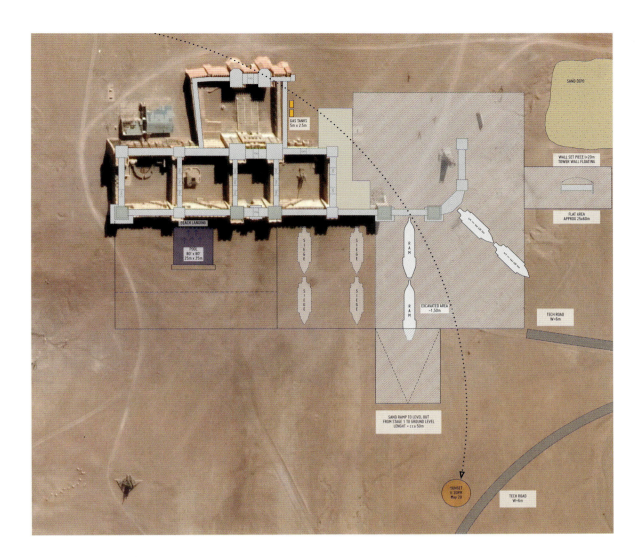

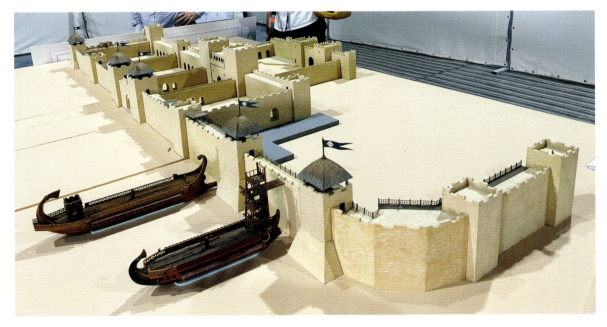

CHAPTER II: DESIGN 53

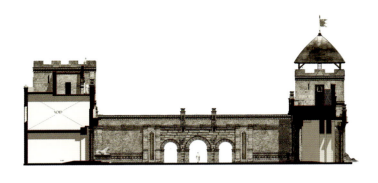
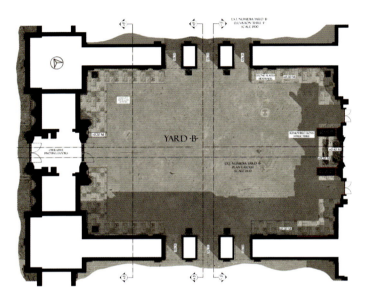

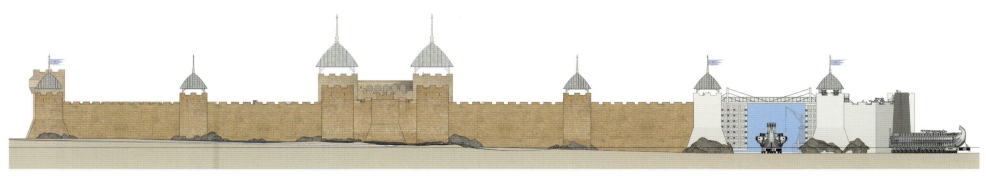
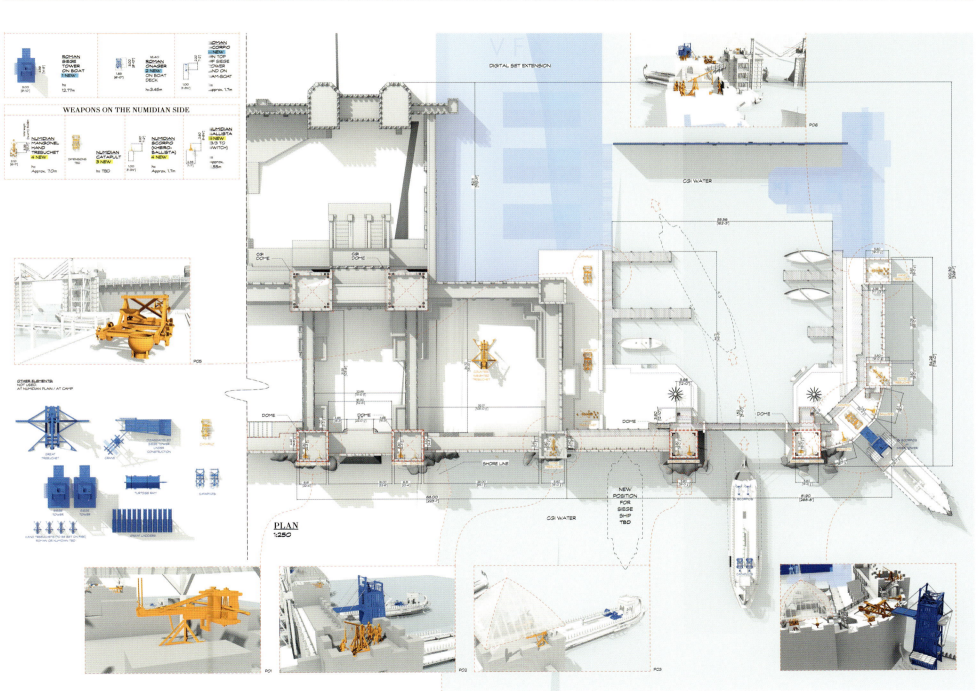

CHAPTER II: DESIGN 55

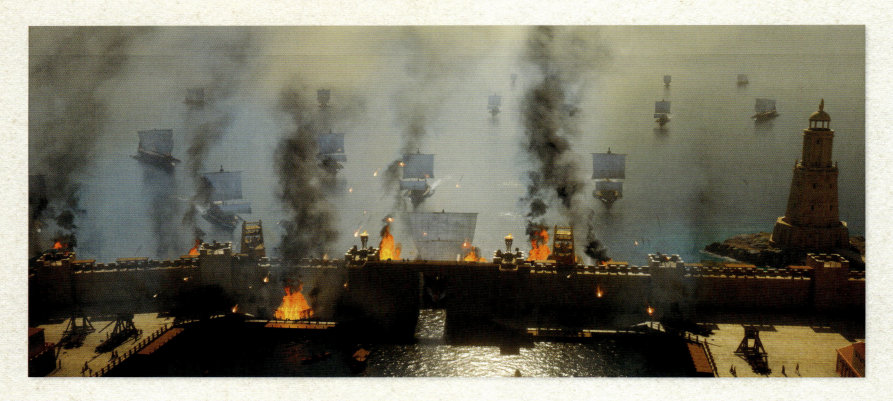

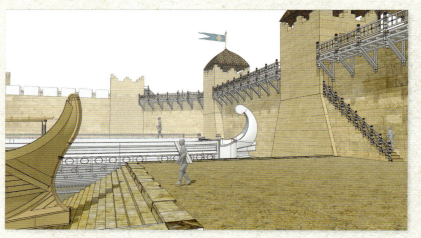

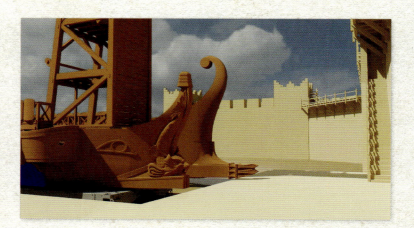

56 THE ART AND MAKING OF GLADIATOR II

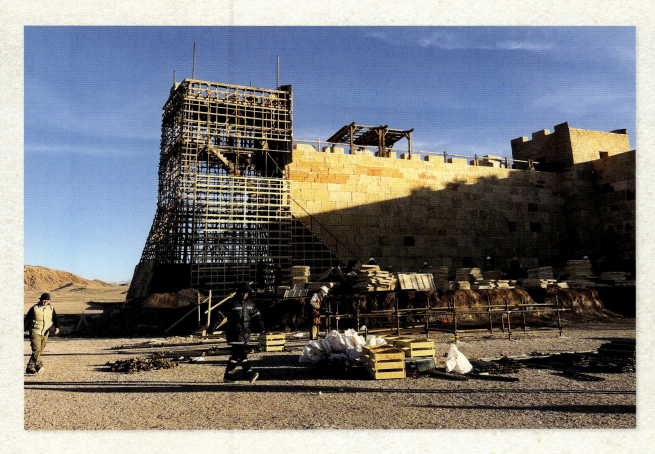

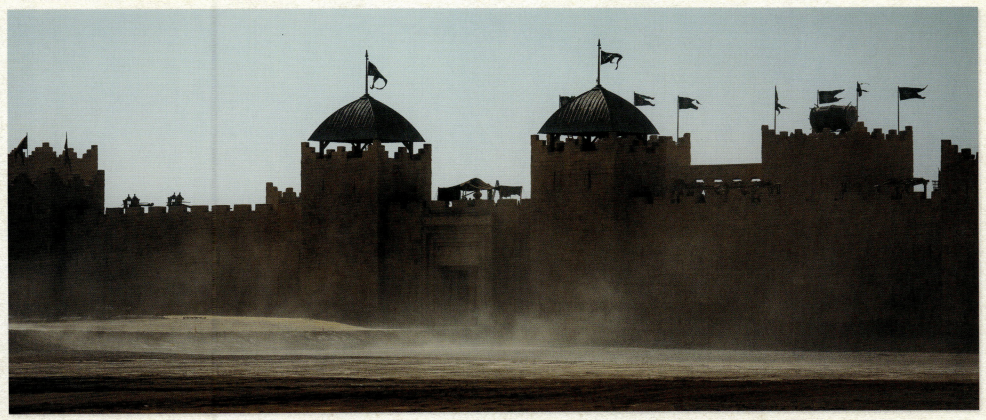

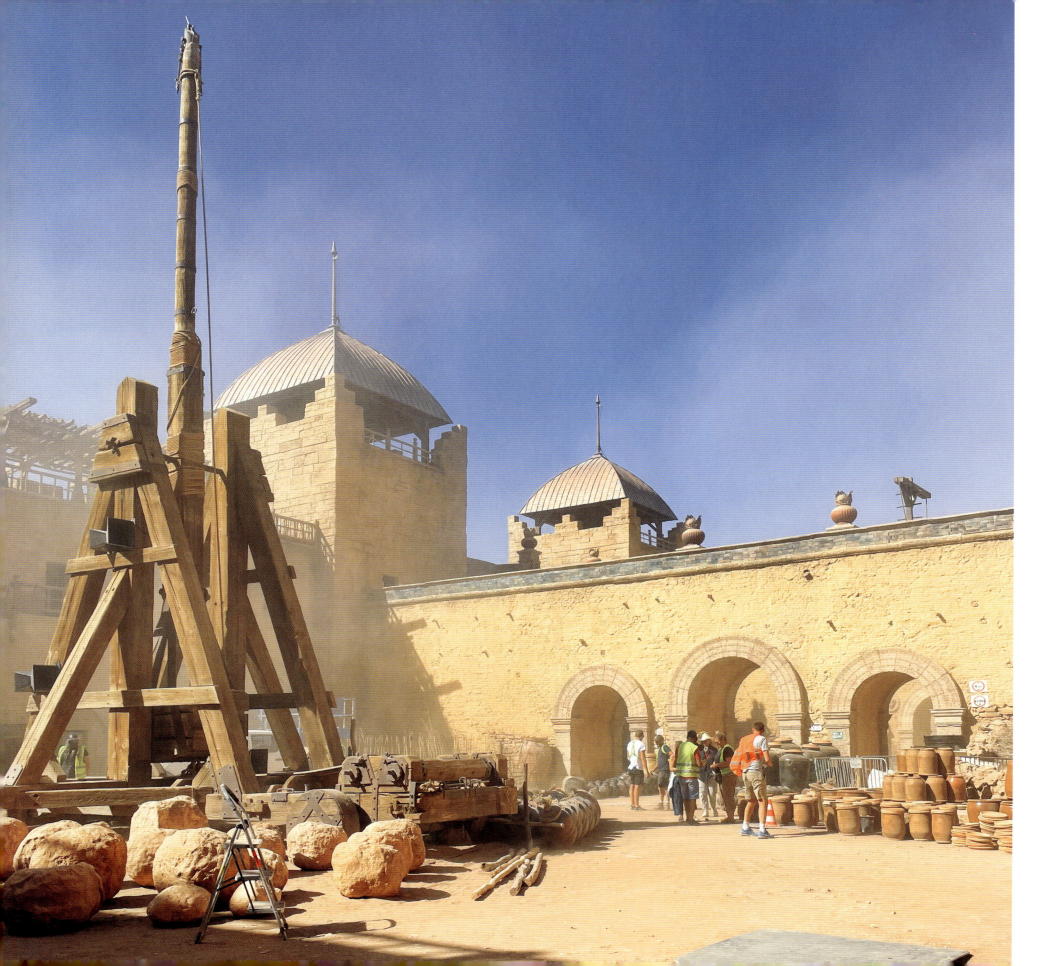

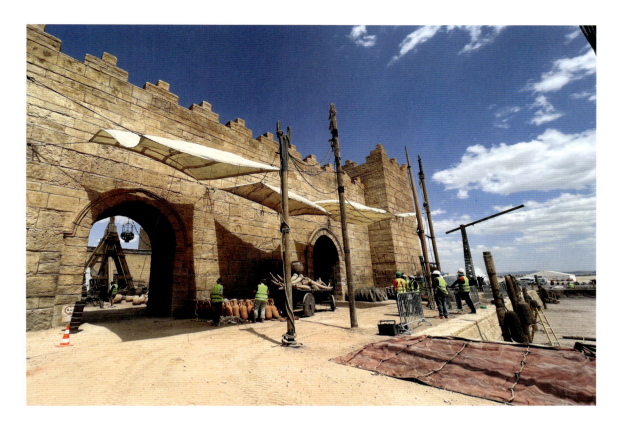
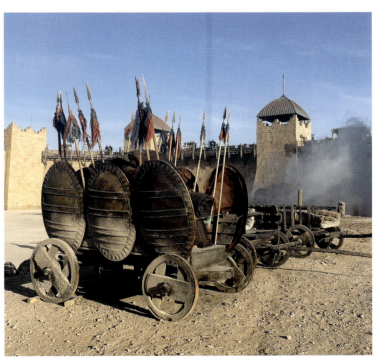

CHAPTER II: DESIGN 59

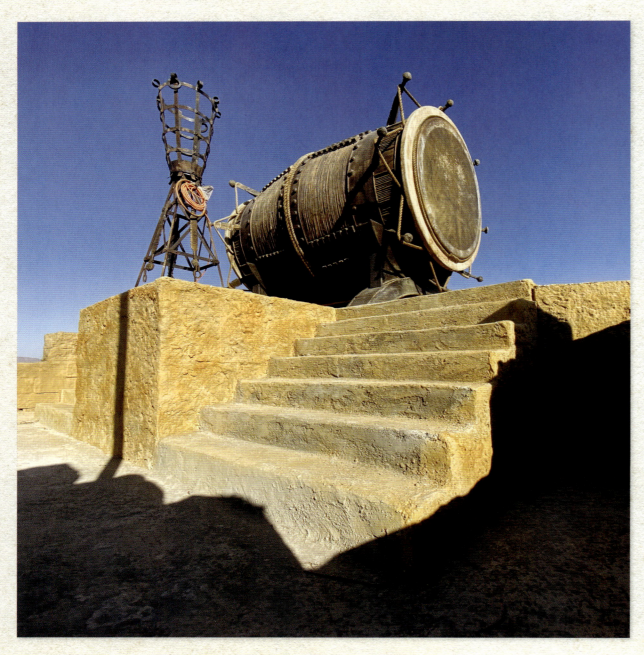

MAKING PROPS

Dressing the sets was another task for the design team, according to Max. "[Property master] Ty Teiger has an elaborate workshop and makes tens of thousands of different kinds of things. I get my nose into every different workshop. I can't stay out of them because I want to coordinate. Part of my job is to keep everybody's style and level of aging and antiquing on an equal plane. That's part of the job to get the look of the film on a uniform level so that everything feels right and feels like it belongs, because many of these things never meet until the day they're shot. They're all made in different workshops and come from different countries. So they have to be blended to work together. Some things come from England, some from Italy, some from France. We have a very international crew of Italians, English, French, Eastern Europeans, Ukrainians, Croats, and Maltese. And they're all speaking different languages as a first language. So I try to visit everybody, hold it all together, and ensure they're working on the same film aesthetically. That's part of the challenge of my job. But it makes it more fun. If everybody was talking the same language, it would be too easy!"

SET DECORATION

Set decorators selected pieces to add to the mood or dramaturgical context. "I can honestly say, if it weren't for [scenic artist] Julie O'Connor, I wouldn't be sitting here today, because she provided the chair and all of the furnishings. Going back to the theme of scale, anything life-size or related to interior furnishings would be set dec, and anything above life-size and monumental would be art department and construction. Julie brought it to life physically on every level, from day-to-day life, ceremonial life, or grandiose imperial thrones to the tens of thousands of common items that she has to deal with . . . She did a spectacular job, because that brings the architecture I focus on to life. We work closely together in terms of layouts and planning how we will use these spaces and how we will make them look different in the end . . . We all play together. It's good fun. It's a team sport."

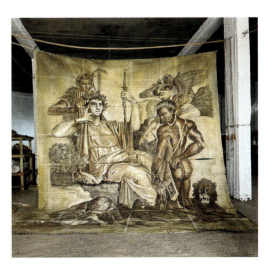

CHAPTER II: DESIGN

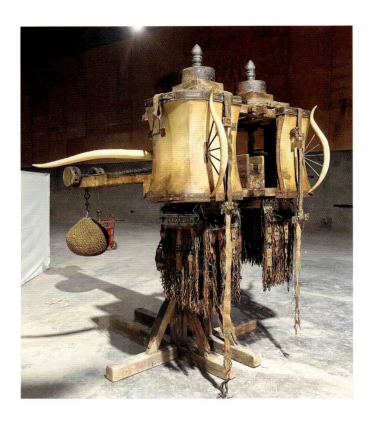
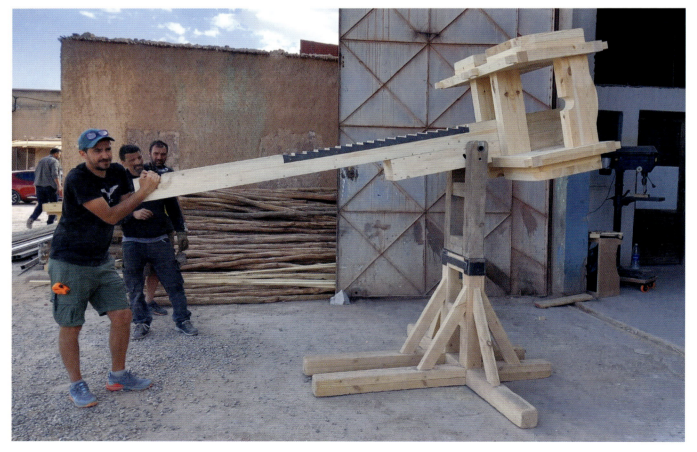

WEAPONS

Corbould's extensive research for the first film came back into use for the sequel. "I kept much of the research material on a bookshelf in my office. So I just dusted them off and started looking through them. I had some old drawings from the first one of ballista weapons and catapults that came in handy. We made a few alterations and had working drawings of catapults."

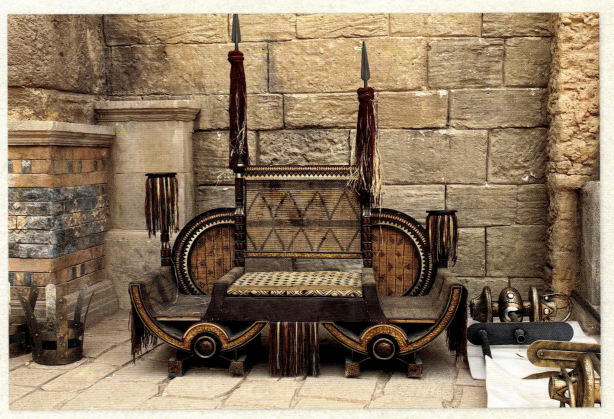

NUMIDIA AND AFRICAN NOVA

Numidia, which covered parts of present-day Morocco, Algeria, Tunisia, and Libya, may be unfamiliar to some in the audience, but it was under the heel of the Roman Empire in the time of *Gladiator II*. Max had to have comprehensive historical design knowledge for the film. "It was hundreds of years after the Punic Wars [the Roman/Carthaginian conflict that led to Roman rule over much of the Mediterranean] and conquered for a long time. It was a well-established Roman province, but North African, and we tried to draw upon the traditional Berber tribal motifs for the design. The indigenous population, the Berbers, date back millennia in this region, so we looked to research their architecture, but very little can be found. We found some sculptures of their early kings, which we included on the set. We saw designs in their jewelry, which they're still making, and traditional motifs incorporated into the sets. Whatever we could find, we used."

CHAPTER II: DESIGN 63

MOROCCO BATTLE

Scott's films have spanned the globe, and when he can reuse a location or a set, he takes the opportunity. "One of the things that Ridley threw at me about this is that he wanted to do the opening battle in Morocco, and we returned to the *Kingdom of Heaven* set," Corbould explained. "We built another big part of the set. Ridley said, 'I want these two 150-foot-long boats, Roman galleons going toward the wall, but there's no water!' For me, it gets the juices flowing and the brain ticking over. I found plant movers from Spain with twenty axles, all rotating bases that move oil rigs around, and all bolt together to mount the ships on and create realistic movements. I went to Ridley with the concept. Normally, you'd stick them on a track, and you could move on one plane, just in and out. But with these, you could go anywhere, so you could set the shot up and not be tied into where the ships were and get the ships to the other side of the set before the cameras could get there, which is unheard of."

ROMAN WARSHIPS

Every detail in the film was scrupulously researched, designed, and constructed. One of the cinematic centerpieces of *Gladiator II* is its portrayal of the Roman navy. "We went to the Museum of Roman Ships for research, and much scholastic material is available. People have devoted their whole lives to studying Roman warships. There are also some re-creations that the Greeks have done, such as practical, physical warship re-creations, which we looked at. We made some stuff up to suit the action, the storytelling, and the practicalities of filming in the confined space of a ship. Then there were those warships for the naval battles in Numidia and the Colosseum boats for the re-creation of mock battles, as they used to do in the Colosseum.

"Then you have visual effects coming into it because we only built two warships, and we rely upon the visual effects department to replicate and come up with alternative versions for a whole fleet of Roman warships that would have been in the hundreds, if not thousands, for a full-scale Roman battle."

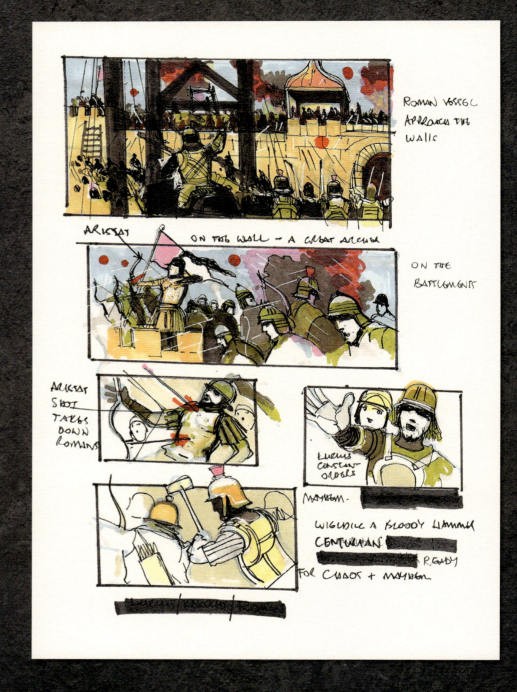

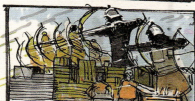
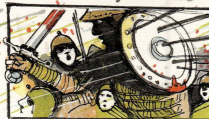

CHAOS

ON THE SEA WALL LUCIUS SEES THE ROMANS INTO THE SOUND BEHIND HIM

HE SEES ACACIUS BELOW AND ROCKCUTTERS HIT AS THEIR ARROWS POUR DOWN ONTO THE ROMANS BELOW

ACACIUS IS SAVED BY HIS SHIELD

ROMAN RETURN FIRE AT THE SEA WALL

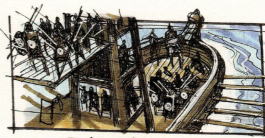

LARGEST VESSEL REVERSES OARS AS IT EDGES UP TO THE WALL

TOWER ALREADY UP TROOPS CLIMB LADDER ROMAN ARCHERS FIRE AS... THE "WINDLASS" FOR THE DRAWBRIDGE JAMS

WE SEE GENERAL ACACIUS - SEES THIS

PREVENTING THE BOARDING — HE STRIDES FORWARD UP THE LADDER

AND HACKS THRO THE HEAVY ROPE. — AS THE DRAW BRIDGE DROPS — HE LEADS THE CHARGE

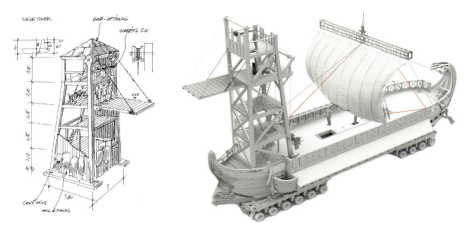
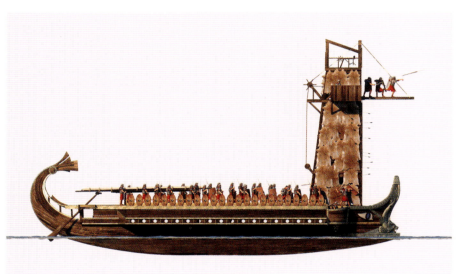
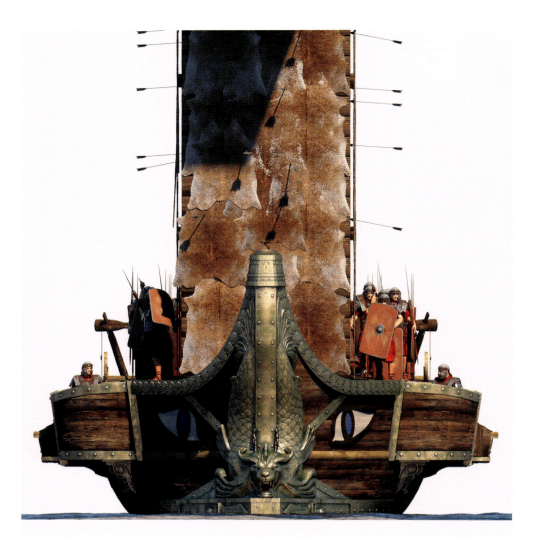
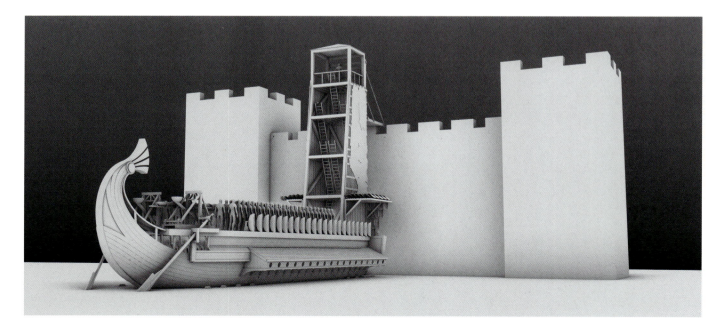

THIS SPREAD
Digital previsualization and production art create the basis for the full-size boats on the next pages.

FOLLOWING SPREAD
The blue areas on the boats allow for the visual effects team to add new elements to the boat's structure, as well as CG water.

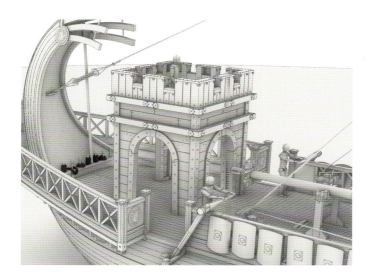
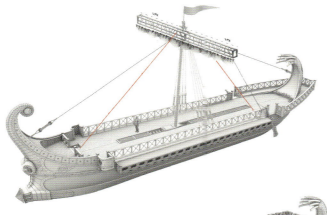
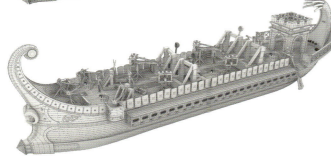
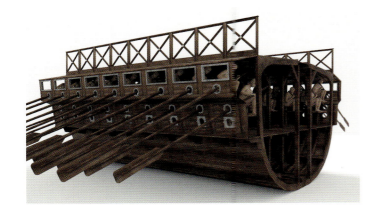
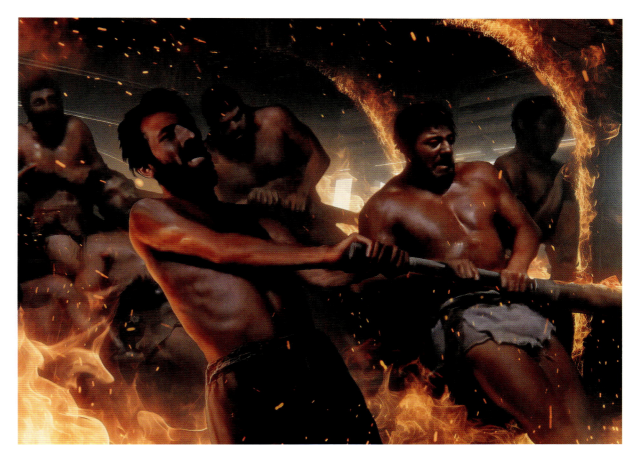
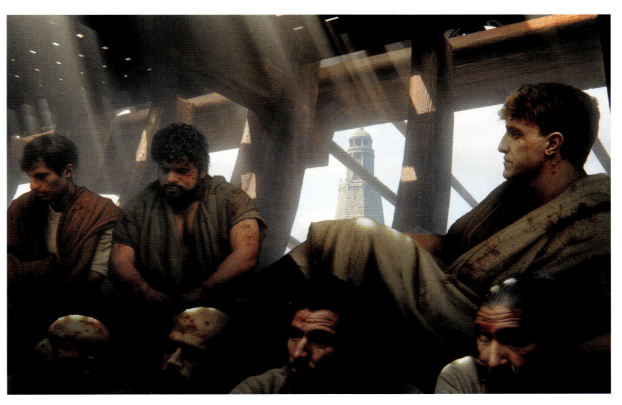

CHAPTER II: DESIGN 67

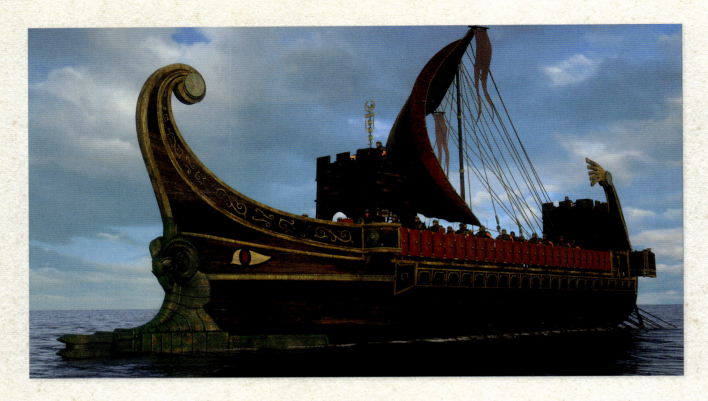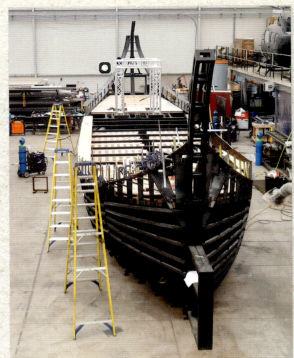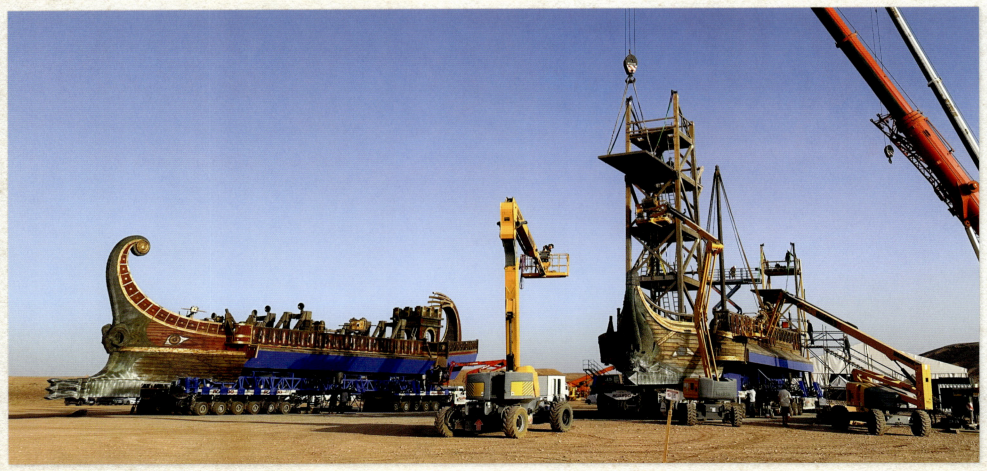

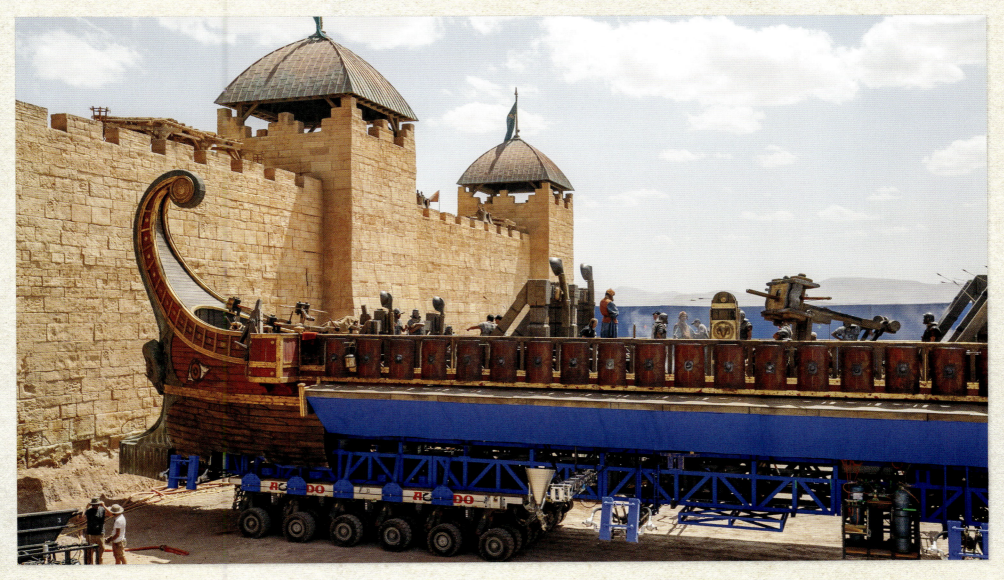

CHAPTER II: DESIGN

1. Camera pans onto Lucius. Black + white + a silver sea. Like thick mercury.

2. POV Lucius. Distant beach figures + a raft. They are being helped onto the large raft.

(Option) Another raft is already moving to a horizon.

3. Lucius feet slow moving in the "thick" silver water.

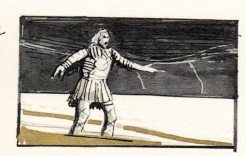

4. He sees Aristat, who does not acknowledge him. He begins to run thro the thick liquid. An impossible task.

5. He calls to Aristat - lightning flashes (see reference) as she stops, looks towards the raft. Lucius (unseeing).

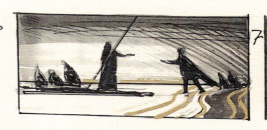

6.

7. She looks at him once as if not hearing or recognising Lucius.

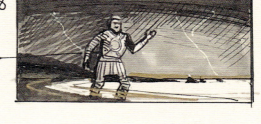

8. Now sprinting towards her. Impossible in such thick liquid. Possibly use ties. Lucius plunges into the

9. Swollen water watching her disappear into silver mist.

10. He goes under and surfaces in the fog.

THIS SPREAD
Lucius's experience in the River Styx was visualized in both traditional hand-drawn storyboard art and computer renderings.

70 THE ART AND MAKING OF GLADIATOR II

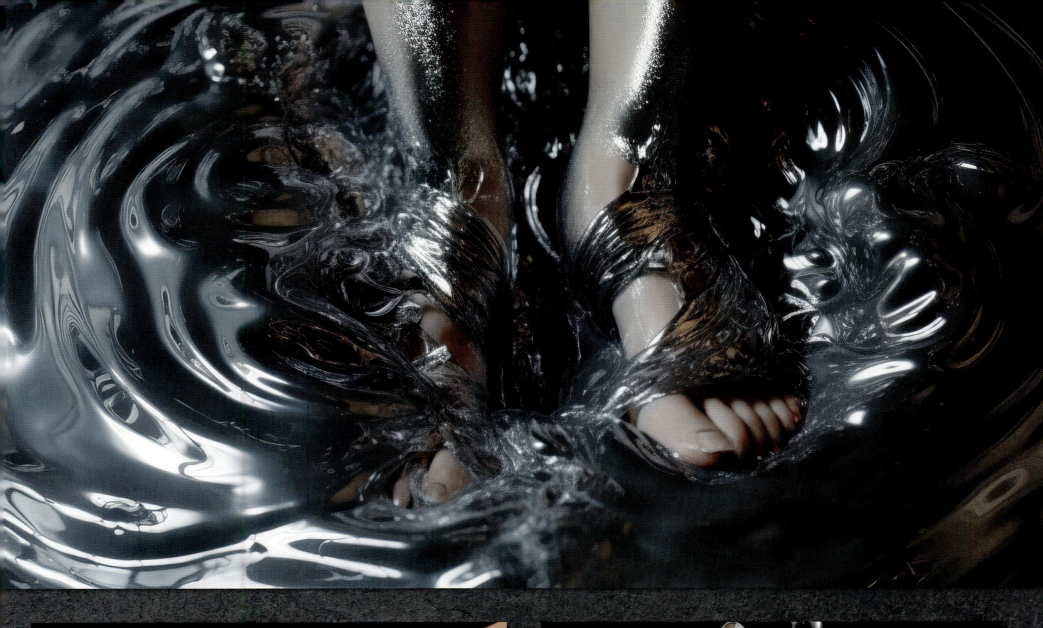

CHAPTER II: DESIGN 71

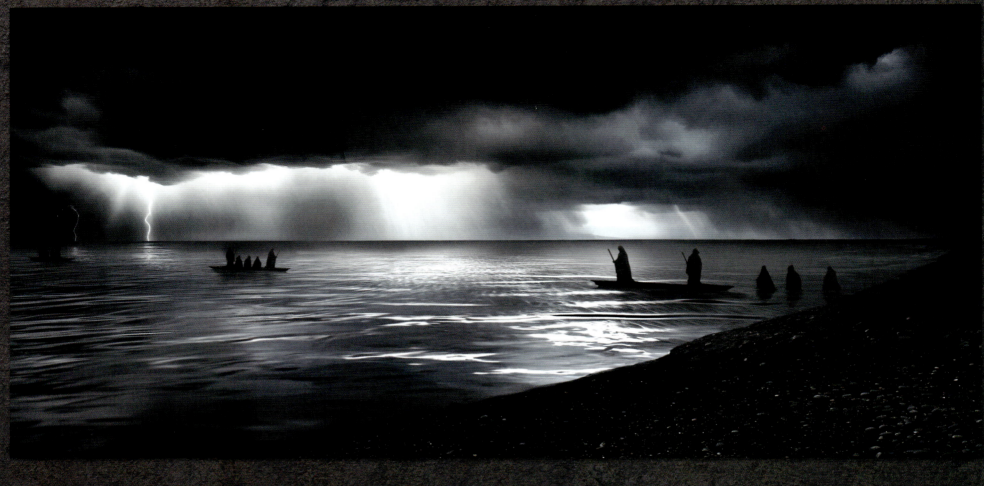
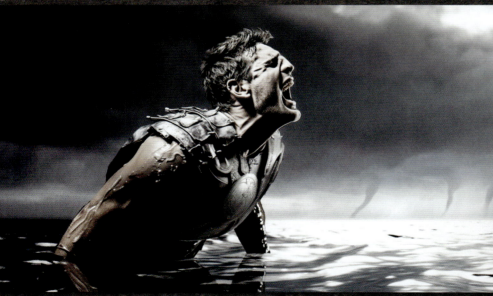

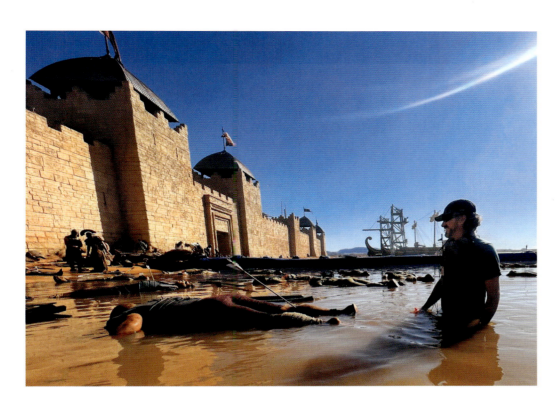
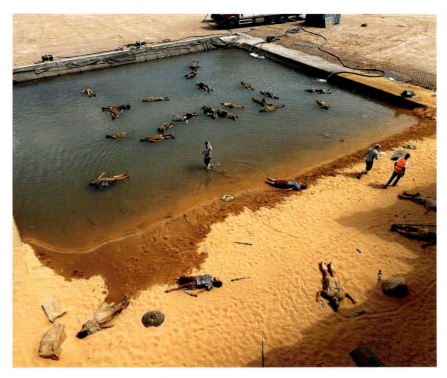
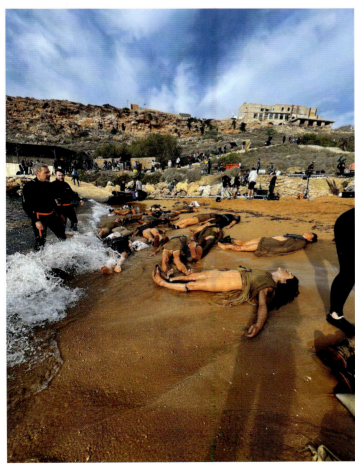
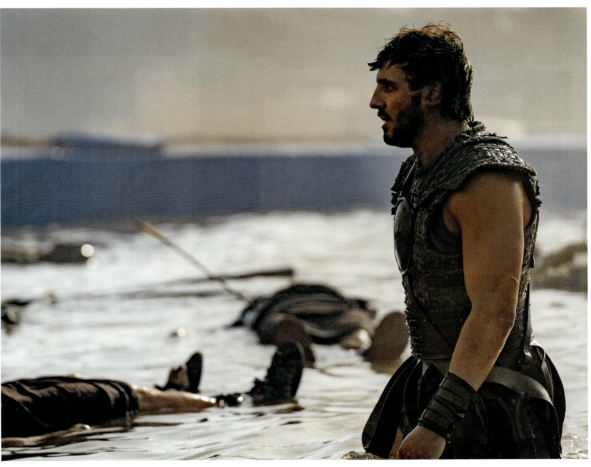

CHAPTER II: DESIGN

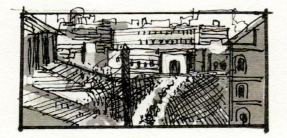
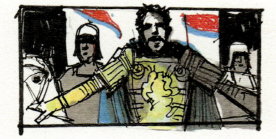

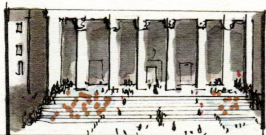

ROMAN ROADS

Hollywood's portrayals of Roman streets have varied dramatically over the years. *Gladiator* made the leap to a realistic environment that set the standard to which all other depictions of Rome are held, thanks to the groundbreaking work of Arthur Max. "The forum in Fort Ricasoli [in Malta] is our Roman Via Sacra, as it was known historically. It's an interpretation using existing buildings with constructed buildings and an authentic and genuine second-century architectural style with some traditional elements, like the triumphal columns erected after every Roman victory. And you would have the gilt Roman victory statue, the Winged Victory, on top of each triumphal column. We have those in a slightly modified arrangement, as the scholastic versions and the re-creations of the traditional Roman Forum would have been, accommodating the confines of our existing spaces. It's reminiscent but also uses the constrictions of existing buildings and available space."

LOGISTICS

Regarding workflow, this was the largest and most challenging film for Max, who revealed the challenge but admitted the scale could sometimes seem overwhelming. "Totally challenging, exhausting, stressful, and gratifying. All of the above. Because of the time frame we shoot no matter what, and we pack the day very densely in terms of what we have to achieve daily. And it's stressful—it's a long day—and I'm not getting any younger. We're still keeping up with the kids, and sometimes you have to encourage them because it's challenging. Most films of this scale take twice as long, have twice the budget, and don't achieve as much. We say that proudly."

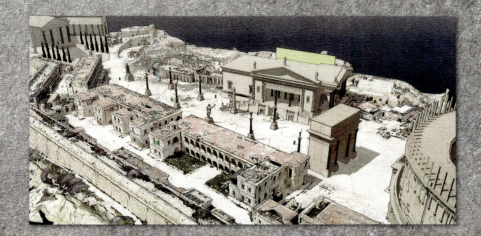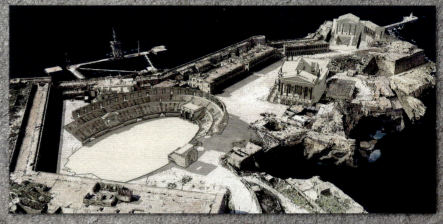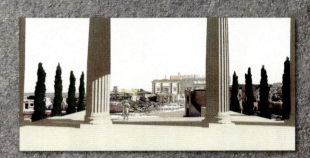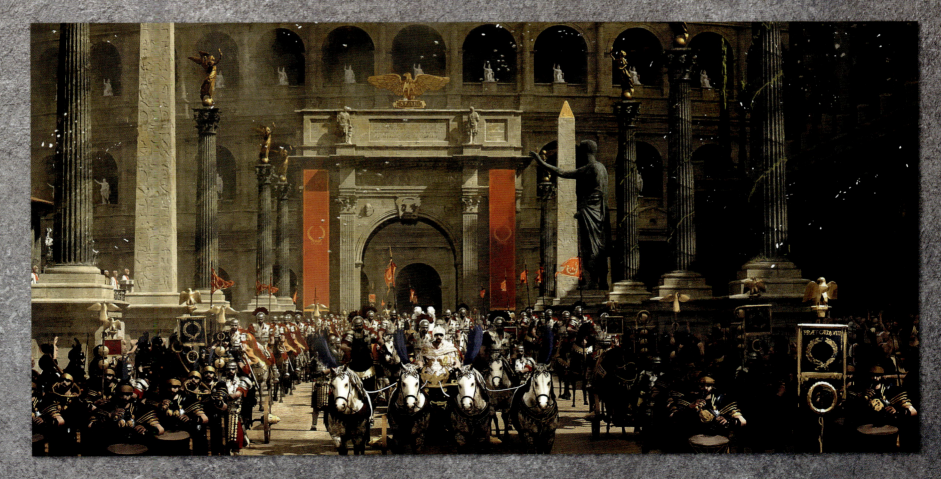

CHAPTER II: DESIGN 75

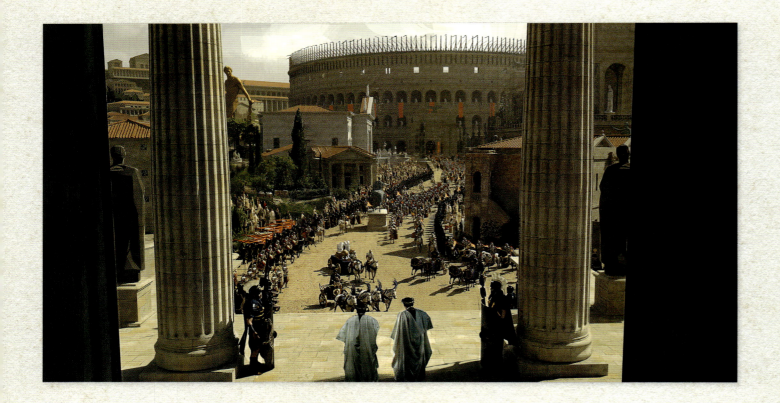

MODEL CONCEPTS

The design work began on paper and computer screens before becoming three-dimensional models. "We started with physical miniature models; tabletop models of the site were the first thing we [made]. We used modern techniques, too, with an aerial drone topographical survey of the site, which we were never able to do before. We built a physical model of the topography of the Rome site in 3D and then started to populate it with miniature buildings and tried to create a layout. From that layout, we did architectural scale drawings, which we then used to develop concept art in color and with people to illustrate scenes from the film."

This helped Scott plan sequences and camera placements and make early changes to the design to better suit the production. "We had a lot of discussions about the processions. The movie had several processions, and we built a giant triumphal arch. We had one on the first movie, but it was a small version of what we ended up with here. At the triumphal arch, we had an enormous military procession for one of the characters returning from the war in victory. That was successful. The way we planned it worked well with all the nooks and crannies of the site. We filmed in various ways and revamped [the set] several times to be various places. We used every square inch of this site to its maximum potential."

VISUAL EFFECTS

Today's evolved technology, as opposed to what was available twenty-five years ago, provides filmmakers with a larger canvas and a chance to fulfil creative ambitions. "The visual effects are another layer of scale. We can achieve a certain amount physically, but we rely on the marvels of visual effects software for anything at higher story levels that we can't physically reach because of our limitations of gravity, budget, or time. But at the same time, they [the VFX team] look to us to design and draw up the extension layers architecturally, as if we were going to build them completely. The extensions [to the sets] that were big in detail, texture, tone, and color were part of our concept art department. There's a great deal of integration between the two parts and where the boundaries are: where the line is above and below the level of physical reality and visual effects, digital reality, and 'reality.' So there's a lot of collaboration between the visual effects department and Mark Bakowski [visual effects supervisor, Industrial Light & Magic] and his team."

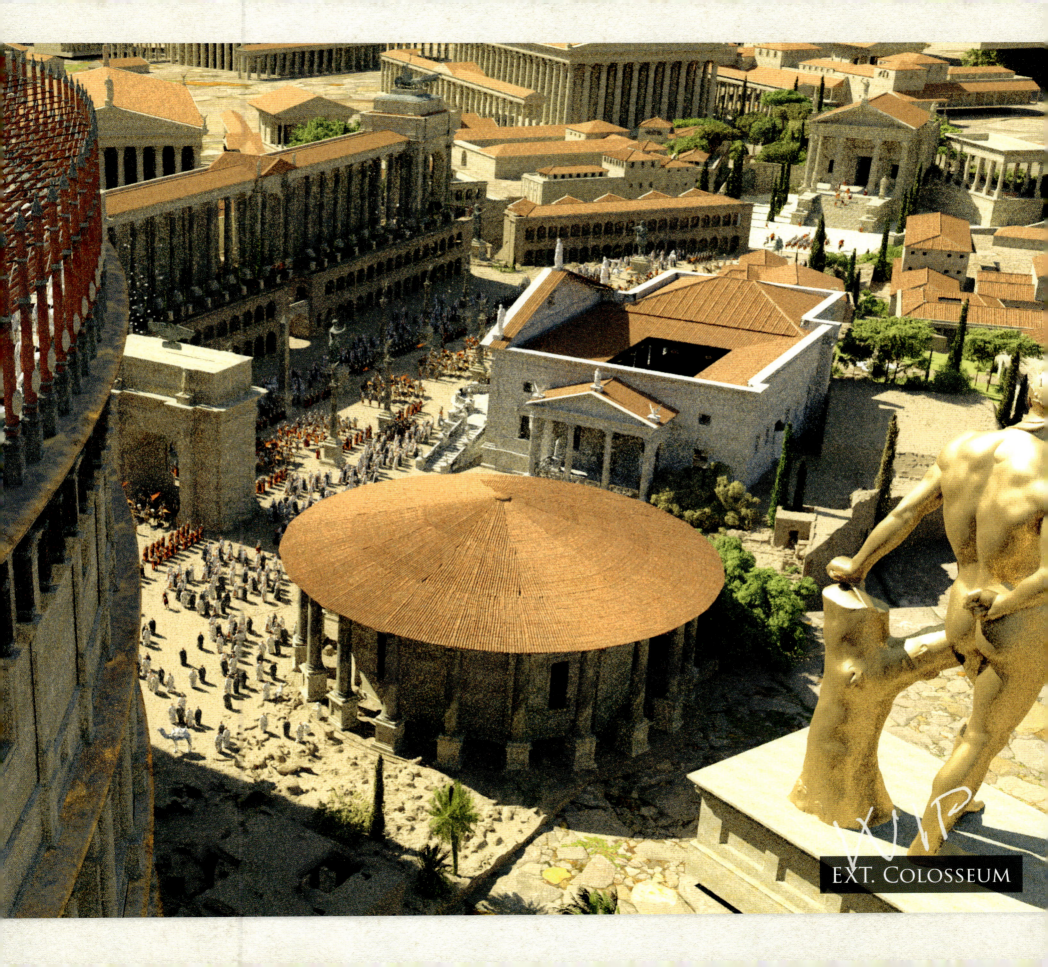

EXT. COLOSSEUM

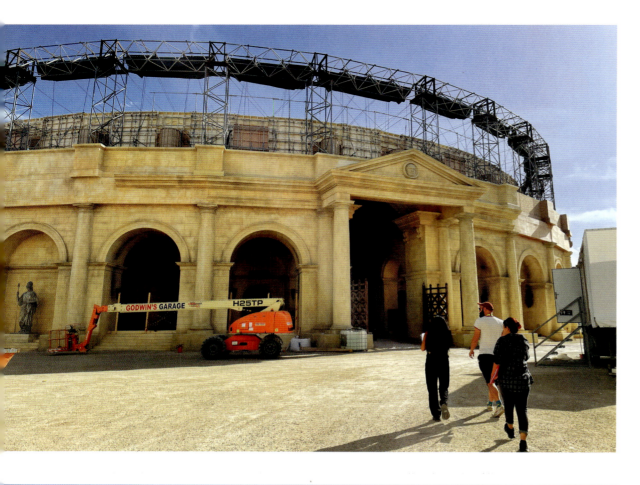

MALTA

"Returning to Malta again and seeing the Colosseum being built in the same place was terrific," said Corbould. "I've stood outside when everyone's gone home and just looked at it. It was pretty emotional twenty-five years ago when we shot the first one. I didn't get it when Ridley told me he was shooting *Napoleon* in Malta for France. And then when we went to the medina, I got it. Ridley has this eye. He'll be scouting another film and go, 'Oh, I'll use that on my next film.'"

TEMPLE OF VESTA

"There was a little anomaly on the side, a small sinkhole of around ten or twelve feet in diameter, during the first movie," said Max. "It was a small danger zone surrounded by fencing because it was collapsing into the ocean. By the time we came back, twenty-odd years later, it had expanded into something five times the size and was a real hazard. The engineers told us we couldn't go any closer than twenty-six feet, so we decided to encapsulate it with a temple. That way, we could keep people out of it, but at the same time create something big that would have a visual impact. So we made a Temple of Vesta on steroids based on the Temple of Vesta in Rome, which is quite a small building, but ours was four times the size. That served a dual purpose. It was a remarkably effective building, but it also prevented anybody from falling to their death, which was, you know, a good thing."

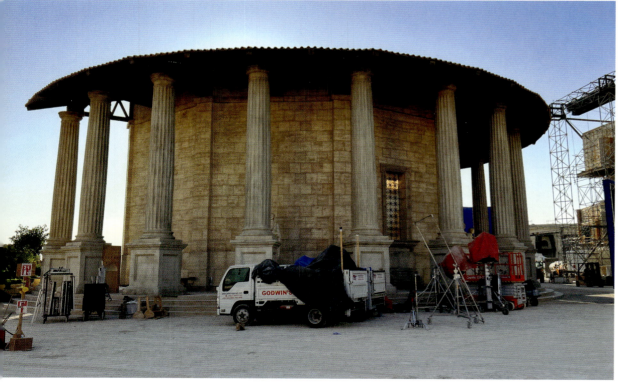

ABOVE
Sir Ridley Scott with production designer Arthur Max (center).

OPPOSITE
Max enjoys the vast world he has created.

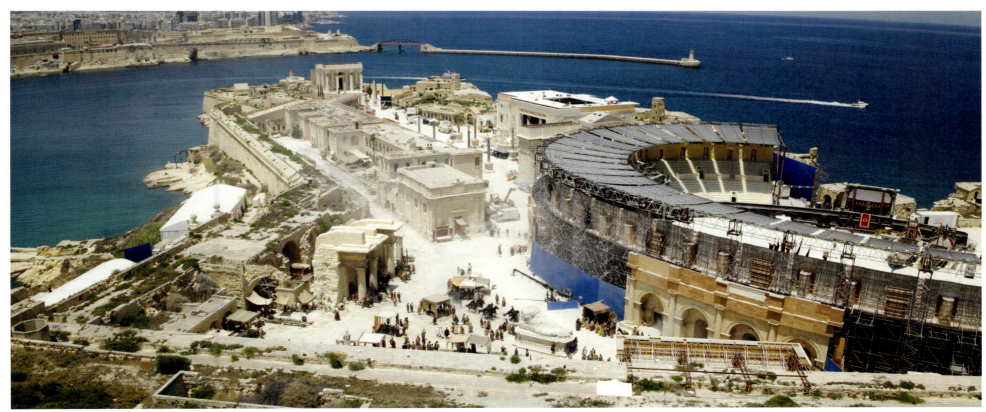

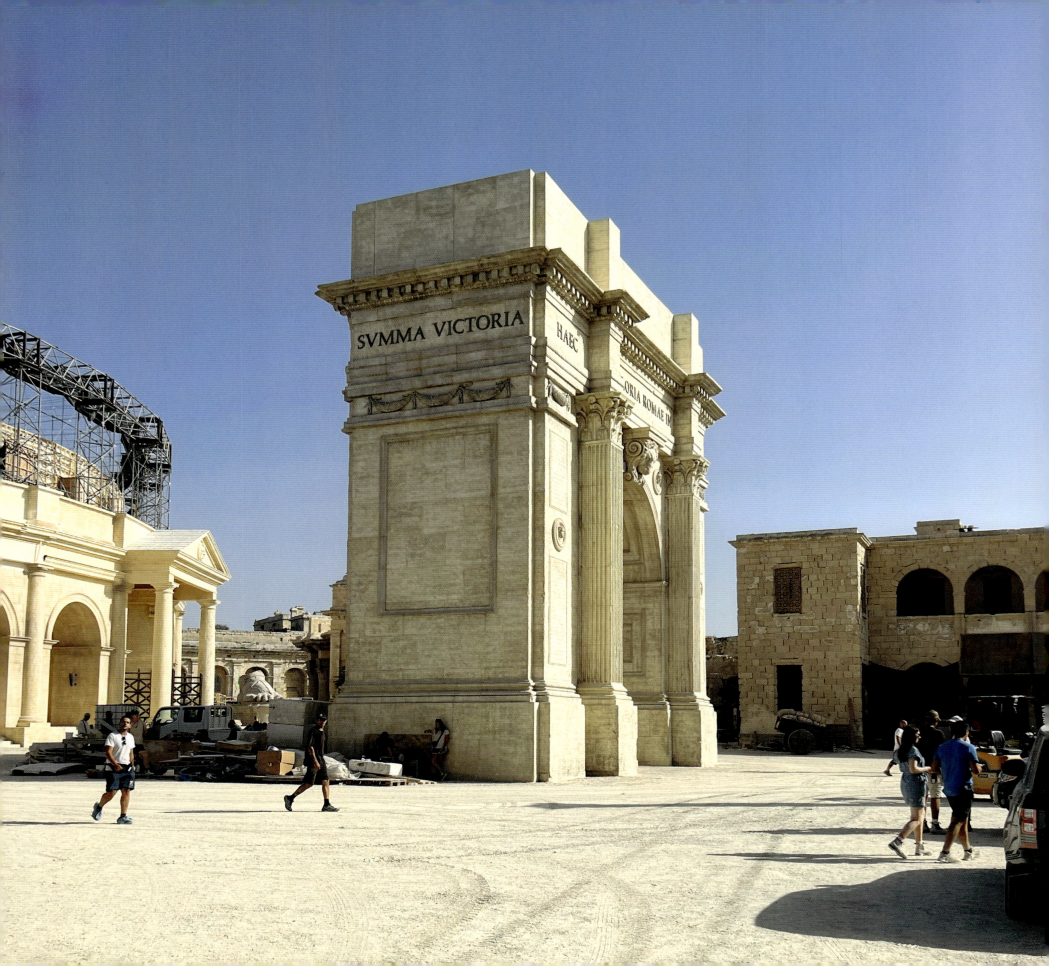

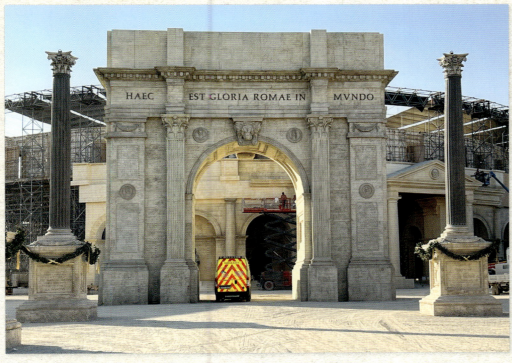

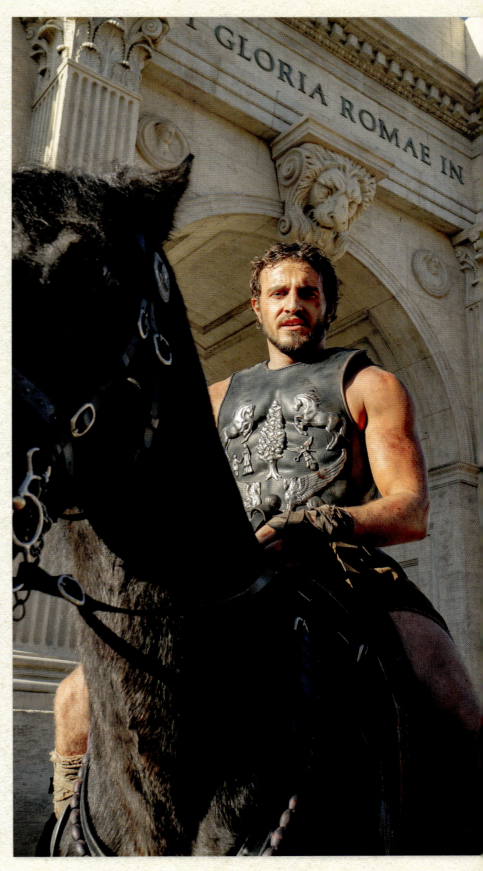

THIS SPREAD
"The scale of the Roman triumphal arch expanded to correspond with the scale of the palace. Everything was bigger," said Max.

CHAPTER II: DESIGN

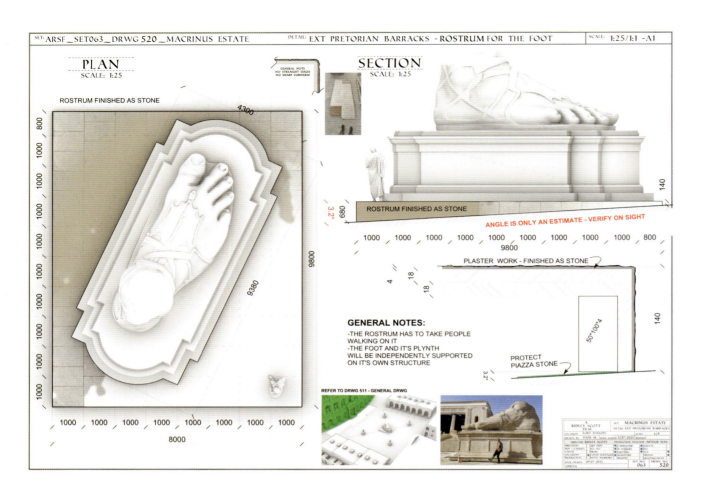

THE NEW WORLD

Technological advancements also helped with Max's real-world solutions to fabrication. "We rely on the old craft skills of molding and casting and physical sculpting by hand. We did a large amount of miniature maquette building; we digitally scan them to enlarge them with computer-controlled cutters made of lightweight foam. For oversized statuary, in the first movie it was done in the old-school technique of building a steel armature, packing it out in clay, sculpting and molding the clay, casting it in sections, and then reassembling it in sections and casting in either fiberglass or plaster, which is time-consuming and heavy to move around. We utilized more modern techniques of maquette scanning and digital sculpting, making it lighter, easier to move around, and quicker to manufacture," said Max.

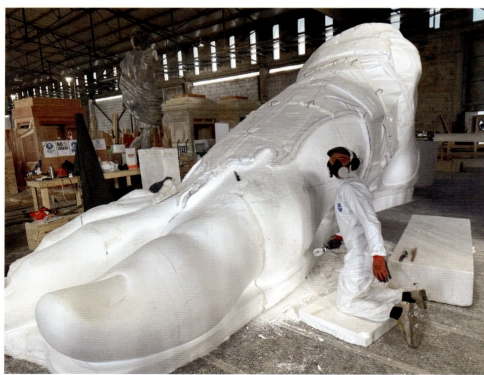

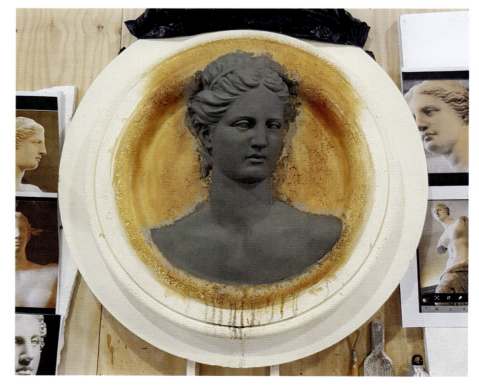

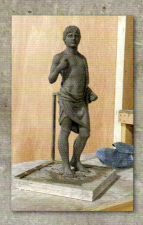
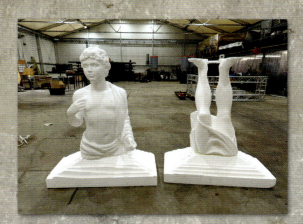
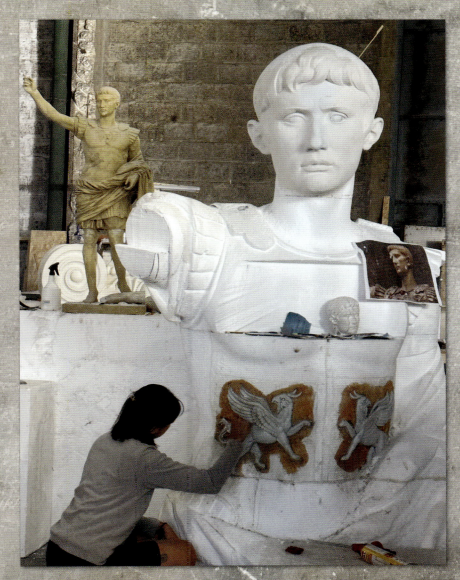
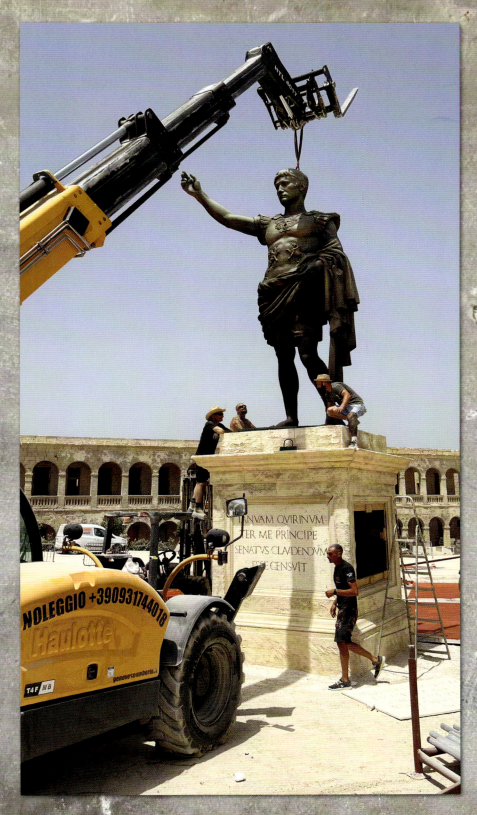

CHAPTER II: DESIGN

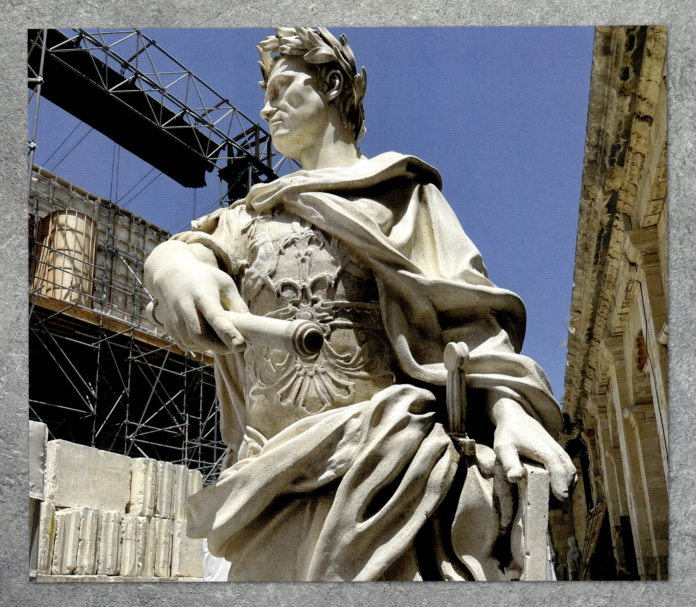
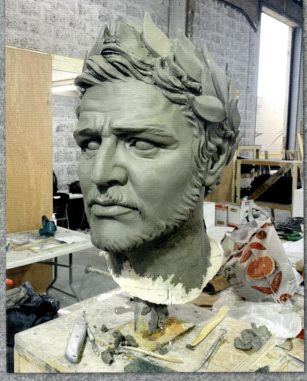
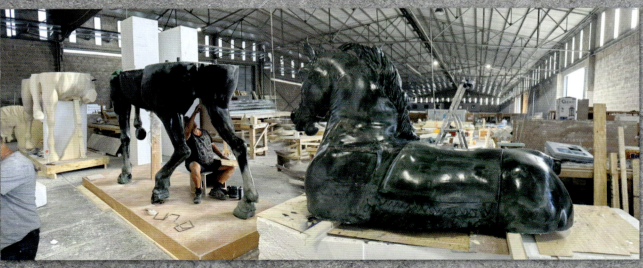
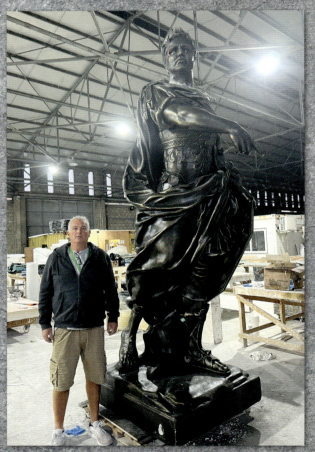

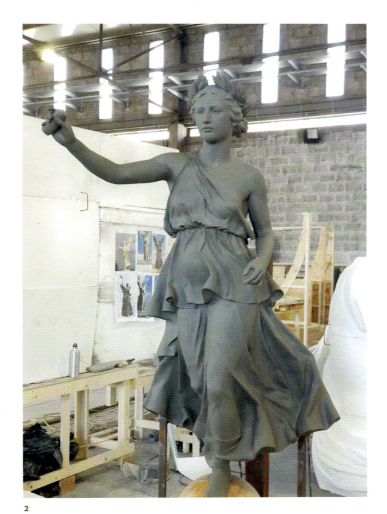

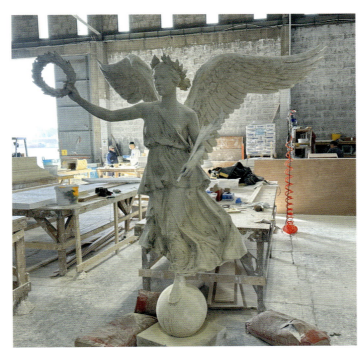
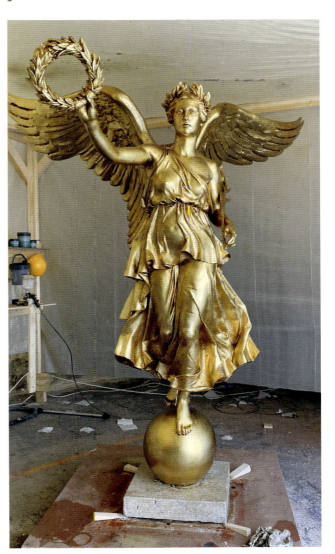

THIS PAGE
The full process of crafting the film's many statues is documented here from initial drawing (1) to clay sculpting (2) to molding (3) to fiberglass fabrication (4) and finally the finished, screen-ready piece (5).

CHAPTER II: DESIGN

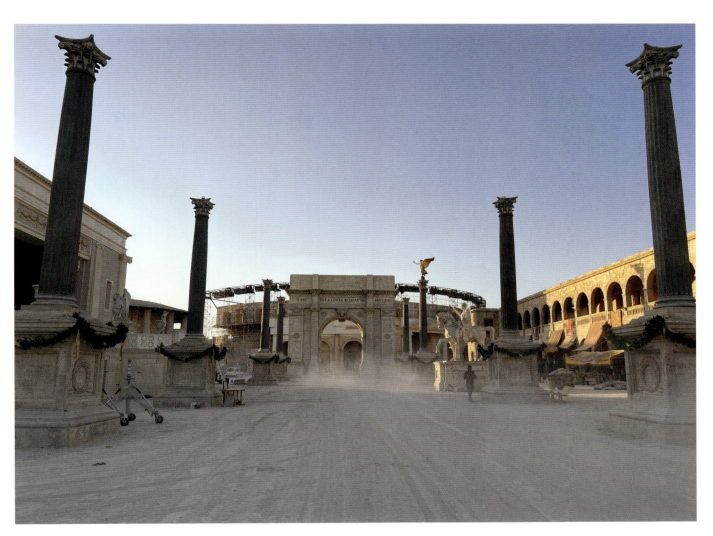
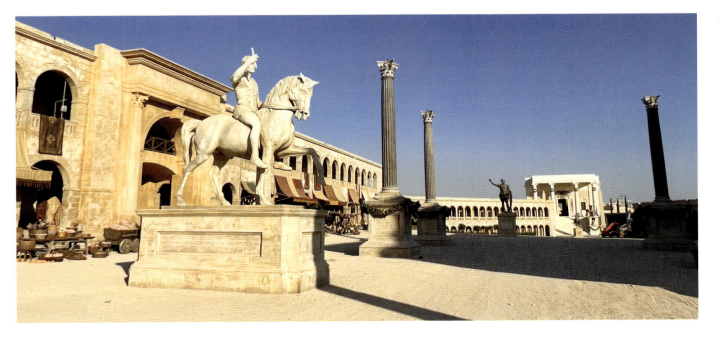

CHAPTER II: DESIGN

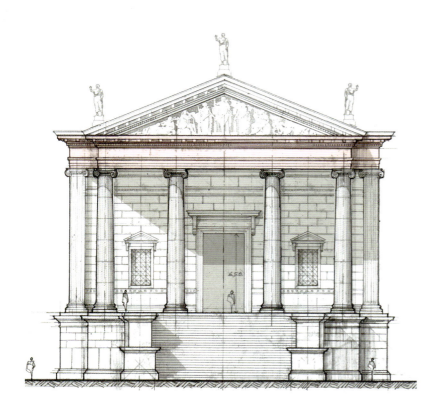
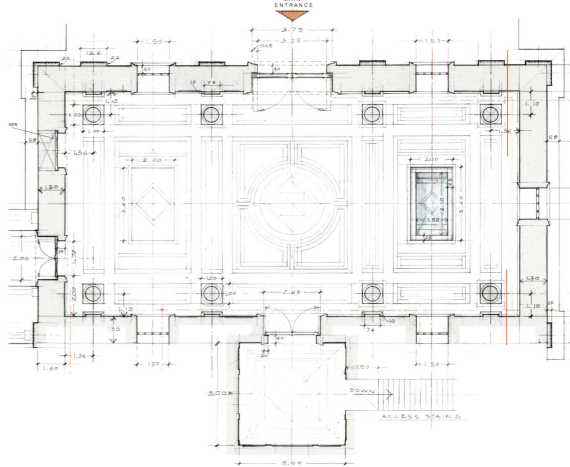

THIS SPREAD

"We had a second palace, the lower palace, which was more of an exterior that we eventually decided to finish the interior of for another scene," said Max.

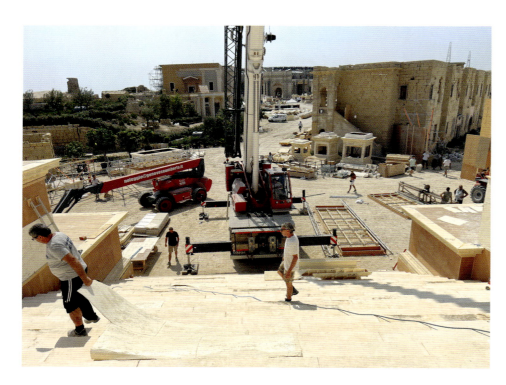
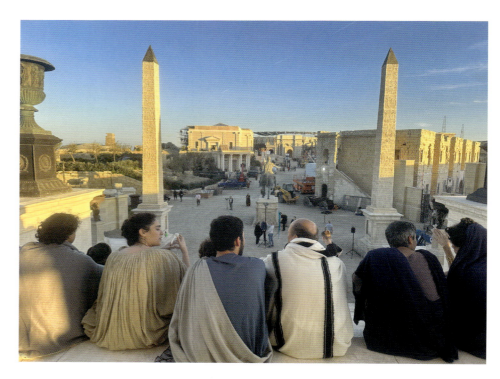

88 THE ART AND MAKING OF GLADIATOR II

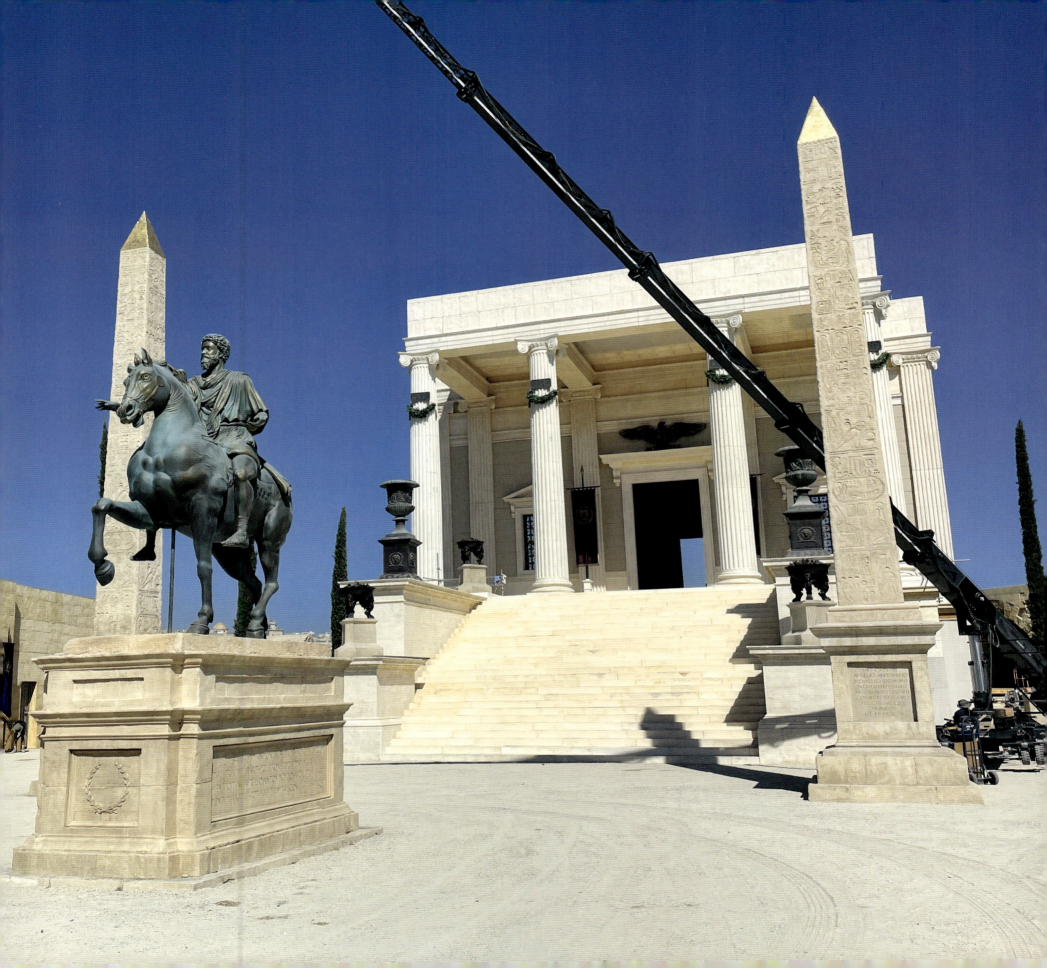

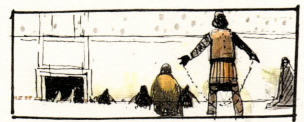

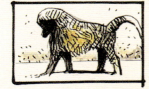

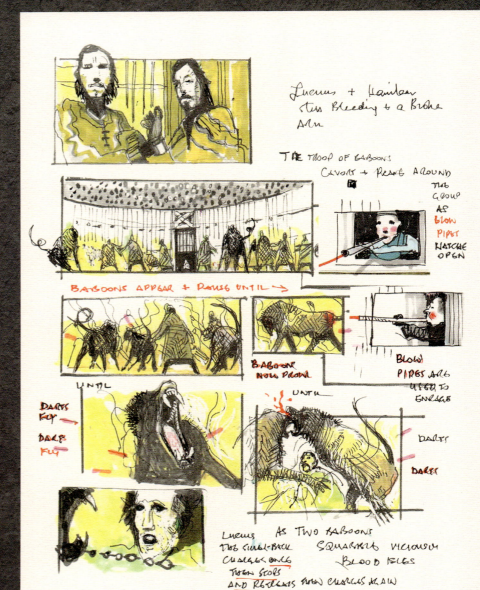

THIS SPREAD
The baboon attack is meticulously detailed via storyboards.

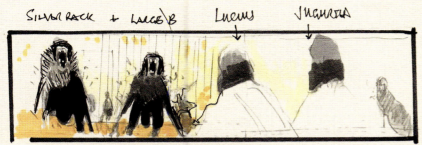

SILVERBACK + LARGE B LUCIUS JUGURTHA

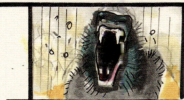

THE SILVERBACK GOES FOR LUCIUS

CHARGES LUCIUS AS LUCIUS RAMS THE CHAIN INTO ITS MAW

AS

IT BITES HARD + SMASHES ITS TEETH (PIECES OF TEETH FLY, BABOON HOWLS IN RAGE

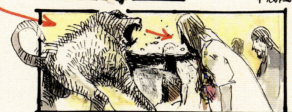

SIMULTANEOUSLY THE LARGE BABOONS ATTACKS JUGURTHA BITING HIM ON THE NECK

JUGURTHA PASSIVE PREPARING TO DIE AS THE BIGGEST BABOON

AS THE LARGE BABOON ATTACKS

* FLIP THIS SHOT. BABOON LEFT TO RIGHT GRABS JUGURTHA AND BITES ON HIS FEMORAL

JUGURTHA WAITING FOR DEATH STAYS STILL + PRAYS TILL THE END

AS LUCIUS CHARGES IN TO STOP THE ATROCITY AS HIS SILVERBACK COMES AFTER HIM.

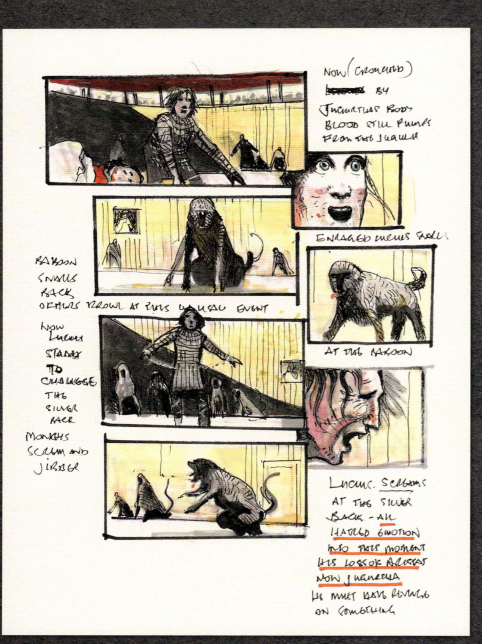
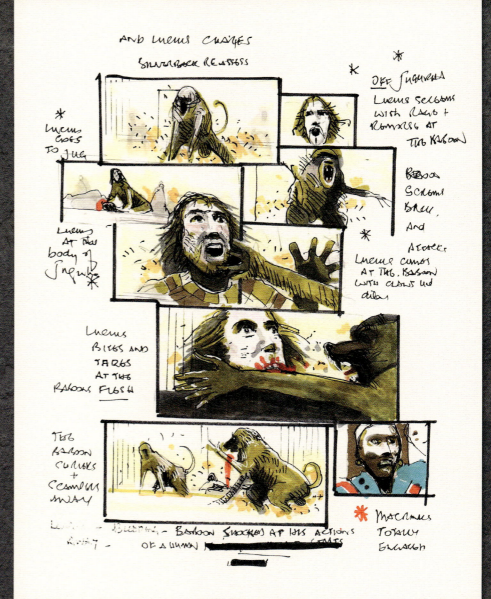

THIS SPREAD
All production departments on the film would rely on these sketches to plan the shoot and decide what was feasible to achieve.

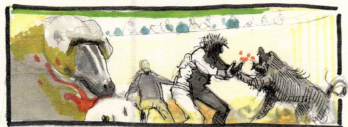

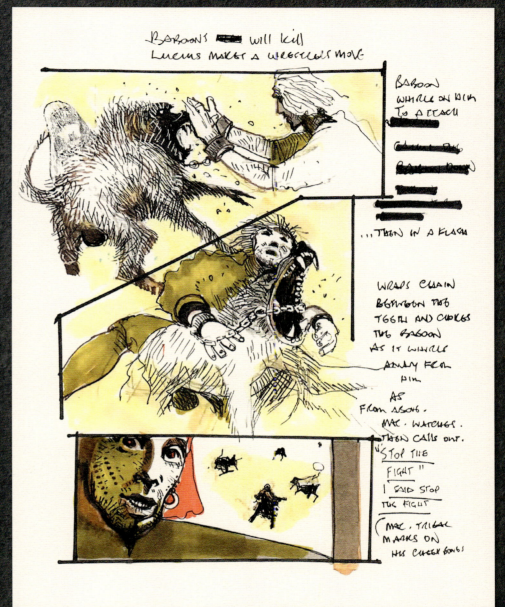

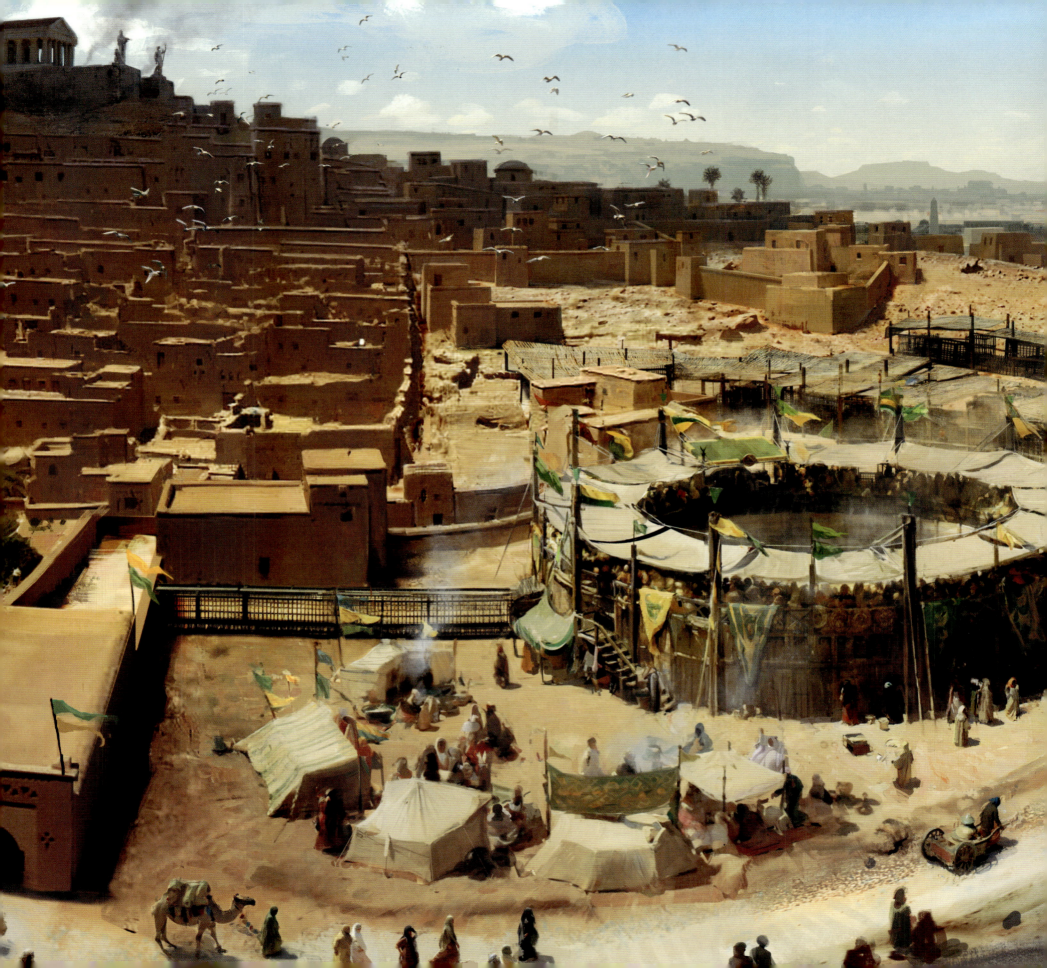

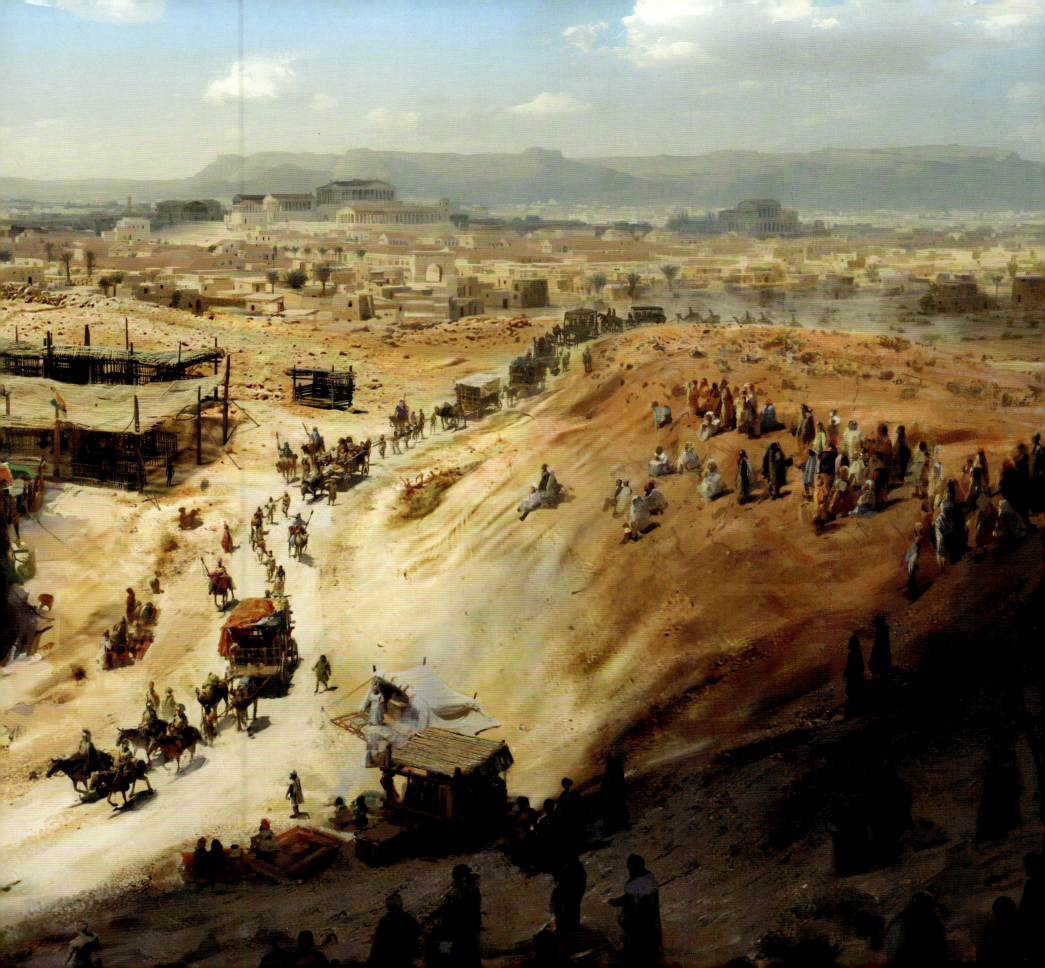

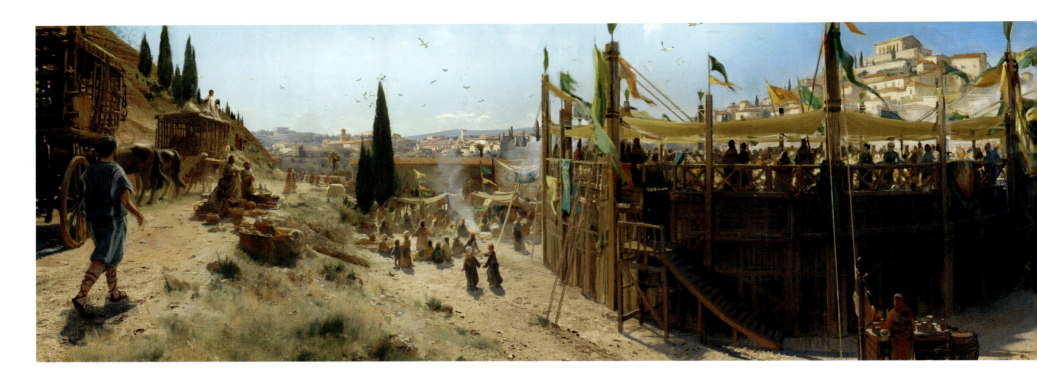
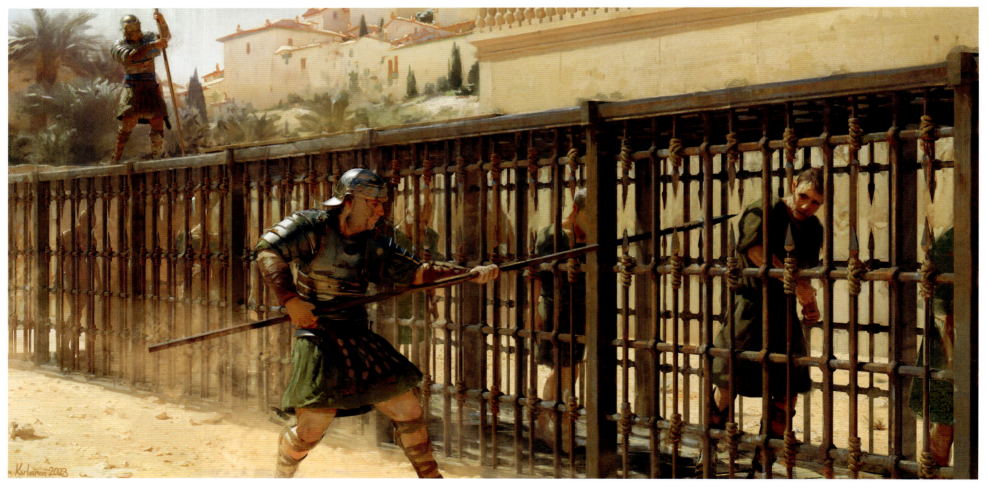

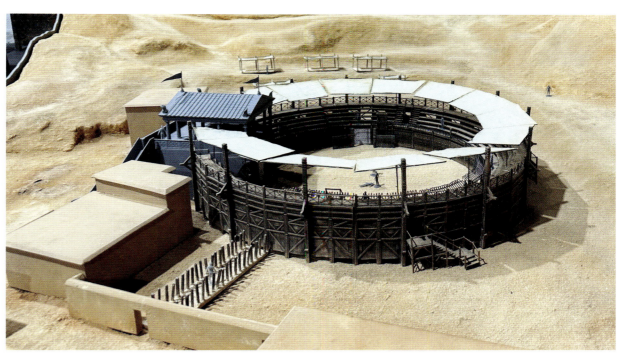
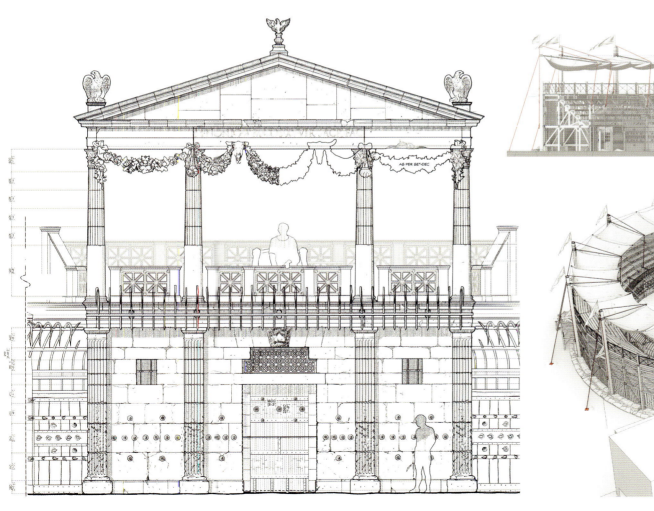
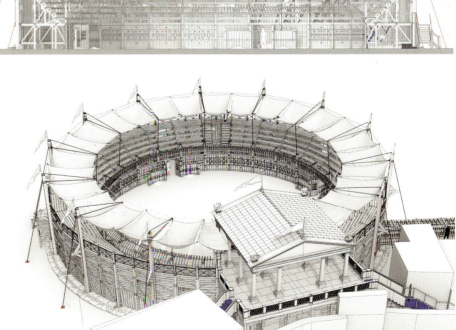

CHAPTER II: DESIGN 97

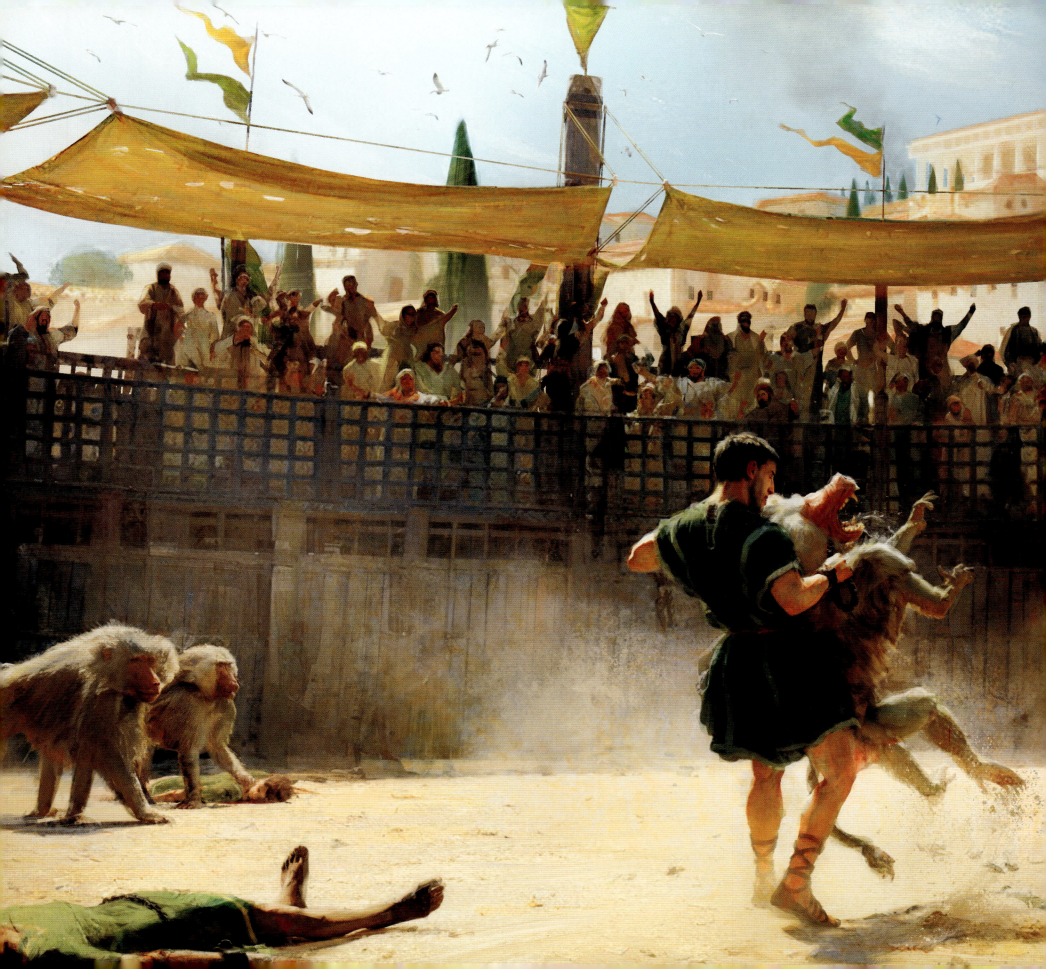

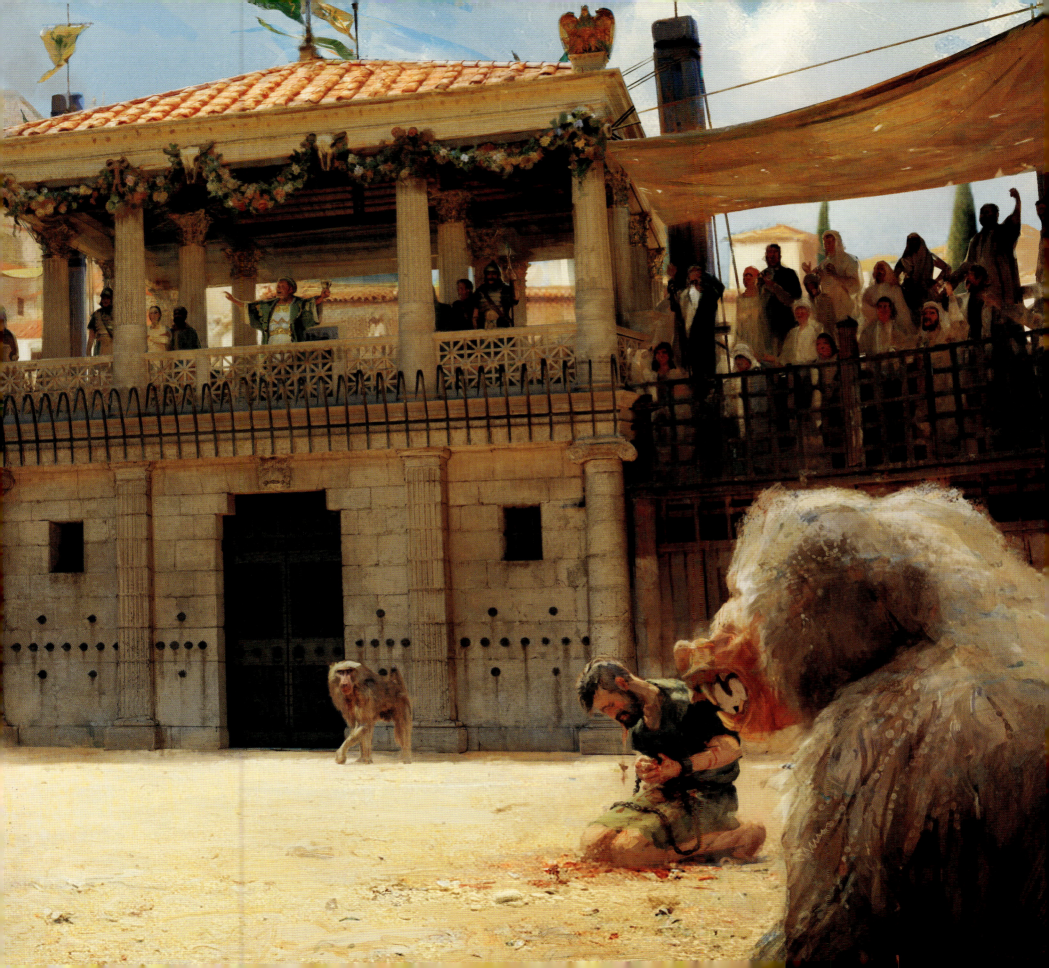

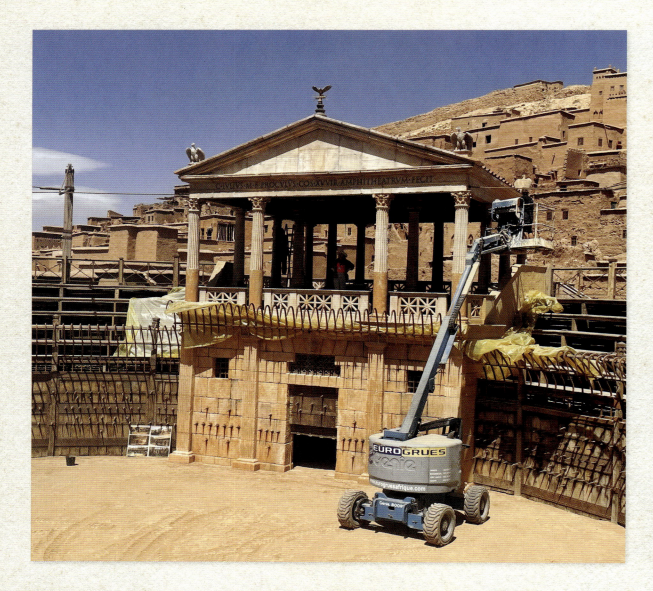

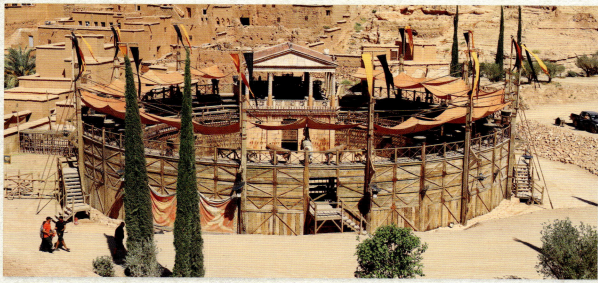

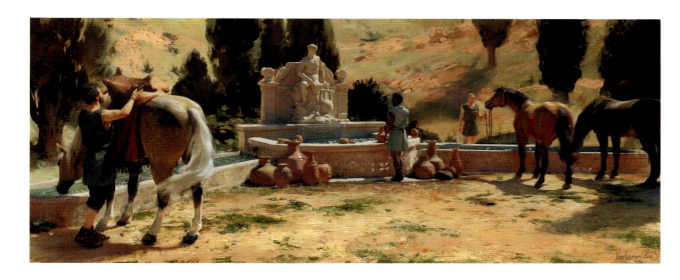

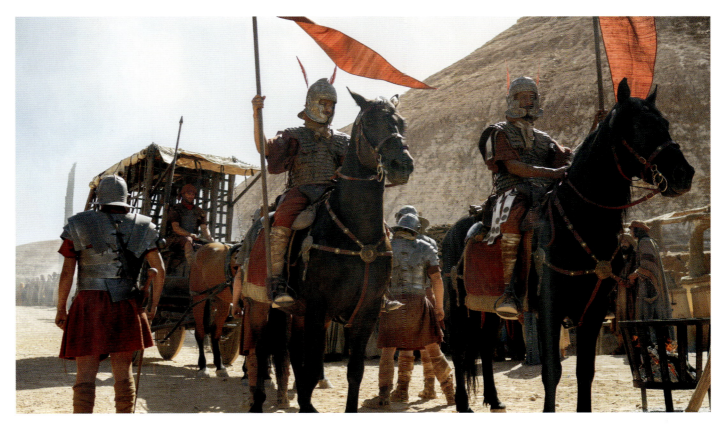

CHAPTER II: DESIGN 101

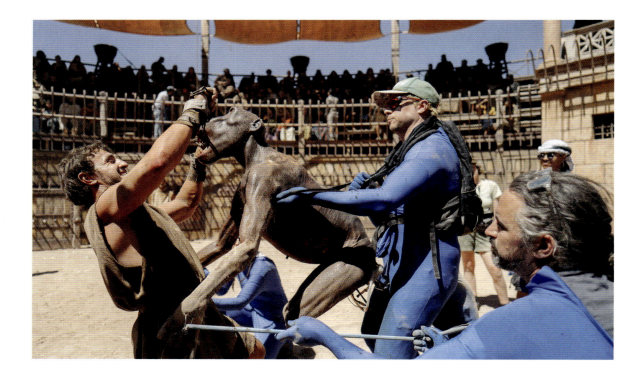

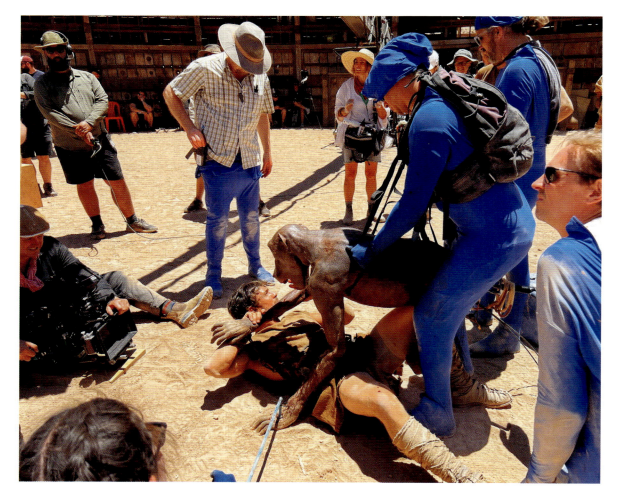

BABOON SEQUENCE BREAKDOWN

One of the most visceral and demanding sequences in the film was the baboon attack. This involved on-set baboon puppeteers wearing blue screen material who would later be digitally removed. Visual effects supervisor Mark Bakowski and the team from Framestore would then provide more movement and detail. The visual element, although dominant, is only one of the four key elements that Scott must consider when making the on-screen sequence as dramatic as possible. Ridley Scott believes four key components create the perfect visual cinematic experience. But getting this balance right is not a science, and his years of filmmaking instinct play a prominent role here. "Sound is one of the four components of anything, which is, first of all, vision, then photography, then story; the storytelling is just in itself. Sometimes a vision is more powerful than a word, and sometimes the word is more powerful than the vision. It's a compound of sound, which is all the volume, dialogue, and sound design, which also means the shrieking of baboons behind closed doors, so you don't know what they are as well. The third component, which is terribly important for me, is scope. There is music as well. A fourth component, which I was trying to get into particularly, we somehow successfully pulled off in *Gladiator*, is the mystical, spiritual thread that runs through the movie. I'm trying to thread that into this from the beginning."

THE POWER OF SILENCE

Sound—or the lack thereof—if deployed correctly, can be a key weapon in the filmmaker's arsenal, as Scott reveals here. "Silence can also be music. You can argue that silence is music to make a dramatic point. The same is true in performance. Silence heightens the drama. I think these two have such great looks. The scene is of two brothers falling out at that moment. It requires silence. In silences, the gap becomes even more electric. Macrinus comes in and sees that this is an opportunity to take advantage of the upheaval. You now see the brothers are in serious disarray. And now's a good moment to step in, which he does."

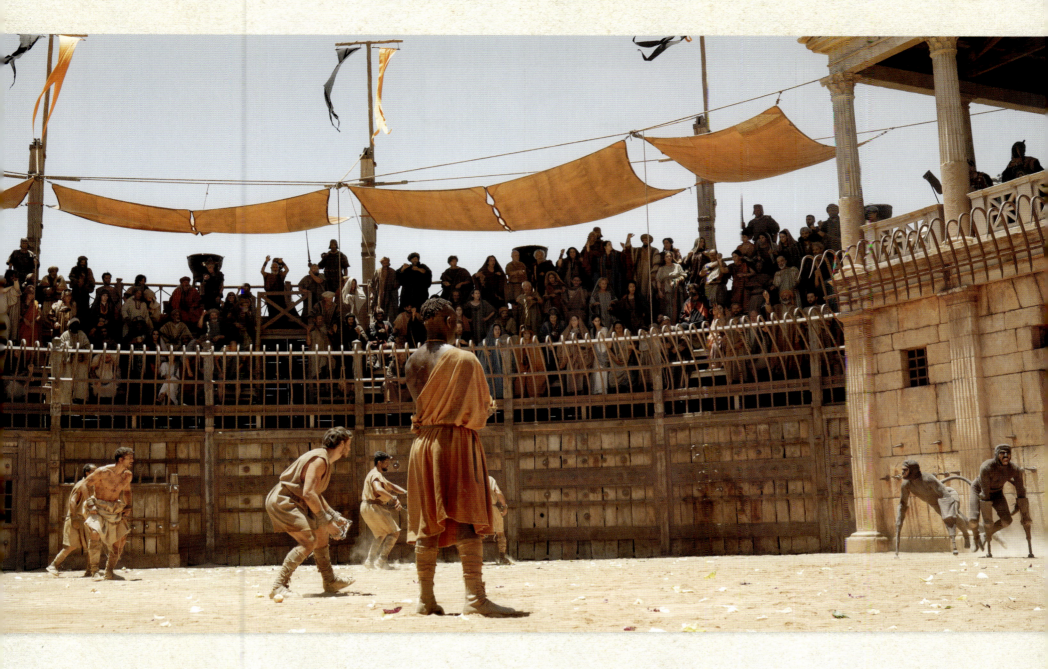

BABOON ATTACKS

The baboon attack sequence also used both on-set physical creature puppetry and CGI. "That was a tough one," said Bakowski. "There wasn't much rehearsal before, so it was a bit of trying to react on the day. That said, we did have a plan going in. The idea was to shoot it once with the stunties [stunt performers dressed as baboons]. We tried to get the stunties as small as possible, or as close to baboon size within reason. That said, I think one or two were still six feet tall. The plan was to shoot once with the stunties interacting with everyone, but in the end, we knew we'd be removing them, as they didn't move like baboons or look like baboons. Plus, as mentioned, they were too large. So, to give us options, we reran the action, removing any 'baboon' who wasn't physically touching somebody. That meant less cleanup for us, but we still had the benefit of the interaction where relevant, as it's quite hard to pretend to wrestle something that physically isn't there. The actors did benefit from the interaction with the stunties. Then we'd additionally film a clean pass as a get-out-of-jail, with no stunties and the actors just miming with thin air. Finally, we'd do our reference passes with silver and gray balls plus clean plates. That gave us most of the formula, but then for a couple of the key close-up wrestling beats, we had an extra option. Conor O'Sullivan's team built a couple of puppeteered baboons used for these bespoke moments. They were better than the stunties, as they were the correct size and look, plus better lighting reference for us.'

THE MACRINUS ESTATE

Fort Manoel was an additional shooting location, conveniently located across the harbor from Fort Ricasoli. Max wanted the authenticity of real locations whenever possible. "All these wonderful limestone vaults were in the interior walls of a Napoleonic-era British fort, which even has earlier medieval roots. This may explain why the texture changes halfway up the wall; it was probably demolished and rebuilt several times. We decided to use some of these vaulted spaces for Macrinus's library and the gladiator school he's running. The exterior of his factory, where he derives some of his wealth, making siege machines for the Roman army as well as training gladiators for the arena, is the old moat of the fort. You can see we love the textures and the proportions of the spaces. We have his gladiator mess hall, dining room, bath scene, Lucius's prison cell, office and library, and the villa he lives in. It's all part of this whole complex. It's a tremendous, giant puzzle, which is another of Ridley's favorite games. He put the movie together like a puzzle from various diverse locations, and multiple spaces and chambers within those locations, and combined them in clever and cunning ways, which is production-friendly because we're not moving from a lot of different places. It saves time when shooting to recycle the same spaces multiple times."

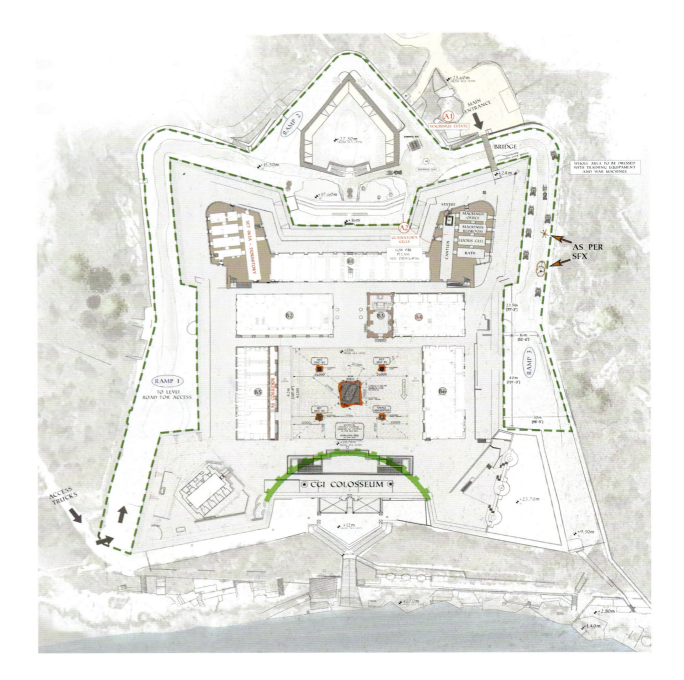

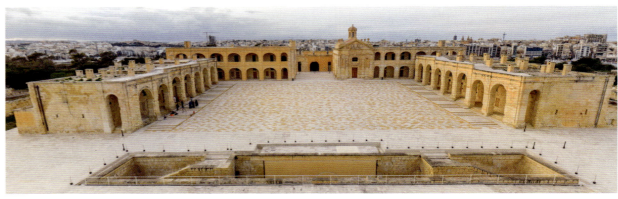

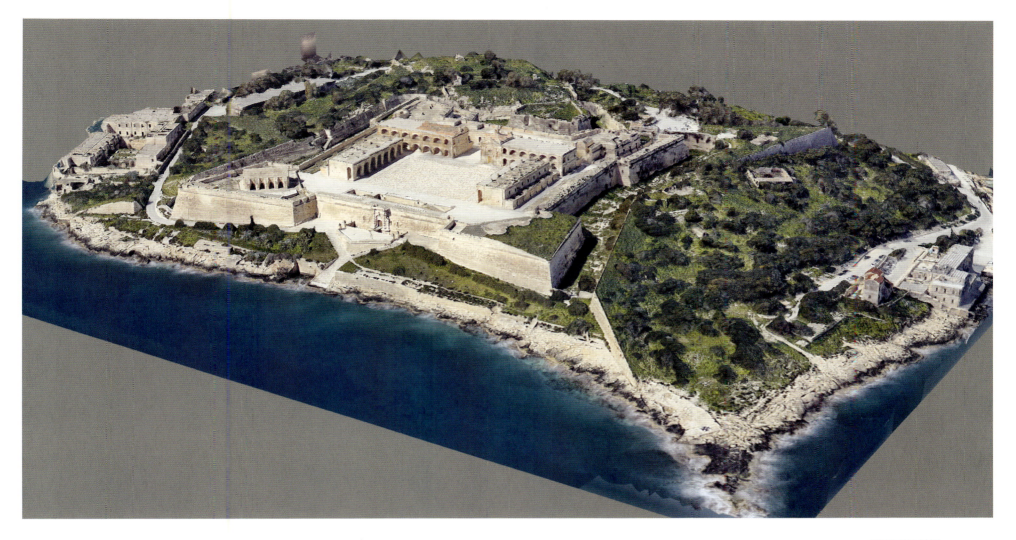

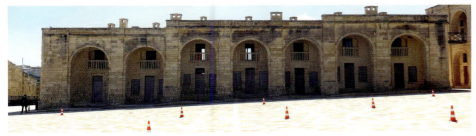
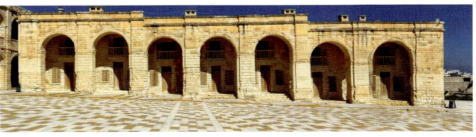

CHAPTER II: DESIGN 105

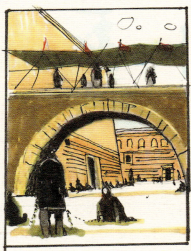

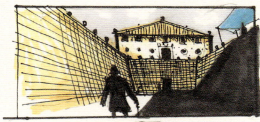

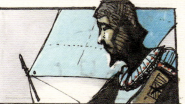

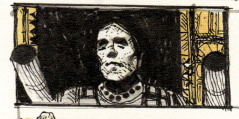

THIS PAGE
Even the dramatic natural light is conveyed in production storyboards.

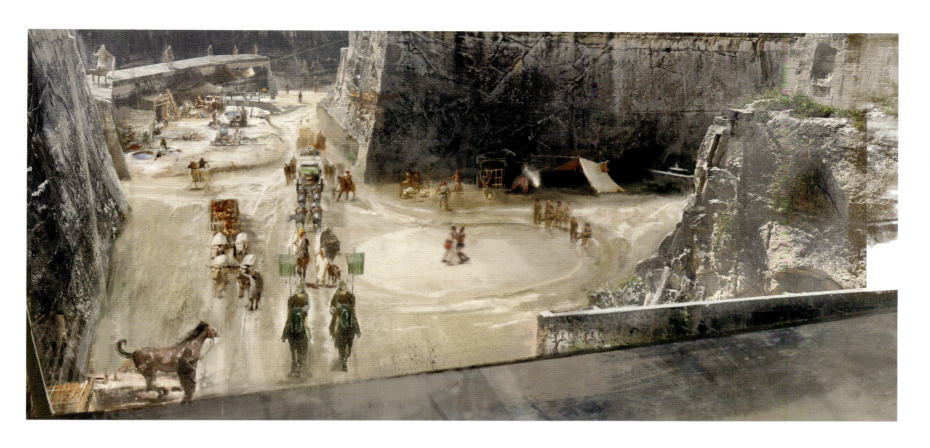
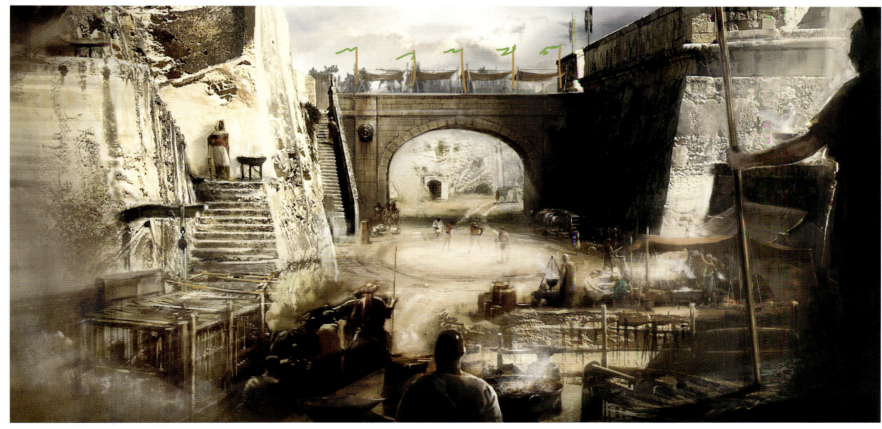

CHAPTER II: DESIGN 107

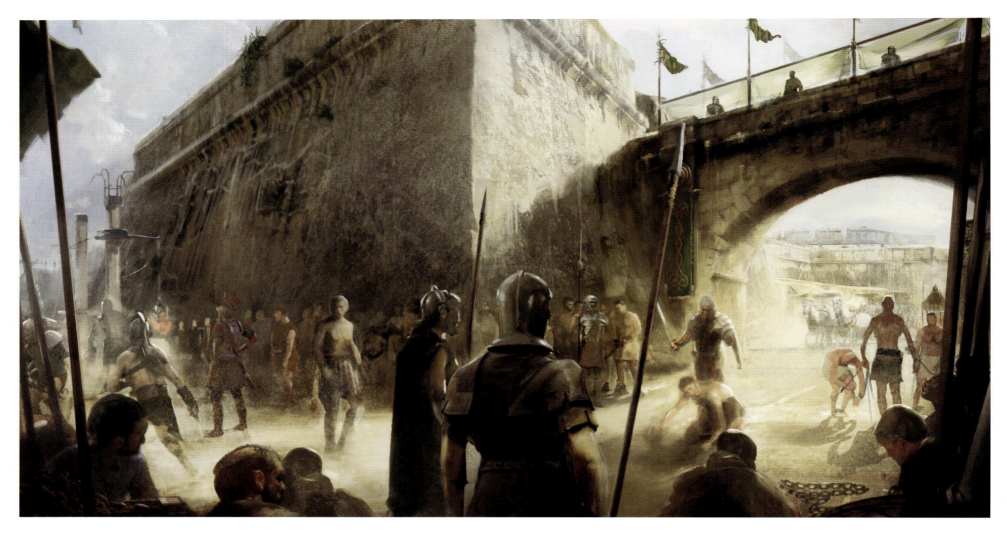
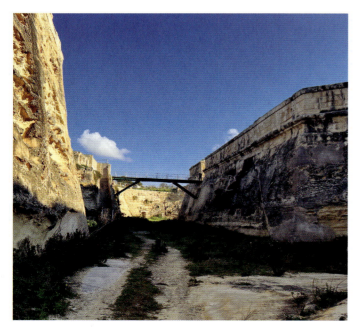

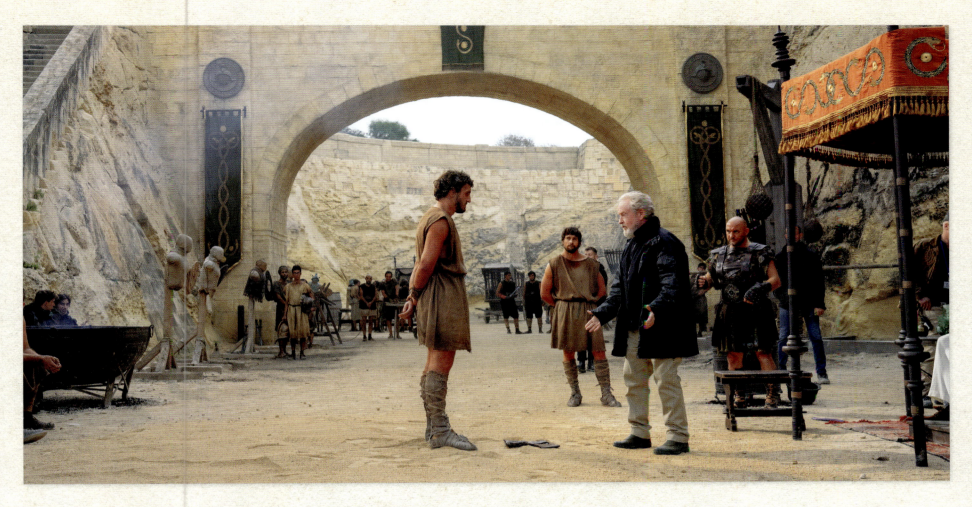

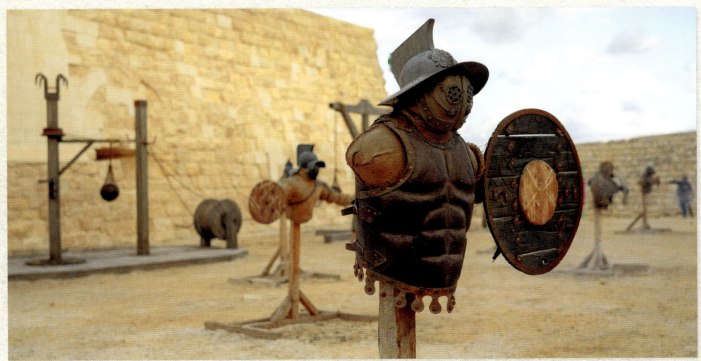

CHAPTER II: DESIGN 109

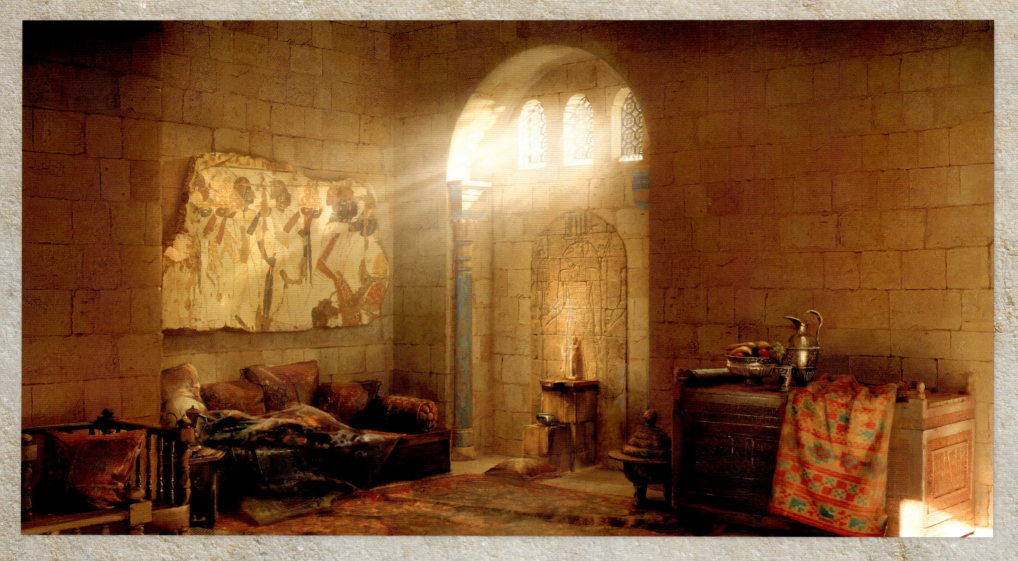

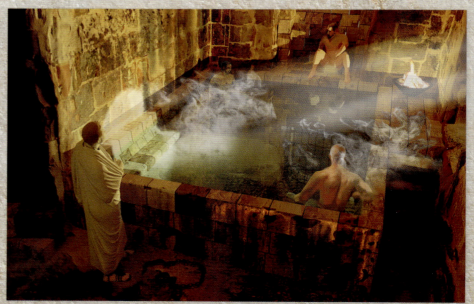

110 THE ART AND MAKING OF GLADIATOR II

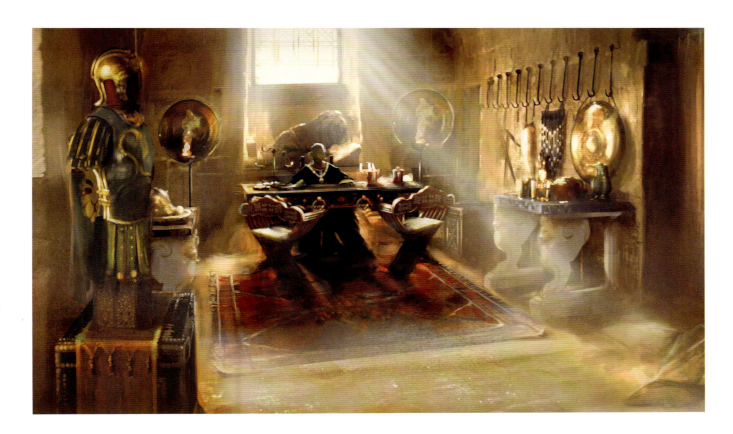

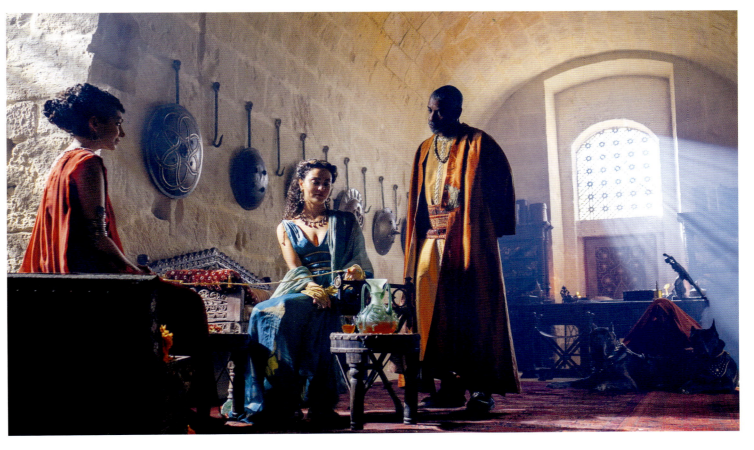

TOP RIGHT

"The quality of the deterioration of the stone, which was flooded at one point. See where it changes in the middle of a block; it's got the pocks below, and then it's smooth above. It's exciting to me," said Max.

THE IMPERIAL PALACE

Even with forty years of experience, some sets still proved challenging for Max. "I have to admit that I bit off a lot to chew there in terms of the scale of the imperial palace. It was an homage to the original palace, similar in plan in that it had an open-to-the-sky atrium. Any good Roman building would have had, in the second century, a peristyle or a kind of colonnade around it; an open courtyard with an impluvium, which is a pool that captures rainwater; and then large interior spaces off of that, which is exactly what we had on *Gladiator*, only this time it was 30 percent taller, longer, wider, and higher—bigger in every way. To accommodate Ridley's request to go for scale, the statuary and columns were bigger, and it was challenging as a piece of construction. We were doing the original models and molds in England and shipping them to Malta for replication and casting, and it was very efficient. Because we're using the skill sets of [people in] two countries simultaneously, it made it achievable."

Max admitted that the imperial palace was his favorite set from *Gladiator II* for one impressive reason: "Because we built almost a full exterior, which we hadn't had in the first movie. That was just a straight, fairly large staircase up to a portico. We didn't spend a lot of time there on the exterior. Now we have a full three-sided palace with a full terrace, a full balcony, an exedra, and a curved balcony front with huge staircases, and we use it in a much more complete way. The interior scale is just breathtakingly big and powerful. If you do a sequel, do it right and pump it up. That was very gratifying. We spent a lot of time on that building, on the detail of that building on the surface of the walls, the pattern of the marbles, the patterns of the floors, concepts for revamps, and the statuary. It was much more elaborate than in the first movie, although derivative of the first, because it was an homage and a celebration."

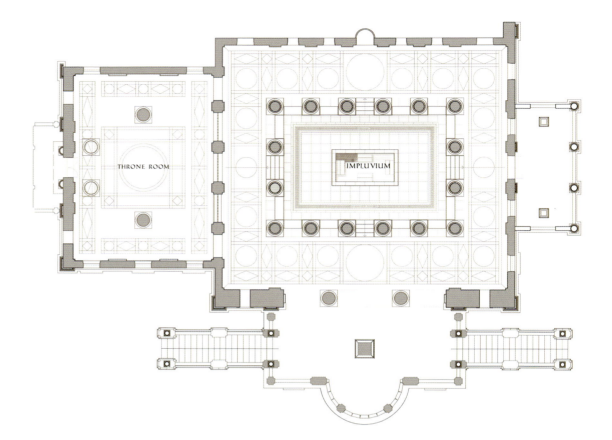

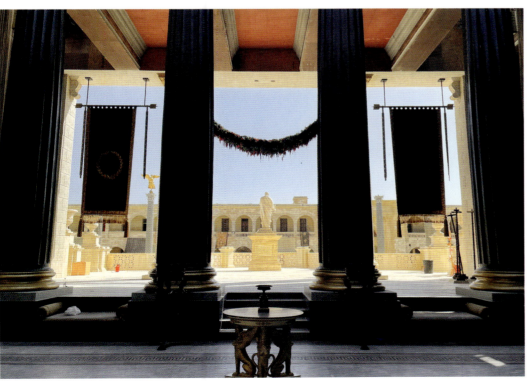

CHAPTER II: DESIGN

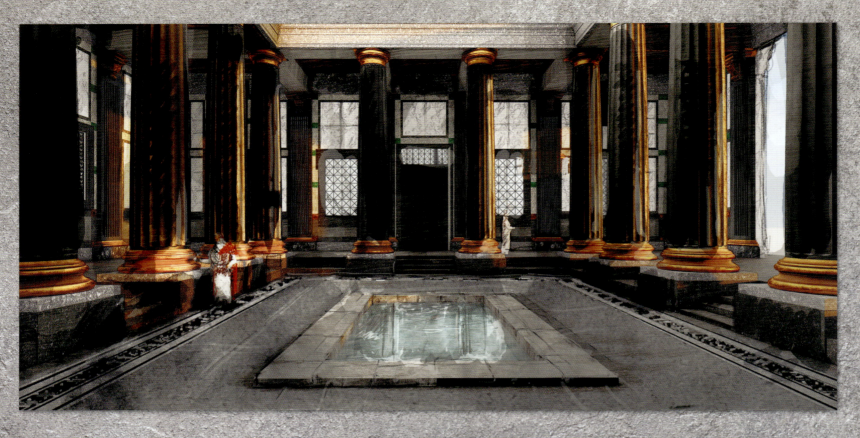
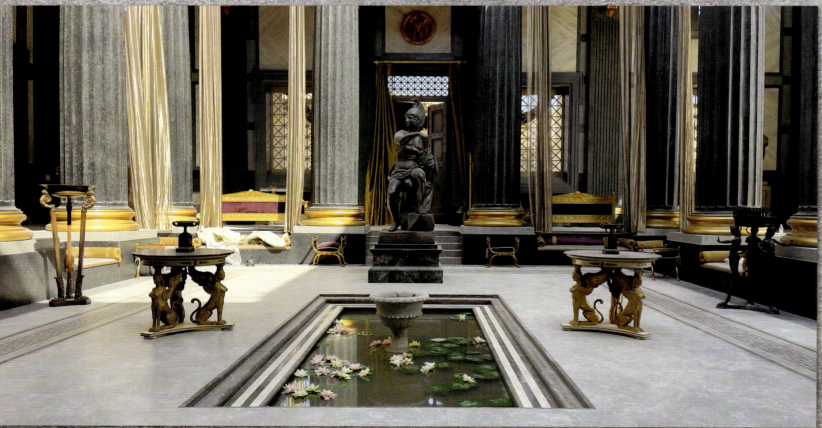

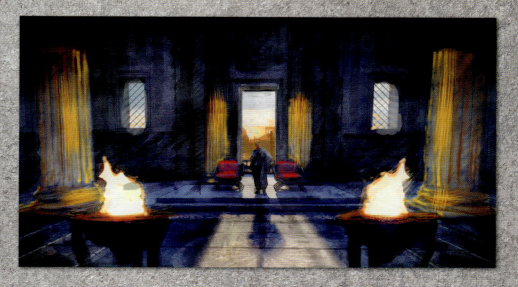
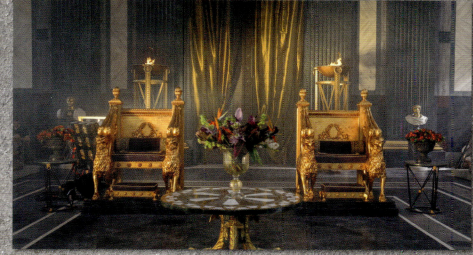
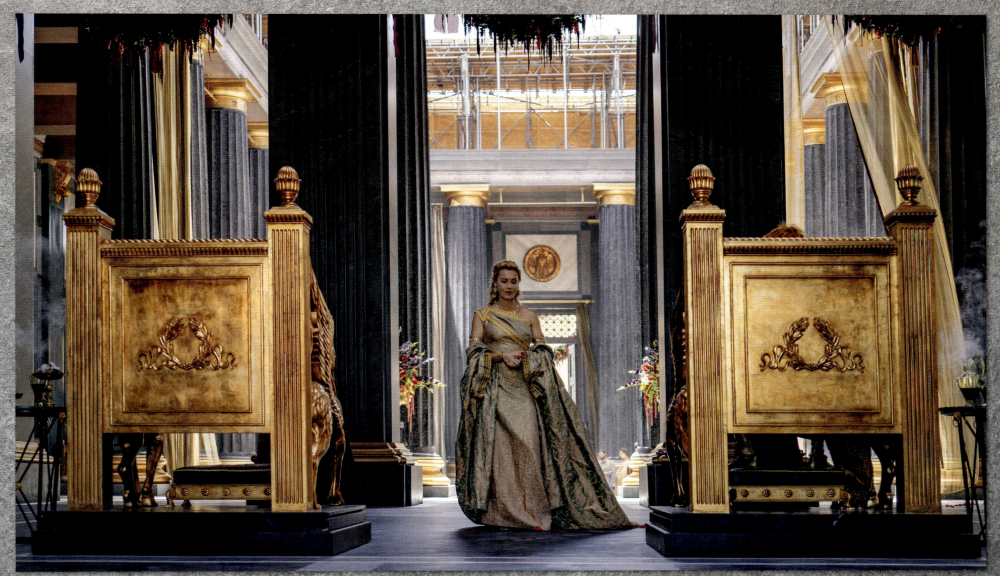

CHAPTER II: DESIGN 115

CINEMATOGRAPHY

British director of photography (DP) John Mathieson also returned from the original *Gladiator* crew. He was nominated for an Oscar and won a BAFTA for his work on the first film. Since then, he worked consistently on Scott's movies. Mathieson started in the music industry in the late 1980s. Max and Mathieson worked closely on *Gladiator II* to achieve ancient Rome's desired look and feel. Max was confident about having him back for this sequel. "I [am very] grateful to cinematographers and John Mathieson specifically because we go back to the days of commercials and [music] videos. John never disappoints; he always brings out the best in what we give him. I think you learn as you go about what DPs need regarding access for lights, slots, openings, windows, and doorways and how to offer up architecture to the best advantage. There was a lot of revamping sets to be other sets and recycling of sets. I worked closely with John about how he would relight and use different color palettes, specifically changing over and textures, how modern cameras perceive patterns, and how broad you must be—or how close and tight you can be with visual elements. It was a great collaboration. We did many full-size samples before letting everybody loose on the sets. I think that's the best way you can proceed with the DP so that he can do testing and advise how things photograph. Any adjustments in terms of tonality or texture can be adjusted before you go mad on the complete set."

ABOVE
Director of photography John Mathieson on set inside a prisoner transport cart.

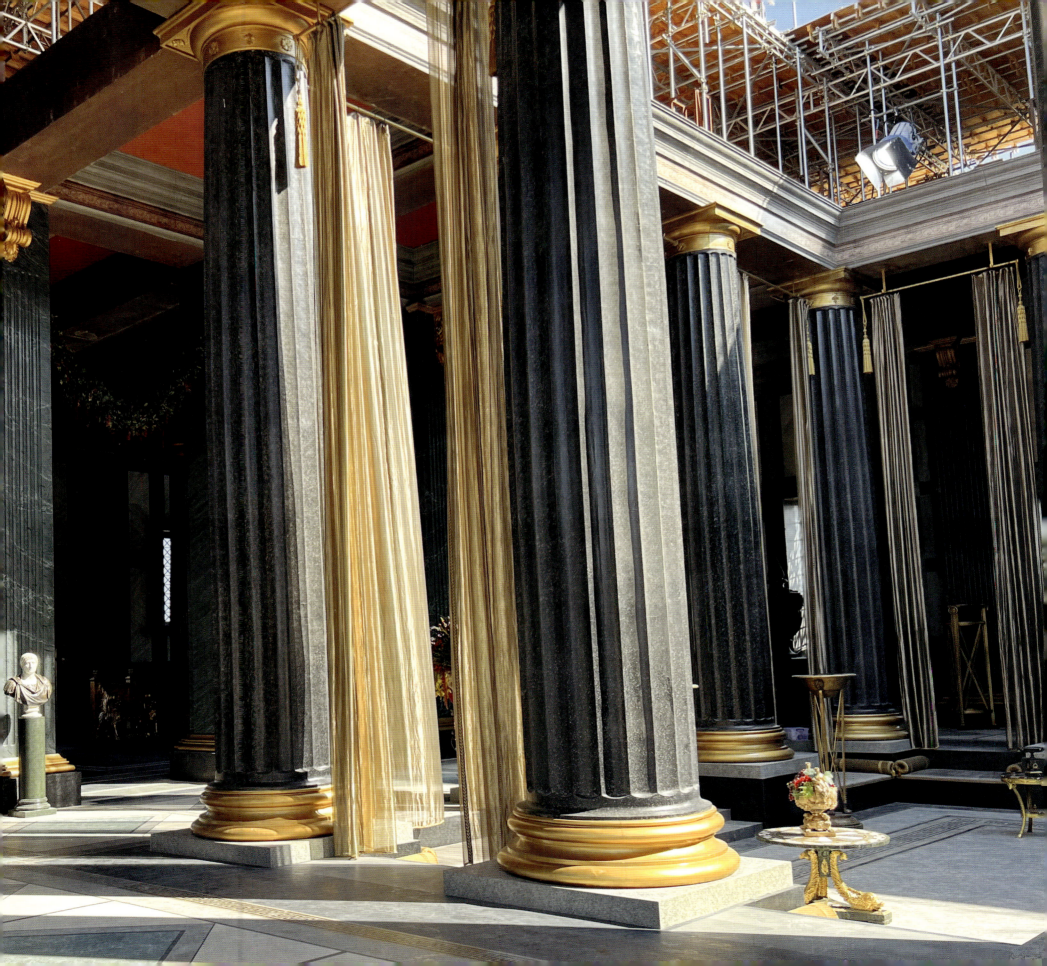

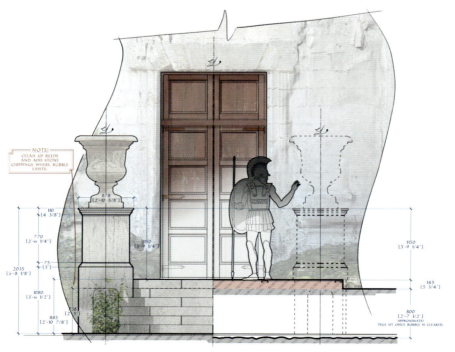

118 THE ART AND MAKING OF GLADIATOR II

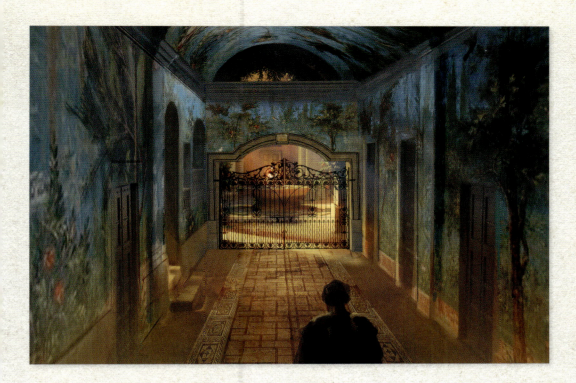

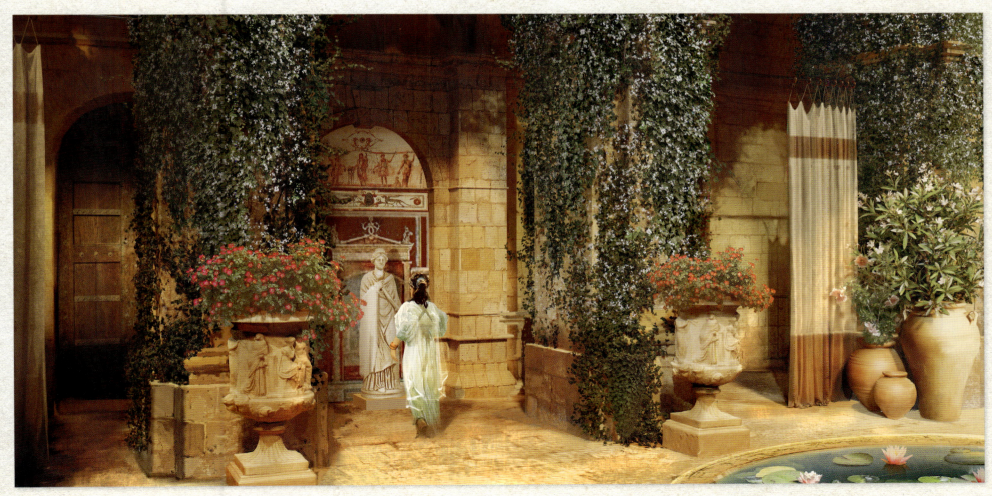

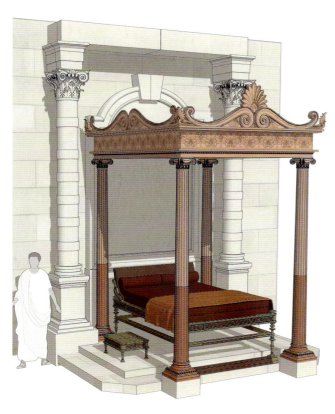

COLOR PALETTE

For Max, color is critical to achieving a realistic outcome. "We went to the sources we used in the first movie for color and palette, mostly nineteenth-century Orientalist painters, Lawrence Alma-Tadema and Jean-Léon Gérôme, who were the inspirations of the first movie because they romanticized and brought to life not only the colors but the life of everyday Rome on the streets and in the marketplaces, the palaces, the processions, and the ceremonies. That was our reference for many things apart from color for furnishings, accessories, costumes, and architecture. And because when you study the ancient world directly in the ruins of, say, Pompeii or Herculaneum, or [when you] go to the museums, which we did—the British Museum, the galleries in Rome, the Medici, the Capitoline Museums, the Vatican Museums—to add the missing details of everyday daily life. These painters brought it to life, fleshing it out and making it live. So we borrowed generously from them."

RIGHT
A Difference of Opinion, 1896, by Sir Lawrence Alma-Tadema

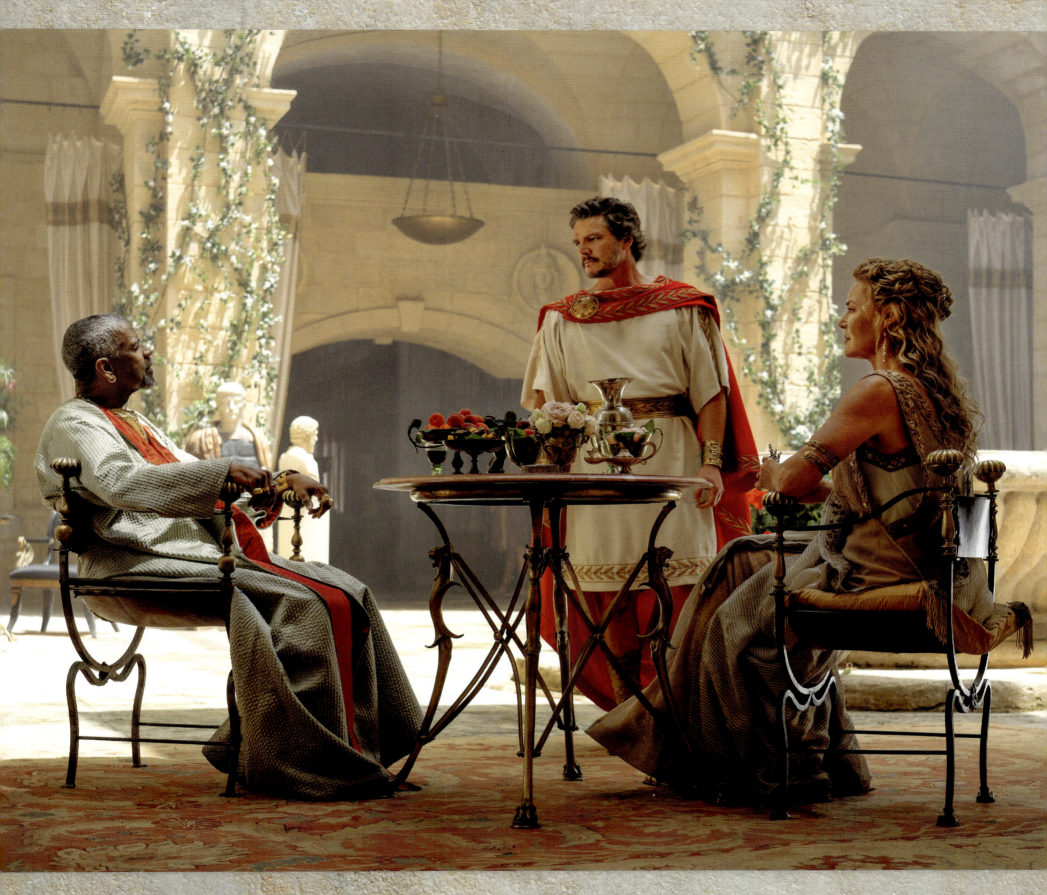

CHAPTER II: DESIGN 121

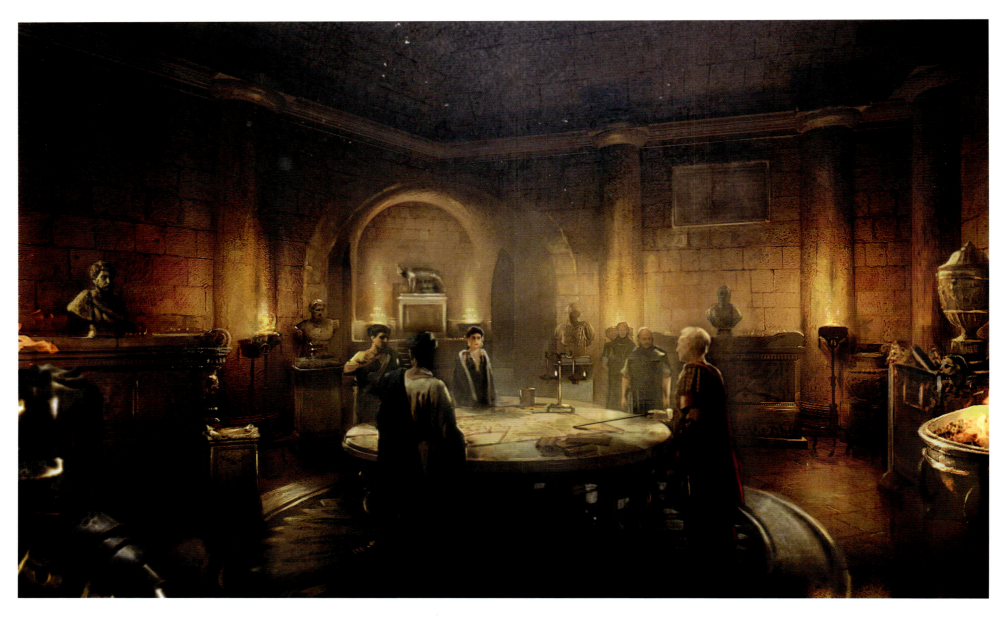

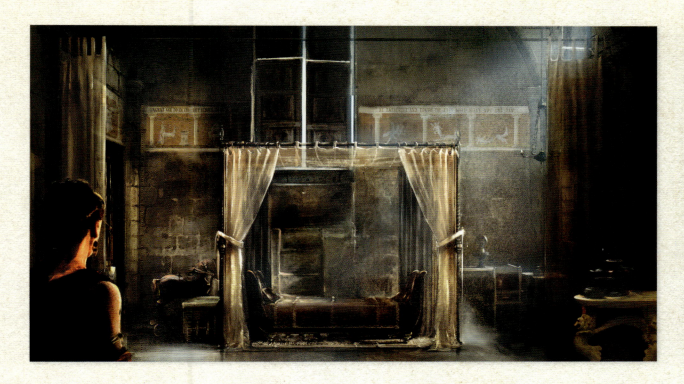

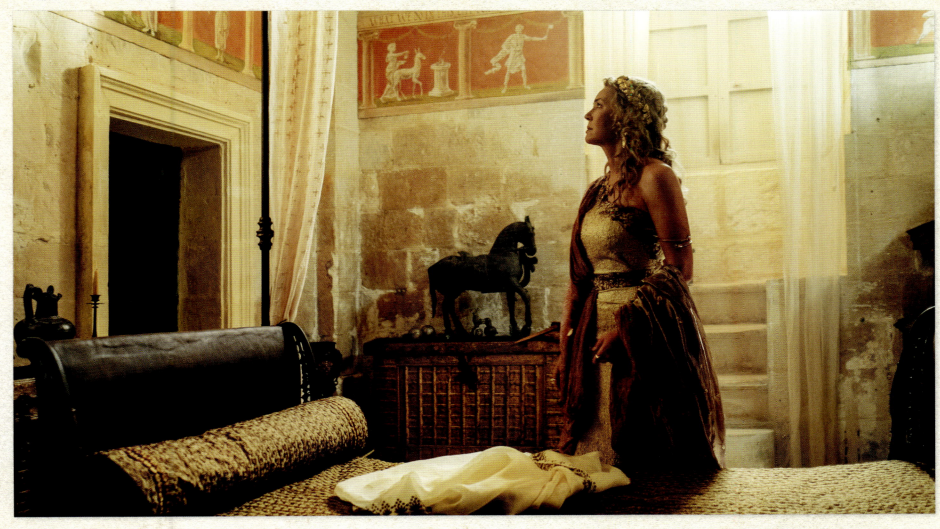

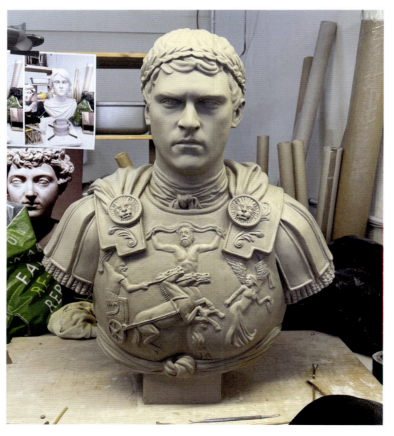

THIS PAGE

"We still did a certain amount of clay sculpting, because you can get a much higher level of detail—for example, when you want the likeness of a face to be accurate [because] we represented one of our actors," said Max.

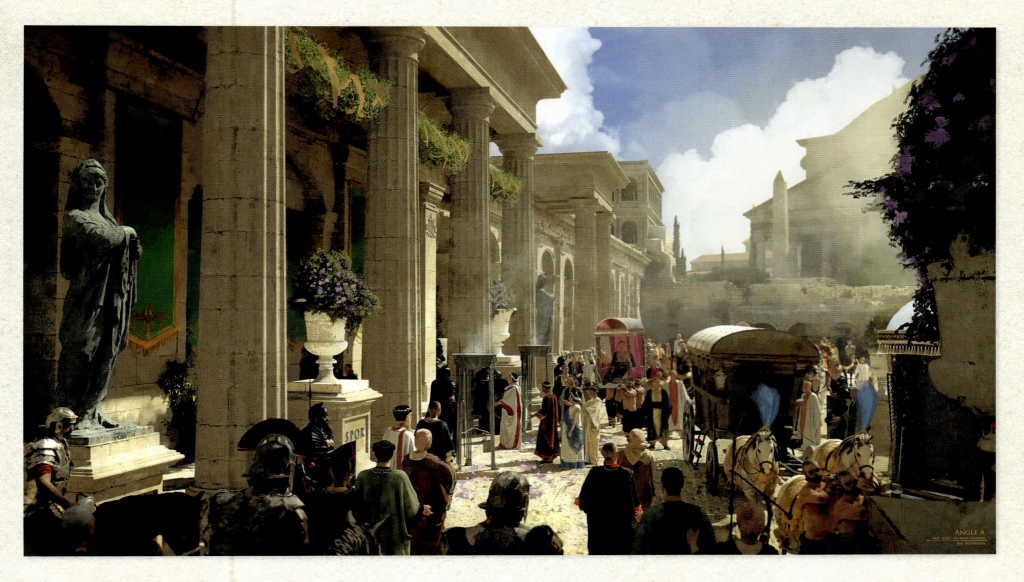
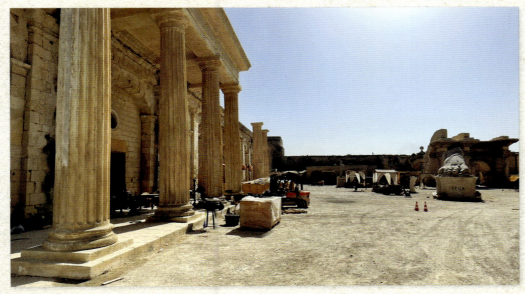

CHAPTER II: DESIGN 125

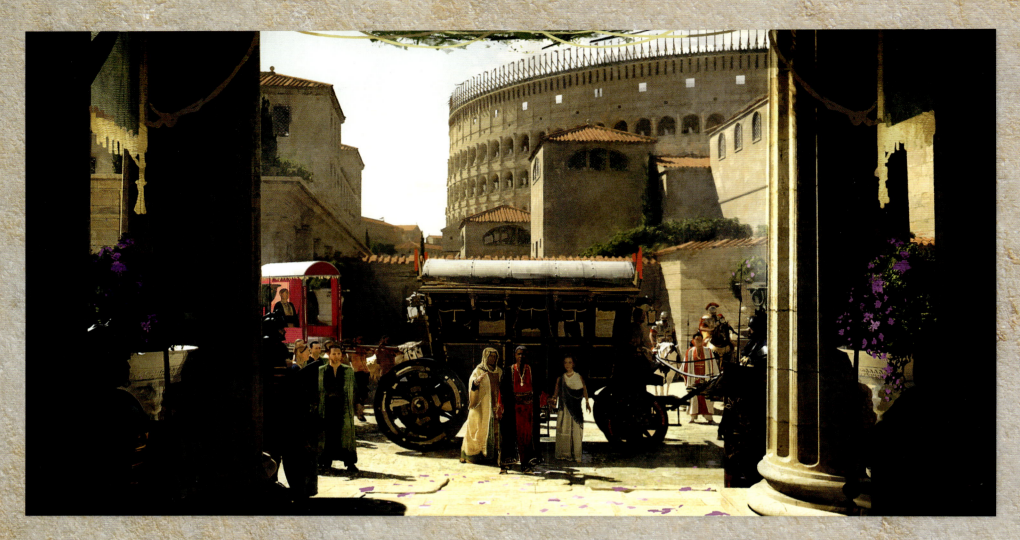
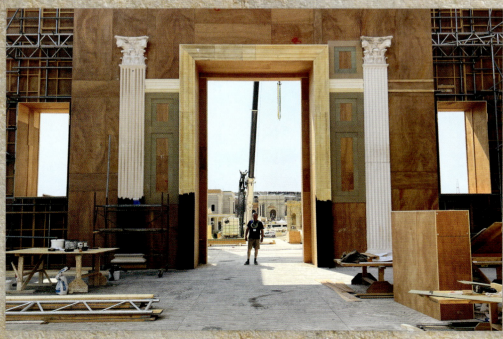
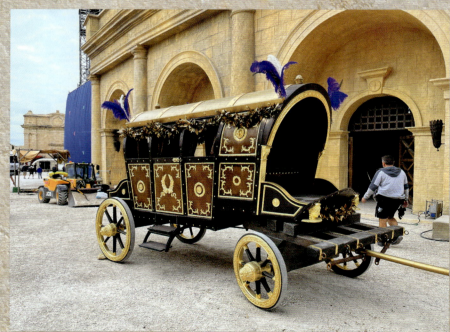

126 THE ART AND MAKING OF GLADIATOR II

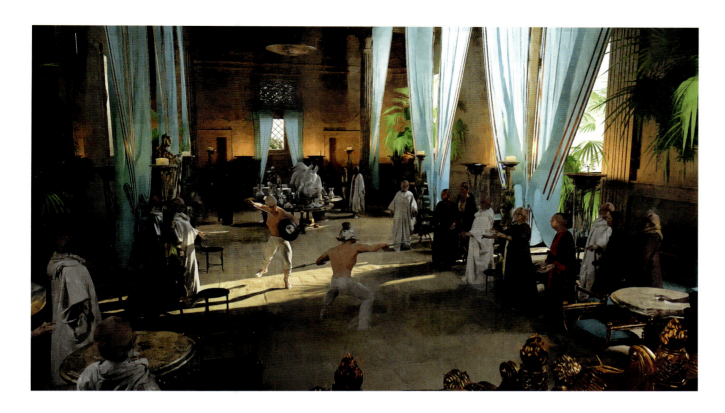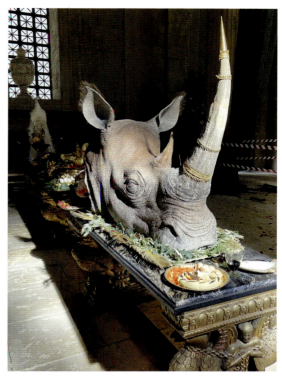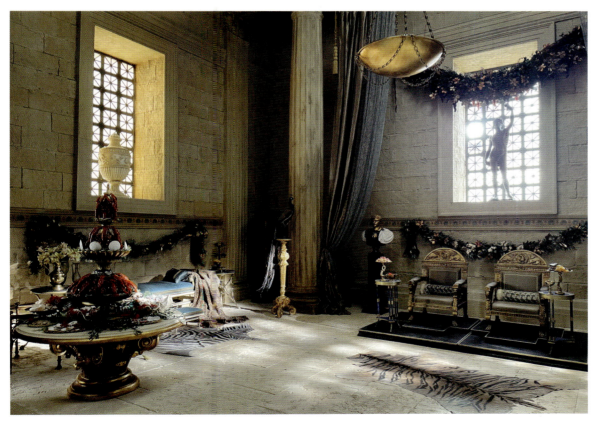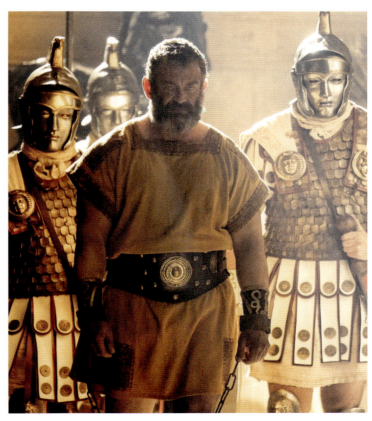

CHAPTER II: DESIGN 127

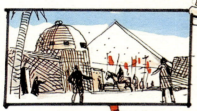

EGYPT. VILLAGE

BOYS YOUNG PLAY A FORM OF HANDBALL BOUND RAGS + TWIGS

WE SEE A RED HAIRED BLUE EYED BOY AMONGST THE EGYPTIAN KIDS - LUCIUS. HIS TROUBLES SEEM FORGOTTEN FOR A MOMENT UNTIL.... HE SEES. A

PLATOON OF ROMAN CENTURIONS BOYS STOP PLAYING TO WATCH

+ CAVALRY · OFFICERS WHO QUESTION. THREATENINGLY.

THE BOY IS LUCIUS WHO DISAPPEARS FROM THE SCENE

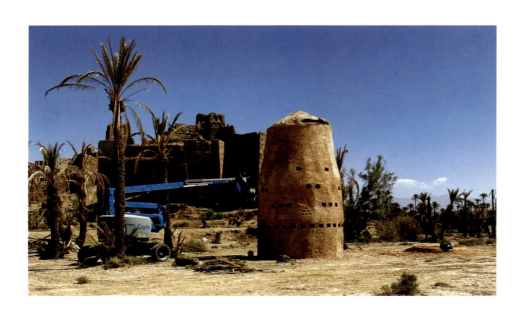

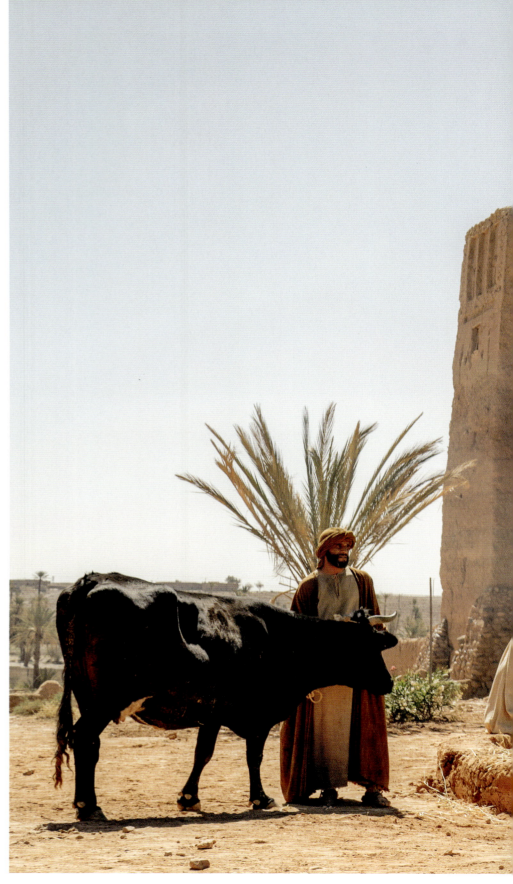

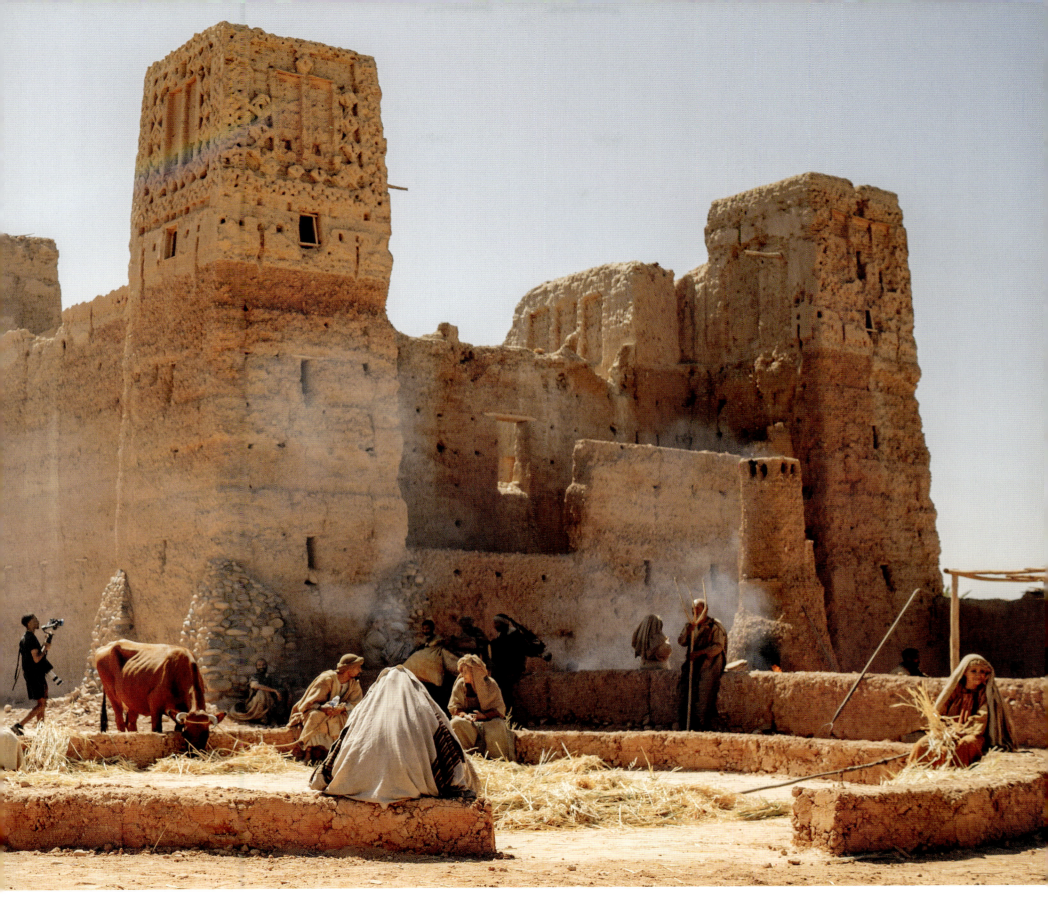

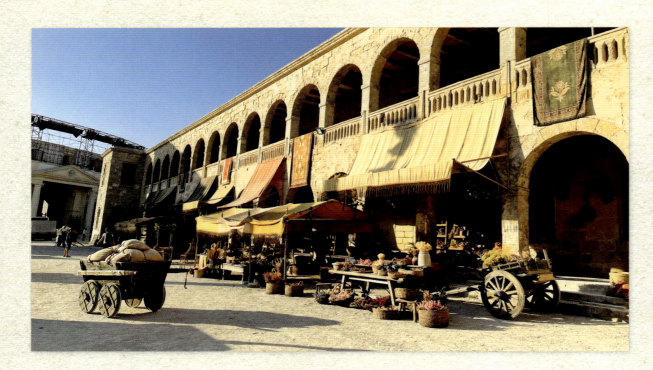

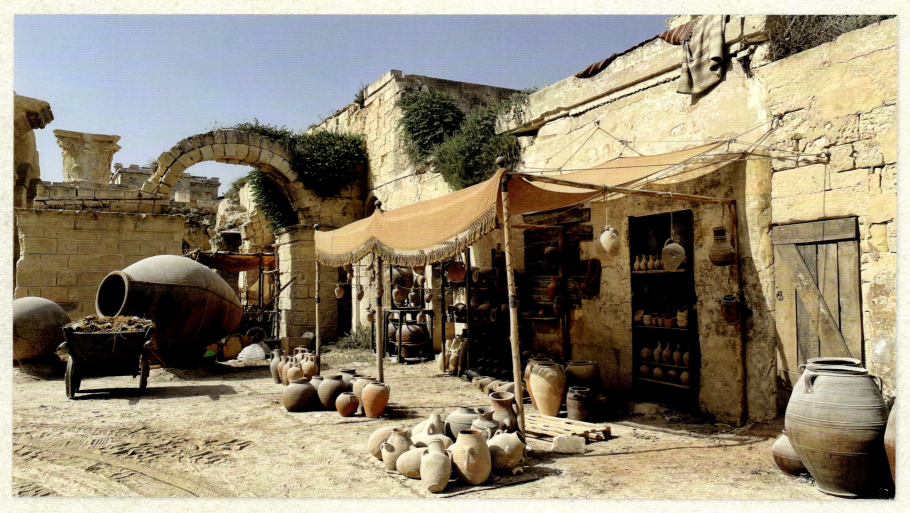

SCENIC ART

A scenic artist's work predates cinema and television. It returns to the days of the theater, using backdrop canvas environments, rooms, or just a landscape to bring the outside world to the audience. On *Gladiator II*, it was used to enhance the set design work. "There's a lot of different levels of techniques for scenic art," said Max. "And you assess what's more appropriate or what's more efficient or less costly—and what the best use of that application would be in the context of what you're doing. A lot of scenic art used to be hand-painted, which is time-consuming. Now we can do very accurate high-level printing, for example, for doors and windows of background buildings where they have modern windows and doors. We do a scenic painted version of one, and then we photograph it, make a kind of wallpaper, and do dozens of windows and doors, which will be similar. We may do two or three versions, and we mix them up, and at a distance, you'll never know. Previously, they had to be individually painted and built physically. That kind of technology also includes fresco painting. Much of that can now be done photographically painted or mechanically from digital models and photographic sources on canvas and presented as real in the background. So those techniques have changed."

RIGHT
In some instances, set decorators used printed material to give the illusion of doors and windows on the busy Roman streets.

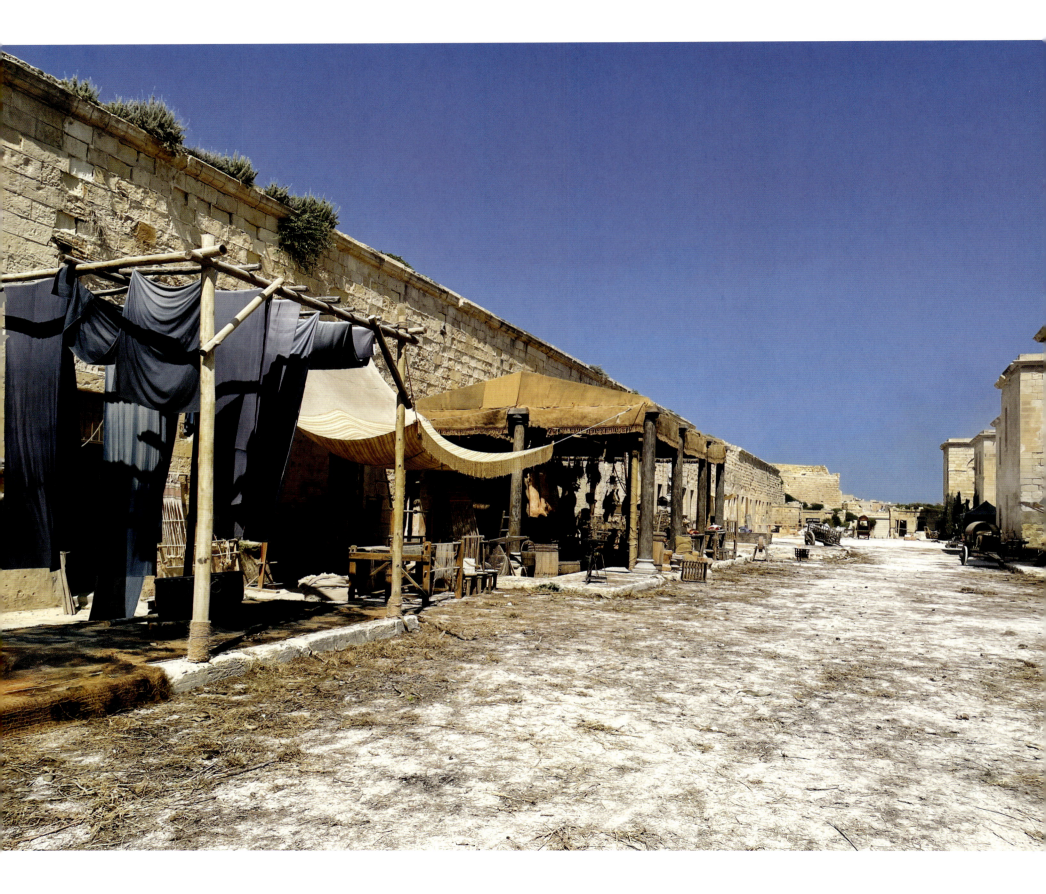

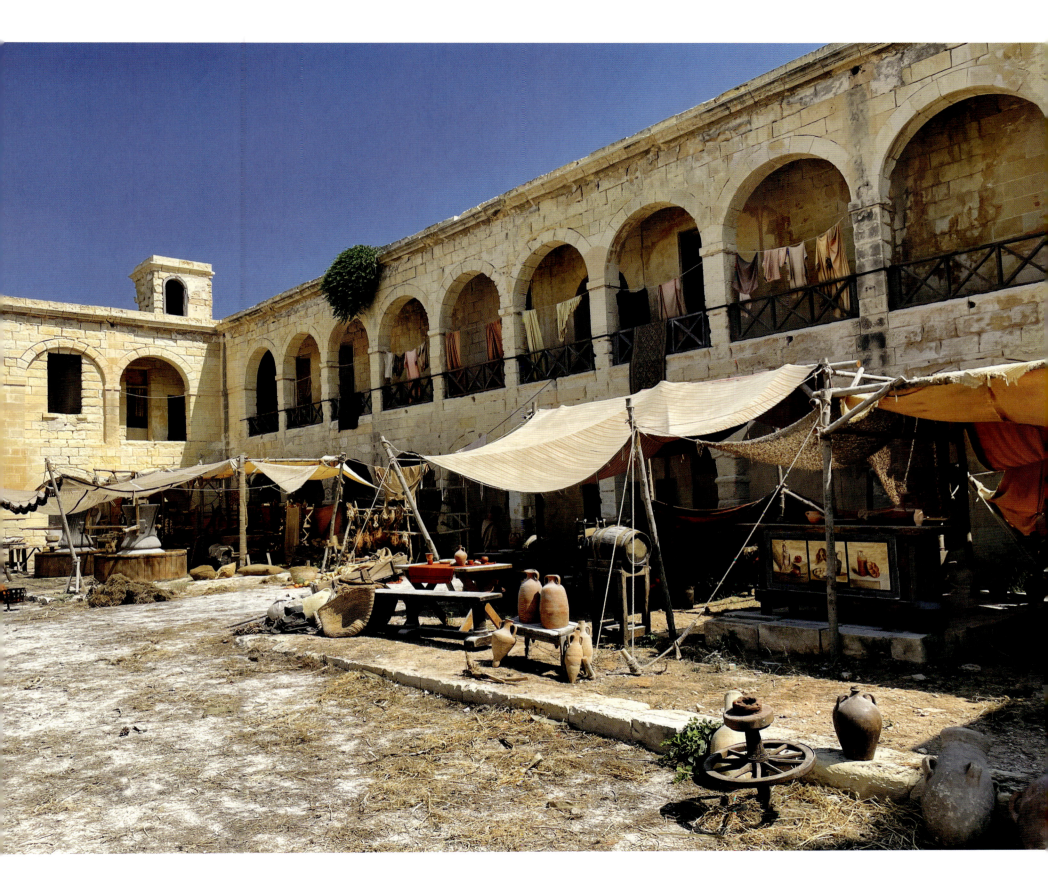

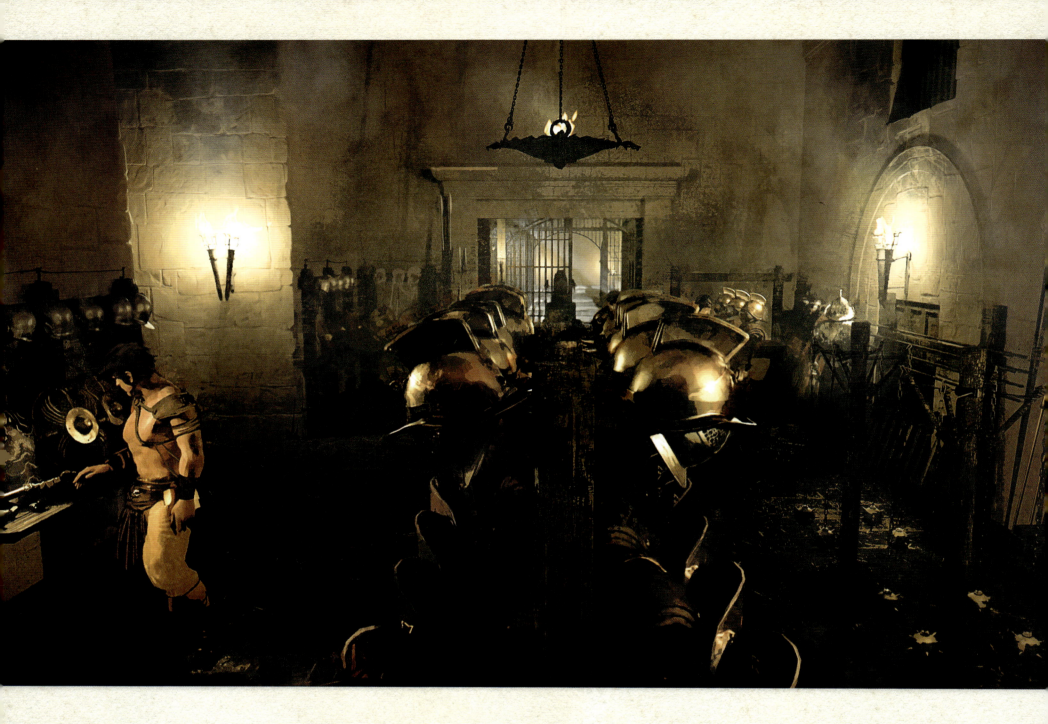

THE UNDERCROFT

The undercroft of the Colosseum is an iconic space where anxious gladiators wait to see if they will fight, live, or die. "In the first movie, we made an elaborate set that was unfortunately rarely used because the storytelling had changed," said Max. "It evolved into the final fight between Commodus and Maximus. It took place originally in the early drafts in the undercroft, so we built a very elaborate undercroft for that scene, but then it evolved into taking place in the Colosseum itself. So the undercroft wasn't that well used in the first [film], but you see quite a lot of it in this one; there are a lot of scenes down there. So that was gratifying. We could go back to it because it's a great space. We used it to its best advantage, the way we built into it, and we filmed many scenes in there."

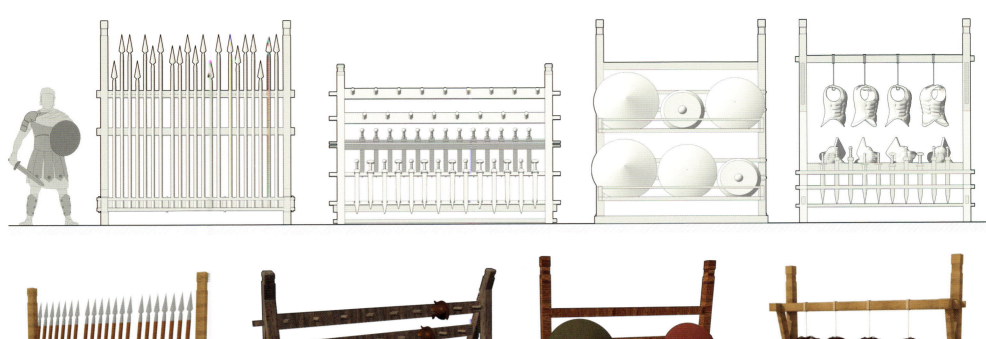

CHAPTER II: DESIGN

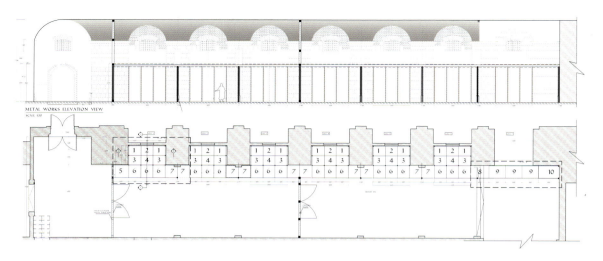
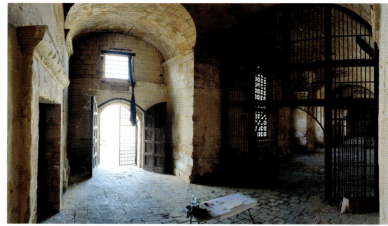

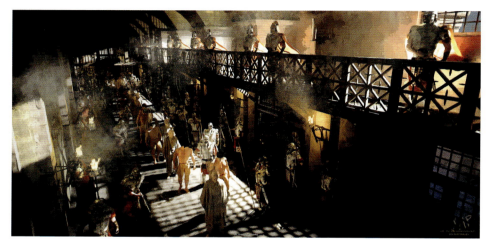
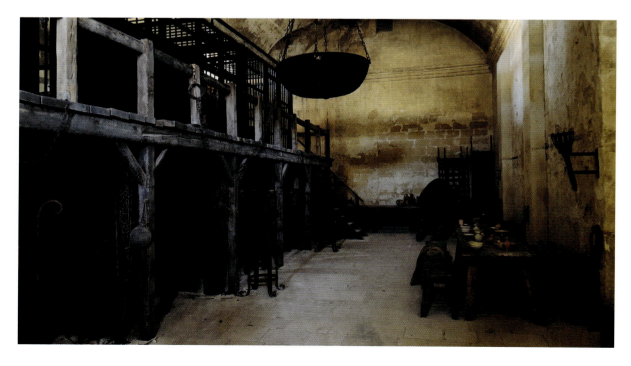

136 THE ART AND MAKING OF GLADIATOR II

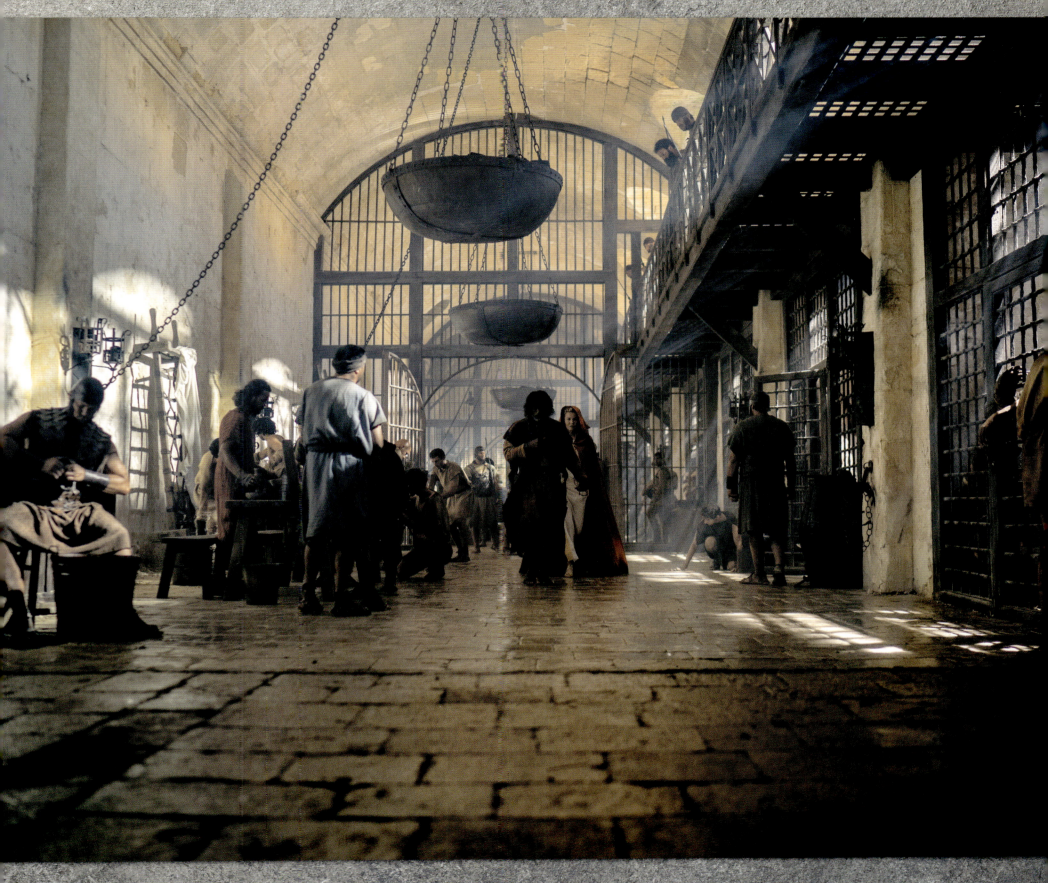

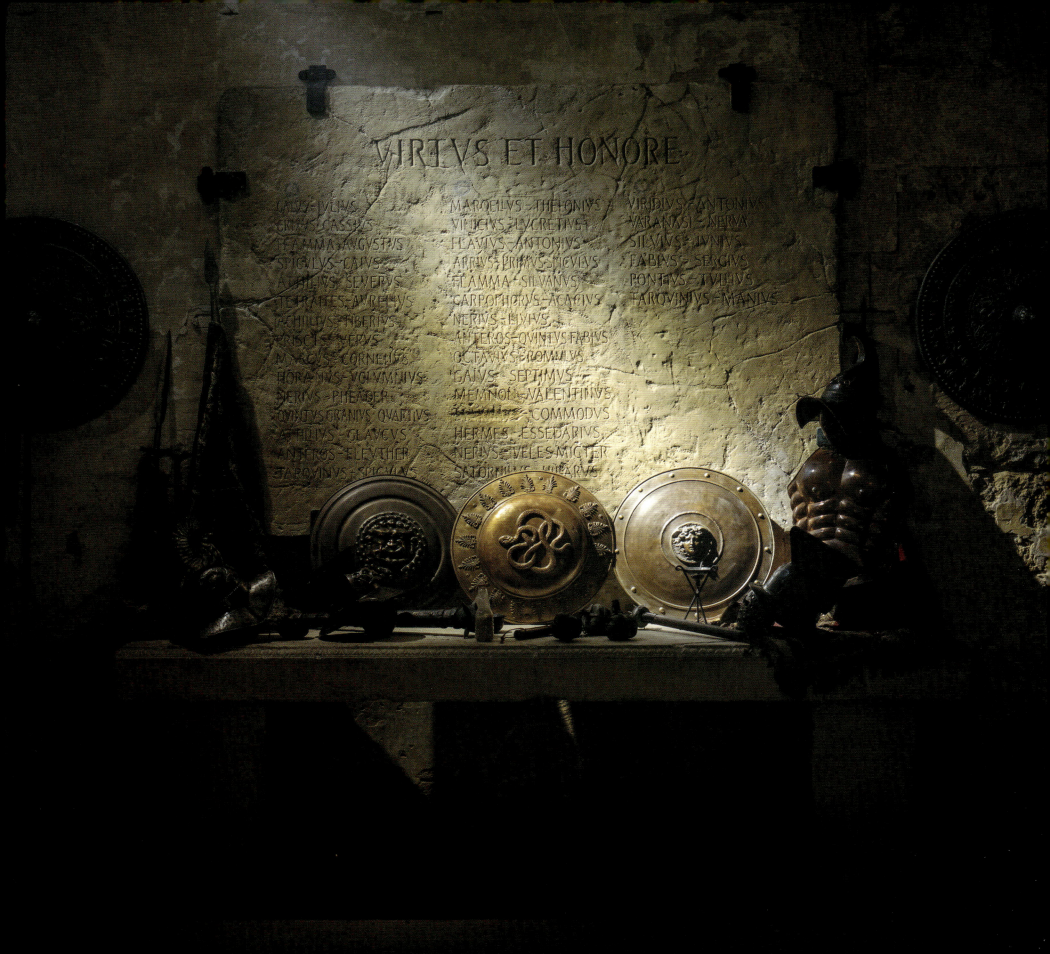

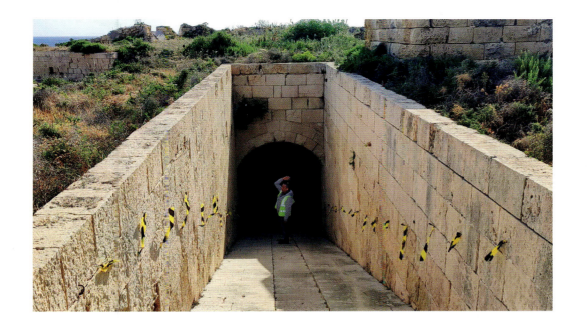
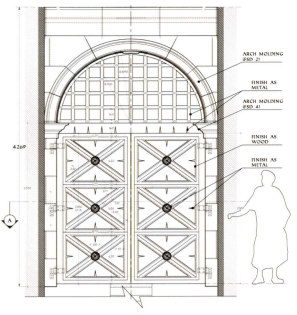
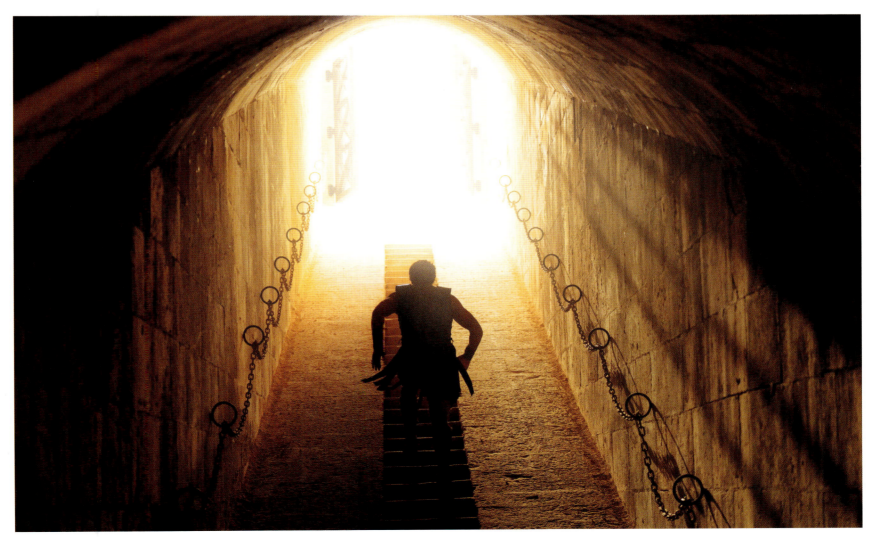

CHAPTER II: DESIGN 139

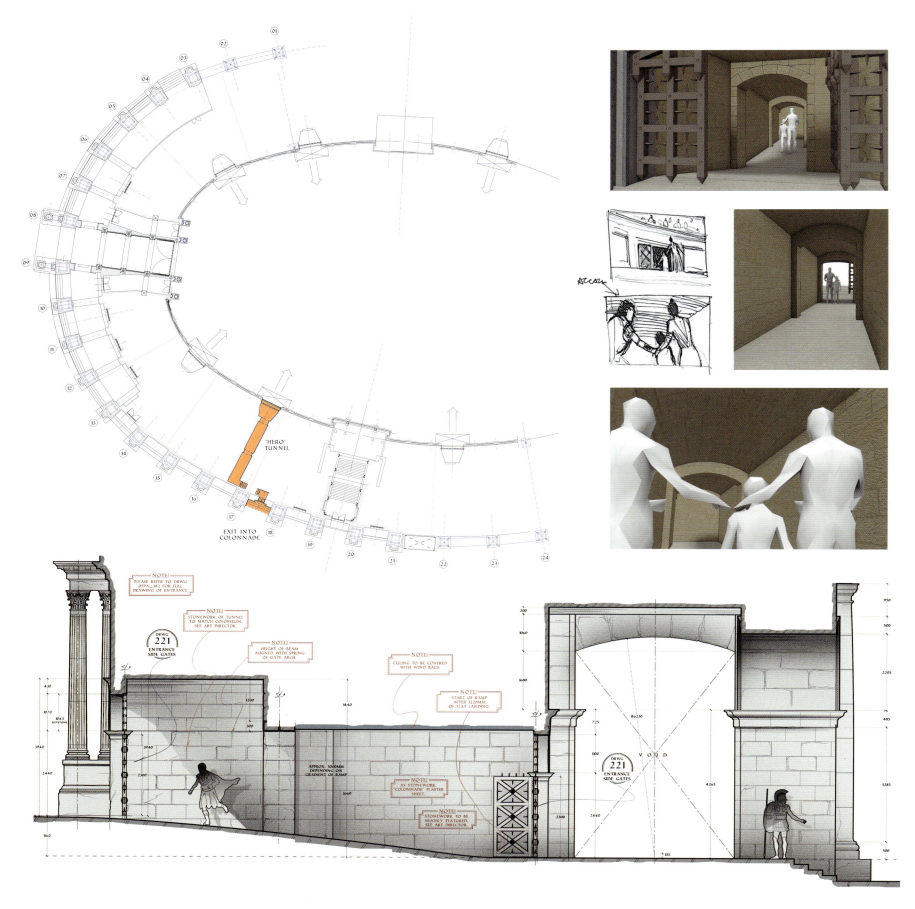

140 THE ART AND MAKING OF GLADIATOR II

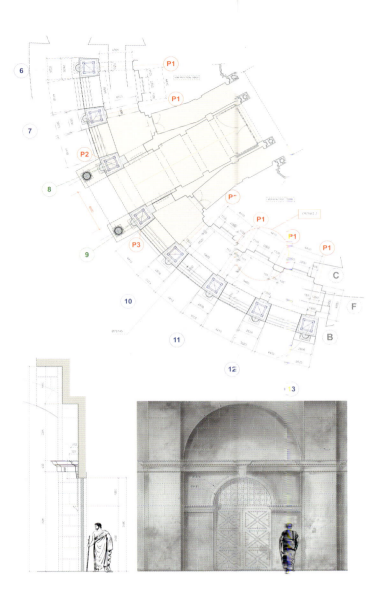

THE COLOSSEUM

As impressive as the larger and more ambitious sets were, the Colosseum needed to have the most impact on-screen in its expanded form. "For the naval battle in the Colosseum, we raised the foundation about five feet... so that we could still see what we wanted to see above the waterline when we flooded it digitally, as well as in the actual tank where we built a partial reconstruction of the emperor's box and some tiered seating on either side. We also enlarged the entry arch from the original to bring the ships in through the gates with their masts and rigging. We gave it a bit of a boost from the bottom up, but essentially, the style you will recognize when you watch the film. If you're a student of the first film, you will find it familiar."

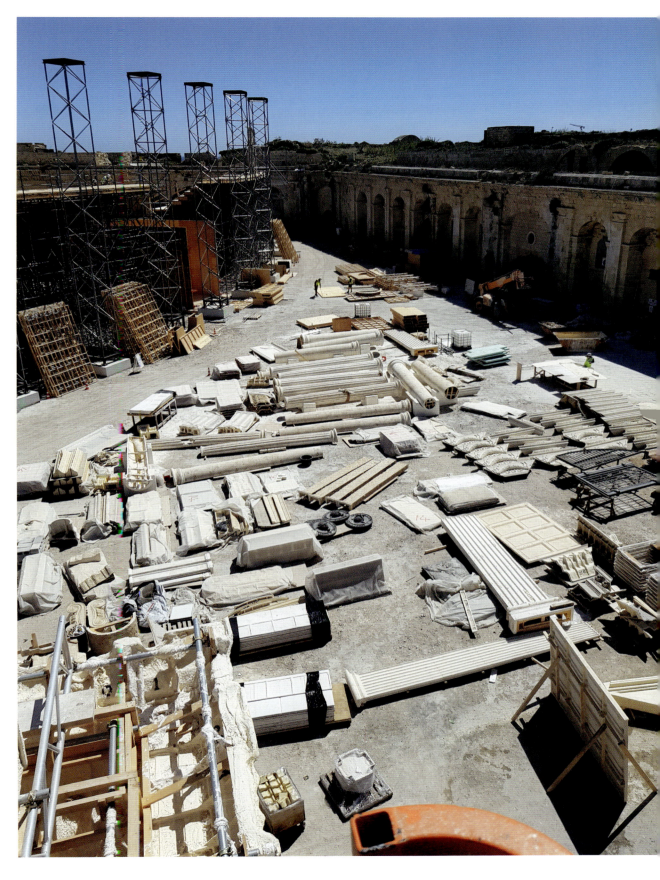

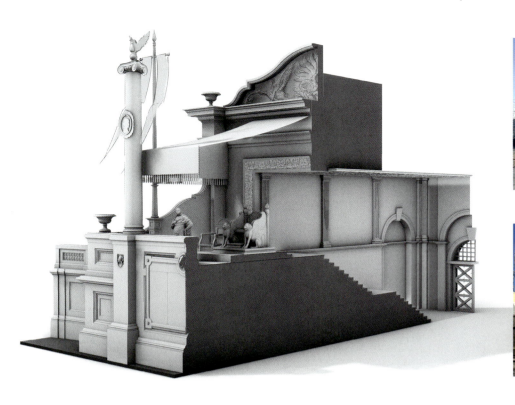

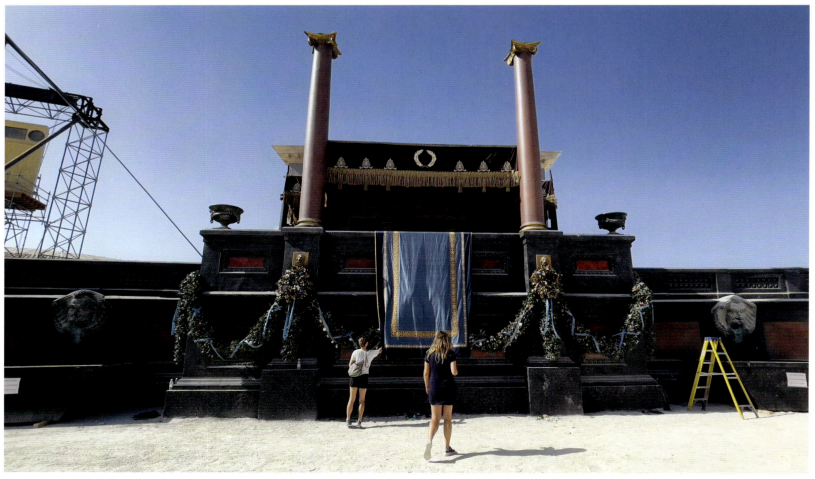

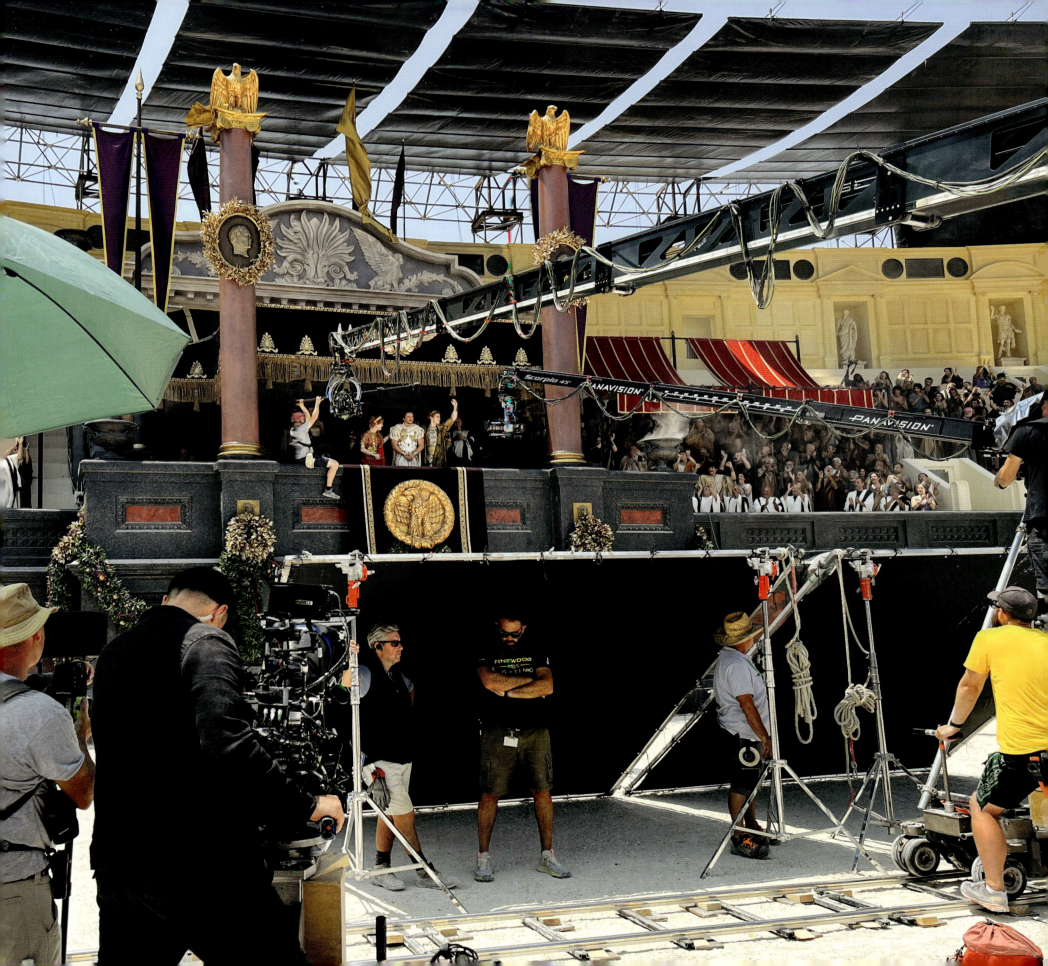

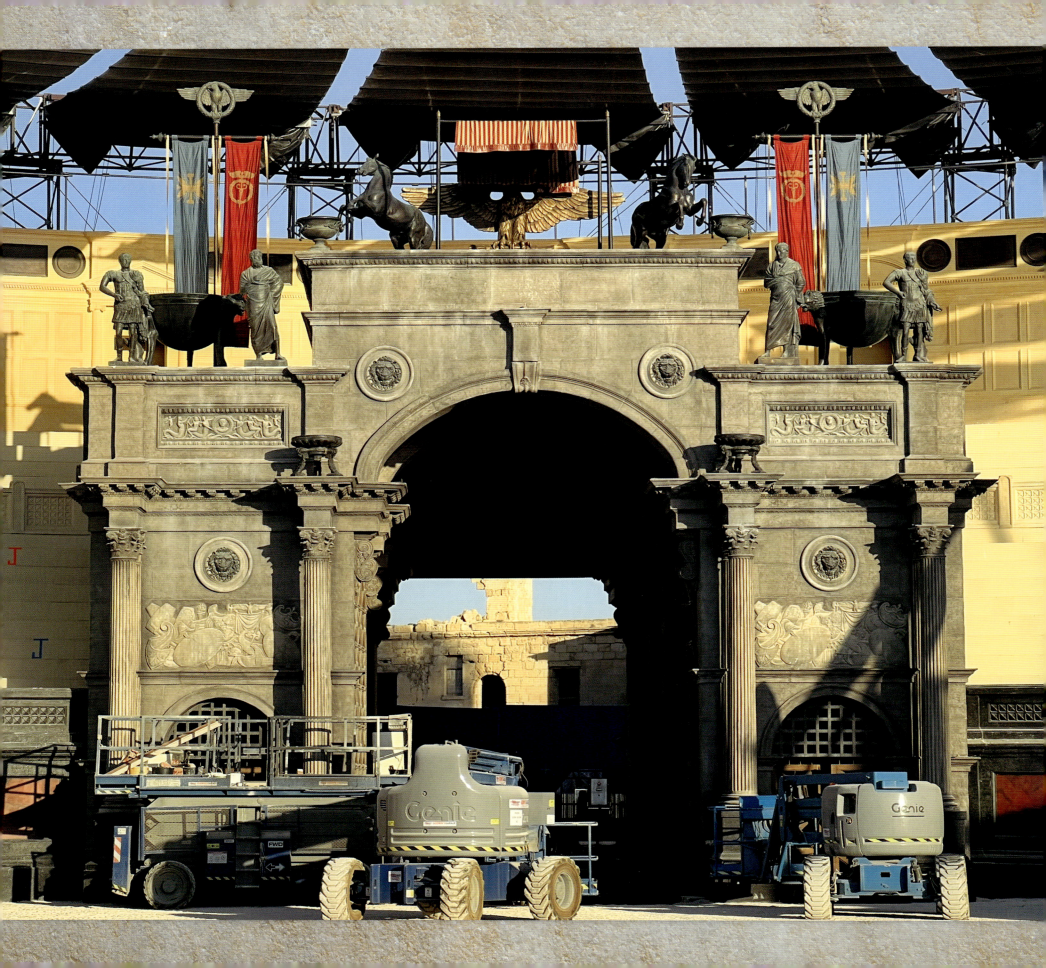

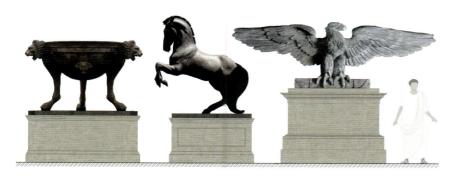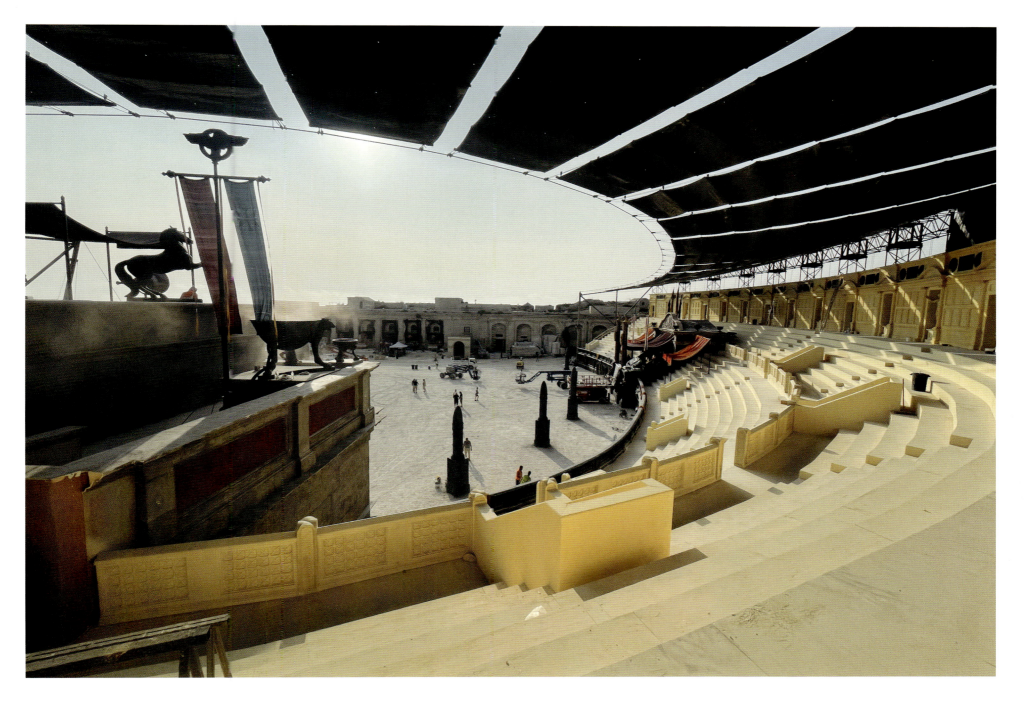

CHAPTER II: DESIGN 145

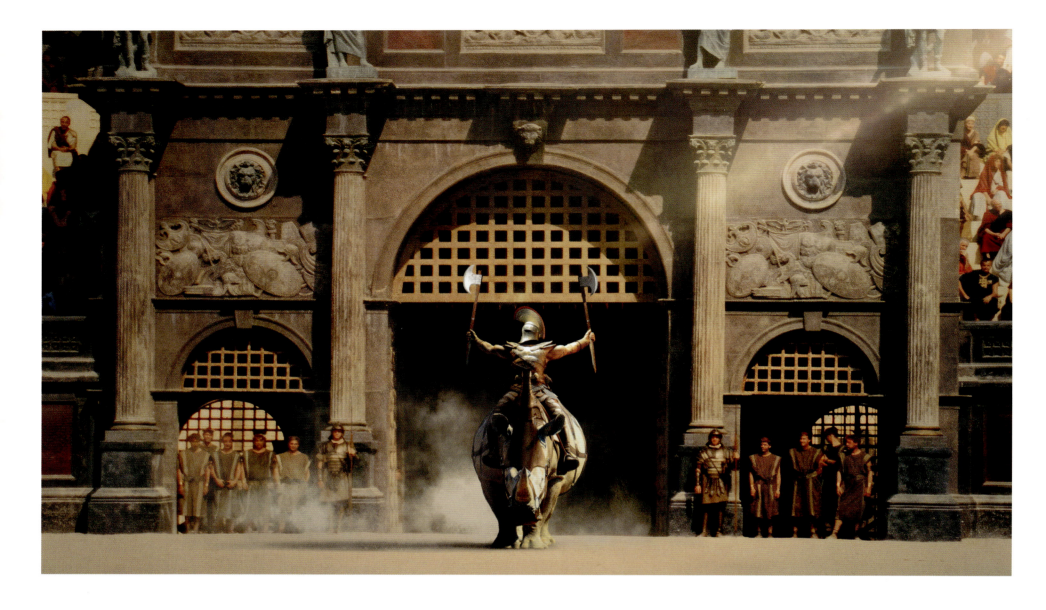

RHINO REVIVED

Special effects supervisor Neil Corbould found an unused idea among his original materials for *Gladiator* that he would go on to suggest to Scott. "I found some old storyboards of the rhino fight. That day, I was going up to see Ridley in London, and I thought I'd take them up to remind him what we didn't shoot on the first [film]. At the end of the meeting, I said, 'I've got something to show you.' And I showed him these pictures of the rhino. He said, 'I want to do that this time.' So that was quite funny."

Ultimately, the rhino fight would be part of the emperor's games in *Gladiator II*. "It was a collaboration between Conor O'Sullivan, the prosthetics supervisor, and me. We built a mechanical base so the rhino could shake its head, flick its head up in the air, and [make] the eyes and ears move. But it was only half a rhino. Visual effects put on all the legs, but we could drive this around the Colosseum like a little go-kart. We had a certain amount of rehearsal, but much was made up on the day. We were practicing as we were shooting. It's amazing how many in-camera shots he got from it because we had cameras bolted all over the rhino. And CG enhanced it tenfold. Using some shots in camera is great, because I think everything feels grounded, and then, you know, as soon as you get something bad, you lose the audience. You must try to keep the quality of visual effects and special effects up to the highest level."

The environment for the sequence was also demanding for Corbould and his team. "The main challenge was the heat that we were working in. Some days, we were working at temperatures over 100 degrees Fahrenheit. The mechanics, because they're electric, overheat, so we had these air blowers blowing onto the electronics to try and cool them down because at some point, they were going to trip and start blowing fuses and stuff. Luckily enough, we managed to get through it."

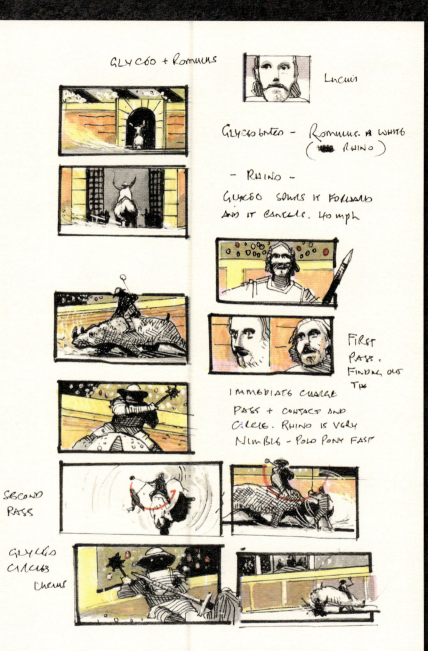
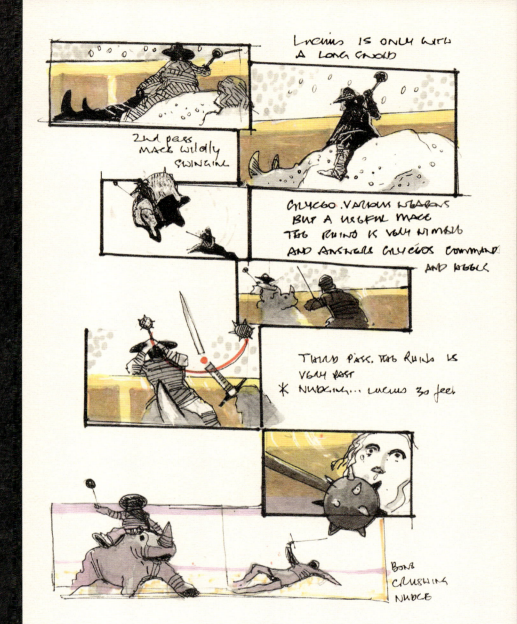

THIS PAGE
The rhino, in all its menacing glory here, would challenge the special and visual effects teams.

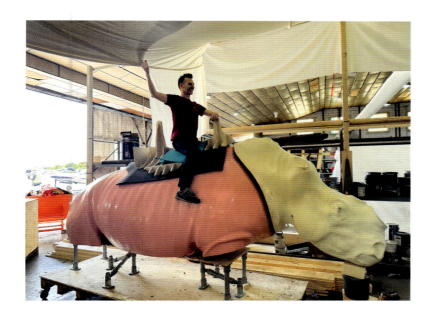
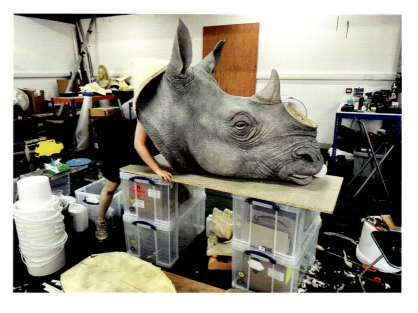
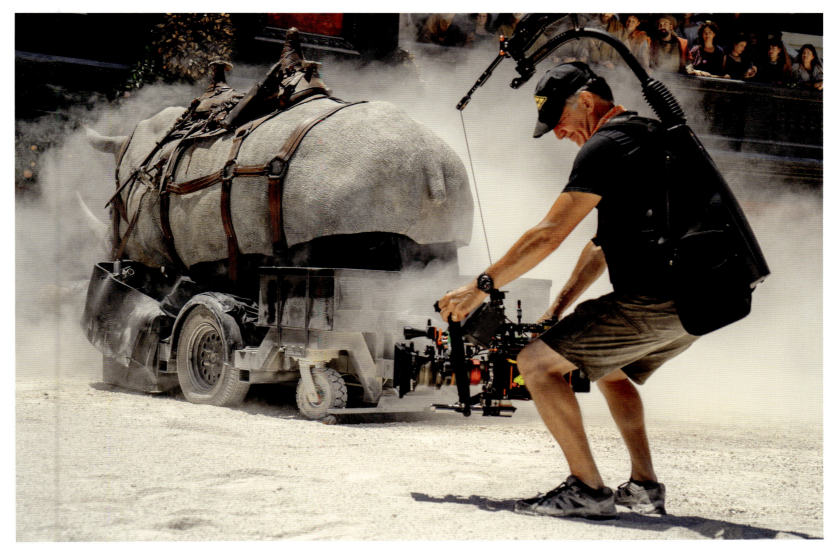

CHAPTER II: DESIGN 149

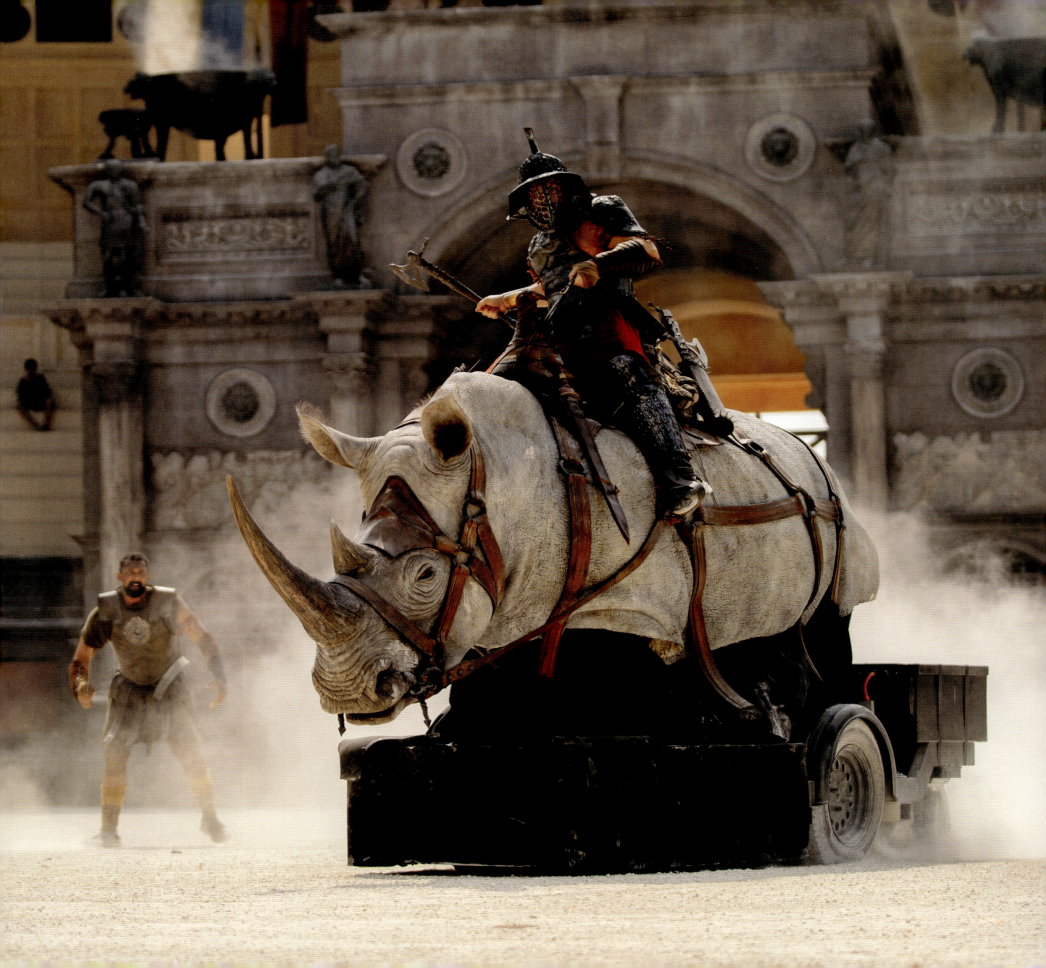

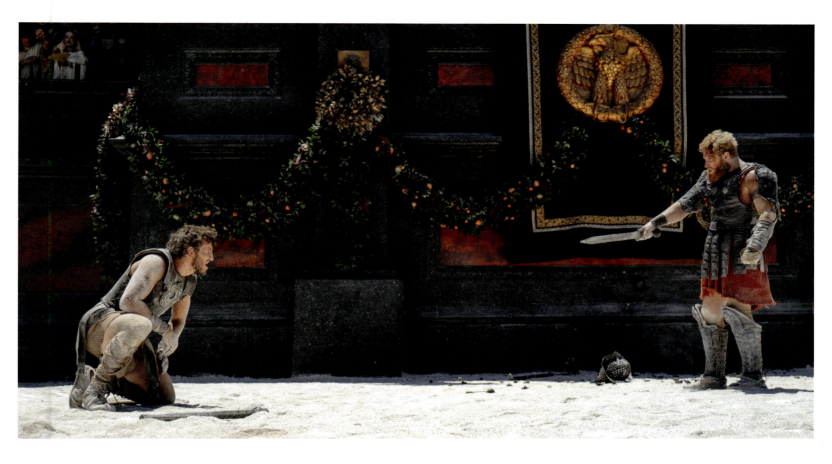

RIGHT
A striking beheading sequence using a highly detailed prosthetic head

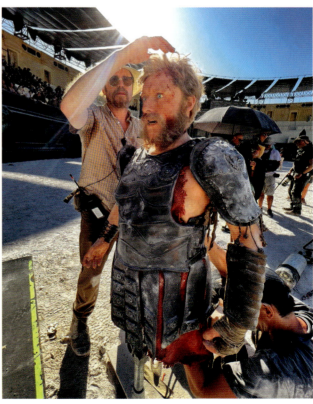

CHAPTER II: DESIGN 151

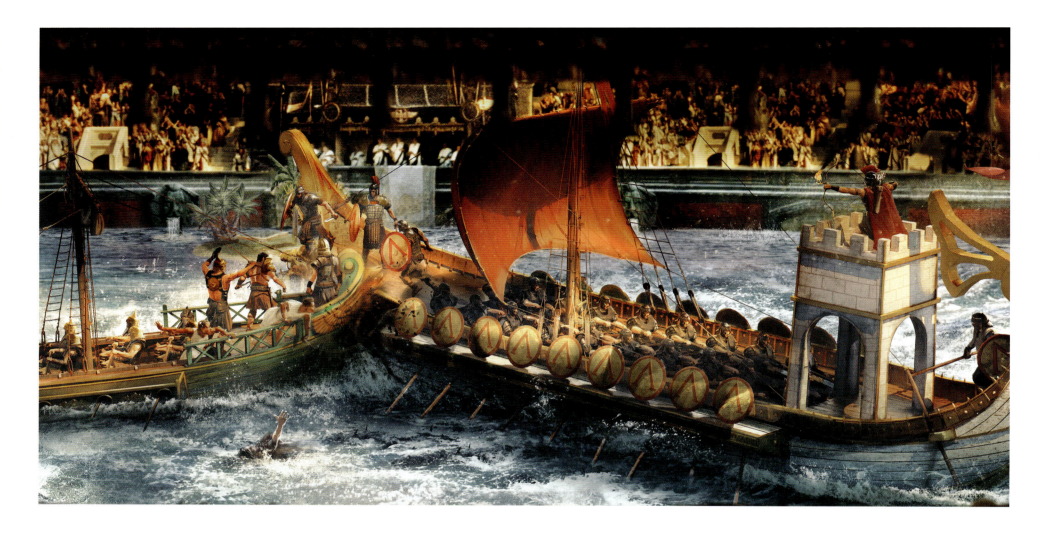

FLOODING THE COLOSSEUM

The limitations of time, budget, and technology kept some ideas off the drawing board for the first film, but all avenues were explored for the sequel. "I heard tales of how they flooded the Colosseum, and I thought, *How could they do that?* So we researched how the Colosseum was flooded," said Corbould. "It was amazing how they used the aqueducts to fill the Colosseum. They could release the water into the farmland and surrounding Rome, so there was no waste. The boats they used for the naval battle were built for that. They were almost like punts or flat-bottomed boats, because the Colosseum would have only been filled to probably four and a half to five feet. We designed some boats to be intentionally theatrical for those scenes—a bit more exaggerated, showy, and blingy than the traditional warships."

Taking an idea like this from a theoretical discussion to a working environment would require some unique thinking from Corbould. "Ridley wanted the Colosseum flooded. There were a couple of ways we could approach this. One was to build the Colosseum in a tank in Malta, which we did partially. We built a partial set or used those same plant movers from Morocco. We built two more boats, a Roman one, which they call the *Athenian*, and a Persian one. And again, we could move these around the arena. They can move in any axis you like. They can crab, go sideways, forward in a circle, and spin on a sixpence [dime]. We also put bellows in the middle so that it gives a natural sort of on-water feel, so when people move around, they move precisely like boats as well.

"On one day, we set up for a crash . . . where one boat rams another and rides up onto the side of the other boat. We fitted a hydraulic ram system at the front to do that. We had a lot of fun getting this sequence together. We rehearsed, and then one had to smash into the other. So we had breakaway sections, smoke, fire, and all sorts [of effects] in the tank. We were shooting sharks, shark fins, and shark attacks. We're shooting the collision of the boats in the water so that we can get the interaction with the water. But on the dry set, visual effects put all the digital water in there. I loved the challenge. When I see an idea come to be realized, it's fantastic."

Corbould knew sophisticated audiences would scrutinize his work, but on set, it was the director he needed to please. "Ridley shoots with many cameras: a minimum of eight, sometimes eleven, sometimes twelve cameras on shots. So you must get something in front of all those cameras, whether that's boats, water hits, explosions, or smoke. You have to get something in front of the lens."

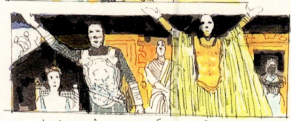

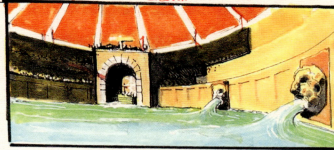
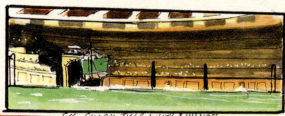

THIS PAGE
The dramatic water-filled Colosseum with sharks could not have been imagined using technology from twenty-five years ago.

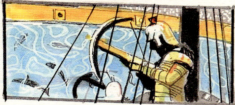

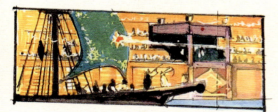

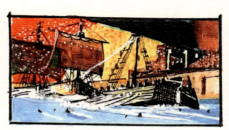

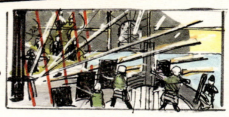

THIS SPREAD
Detailed side notes referencing on-set visual effects and makeup notes about gold teeth make this more than just a graphic comic of the film's screenplay.

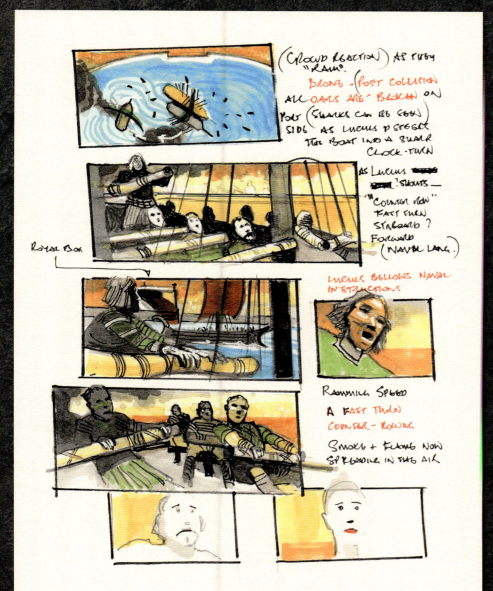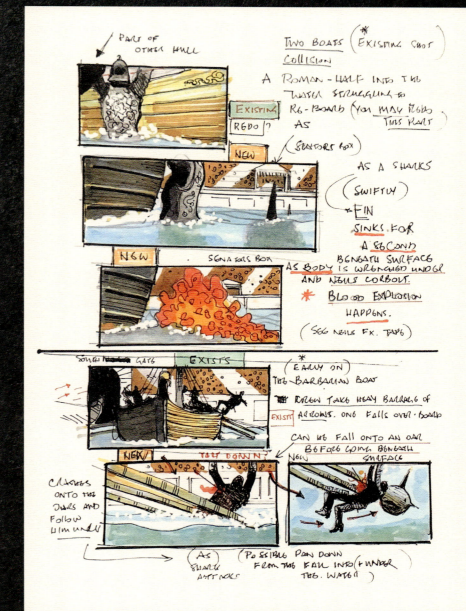

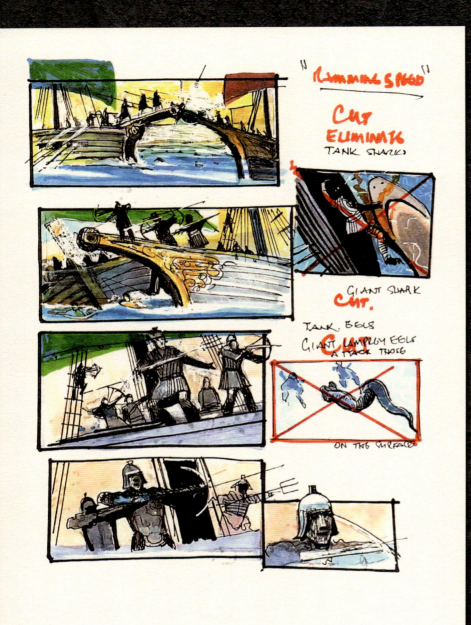
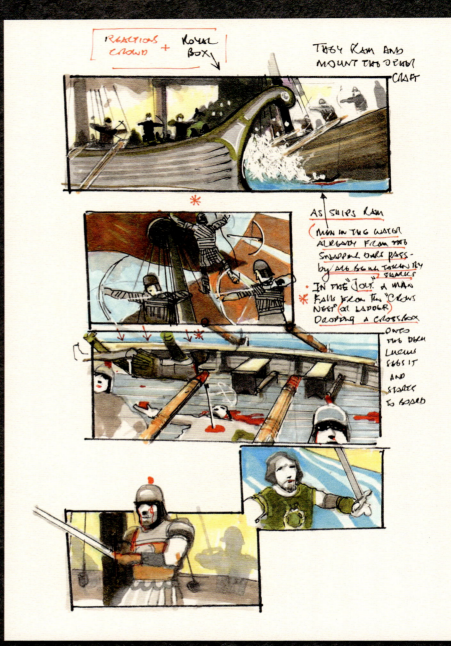

THIS SPREAD
These red ink–marked changes reveal shots of the giant eel cut, allowing the filmmakers to make decisions on paper first before committing to shoot one of the most complex and expensive sequences in the film.

ACTION FX
← ROYAL BOX

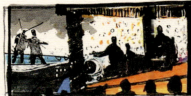

LUCIUS BOW + ARROW FIRES INTO THE ROYAL BOX AS THE BOAT (OUT OF CONTROL) RAMS THE BOX — LUCILLA + ACCACIUS MEN HAVE LEFT

Lucilla + Accacius will have left by now

BESIEGES ANXIOUS — NOT SURE IF THIS IS PART OF THE SHOW

THE BOAT POSSIBLY RAMS THE ROYAL BOX... THROWING LUCIUS AIM OFF TARGET OF ACCACIUS!

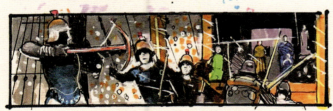

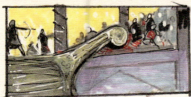

LUCIUS BOAT RAMS THE ROYAL BOX

JUST BEFORE IMPACT LUCIUS RELEASES THE BOLT MISSING ACACIUS. THE UNIMPRESSED LUCIUS THROWS THE AND AIMS AT THE TOP ... OF AS HE REACHES LUCILLA (CARACALLA) FINALLY HITS ACCACIUS

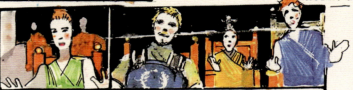

AS THE BOAT COLLIDES WITH THE EMPEROR'S BOX LUCIUS IS THROWN FROM THE BOAT SLAMMING INTO CARACALLAS CHAIR JUST MISSING THE PRINCE CARACALLA (MAKE-UP + ALL) "TOGETHER!"

AS HIS BROTHER GETA SQUEALS AND RUNS OFF PLATFORM WITH HIS MONKEY

CONTINUES: SCENE.

PRAETORIANS MOVE IN ... THE SMOKE IS NOW DENSE

THE IDENTITY OF THE ARCHER IS — (CONCEALED)

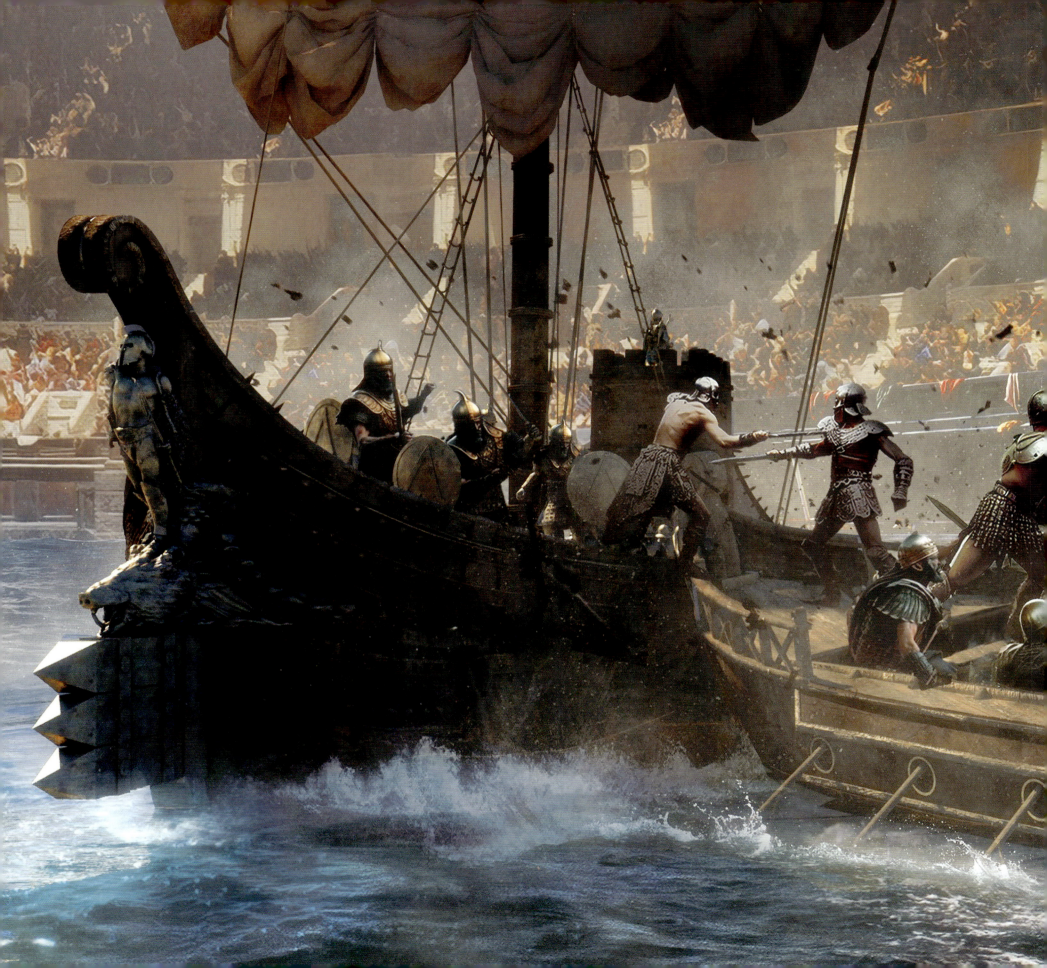

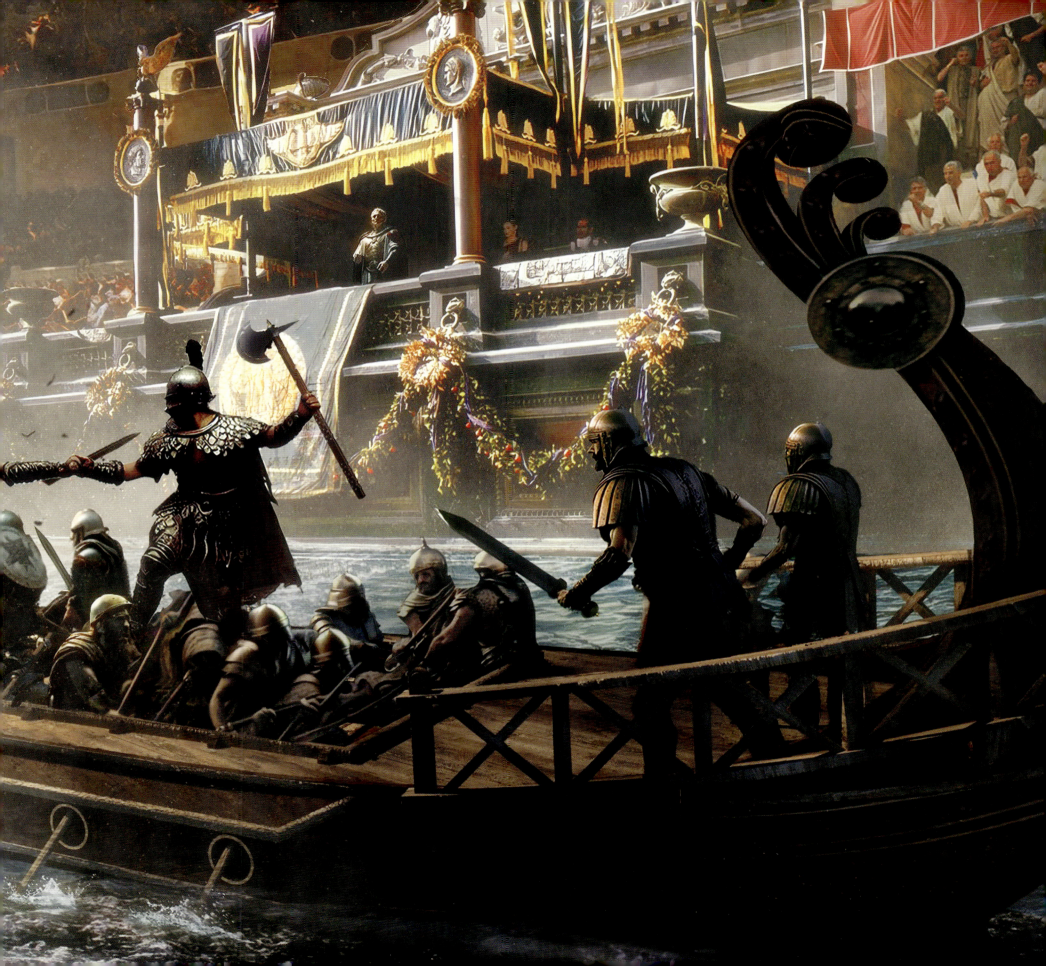

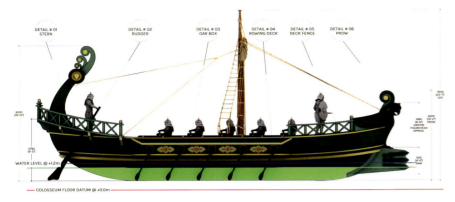
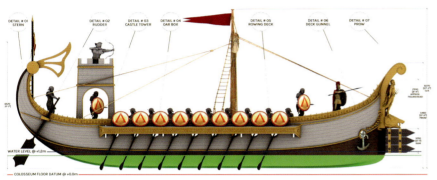
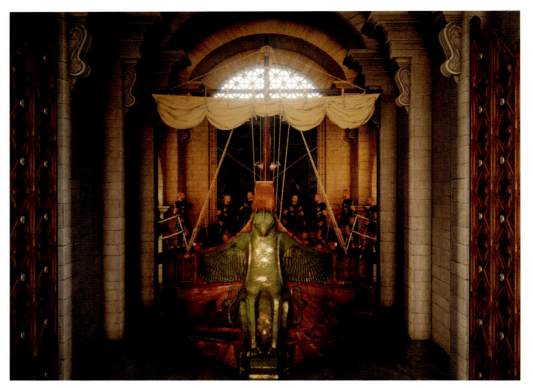
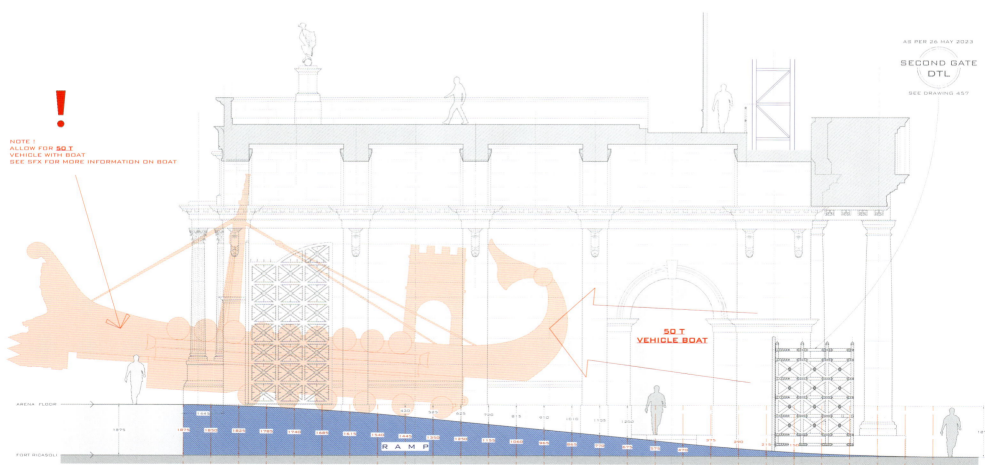

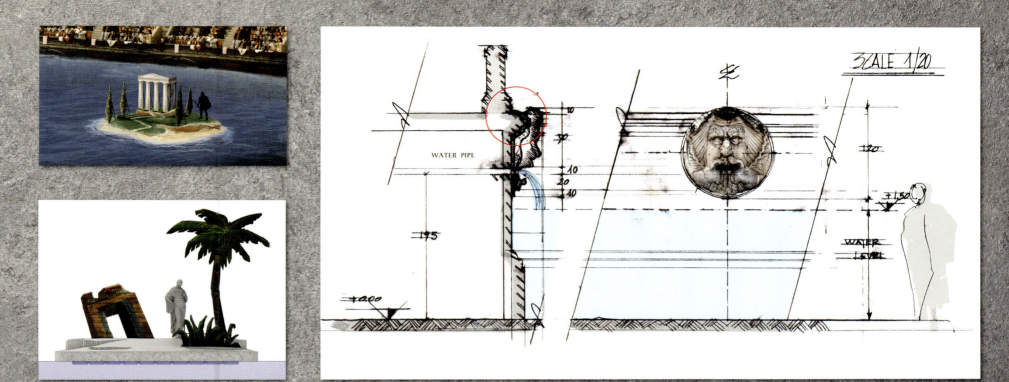

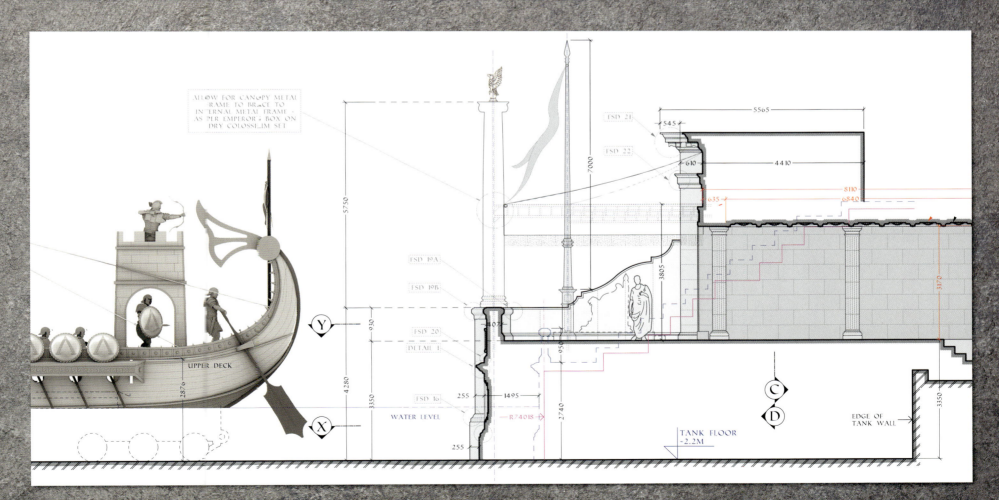

CHAPTER II: DESIGN 161

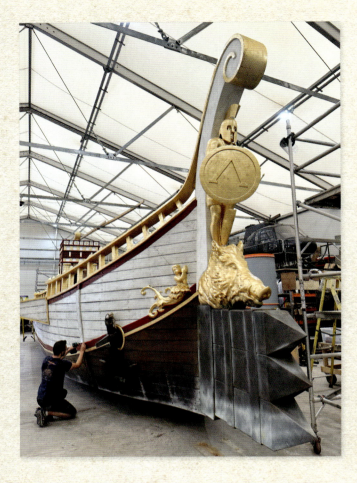
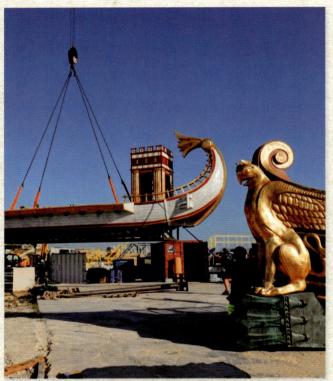
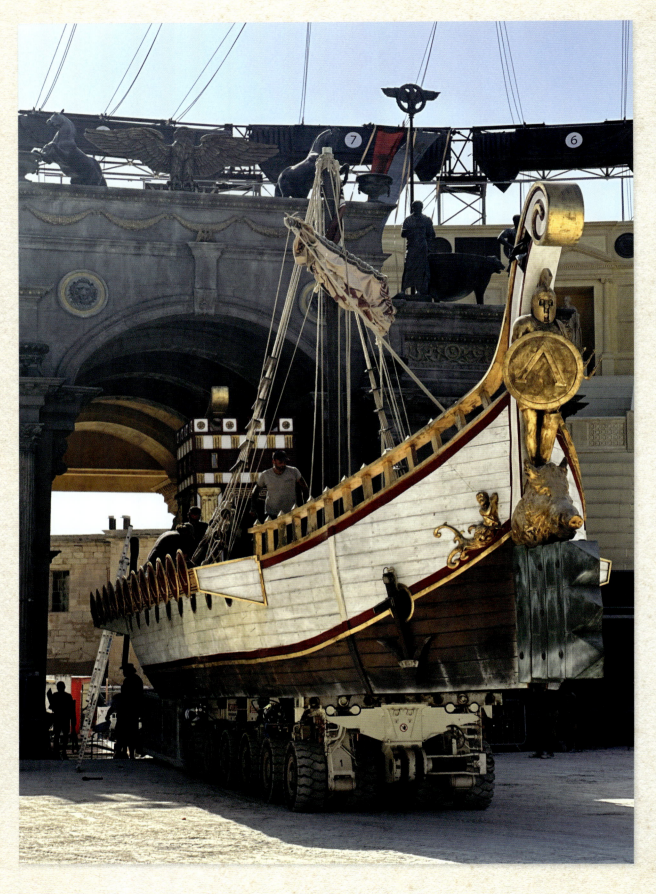

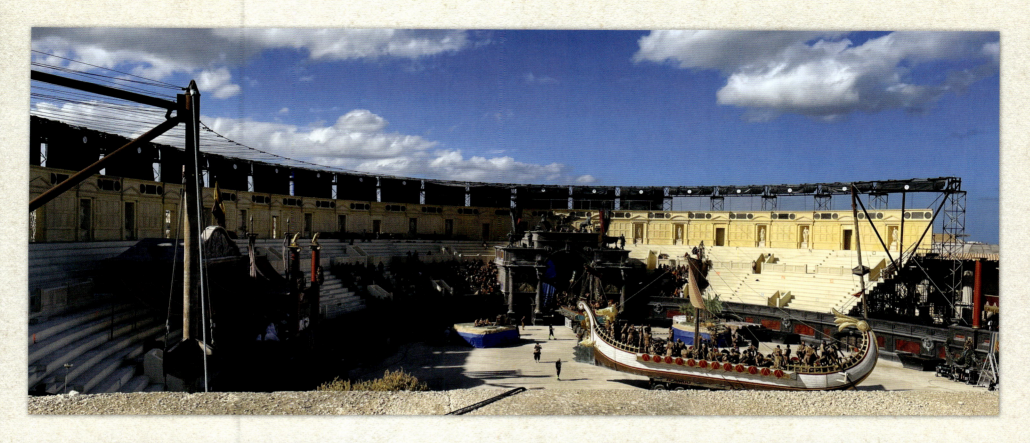

THIS SPREAD
Despite the advances in technology, Sir Ridley Scott wanted as many practical real-world props as possible to bring the ancient world alive on-screen.

FOLLOWING SPREAD
A huge water tank was used to give the appearance of floating boats.

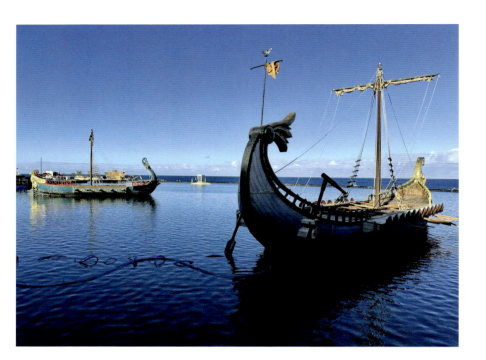
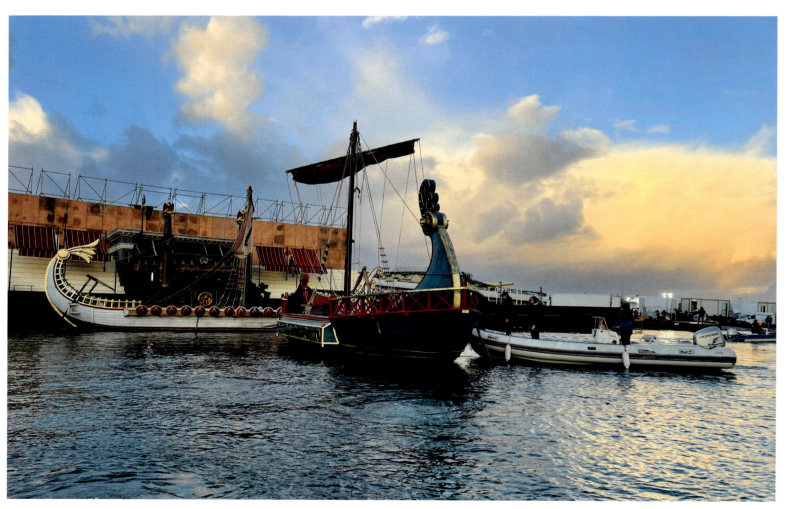

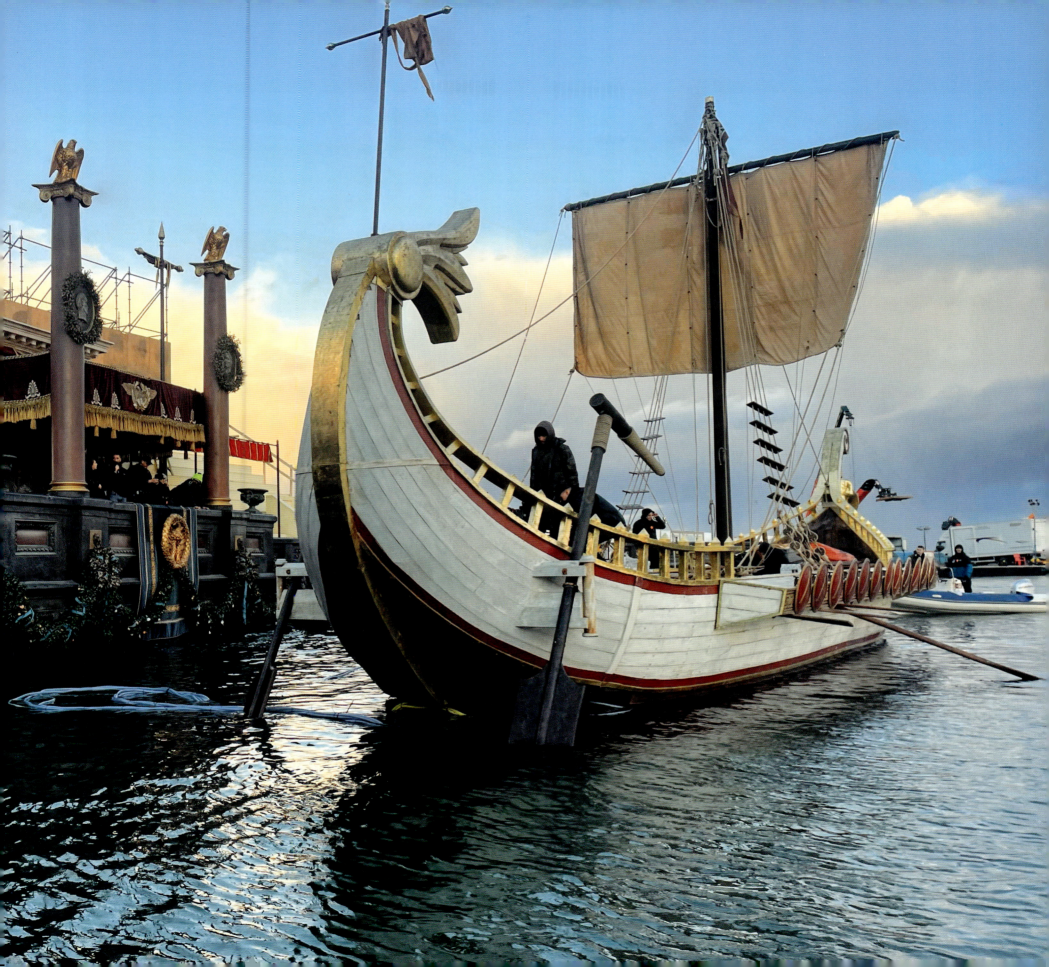

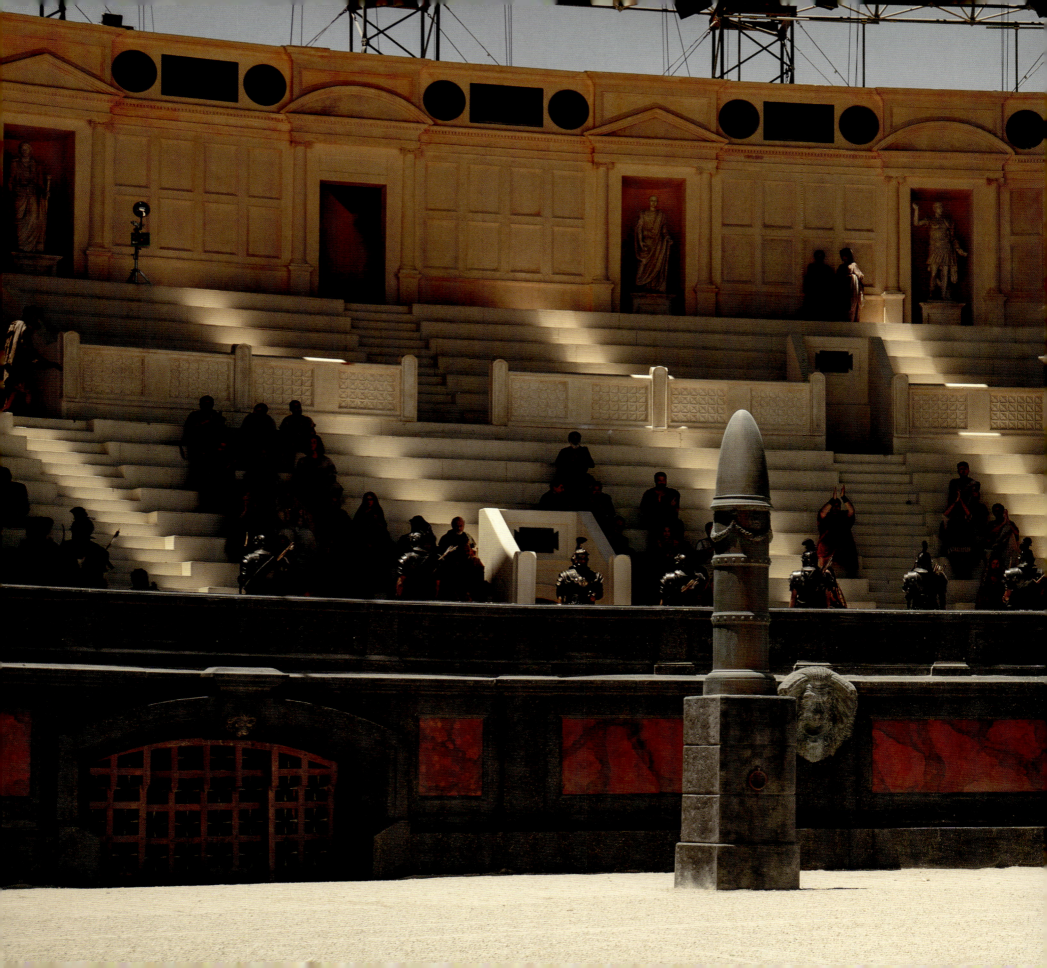

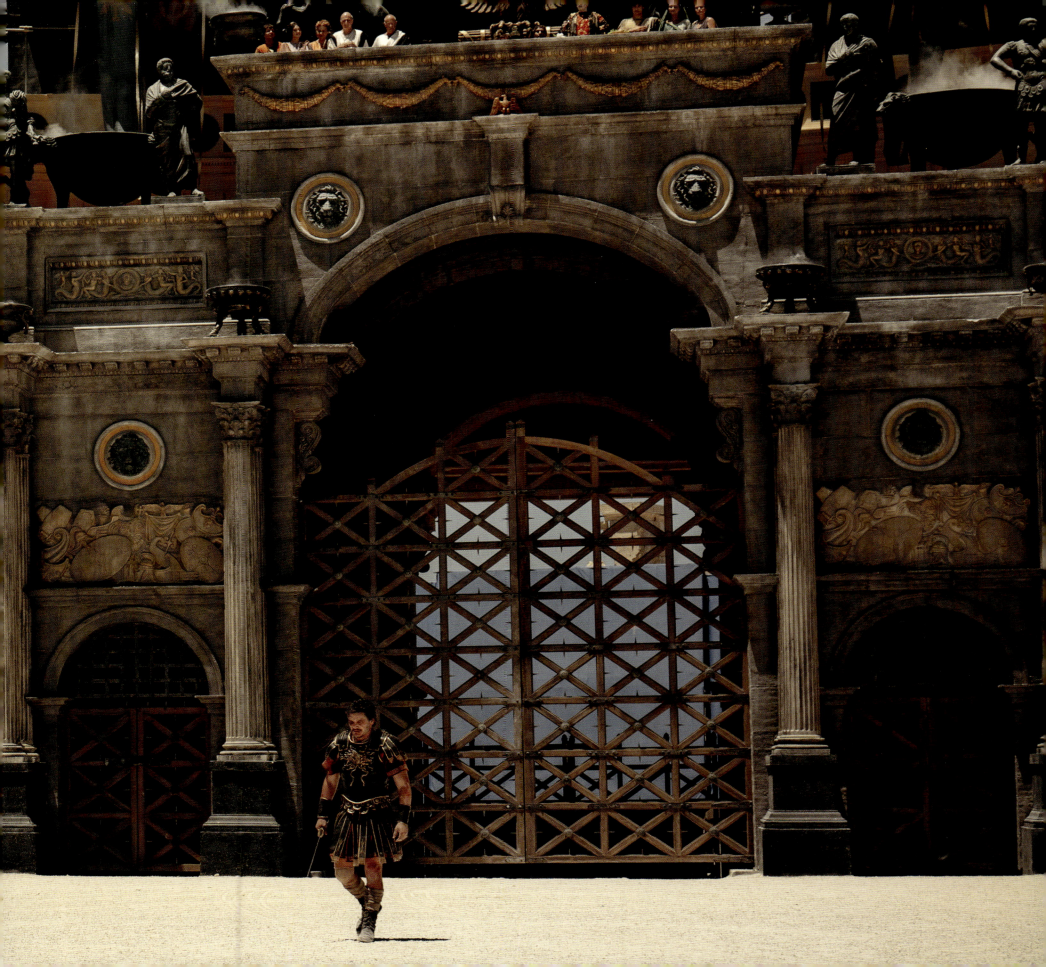

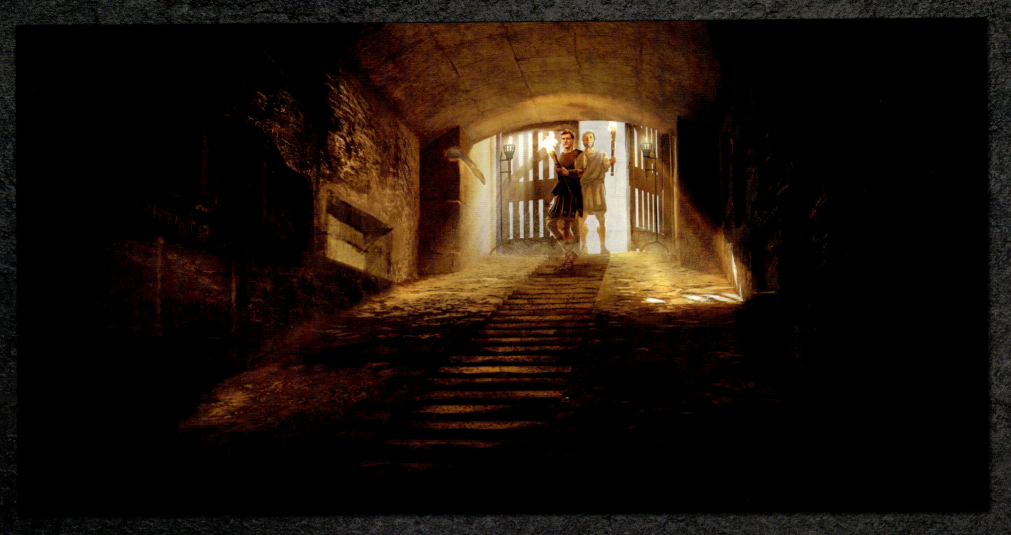
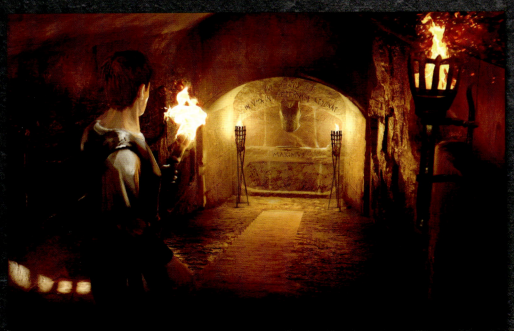

168 THE ART AND MAKING OF GLADIATOR II

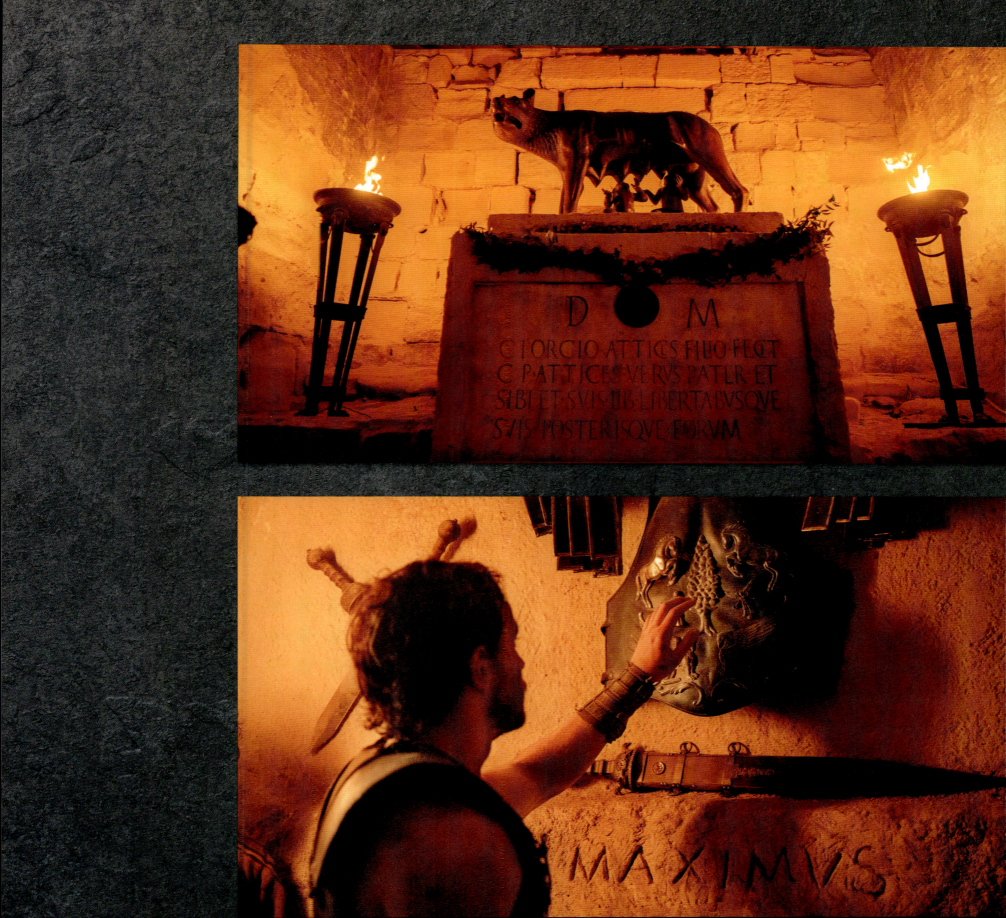

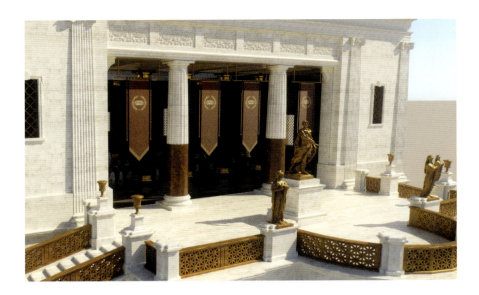
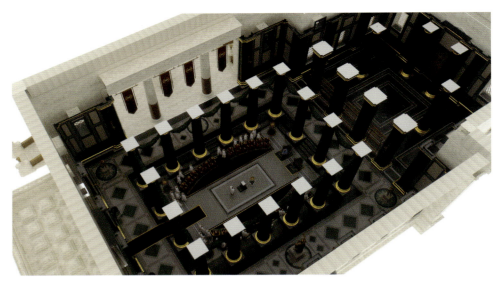
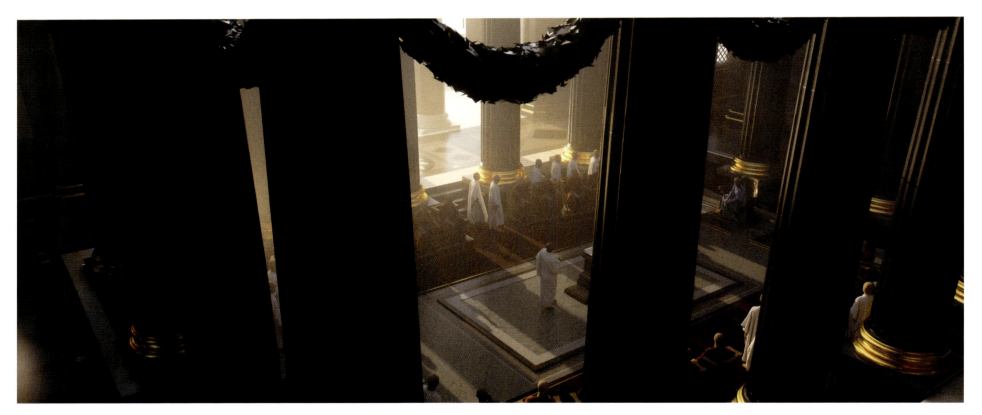

THE ROMAN SENATE

Max took some creative license to bring the Senate set from the first film back for the sequel. "The interior of the Roman Senate was as we did in the first movie: a revamp of the atrium of the palace. I think it's not a re-creation of the historical Roman Senate. It's a meeting of the Senate in a wing of the palace. You will recognize the architecture, although we have changed it as much as possible. But it's still the physical language of the palace. So let us say that the senators have been assembled in a wing of the palace because we did change it quite a bit."

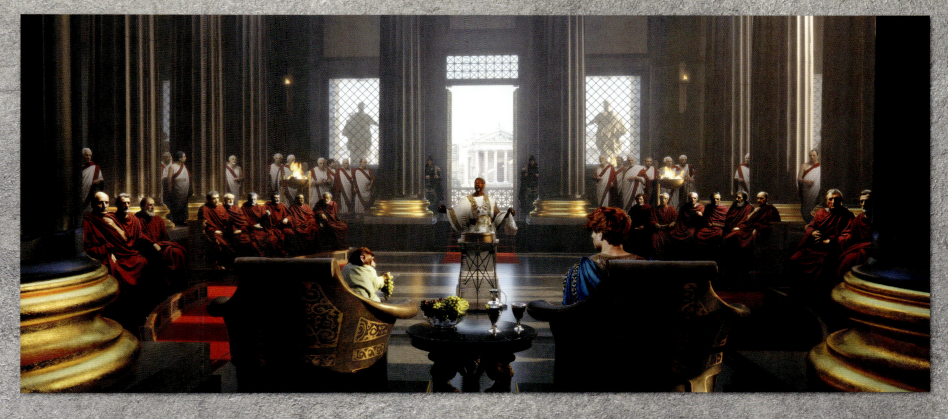
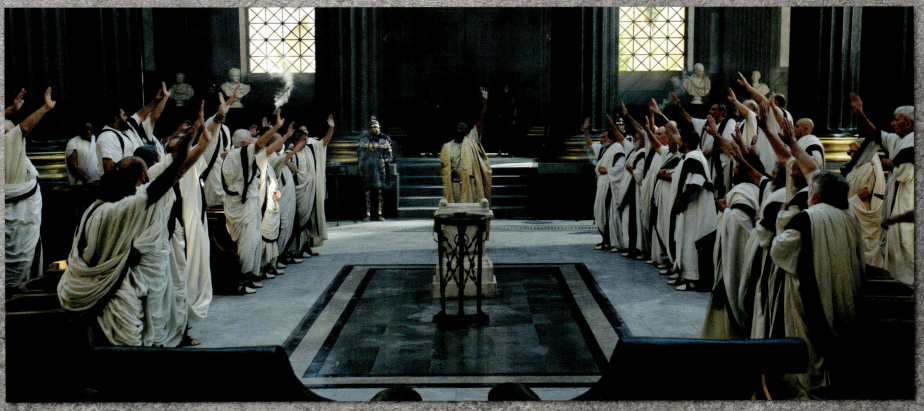

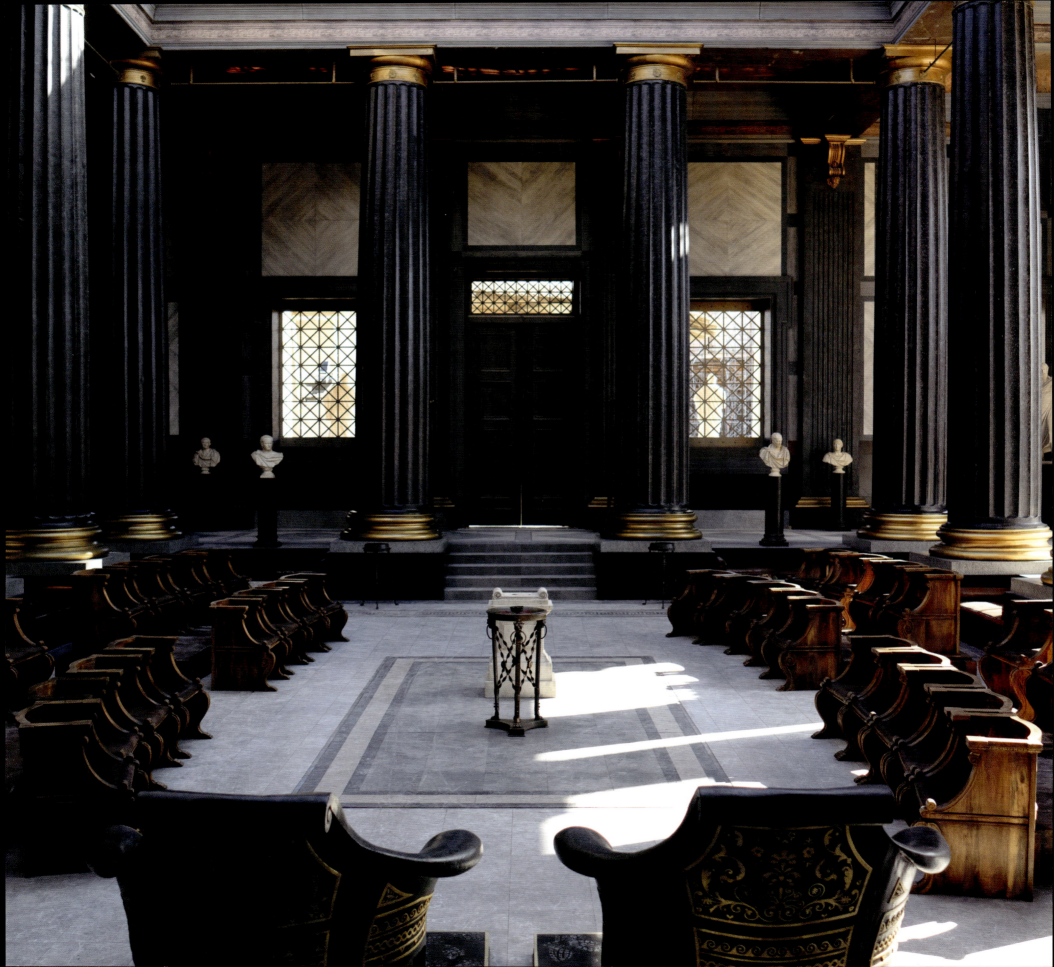

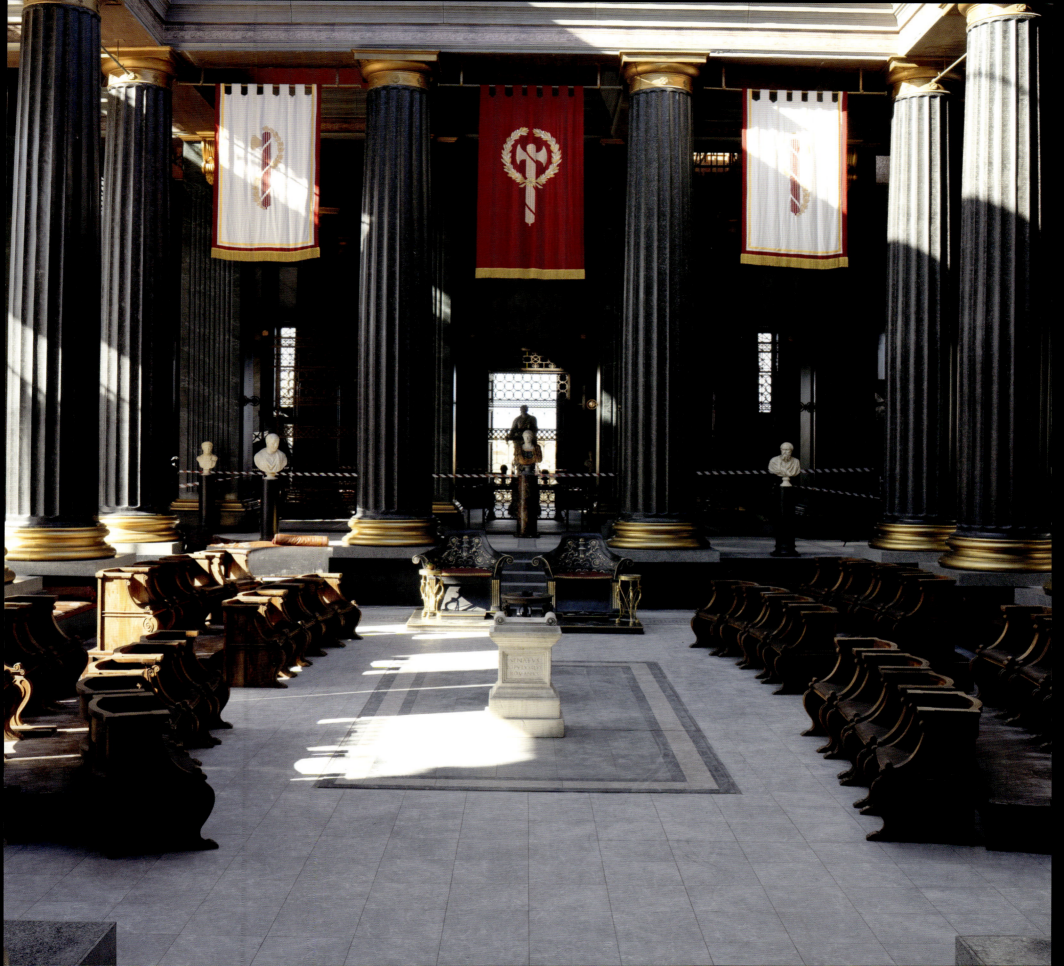

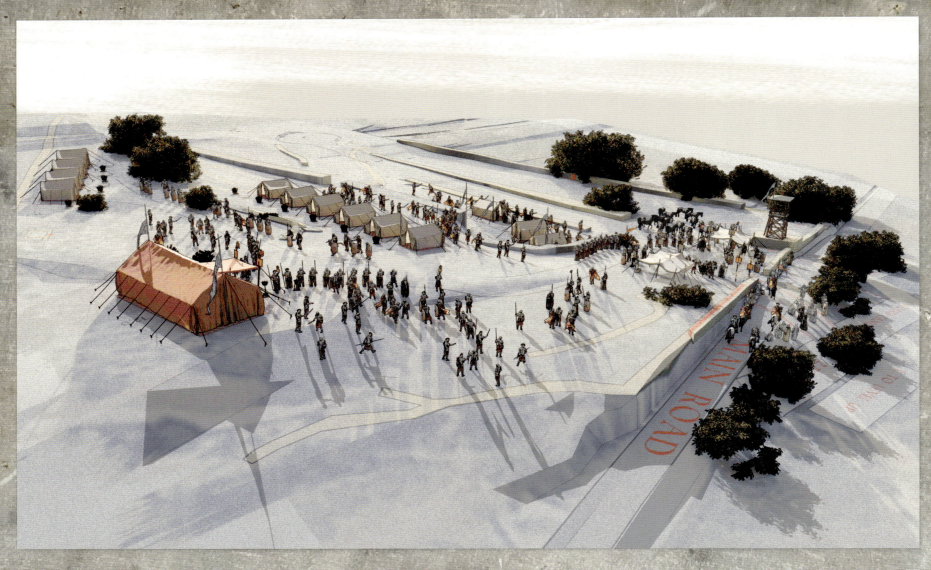
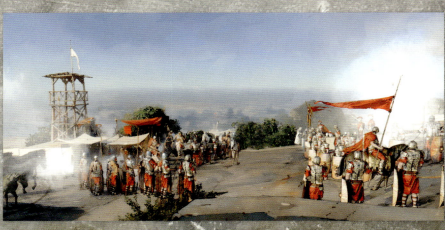
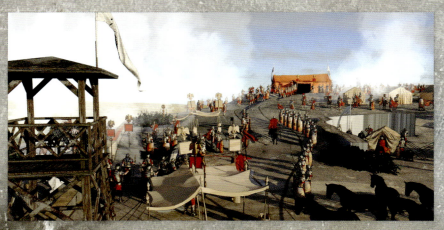

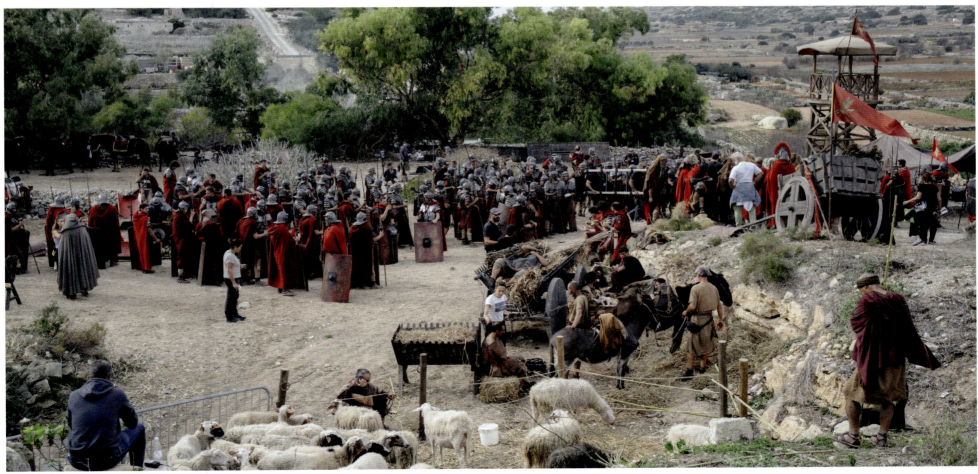

CHAPTER II: DESIGN 175

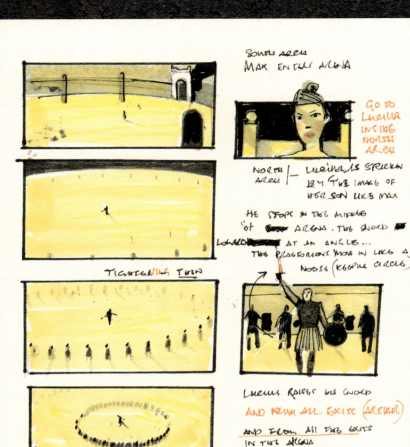
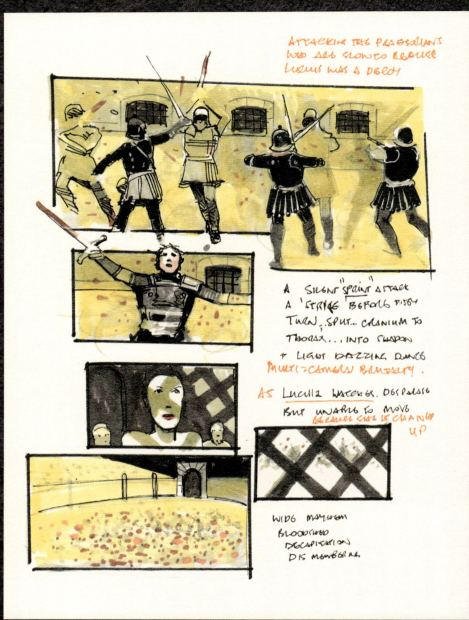

THIS SPREAD
Staging elaborate fight sequences on paper forms the basis for discussion between Sir Ridley Scott and military technical advisor Paul Biddiss.

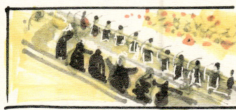

SIMULTANEOUSLY THE ARCHERS PRIOR TO GLAD APPEARANCE HAVE NOW DRAWN BOWS AND POINT AT THE CROWD

BOWMEN KNOCKED

CROWN CONTROL AS CHAOS GOES ON IN THE ARENA

CROWN BECOMING UNCONTROLLABLE - GROTESQUE + VERY VIOLENT. OBJECTS ARE BEING THROWN

GROTESQUE PEOPLE ROWLANDSON OF ROME

BIG SHOT FROM THE STAND LOOKING DOWN ACROSS THE ARENA

AS LUCILLA → INT. NORTH ARCH IS LEAD DOWN BY LUCILLA FREED BY DOCTOR

LUCILLA LEAVES TO NORTH ARCH

CLOSE SHOT (CUT AND GORE) MUD + SAND A MULCH OF BLOOD

LUCIUS SEES HIS MOTHER LEAVE

LUCIUS SEES MOMENTS IN THE BOX

MAC BEHIND DAMAGED CURTAIN KILL HIM

LUCIUS GLIMPSES HIS MOTHER LEAVING - (FREED) AS BATTLE RAGES THEN LOOKS UP AT THE ROYAL BOX TO SEE MAC BEHIND THE CURTAIN, WHO PROCEEDS TO KILL HIM

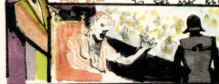

STILETTO IN THE EAR AND EXITS

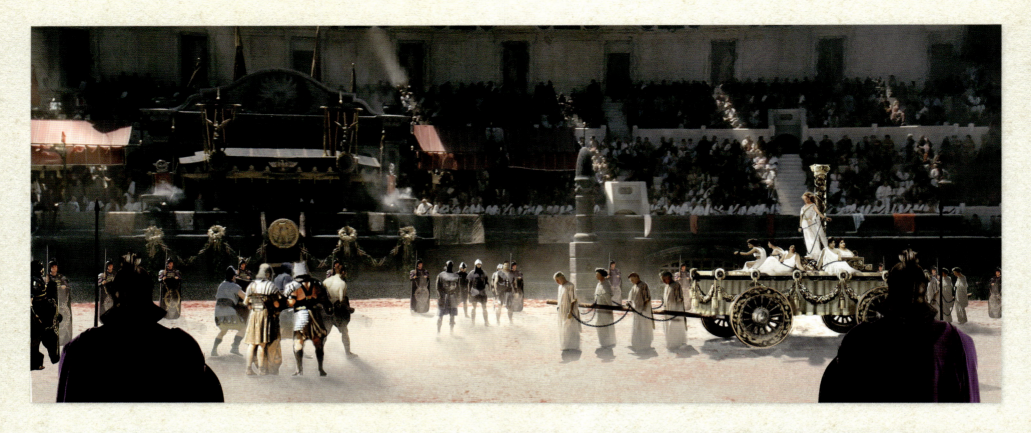
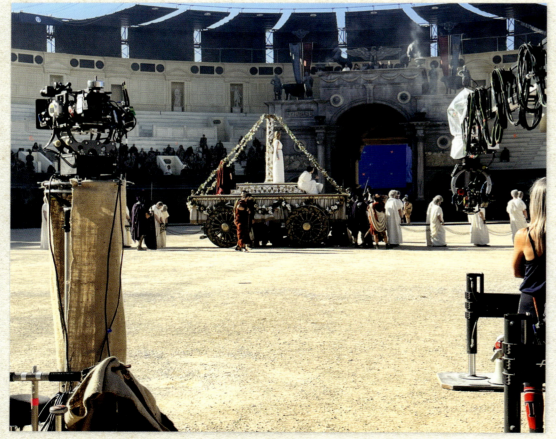
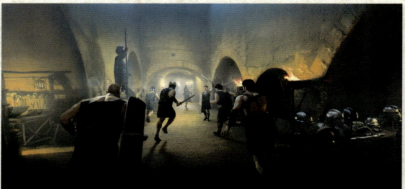

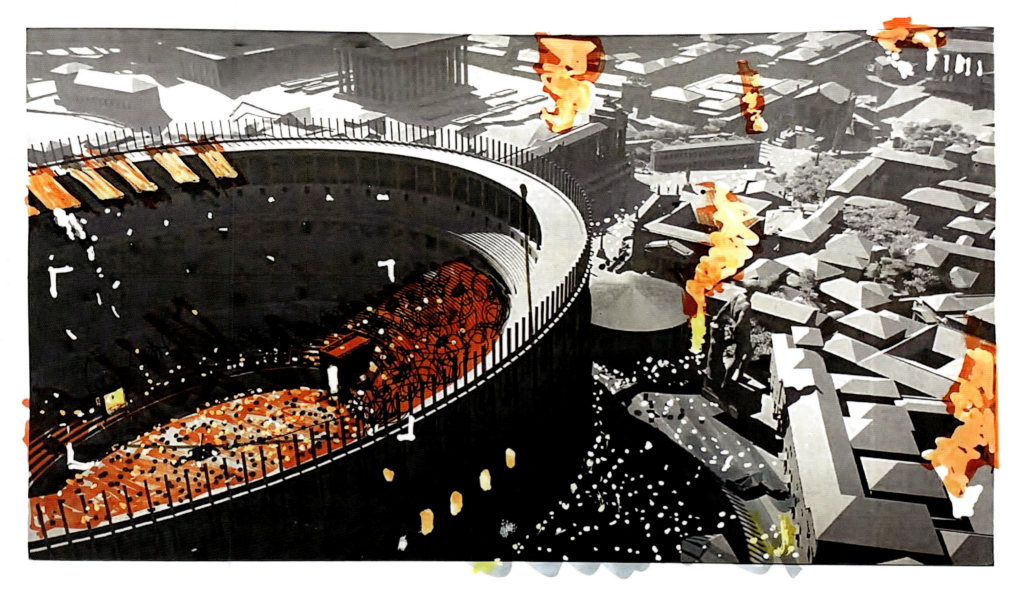
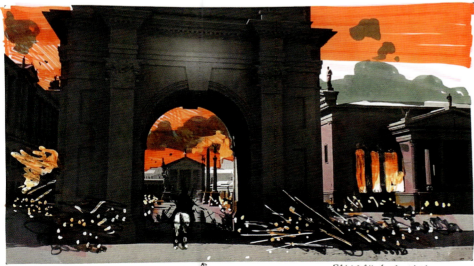
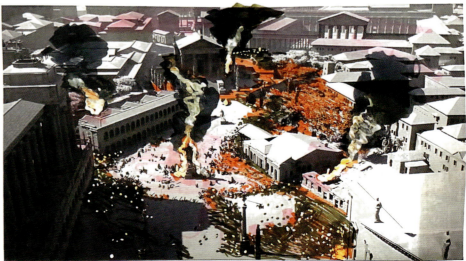

CHAPTER II: DESIGN

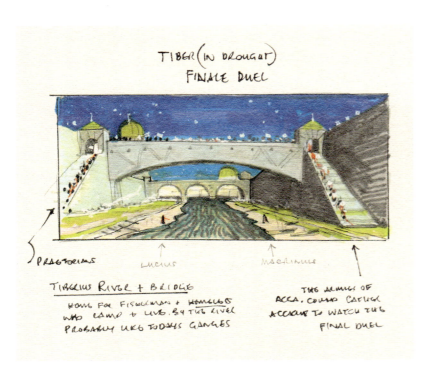

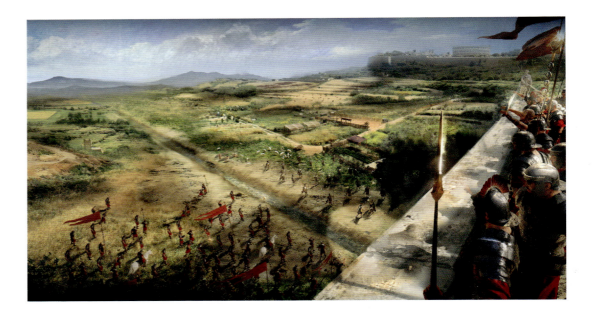

THE RIVER SETTING FINALE

The film's big set-piece ending, which involves an elaborate hand-to-hand duel on the banks of the Tiber river, presented another challenge. "The original concept for the final confrontation between Lucius and Macrinus took place on a bridge over the River Tiber, and we conceived of that as it still exists in Rome today as the Ponte Rotto [Broken Bridge], which is a bridge that was partially demolished by a flood tide in the second century. We were going to build it initially because we were led to believe there were no bridges in Malta of an ancient Roman style. We decided to go back to what was in the first movie, the Road to Rome [re-creating the fabled path to the capital], because it's a spectacular valley. We put Rome on one hillside so that we would have the confrontation and create the river in the valley. We have the two armies: the Praetorian Guards supporting Macrinus and the legionary army of Acacius supporting Lucius. It boils down to a biblical fight of champions, much like David and Goliath in the Bible. We have Lucius and Macrinus fighting it out in front of the assembled armies on both sides of the valley for a spectacular confrontation in the middle of it all."

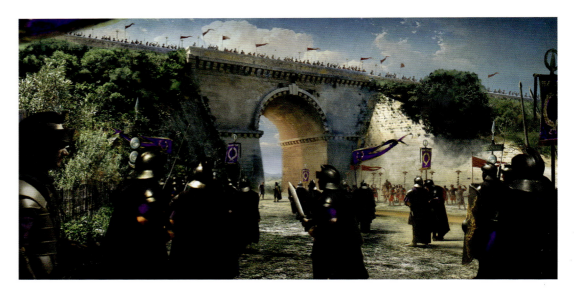

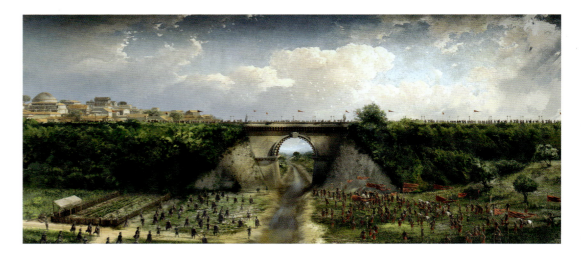

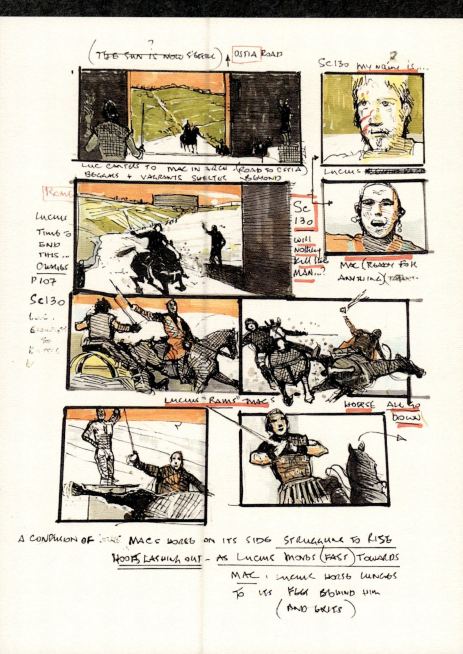

THIS PAGE
The storyboards here include scene numbers from the screenplay and, in red, directions for the horses.

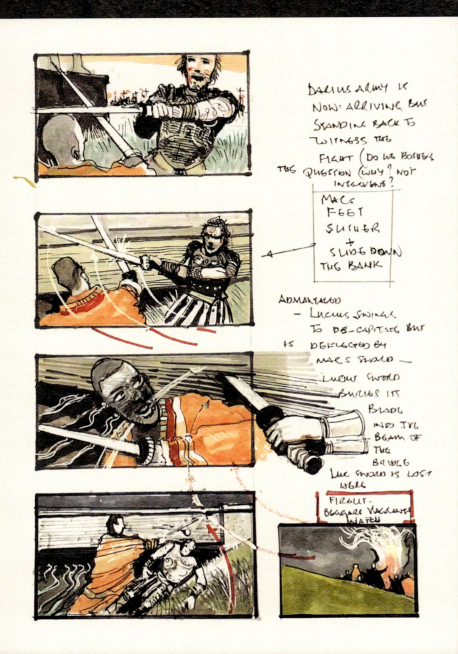
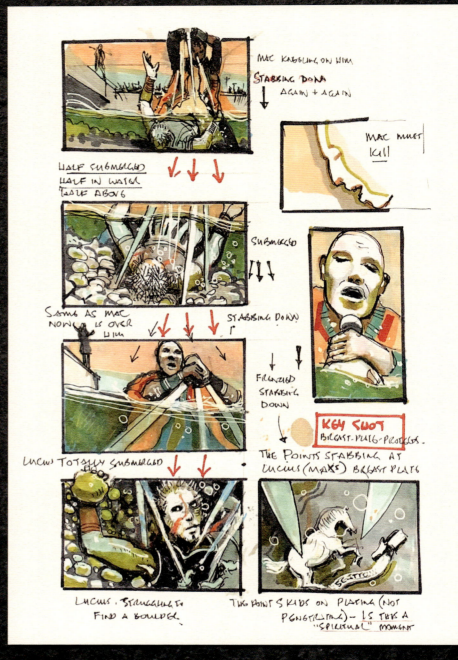

THIS SPREAD
The film's dramatic finale depicting the brutal death of Macrinus

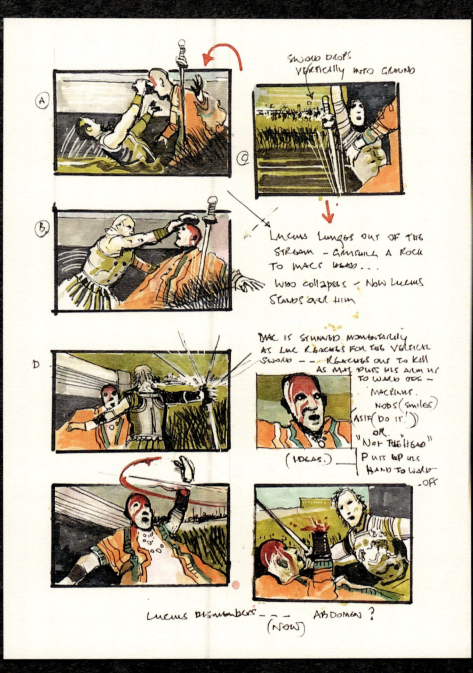

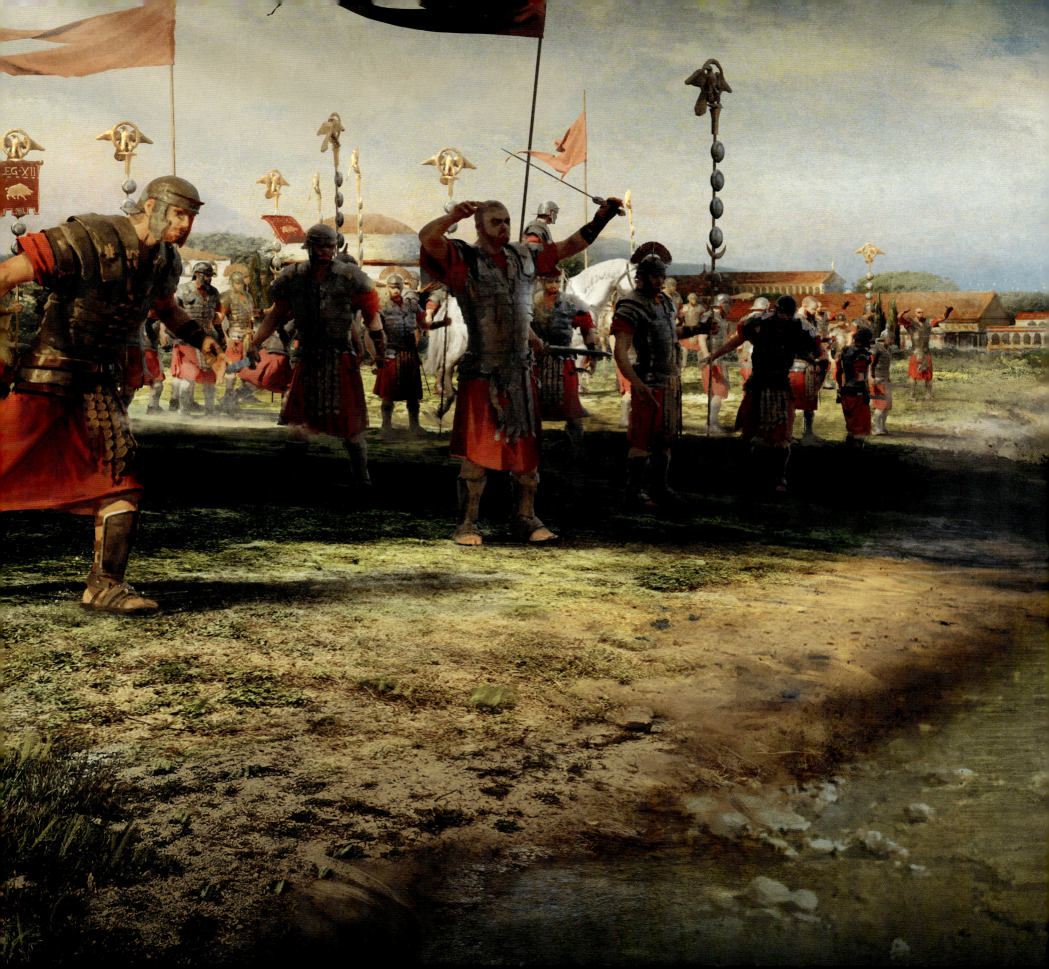

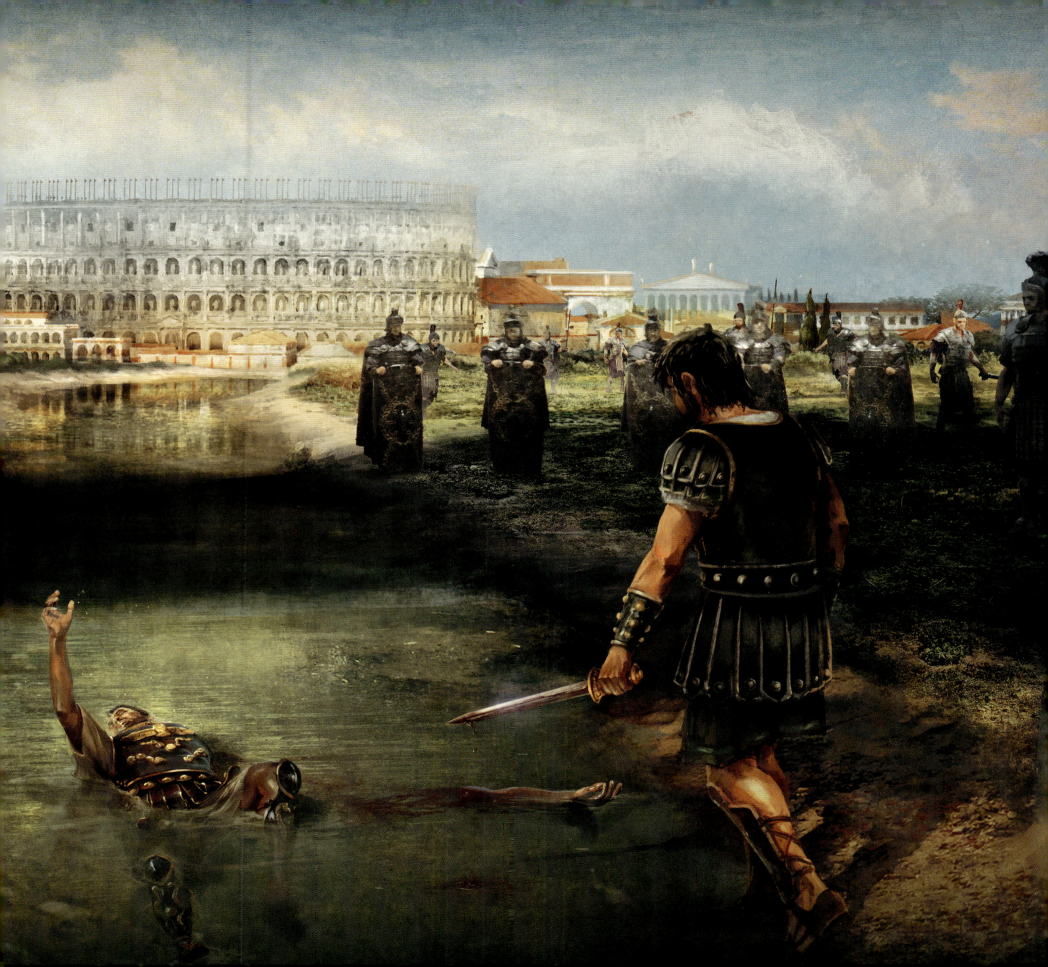

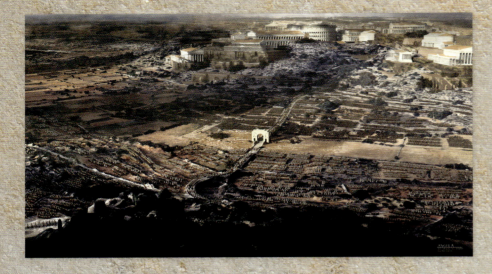
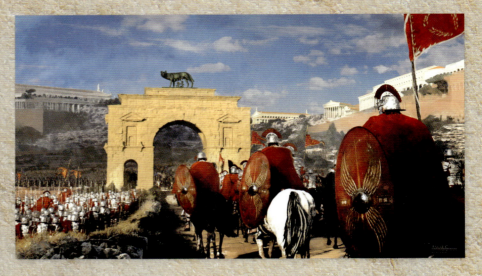
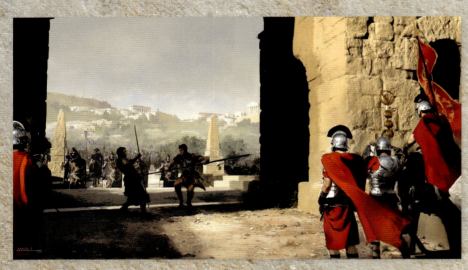
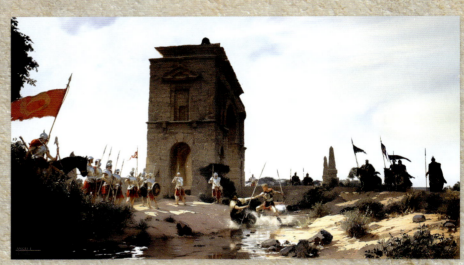
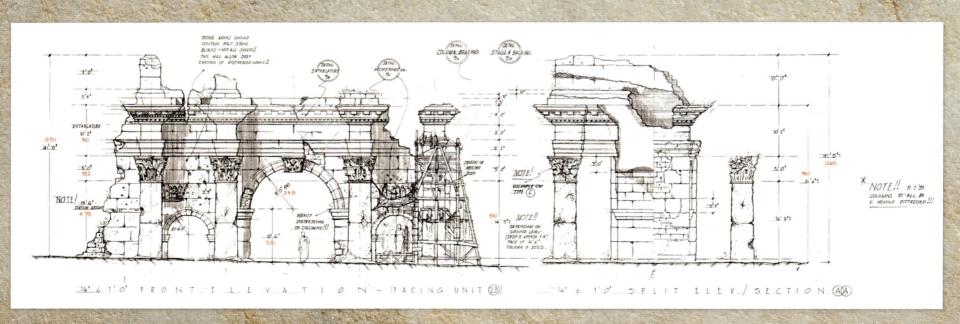

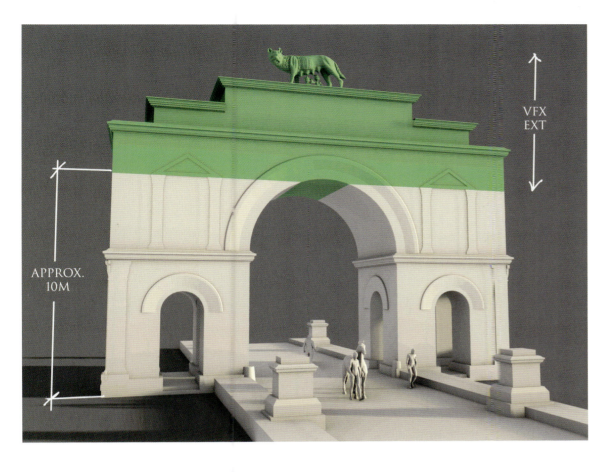

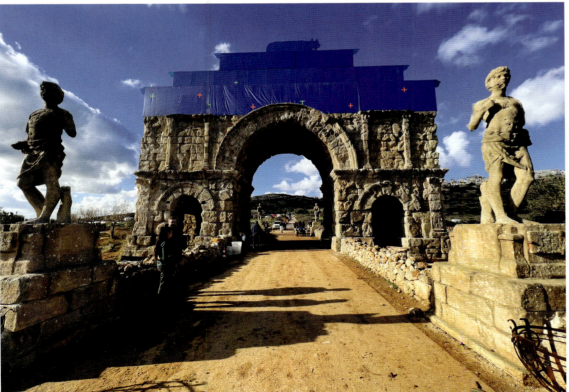

GHOSTS FROM THE PAST

Russell Crowe's and Richard Harris's characters may be dead, but in the sequel, there are echoes of them from the first film. "We've done a couple of portrait busts in the family tomb from the first movie. We used some of the original footage in flashback from the original movie, we've tried to use the color palette of some of the sets, like the Colosseum and the palace, so we can cut in any footage from the first movie in flashback that might have been required. And I think some of the motifs of the more spiritual side of the first movie are the little household gods, altarpieces, and shrines that Romans would have kept close by in their interiors. But we've moved away from relying too much on the previous generation, and we're trying to build a story around the survivors who've turned up and the new characters. But there's a familiarity of style, and it's very much the same world because we're only twenty-odd years later in real time and storytelling time. It's fresh in many ways but has familiarity with the past."

Max wanted the audience to feel enriched by their return to the world of *Gladiator* and experience even more wonderment at the ancient world than they did in the first film. "Hopefully, we recaptured that. I think that's very important. And also the physicality and visceral brutality of the ancient world and its opulence. Enjoy the opulence of it all, because we spent a lot of money doing it!"

CHAPTER II: DESIGN 187

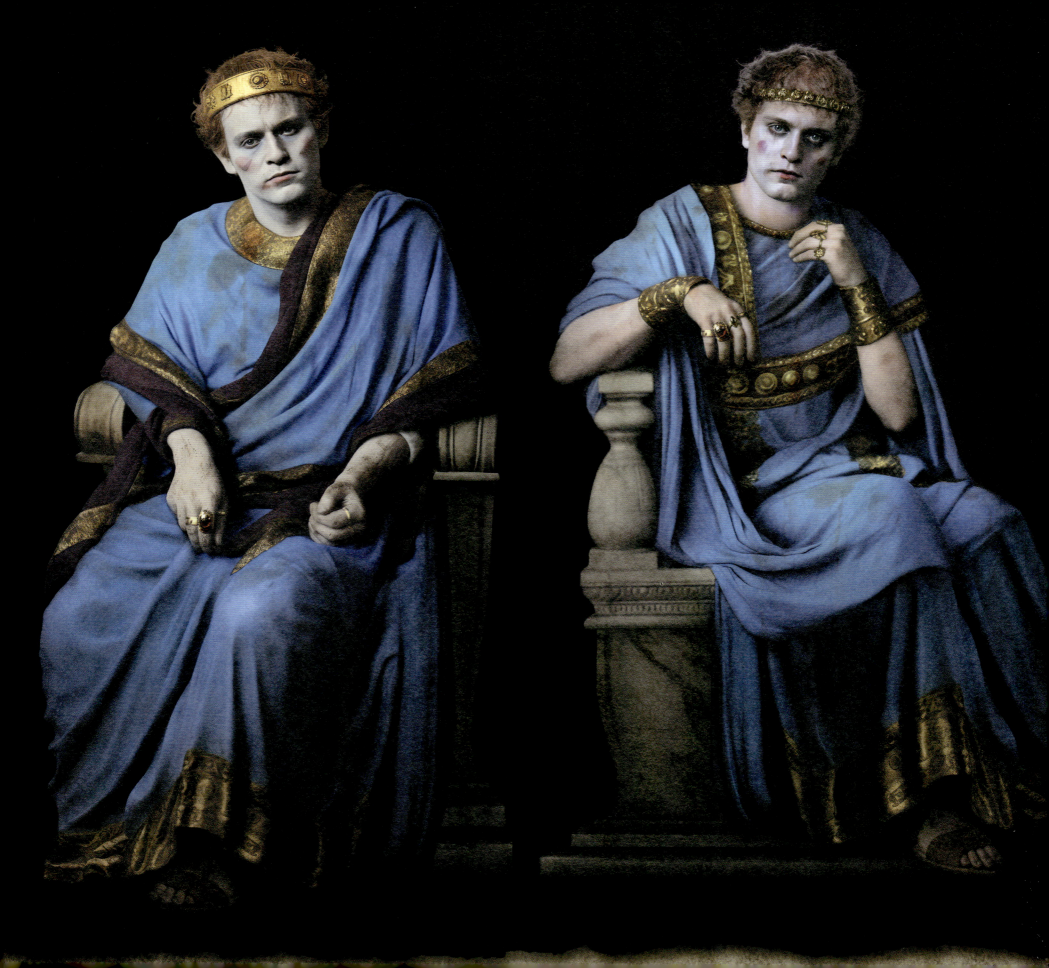

COSTUME DESIGN

BRITISH-BORN COSTUME DESIGNER JANTY YATES, RENOWNED FOR HER WORK ON GLADIATOR, MADE HER MARK YET AGAIN IN GLADIATOR II. HER FIRST COLLABORATION WITH SCOTT ON GLADIATOR WAS A RESOUNDING SUCCESS, EARNING HER AN OSCAR FOR COSTUME DESIGN.

Since then, she was a key creative force on fourteen of Scott's films. "*Gladiator* was the first sword-and-sandals [film] to come into public vision since *Spartacus*," said Yates. "It had Russell Crowe, who is just spectacular. There were the most wonderful fights, female charioteers, and tigers, plus they died in the end, which is always a bonus. They go hand in hand over the horizon for a Hollywood film. It was very impactful, with the two deaths in the end. So it was a whole wide range of concepts. And, of course, Ridley's amazing direction and visuals."

PERIOD FASHIONS

When she read the script for *Gladiator II*, Yates was transported back to her Oscar-winning success and ancient times. "It was glorious to do because it's the most wonderful period [with the best] fashion concepts. We had some great ideas for this new one. It's a marvelous era to work in. You can fit all sorts under a tunic and a toga." Though she was familiar with the setting from the first film, Yates did more detailed research for the sequel. "The original scripts had periods in Egypt and Carthage. There was even Babylon, so there was a lot of new research. The first film was a very long time ago. I've [worked on films set] in space three times, and I've done a lot of other periods and a lot of contemporary work, so I had to give myself a very good brush up. There's nothing better than just walking through Rome. We rent a lot from the wonderful Roman costume houses because they have the original costumes from *Ben-Hur* and [do] beautiful embroidery. You can't get that done easily now. You wander through Rome, and Trajan's Column tells you nearly everything you need to know about the military."

RIDLEY'S VISION

Scott's team of talented creatives loyally follow him on his productions, and Yates has been no exception. "Ridley Scott's vision is quite extraordinary. It's so inspiring. In the middle of the day, he might say, 'Have you got anything in red? Let's put them all in red.' He is constantly full of ideas. There's a lot that's different from the original. But he, for example, said we would have the senators again, white with black, but their cloaks would be red. Just little touches. When we were making Denzel's costume, Ridley was inspired by the Orientalist painters of the nineteenth century: Gérôme, Benjamin Constant, Alma-Tadema, and the Moorish influence that came with the Orientalists. We did a sort of split Roman aesthetic, because, as Denzel said, he didn't want to be different when trying to ingratiate himself with the emperors. So he started with a more Moorish design."

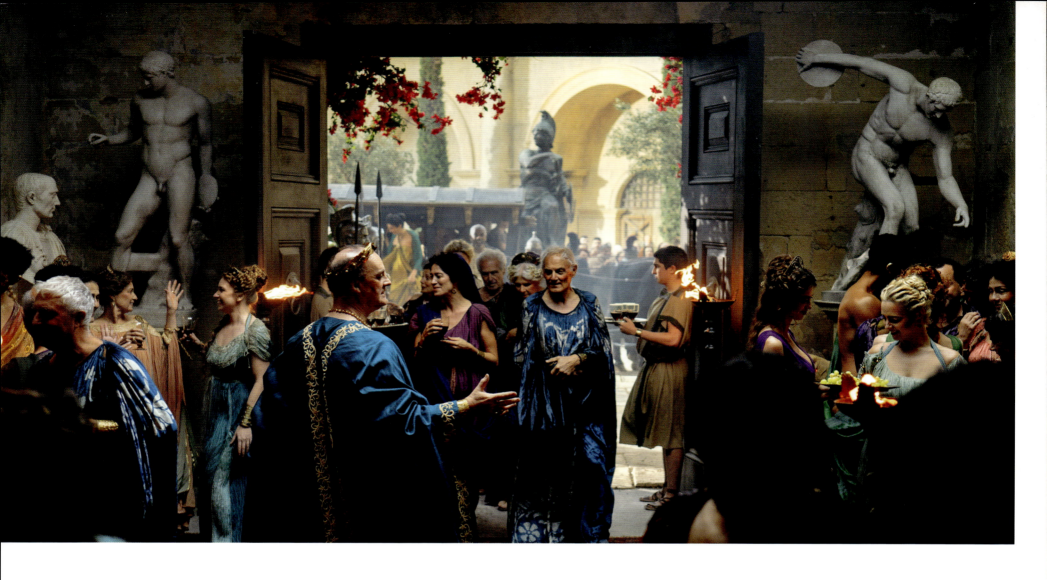

DRESSING OF THE THOUSANDS

CGI may be widely used in films to populate a scene with thousands of extras, but in *Gladiator II*, Yates dressed a literal army practically. "We were fitting three thousand extras a day on the original one. We started at two-thirty in the morning, so it's a huge bonus only having maybe a crowd of 750. The Colosseum is a lot larger. The streets of Rome are all the same size. Arthur [Max] is in his wonderful role . . . and always delivers beautifully. His set decorator, Jille Azis, is doing an extraordinary job. We were scheduled to spend five weeks in Morocco, [but] Ridley cut that down. So we weren't as long as we thought we would be. But that's an amazing scenario. We're in the middle of the Sahara. You're prone to dust storms, whether they're scripted or not."

LET THERE BE LIGHT

Yates worked closely with the key creative departments on the film, none more than director of photography John Mathieson and production designer Arthur Max. "John and Arthur and I, and to a lesser part the makeup and hair, we'd always sit down and discuss color palettes. For example, we mustn't have a burgundy gown against burgundy silk walls. Arthur and I liaise constantly about [things like] that. John is the most discreet, most wonderful DP. He did the first [film], of course, so we have a shorthand. But you always have a palette meeting at the kickoff, during prep."

Crucial to the lighting is the dressing of the actors and the way this design relates to both Max's and Mathieson's work. "We've worked together since *Gladiator*, where I first met Janty," said Max. "We collaborate regarding the palettes she's using because you suddenly don't want to have the same background as the costumes. And the same thing with the armaments. We had just finished *Napoleon* together. You cross-pollinate between costumes, the interiors, and the iconography of whatever scene you're doing, from the slum streets to the palace throne rooms. You've got to constantly communicate and stay in touch with each other about the level of color."

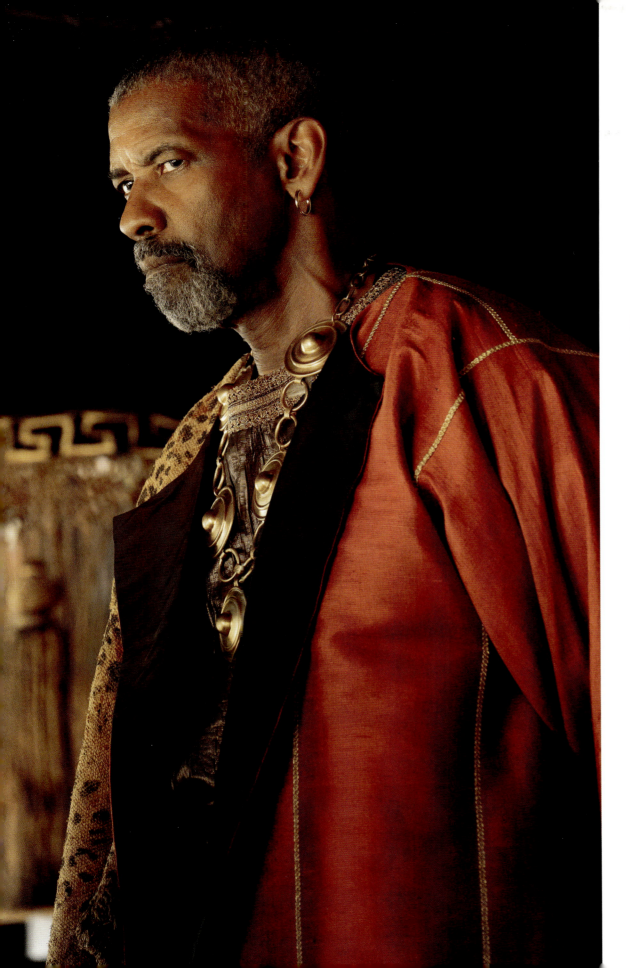

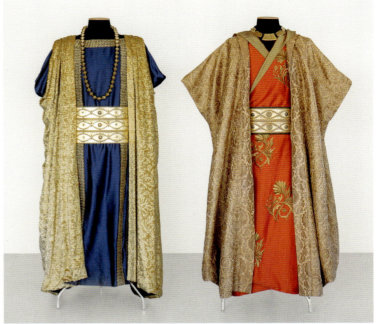

COSTUME POLICY

Established actors often have strong feelings about their costumes, since they inform so much of their characters. Yates devised a diplomatic way to deal with this when it arises. "My policy regarding actors is very much 'a happy actor is a great actor,' so it's a huge collaboration. I don't force anybody into anything. Often, I'll be between Ridley saying, 'I want them in black' and [the actor] saying, 'I'd prefer not to wear black.' So you don't know. You're the umpire at that tennis match, and it always works out."

DRESSING MACRINUS

"Denzel was vocal about not wanting to be a Moor," said Yates. "He didn't want to emphasize that, because he said his character worked and lived in Rome. This was when the original script had him living elsewhere. Then he said, 'I'm getting quite ambitious, and I don't want to stand out in a turban and have a big pointy beard,' which Ridley drew. And he said, 'I don't want to do that at all. I want to be more Roman.' He didn't want the fezzes. He didn't want the curly-toed slippers. We've achieved what he was after: a rich, expensive look. And that's all down to my wonderful cutter, Dominic Young. Without him and his input and stimulation, we wouldn't have gotten the look we had for Denzel."

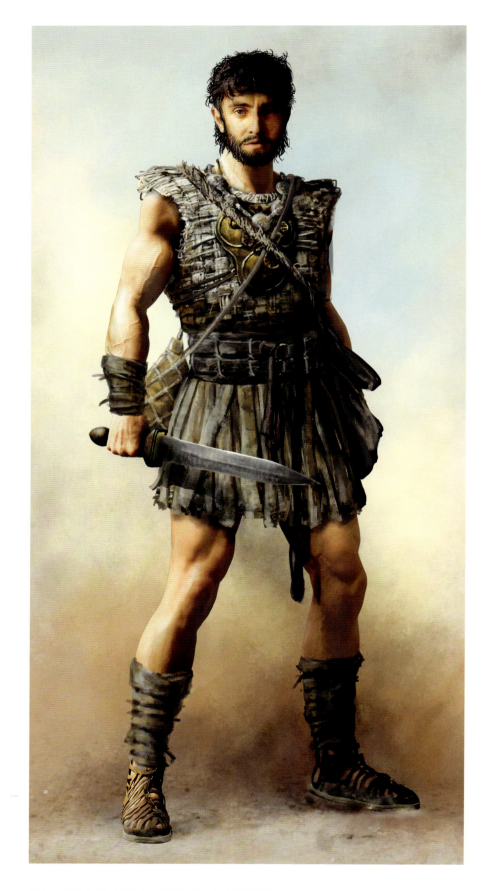
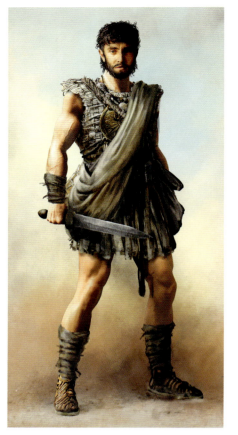
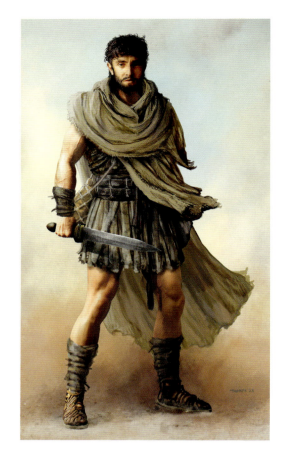
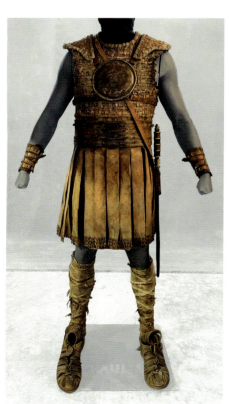
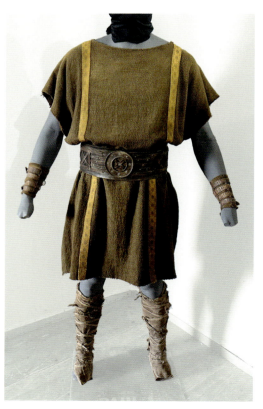

192 THE ART AND MAKING OF GLADIATOR II

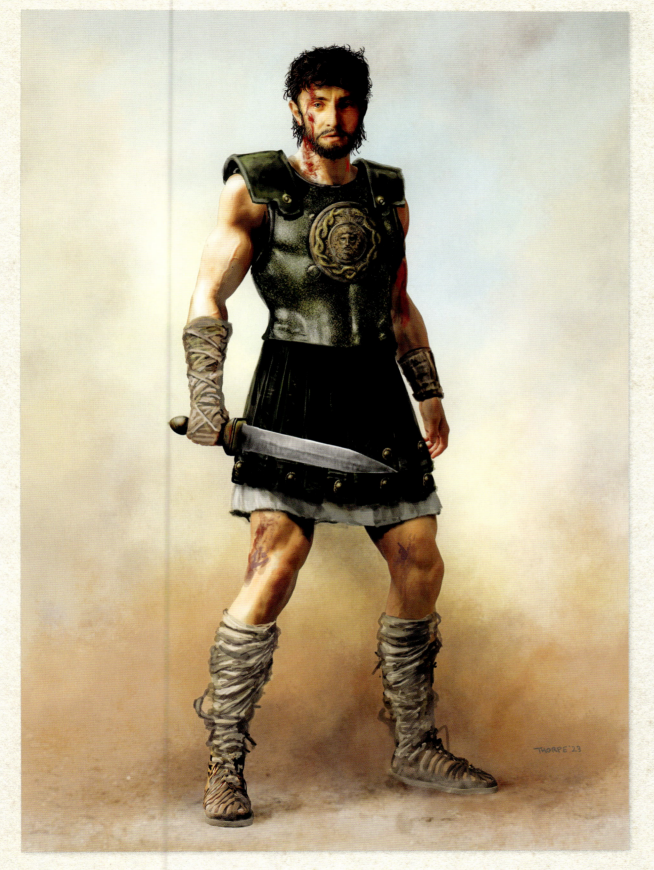
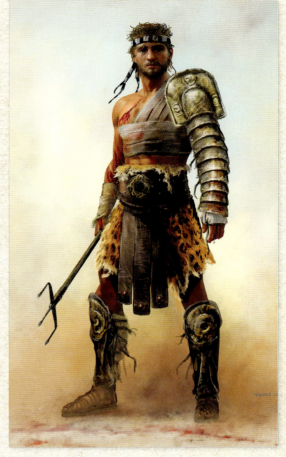
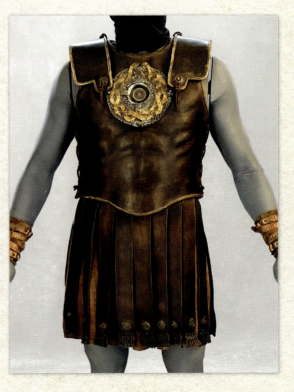

CHAPTER II: DESIGN

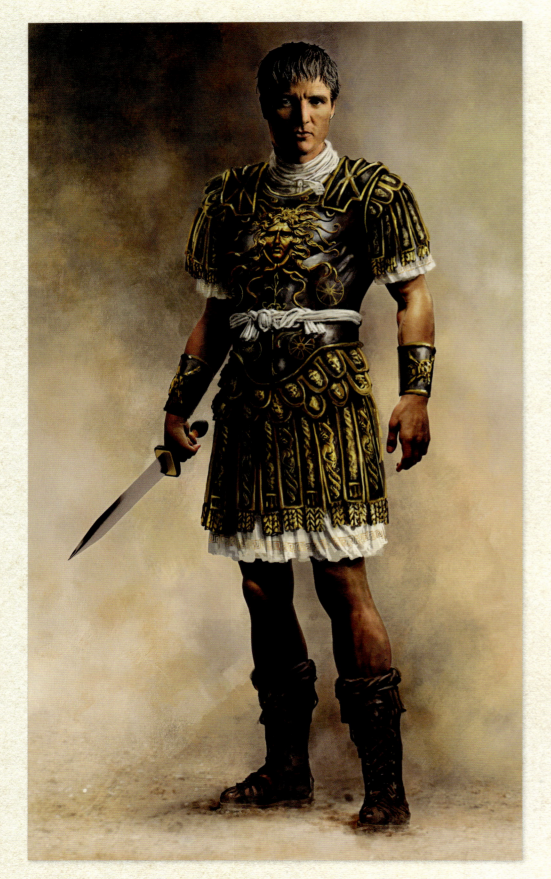
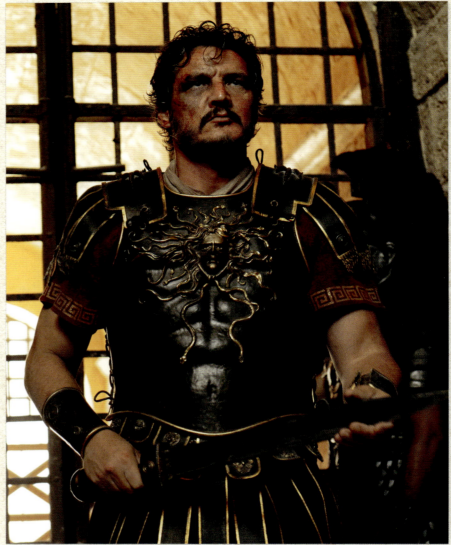

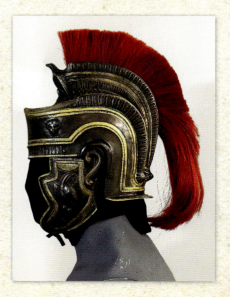

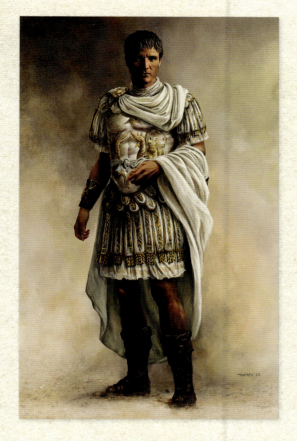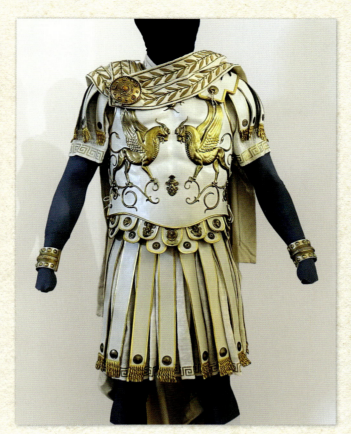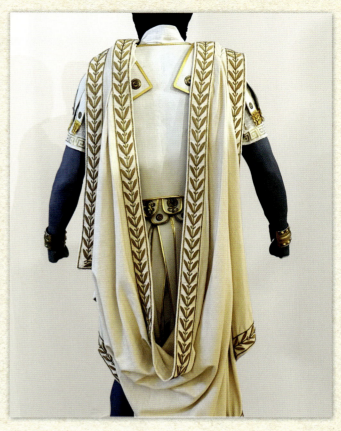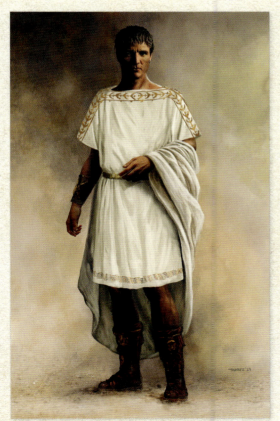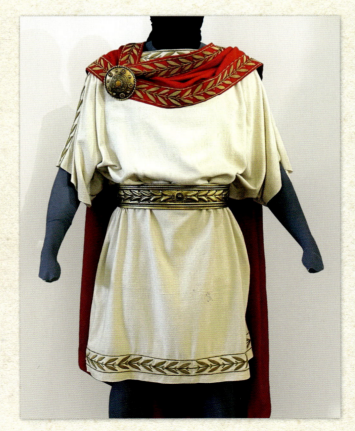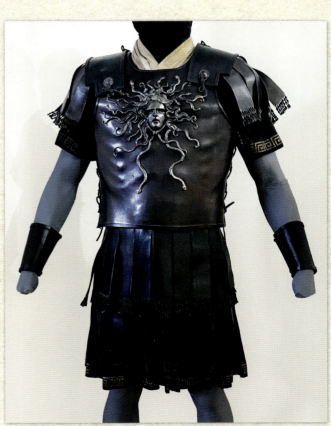

CHAPTER II: DESIGN

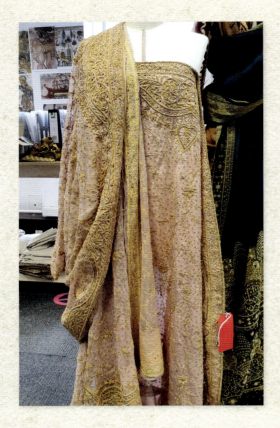

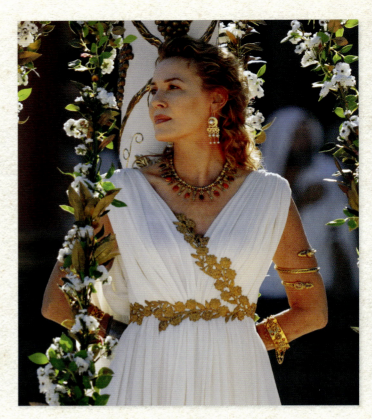
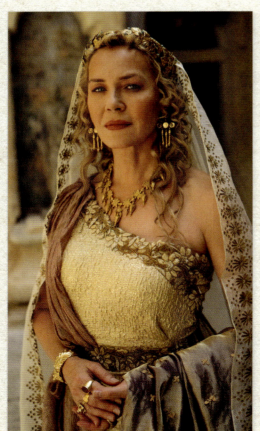
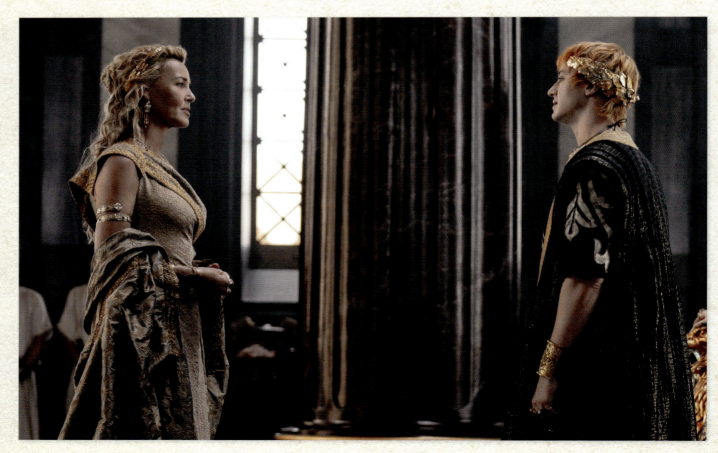

196 THE ART AND MAKING OF GLADIATOR II

DRESSING LUCILLA

The cutter is responsible for making patterns, fitting, and producing costumes based on the design briefs from Yates and her team. The cutter may also help choose materials and manage the costume construction. "Dominic did Lucilla as well. He did something like fifteen looks for Lucilla. So that's great. [When] we fit her in Los Angeles . . . and Ridley saw it, we went very couture. We took a lot from the last century: Halston, Courrèges, and people like that. Ridley looked at them and said, 'Yes, great colors. I want a lot more bling, a lot more zhuzh.' So we returned to the drawing board and put more trim on. We've got embroidery and jewels. It's just spectacular. It's all down to the fabrics—the gold and the green-gold of the cloak. It was a joy to do, as were the emperors."

DRESSING GRACCHUS

Sir Derek Jacobi is an elder statesman of the British acting community and one of only two returning actors from the first film. Consequently, Yates had a special place in her heart for him. "Sir Derek Jacobi came back—so wonderful. He's eighty-five now and as sprightly as he was twenty-five years ago. He's a senator, so he's straightforward. It's a white gown with a black stripe, and we just fit him. He wore it. He hadn't changed a centimeter in his measurements. How amazing is that?"

DRESSING THE EMPERORS

Joseph Quinn, as Emperor Geta, and his on-screen brother, Fred Hechinger, as Caracalla, were a delight for Yates to dress. "They were a joy to do. I mean, it was so wonderful to [design for] these young boys. They're both in their twenties. They're both completely mad, and they have red hair. We were dressing them out there, as far as we could go. But using fabulous fabrics, using lots of embroidery, using just wonderful gold on gold, silver on silver, and ancient embroidery—ancient, not saris, but ancient Indian embroideries. It was very exciting."

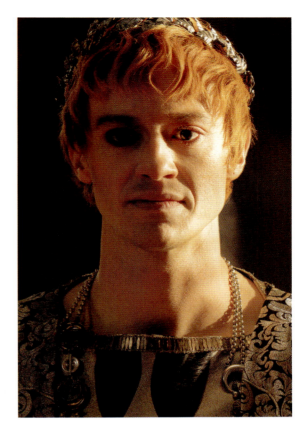
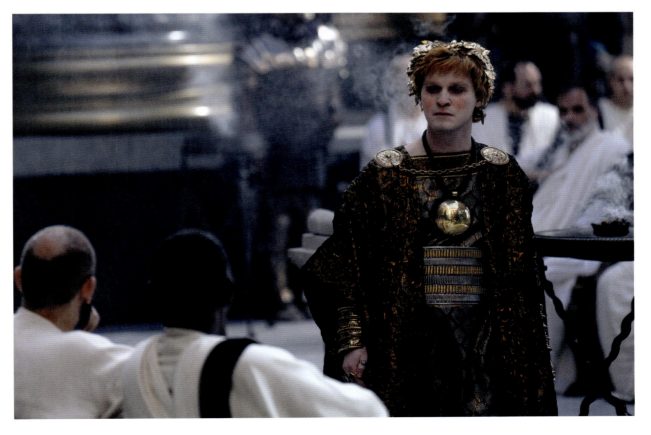

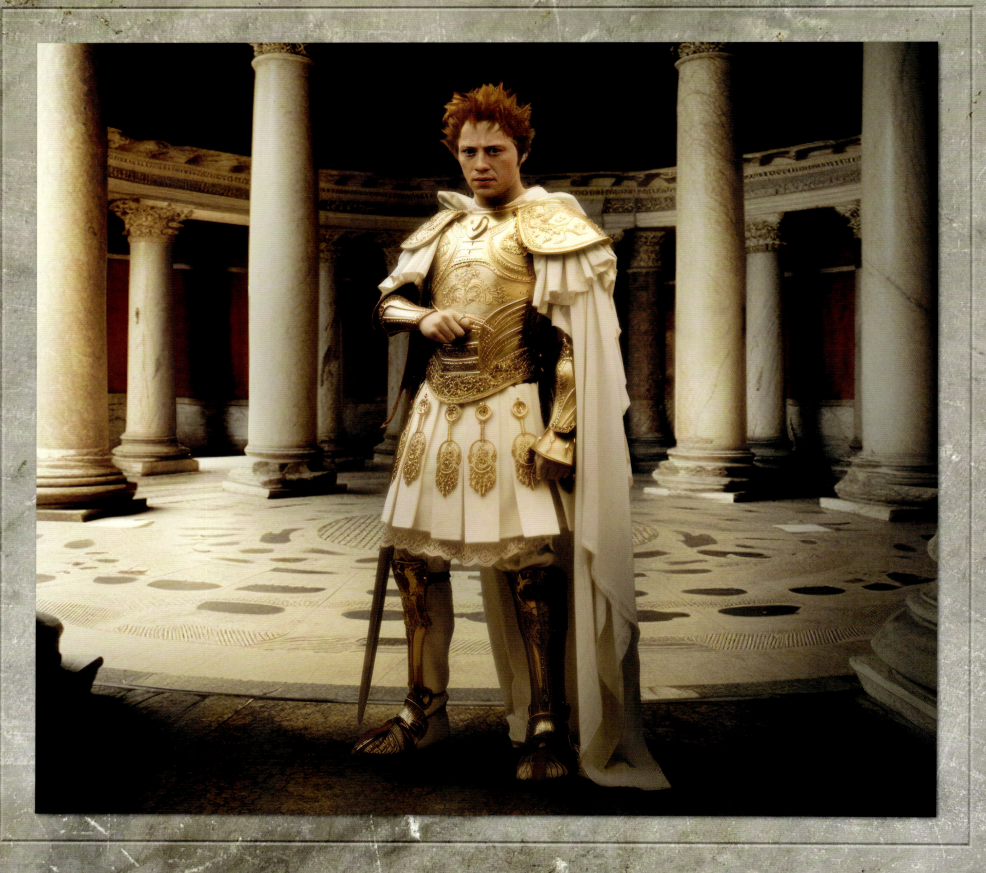

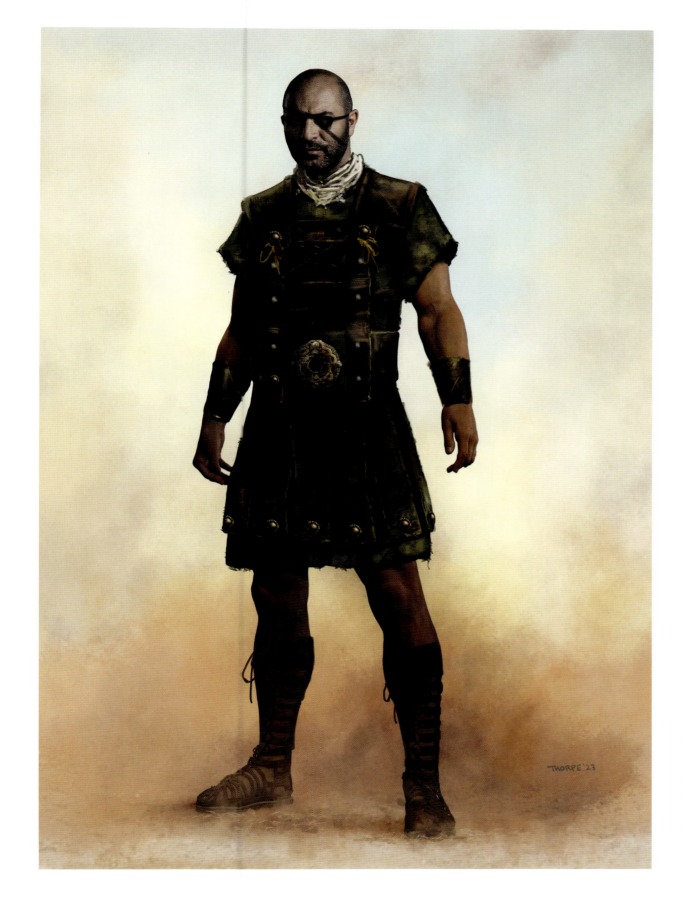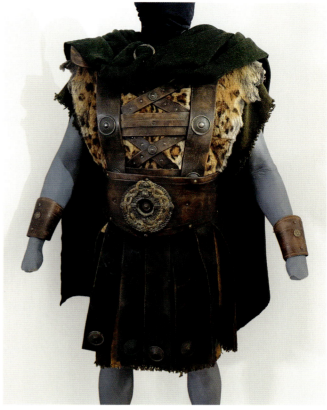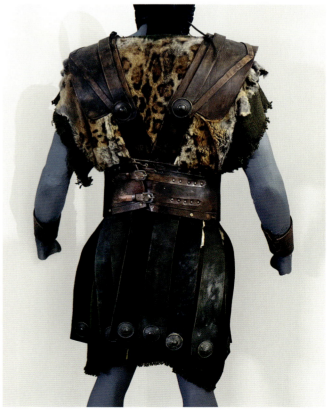

CHAPTER II: DESIGN 199

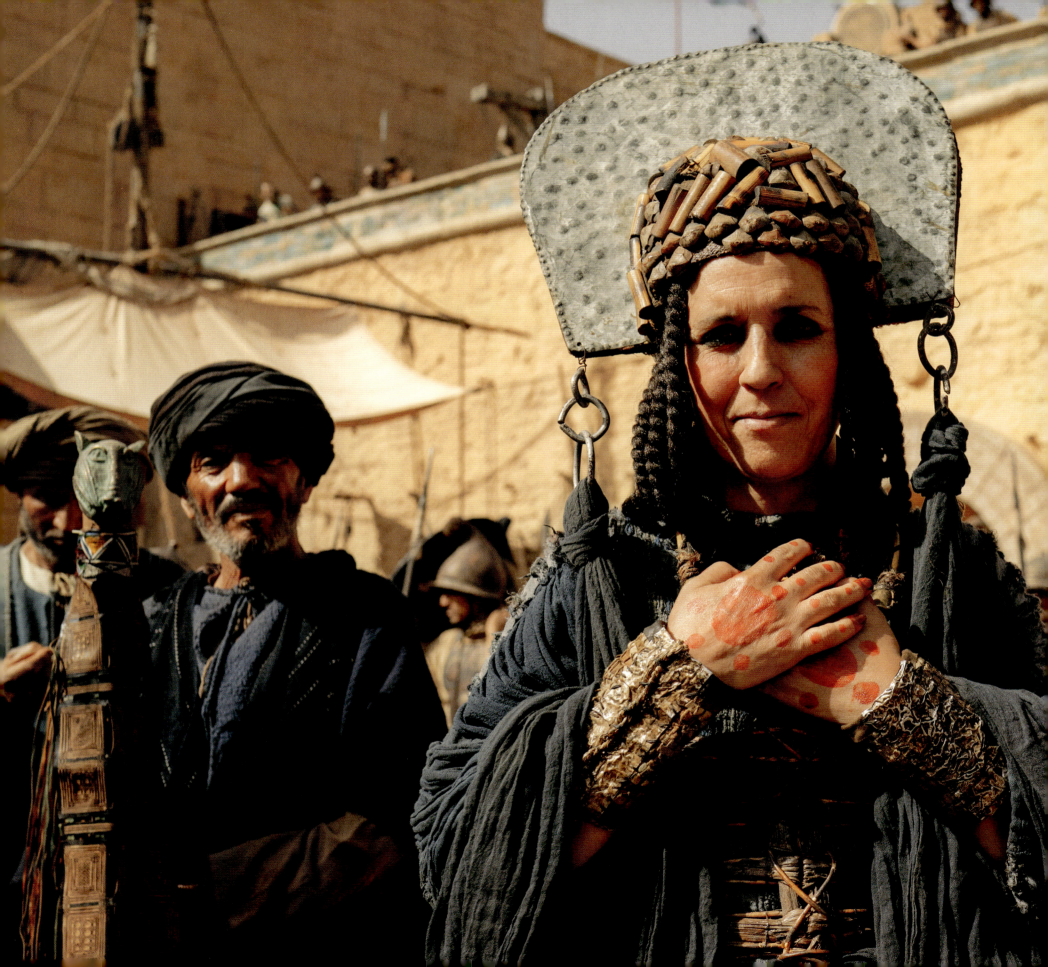

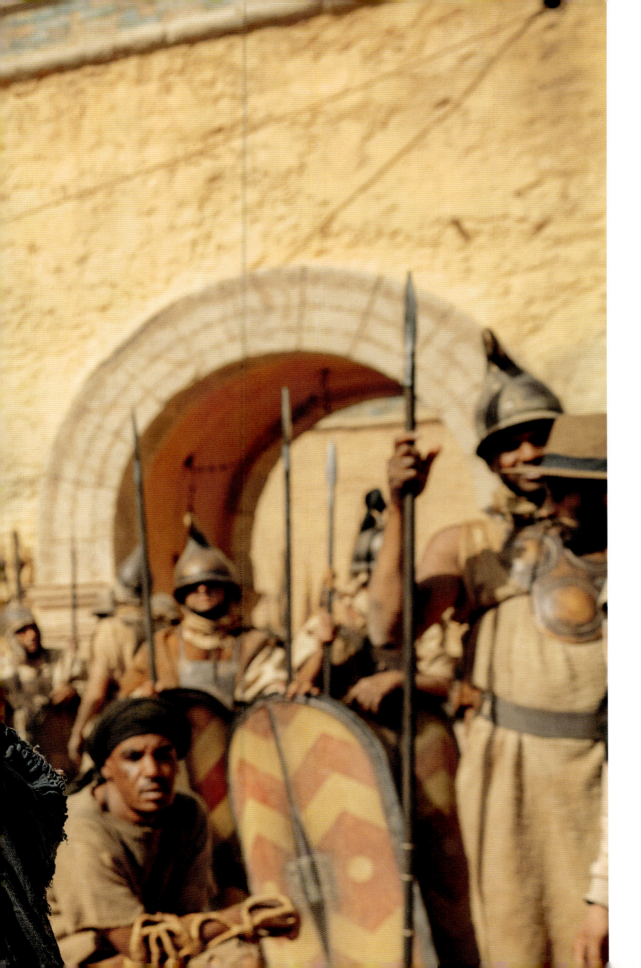

COSTUME VILLAGE

Part of creating costumes for the film involves breaking down fabrics, artificially aging them, or dyeing them. This can include adding artificial dirt and blood. Dressing hundreds of actors, extras, and stunt performers is an epic task on a film of this size, so a sizeable logistical solution was needed. "Every film I've done with Ridley, we have costume villages wherever we are. We had a huge one in Morocco because Stefano De Nardis [costume designer] looked after the crowd with his cutters, leatherworkers, metalworkers, jewelers, and embroiderers. He made a considerable quantity of garments for the film. He had dyers, breaker-downers, which were the agers. Then he would send them off to wherever they were being fitted. I have two other wonderful Italians who are very creative with the background crowd. Their colors are lovely, lots of burgundies, and it's always a lot of beige. But, you know, there are jewel colors in that look."

HANDMADE MATERIALS

Despite technological advances that benefited other departments, costume designers still performed much of their work by hand, including multiple copies of the same costume. "Everything was made from scratch. I had my cutter, Dominic Young, in London with his seamstress. We also farmed quite a lot out because Denzel requires repeats. Four repeats of everything. So that was quite a big workload to give anybody. We used sewing areas around the south coast of England, making clothes for the emperors and Fortuna. Then we had another cutter in another area for the background actors. It was handmade because the only worthwhile things are the ancient, beautiful embroideries you can't put on a principal actor anymore, as they are so delicate. Maybe one or two, but not really.

"From the research down to the making and fitting, that's always quite nerve-wracking. You're unsure if you're going down the right route, showing Ridley, and then seeing them on set. Nerve-racking but so satisfying in the end. I must give a shout-out to my assistant costume designer, Melissa Moritz, without whom I couldn't move forward. She's my right hand and my left hand."

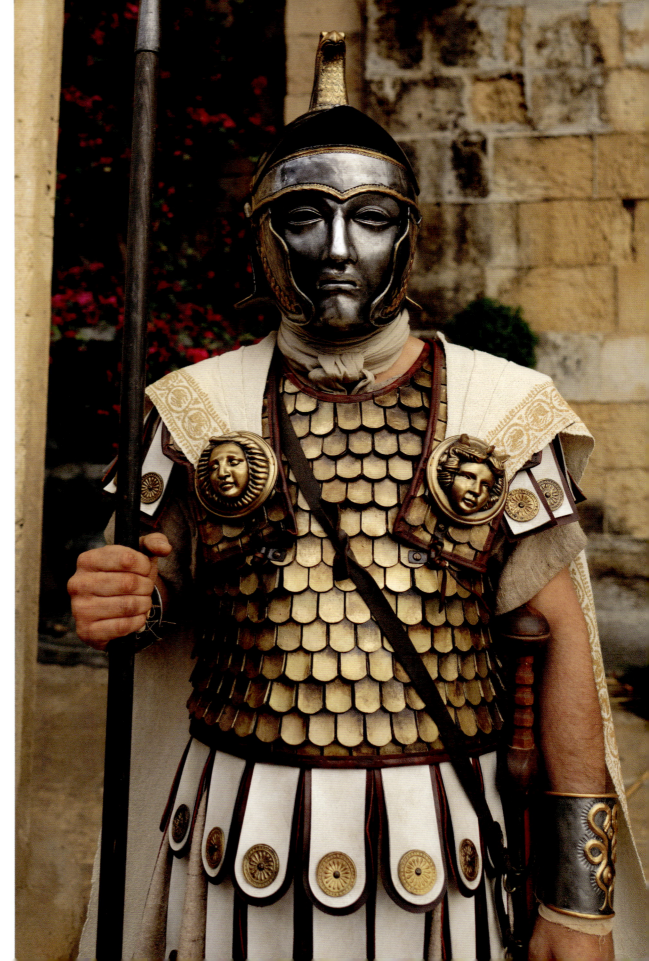

MILITARY UNIFORMS

A specialist dressed Paul Mescal's Lucius in military uniforms. "David Crossman, who takes complete charge of the military, dresses all the Praetorian Guard members, all the Numidians, all the Roman legionaries, and all the gladiators. We had to do 150 gladiators. So everyone is different. He's done such a brilliant job. He's just augmented the whole film. Considering the last time I did them all, it's quite something to share. It's a delight."

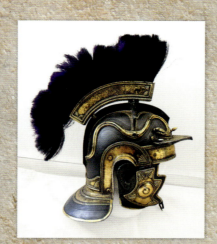
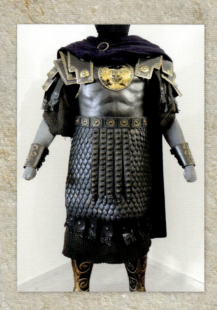
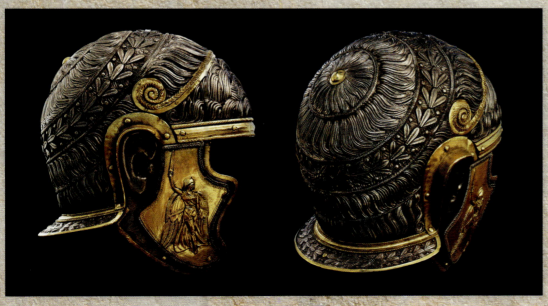
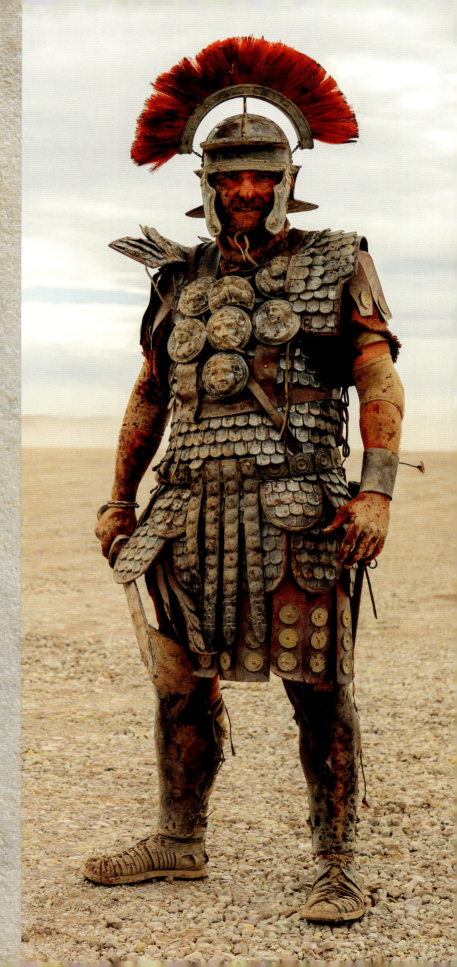

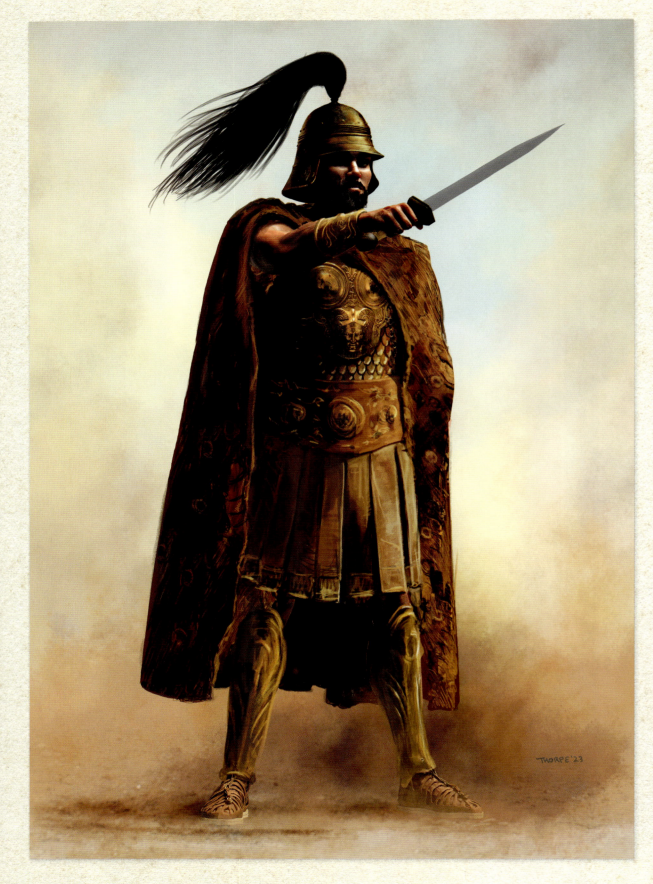
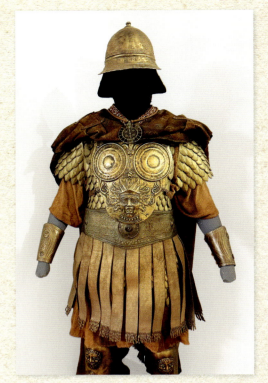
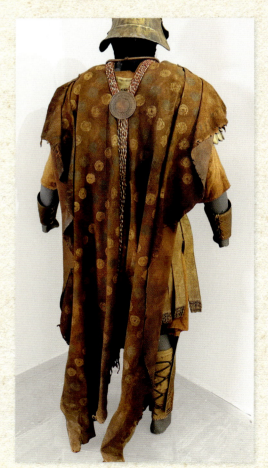

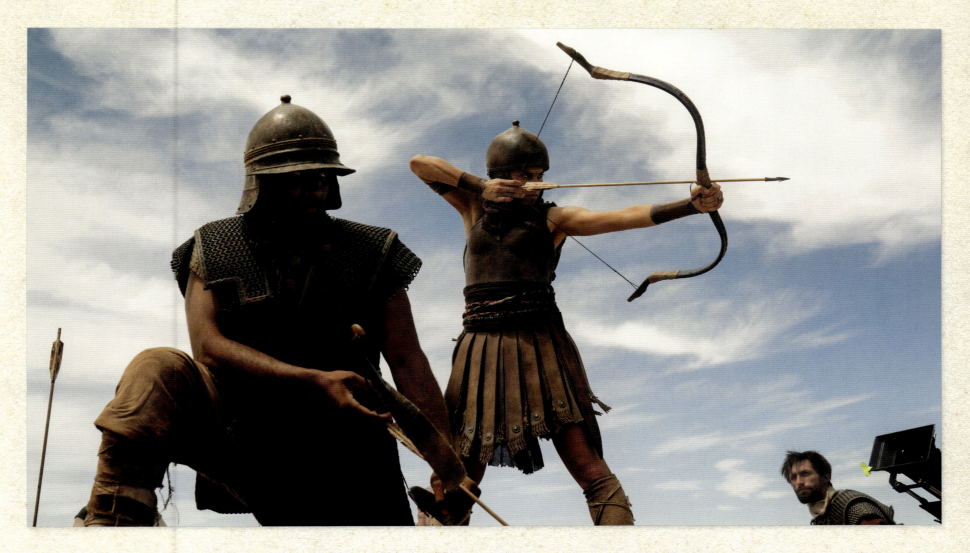

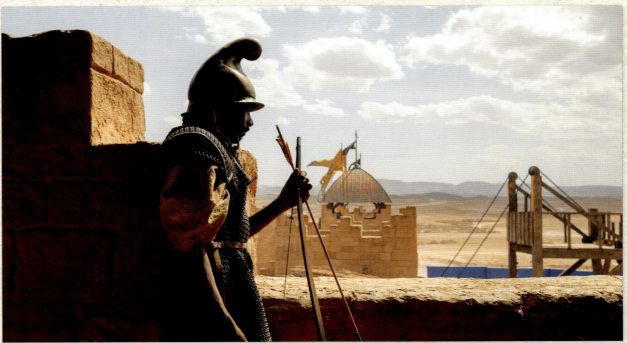

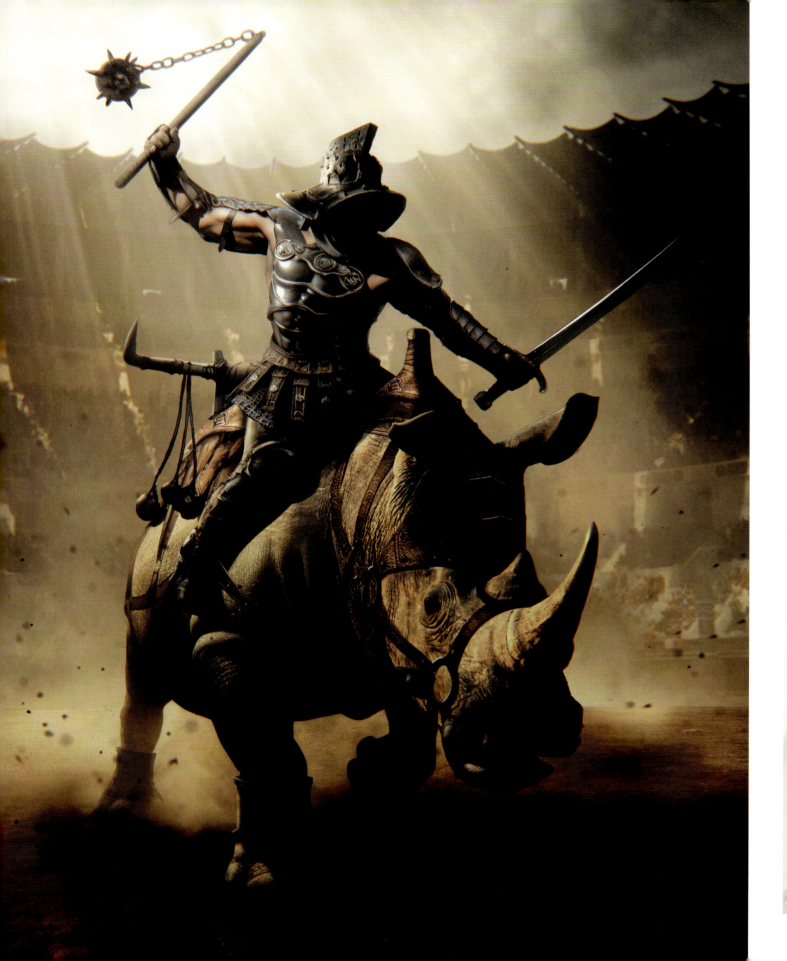

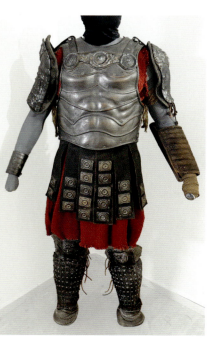

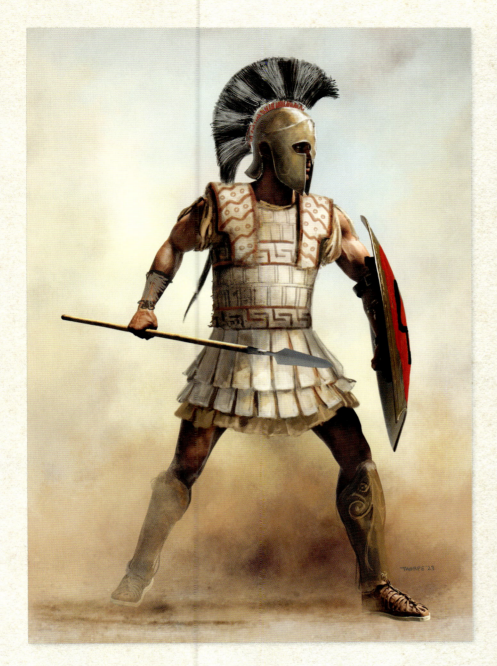
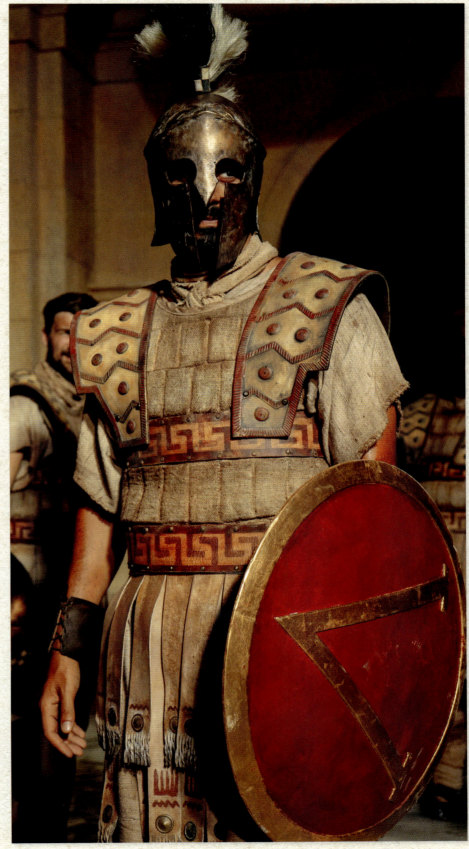
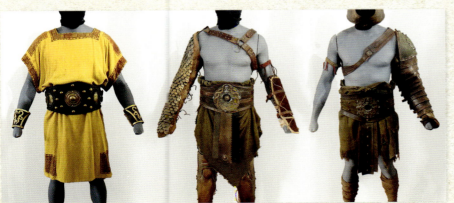

CHAPTER II: DESIGN 207

THE RIGHT MATERIALS

Yates ensured that the fabrics seen on screen not only were historically accurate but also added to the drama and spectacle of a Ridley Scott film, which sometimes means relying on modern materials. "I did a huge amount of research for the fabrics on the first one, and then you move away from the research. So I'm afraid we've cheated hugely, and we've used a lot of damask and huge amounts of gold or silk mixes because you don't get the fall of a toga or a fall of a tunic in a man-made fabric, so it all had to be silk or silk derivatives. I know David [Crossman] will tell you all about his quite extraordinary finds. Even when I did *Gladiator*, we used urethane for the armor. We always buy materials in Italy. We always buy in France and India. I know that Arthur's set decorator, Jenny, went to India. We were trying to get to India, but work just took over. We found a contact who could use her Indian or Pakistani contacts for gold bullion. And they did the most wonderful embroidery. Faultless." The same dedication was placed on the footwear. "We create the sandals and shoes and send them to the shoemakers in Rome, who make them. Nothing is not thought about."

AGING

"One of the most important departments is breakdown dyeing and printing." In the process of breakdown, the garments' aging and distressing need continuity throughout the production. "Michael McNamara heads up breakdown dyeing and printing. He has done the most spectacular things, and especially with Denzel requiring four of everything, he's done the most wonderful prints of ancient blankets and ancient embroidery. And because we need four, and they're just one-offs, he's done the most amazing copies. Just beautiful. He's broken down all the army, all the Praetorians, and all the gladiators. And he's dyed for us. He and his team made so much printed [fabric]. We're dyeing every day. Huge amounts. You can get the [exact] color you want when you're dyeing."

THIS SPREAD
A wide range of textiles and materials employed by costume designer Janty Yates (bottom right) brought ancient Rome to life once more.

CHAPTER II: DESIGN 209

JEWELRY AND LEATHERWORK

Yates was responsible for every detail, including the jewelry. "I had the most wonderful jeweler with his team. He was superb. And he's worked with me since *Exodus: Gods and Kings*, where he made all the wonderful Egyptian jewelry. And now he's making Roman jewelry like it's coming out of his ears. It's just giving him so much to do. I have the most wonderful leathermaker, Giampaolo Grazzi. My jeweler is called Lorenzo McEntee . . . They've created the most extraordinary looks for everybody: for the leader of the Numidians, for Paul Mescal from his Numidian outfit through to his replica of Maximus's cuirass, and for Pedro Pascal's beautiful cuirasses and wonderful helmets. He's even got a white one. Just spectacular. So that's a shout-out for Giampi [Giampaolo Grazzi, costume armor master]."

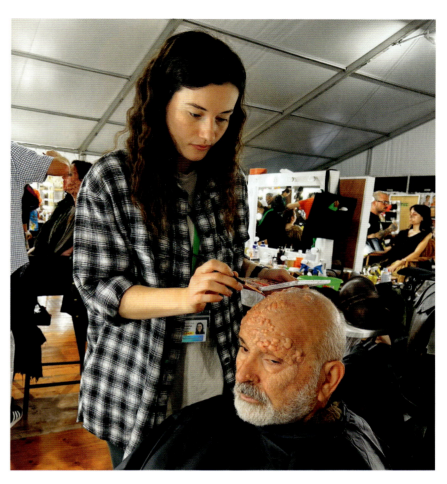

MAKEUP

Makeup designer Jana Carboni first worked with Scott on *Proof of Life* (2000) and has gone on to work on a total of eight feature films for the director (so far) and been nominated for a BAFTA twice: for *House of Gucci* (2021) and *Napoleon* (2023). Yates explained how they always work closely to create a synergy in their work together. "Jana always comes to me when she starts because I have all the research. Like every makeup chief, she comes to me and nicks all my research, but they also do their own. She shocked us all by putting in some amazing looks for the Numidians, which was very Tuareg and Bedouin influenced, and Ridley loved it. So the direction of the Numidians changed from just what was researched, which was boring."

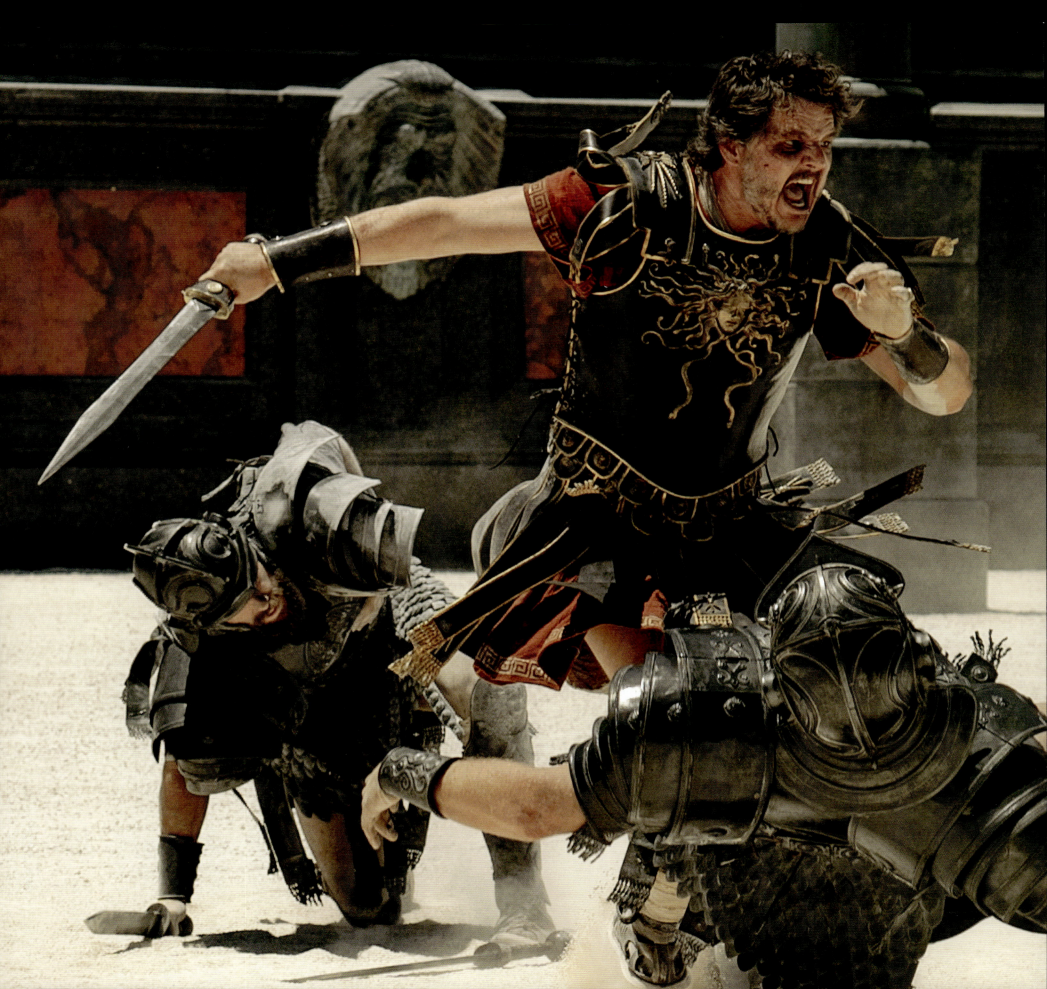

III

COMBAT

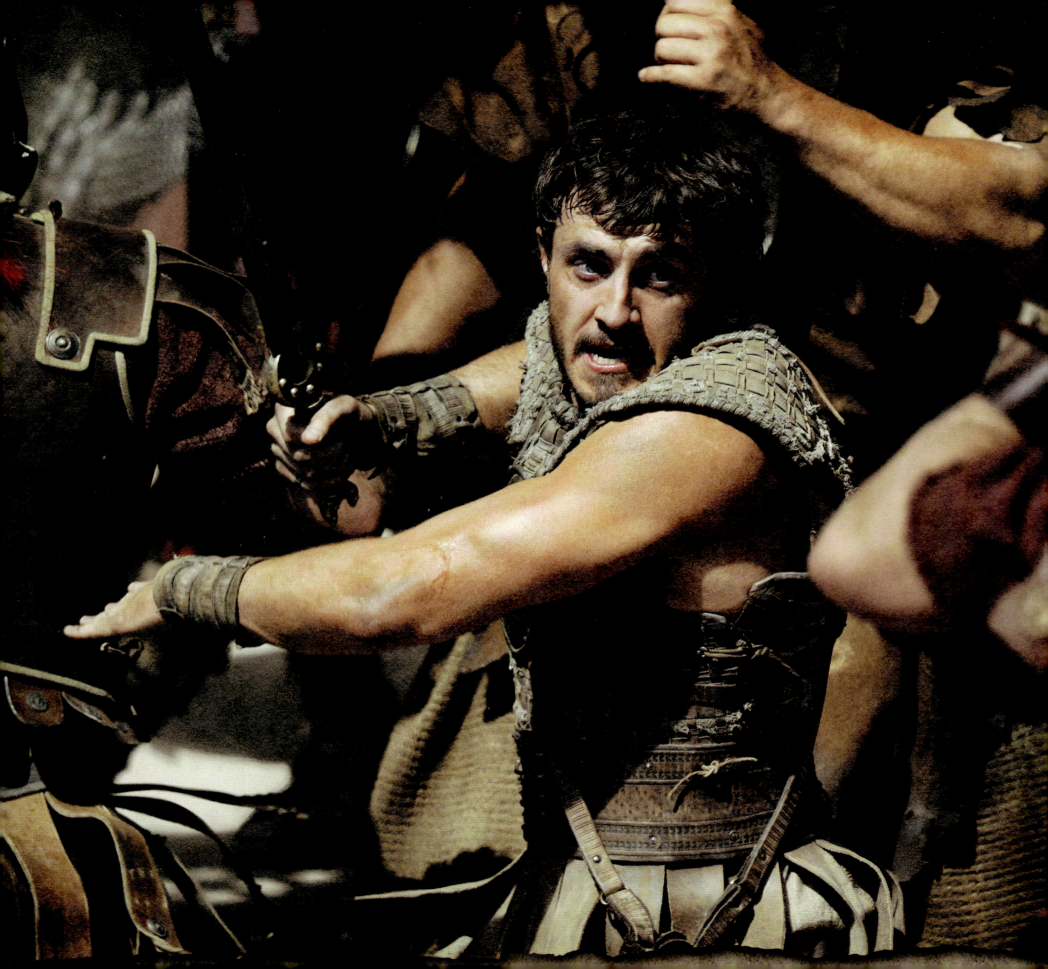

British-born Paul Biddiss has more than twenty-four years of global deployment experience with the armed forces and seemed an obvious choice for military technical advisor on *Gladiator II*. Stunt coordinators and armorers employed his expertise to ensure historical accuracy and a safe environment for the whole production.

He first worked with Scott on *Napoleon* (2023). "My job is to train large volumes of men in the drills. I have to research the tactics used within the eras depicted. I had to research Roman drills and formations for the specific era because different weapons and tactics formed over many years within the Roman Empire. That's my job to research—as a soldier and as an advisor. Research is 60 percent, and 40 percent is your experience as a soldier. The tactics will change, but soldiering—the actual mindset of a soldier—doesn't."

DIRECTOR'S DEMANDS

All decisions about performances in front of the camera fell to Ridley Scott, but Biddiss appreciated Scott's directness. "Ridley is always very clear on what he wants. So he discussed with me what type of formations he wanted for some of the battles, particularly on the siege boats and some of the formations of our Praetorians within the gladiator ring. He wanted some very specific formations that I needed to make sure I researched, and then I trained my army to do it on the first take." Scott worked closely with Biddiss to get the right look on-screen. "He would look at the camera when he's framing up and see a face he would or wouldn't like. He'd swap it with someone else if he didn't like that face. Ridley knows the type of face that he wants on camera. As long as he can do the drills properly, everything's fine. Ridley would make many decisions on the right faces, which is important to ensure that everyone you train can do the job because there's nothing worse than him picking a face, and that face can't do the job."

ACTOR BOOT CAMP

Biddiss worked closely with the cast for their physical training. "Everyone goes through a physical assessment to ensure they are robust. Then we'll go through the training and the stunts as well. Part of this is training them to use and operate weapons: the gladius, the sword, the scutum, and the shield. [The cast] needs to be able to carry these. They're not light. [The cast] has to be conditioned to hold this equipment for long periods. There's a lot of intense training. It's a lot of muscle memory. You've got to train guys so they can do it because if you train them once, they could go away for a couple of days, come back, and they might forget it. So you've got to train them, and it's repetition training. So there's a lot of that during the boot camps."

Once training was underway, Biddiss had to teach the cast and extras the best way to handle the weapons quickly. "To prep for battle, I will check your equipment, ensuring your gladius and pelham are in position like your spear. You'll form the dense, which is a shield wall or a half shield wall, protecting the archers. Then there will be the prepare-to-attack, when the archers come up and start forming. They will prepare to bolt, which is when the soldiers break formation and start moving toward the towers to commence the assault and breach the walls. Those are the stages of battle—prepping when you're out of range and then getting in formation to take on any incoming fire while providing supporting fire. And then the final stage is the actual assault and the breach itself."

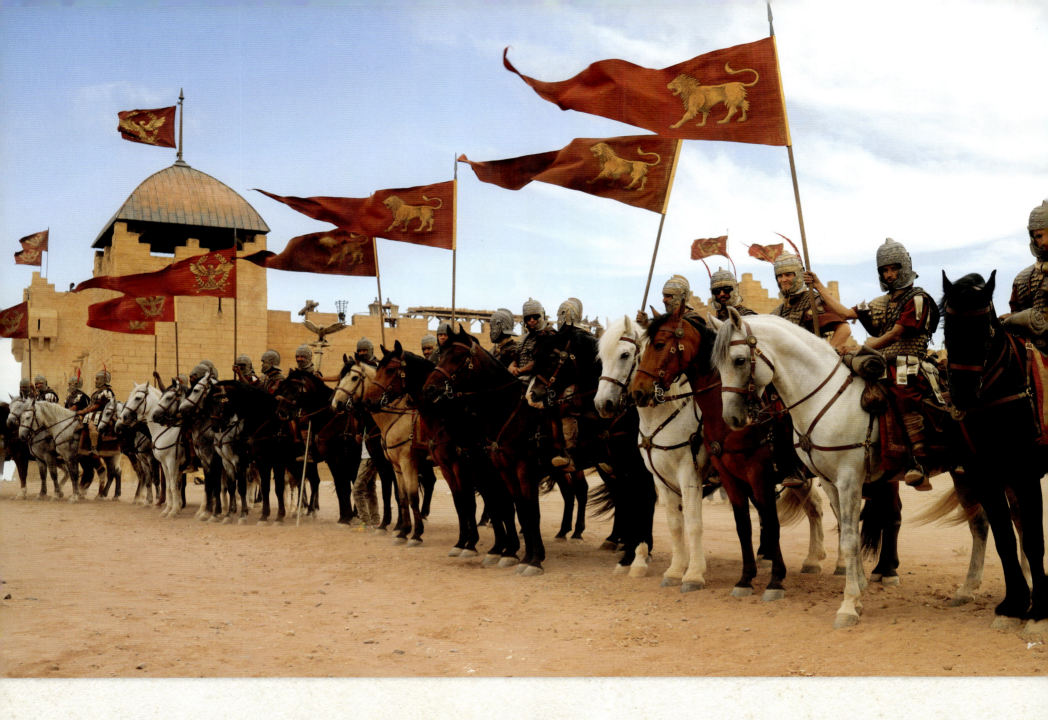

FIGHTING EXTRAS

Working with trained actors is a world apart from working with hundreds of mostly untrained support artists. Biddiss was up for the challenge. "I had to round up about five hundred extras in Morocco, and there's a language barrier. I'm used to working with extras from different parts of the world, so I have a good system now and know how to articulate certain things I want people to do when we have a language barrier. We break them down into groups and ensure they are physically robust, the same as I did on *Napoleon*, because there's no point in having five hundred extras, and one of those guys is weak because he's unfit or has an injury. I need to reassess and weed out the guys who will not make it because it's that one guy who can ruin the shot if he can't keep up. We [go through] very basic [training], small steps at a time until we've got them learning how to march and put one foot in front of the other in time as a body of men. And then we'll teach them formations, we'll teach them weapons training. I base the training exactly on the same doctrine as Roman training. What I found through my research is that the British army, their training, even today, mirrors the Roman training system."

FIGHT LIKE A ROMAN

Using the weapons was only part of Biddiss's work. Making sure the weapons were held in the correct manner added to the film's authenticity. "We teach them everything about the equipment and how they hold it so they can look after each other . . . but we also teach them different formations. The testudo was a very important formation used by Romans, and the dense line was a formation that was there to help protect archers during an assault. [This was a tortoise shell–shaped arrangement of fighters to create a shield wall formation commonly used by the Roman legions during battles and sieges.] We taught them all these different formations using the shield, pilum, or arch of the bows and composite bows. [The pilum was a javelin, approximately six feet, seven inches, with an iron shank twenty-four inches long and a pyramidal head attached to a wooden shaft.] On top of that, we also had to teach extras how to use siege equipment like the ballista and the scorpion, which were all quite technical. So there's a lot of technical information that we need to impart with the extras so that they can all work as a team." Biddiss worked closely with the film's military costume designer, David Crossman. "We were working out the ages—who should be in the right ranks, who should be a centurion, and who should be a normal legionnaire. That's important as well."

RANKINGS

There were differences between the Praetorian Guard and Acacius's men. "Praetorians are like the elites that have come from the cream of the crop and from various legionary armies. The legionary army is not an army; they're a different unit. It's much the same way you have armies today. You'll have a standard unit, then a slightly specialist unit, but not the cream of the crop."

CENTER LEFT
Paul Biddiss surveying his troops

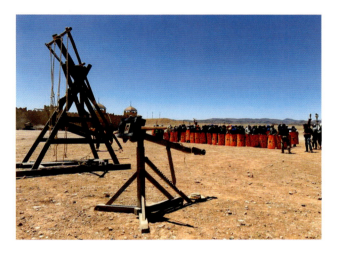

BOAT FIGHTING

Choreographing the soldiers was key to the film environment and being able to repeat moves on demand. "I was commanding one of the siege ships. Once on one of these boats, I commanded up to one hundred men. While the boat is going forward, you've got another boat to your right, so I'm commanding artillery and soldiers while working as an advisor and acting as a centurion. That was quite a lot to take on. There are a lot of moving parts. It had to be carefully choreographed because there are a lot of things that can go wrong. As the ships move, we're forming a dense line, and the archers are ready in what Ridley calls an armadillo. And it works like an armadillo. Its armor comes up. When you say, 'Archers ready!' the armor comes down and the archers come up, fire their arrows, go back down, and the armor comes back up again. It's a very finely tuned movement, which looks impressive."

FINAL BATTLE

Biddiss boasted with pride about the main fight sequence during the film's finale in which the Praetorian Guard form a tight circle. "Ridley was clear about the formation he wanted when the Praetorians encircle Lucius. Lucius was walking toward the carriage with his mother, and Ridley wanted a precise movement of Praetorians, who were moving out of the shadows all in one and forming this perfect circle. The circle for *Gladiator II* was my sleepless night because I had to make sure I got that spot-on. Luckily, I got it spot-on—and another thumbs-up from Ridley."

PREPARING FOR BATTLE

Even though the men he worked with were not army recruits, Biddiss had to be strict with them for their safety. Still, he wanted them to enjoy the experience. "It's all about your communication with the extras and having a bit of banter with them. You build a relationship, but it must be ferocious for them to wake up sometimes. At the same time, there's respect, and you show them respect and get the best out of them. But it's similar to how we are in the army. I tell them, 'You're my army, and I'll try and look after you as much as possible, as long as you look after me and make me look good.'"

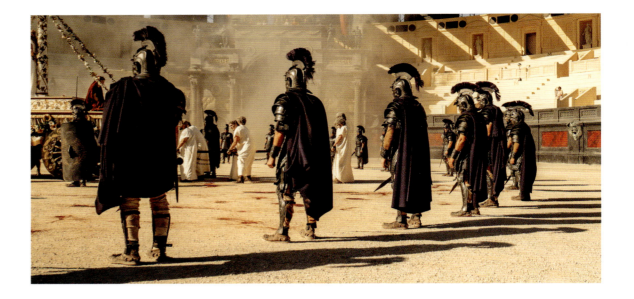

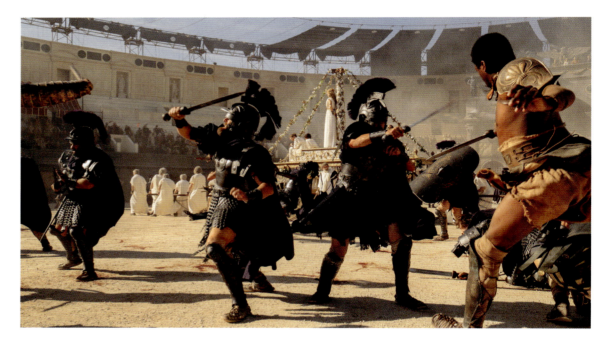

Biddiss could tell if he had bonded his men from the way they start to interact with one another. "I find that different units that train with [specific] equipment will stay together when they go to the table and eat; they will eat with that unit, and there's a bond. During training, I create an ethos between the companies and between the platoons. They're competing against each other for who's the best platoon and who's the best company or the best legion. When we're filming, they're still in a competitive mode, making them work harder and want to win."

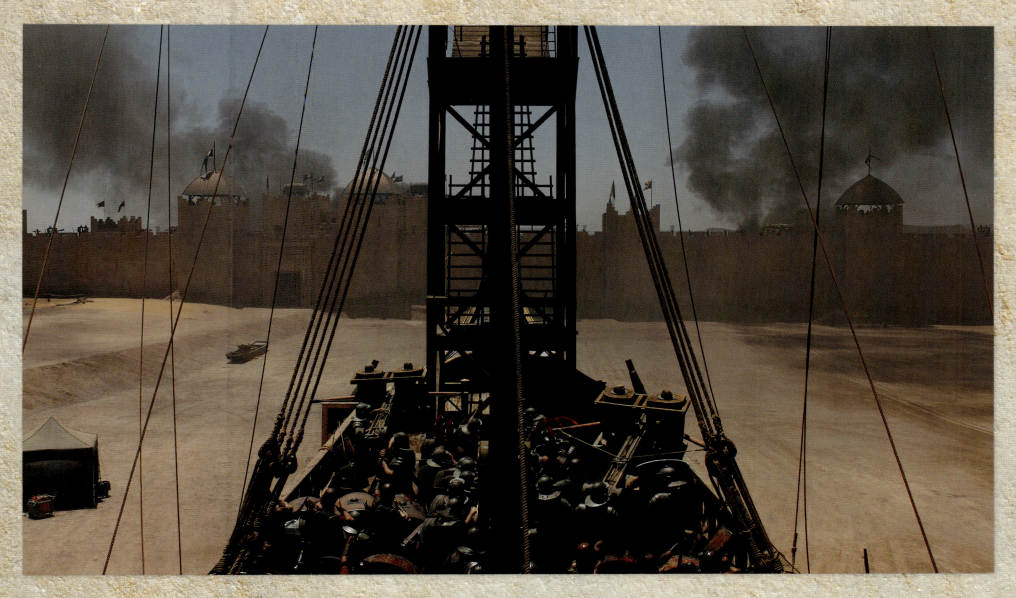
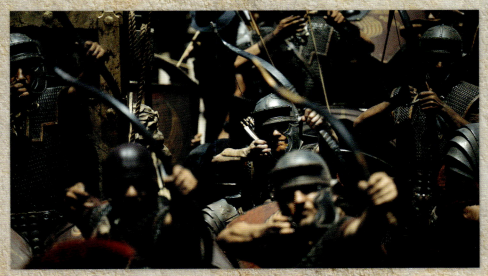
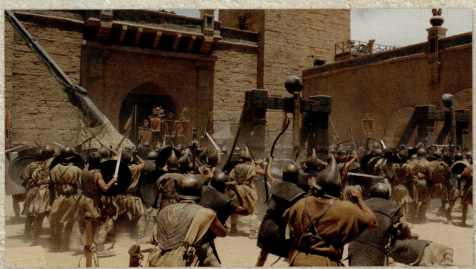

CHAPTER III: COMBAT 219

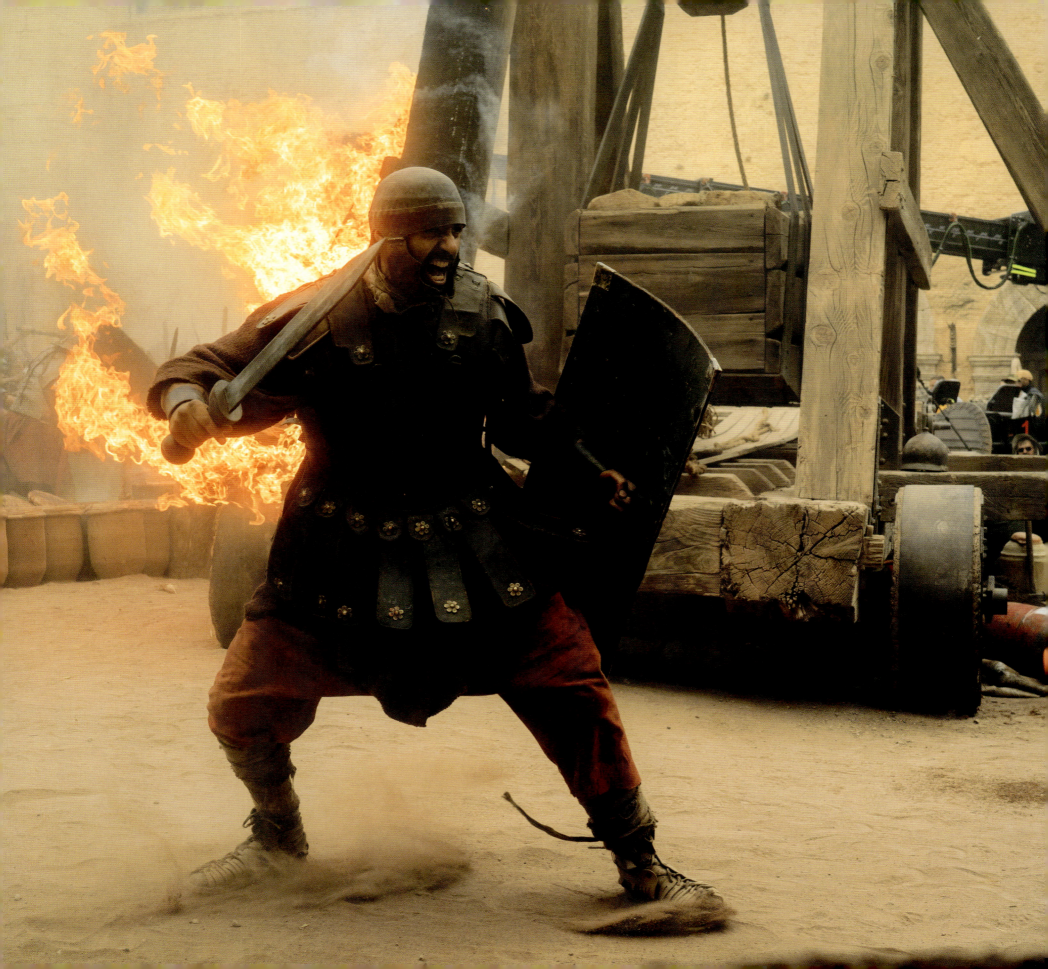

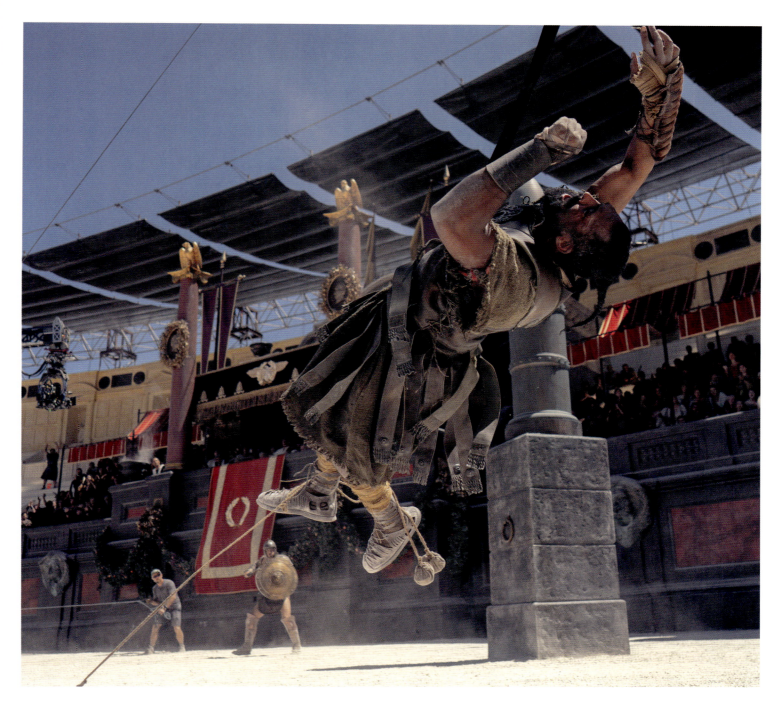

STUNT ARRANGEMENTS

The special effects team worked hand in hand with all the disciplines on the film, including the stunt performers. "I worked with [stunt coordinator] Nikki Berwick on *Napoleon*," said Corbould, "so I had a good working knowledge of her, and we just did loads of tests and showed her the tests of what we'd done. Then we'd get stunt people involved with our test as well. Nobody wants any surprises, so we make sure that that they're fully informed of what's going to happen. We test every effect we do, and then we get input from Nikki and Peter Wyatt, Nikki's assistant, to see if there's anything they want us to change or add."

CHAPTER III: COMBAT 221

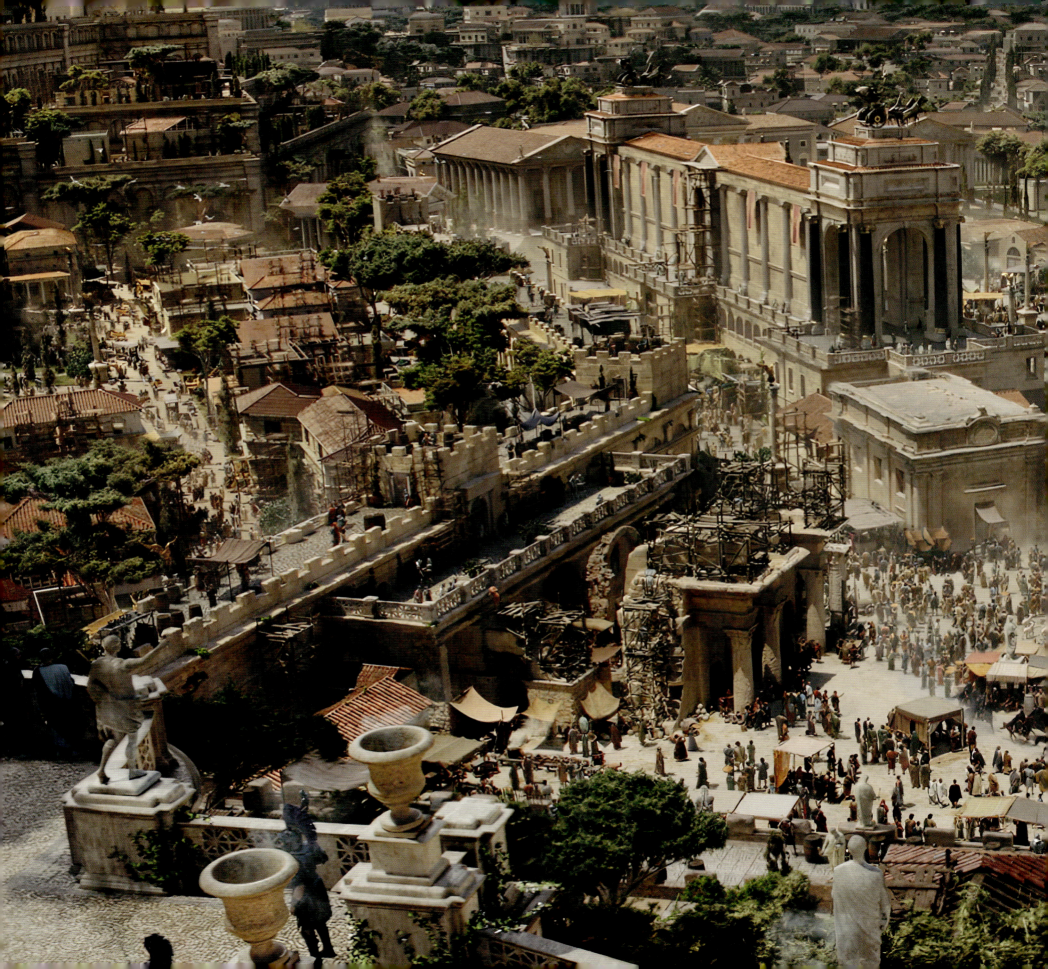

IV
SPECIAL AND VISUAL EFFECTS

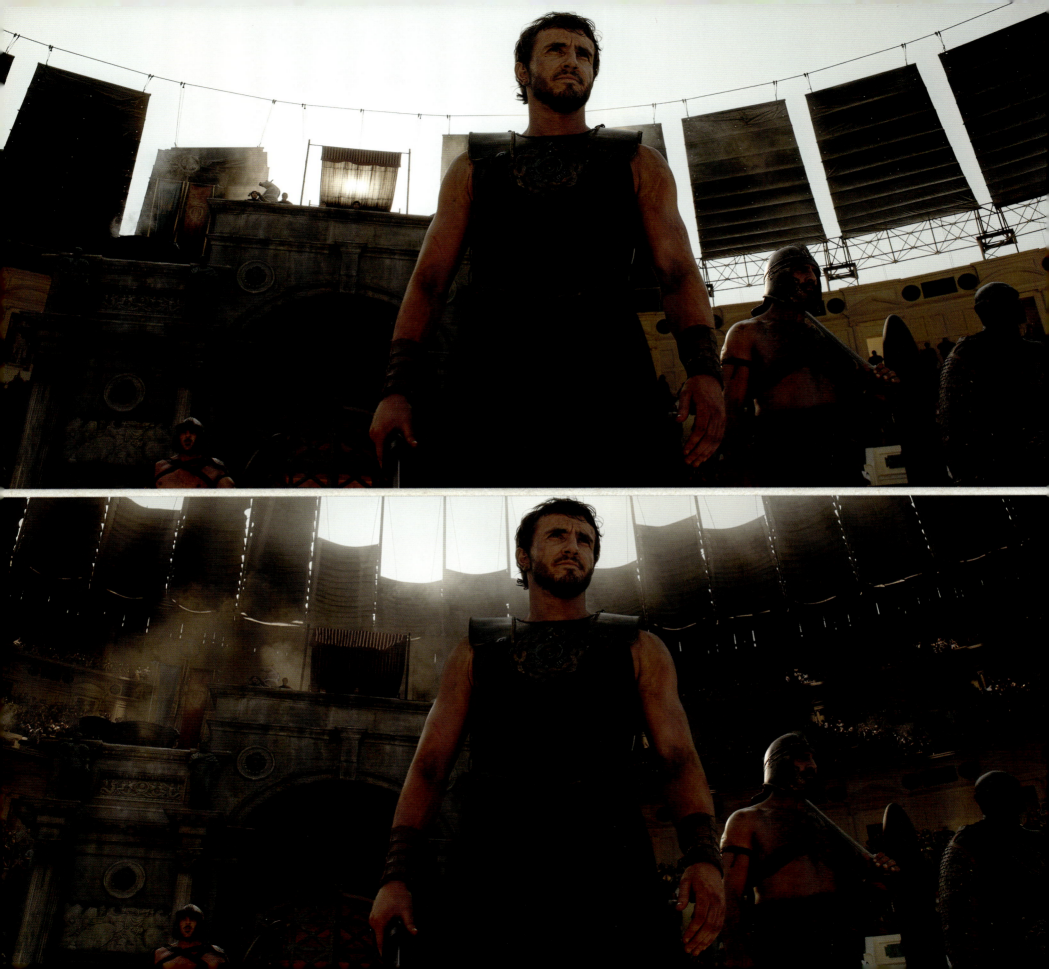

BRITISH SPECIAL EFFECTS SUPERVISOR NEIL CORBOULD ALSO WORKED ON THE ORIGINAL GLADIATOR, WINNING AN OSCAR FOR HIS EFFORTS. HIS CAREER BEGAN ON RICHARD DONNER'S CLASSIC SUPERMAN (1978), WHICH REDEFINED VISUAL AND SPECIAL EFFECTS FOR A GENERATION.

Corbould continued apace with subsequent work, including such massive, effects-heavy films as *Saving Private Ryan* (1998), Ridley Scott's *Black Hawk Down* (2001), and *Rogue One: A Star Wars Story* (2016). Prior to *Gladiator II*, he also worked on Scott's *Napoleon*.

In the ever-expanding world of special effects, the audience can distinguish a mythical creature or an interstellar dogfight as a conjuring from the visual effects experts. Less noticeable, however, is the work that enhances Earth's natural and historical locales. In *Gladiator*, the special and visual effects work was groundbreaking with its large, expansive cityscape extensions to existing sets. The team added battalions to an army of figures and even had a live tiger interact with the principal cast in the Colosseum finale. Twenty-five years on, with the audience's ever-increasing expectations, Corbould and his team had an epic mountain to climb for the sequel.

Corbould admitted that the way the audience embraced the first film came as a surprise. "I don't think anyone realized the vast success it would be. So when it came out and did so well, it was incredible. And it was amazing to be associated with a movie like that. That was Ridley at his best. Many people didn't give it much hope because it was a different genre."

The stakes had to be higher for a sequel to meet audience expectations. "Ridley had been mentioning *Gladiator* [II] for a couple of years, saying how good the script was. When we finished *Napoleon*, I got the script. After reading it, the excitement started to boil. It was a great feeling returning to this genre again."

STORYBOARDS

A project this big demanded that the special effects team work closely with the director. Scott's eye is perhaps the most creative in the visual arts, and his vision is best communicated in visual mediums. "I've worked with Ridley on quite a few movies. I know how his brain works to a certain extent, his standards, and the quality of work he wants. Ridley is fantastic at conveying the vision that he wants through discussion and his storyboards."

VISUAL EFFECTS VS. SPECIAL EFFECTS

Corbould's artistry was in the physical, real-world arena where his practical solutions to story or logistical problems could be seen and felt. His work needed to dovetail seamlessly with the visual effects of green and blue screens and CGI. Corbould recognized the advantages for the other creatives working on the film, including the visual effects team. "If we can do it in camera, even if visual effects use it as a reference, it's better to have something there than nothing. It's better for the actors. It's better for Ridley. It's something there that visual effects can enhance. Ridley doesn't like using blue screens too much, and he'll shoot into an area where there are things with trucks in the way. But Mark Bakowski [visual effects supervisor] is great; he would work around it. He will do it if he can get a blue screen in there, but he knows about our time constraints, and there are some battles he wins and some battles he doesn't."

Corbould was happy that the original film's production designer, Arthur Max, would also return. "Working with Arthur is always a treat. He's so passionate and knowledgeable. He's been in the business, and going into his art department and seeing all the drawings, concepts, art, and reference material is excellent and makes my job a lot easier."

Max was thrilled to work with Corbould and his team. "Neil is a friend, a colleague, and a brilliant engineer. I was happy to be involved in some of his work. He's updated his workshops to a very high level of technical sophistication, with computer-controlled cutting machines and a whole computer design department. He has retained many physical aspects of the old traditional craft skills. So I was in and out of that workshop often, building the warships, the siege towers, and the siege machines—and collaborating closely with Neil. Right up to the end, we were working together on all the special effects scenes we did in the tank, along with all the effects, fire stunts, burning ships to the ground, and all that good fun we had every day."

THIS SPREAD
Before-and-after images showing the final composite visual effects applied to the location photography

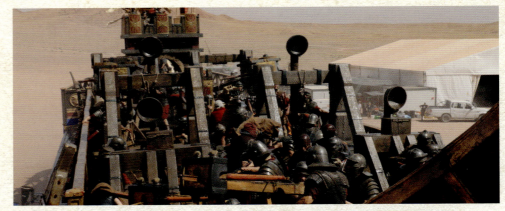
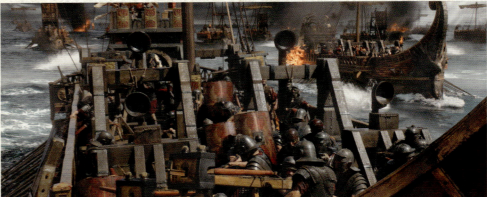
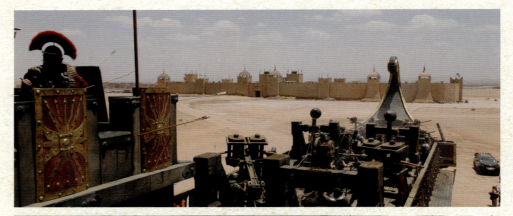
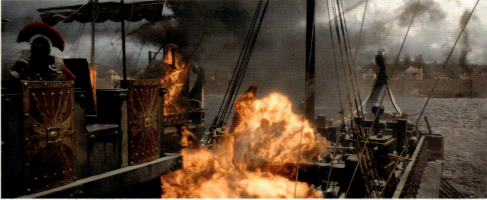

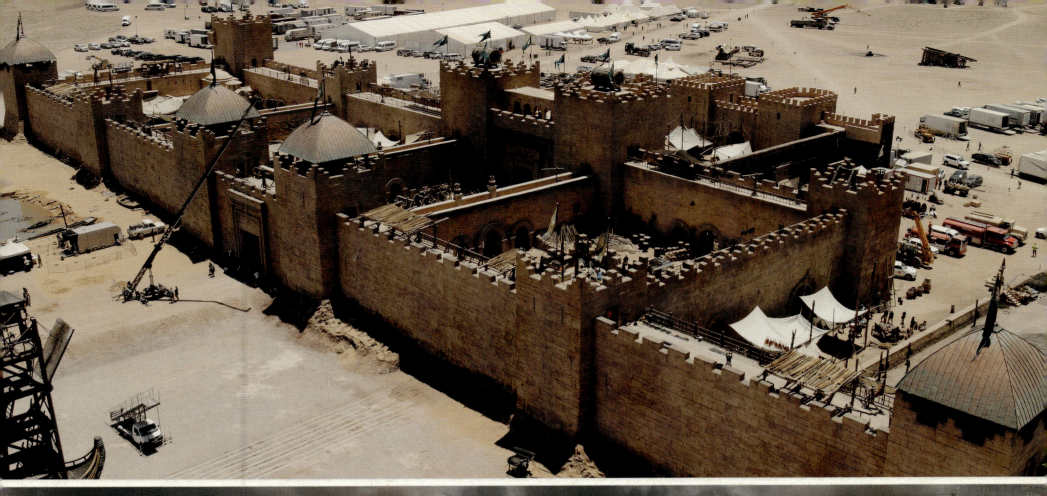
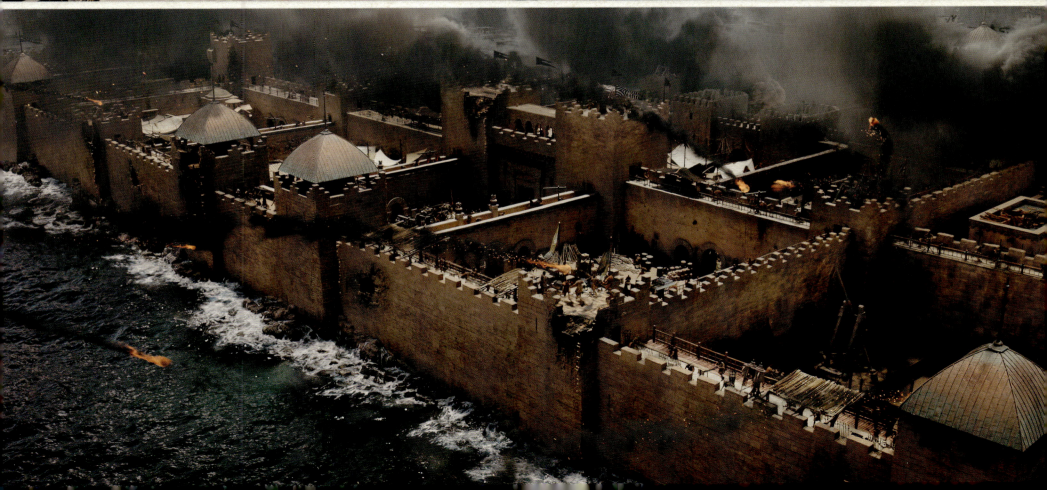

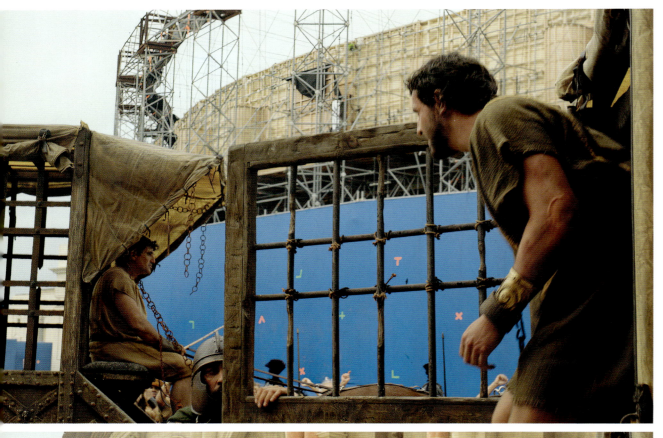

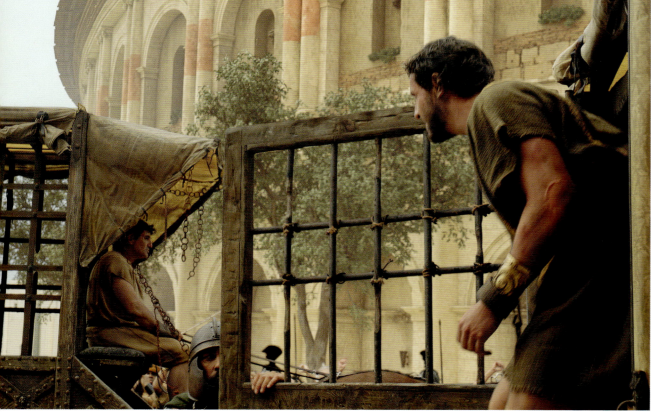

VISUAL EFFECTS

Visual effects were a large part of the postproduction world in cinema following the Second World War. Today, they are an intrinsic building block in the principal filming. From interviews with Corbould and production designer Arthur Max, it is clear that *Gladiator II* VFX is part of the built-in DNA strands of the live-action shoot. Industrial Light & Magic (ILM) and Framestore are the primary companies that created the visual effects on *Gladiator II*. ILM was founded on May 26, 1975, by filmmaker George Lucas to create the visual effects for the first *Star Wars* film (1977). Since then, ILM has become a world leader in visual effects, winning fifteen Oscars for Best Visual Effects. British visual effects company Framestore was founded in 1986 and has grown to become the biggest production house in Europe, with ten BAFTAs and six Oscars under its belt, including one for *Blade Runner 2049* (2017).

SOLUTIONS, NOT PROBLEMS

Mark Bakowski served as the visual effects supervisor for *Gladiator II* from ILM, and was able to provide a comprehensive understanding of interdepartmental collaboration during principal photography. "It's essential for us to be involved not just in the shoot but also in the planning beforehand. Every department brings knowledge and skills to the party, but just as you wouldn't want to assume a stunt is safe if you're not an expert, it's dangerous (financially, not physically!) to assume the same of VFX. There are many ways to approach the same problem; some are more expensive or will give a worse result. The best solutions come when everyone discusses each department's pros and cons. Sometimes, it's a bit of a horse trade, but it's still best to talk it through beforehand and devise a game plan everyone can agree upon. Of course, on the day of the shoot, things change. As they say, no plan survives contact with the enemy, so it's essential for VFX to be there to advise and gather as much data as possible so teams downstream are set up for success."

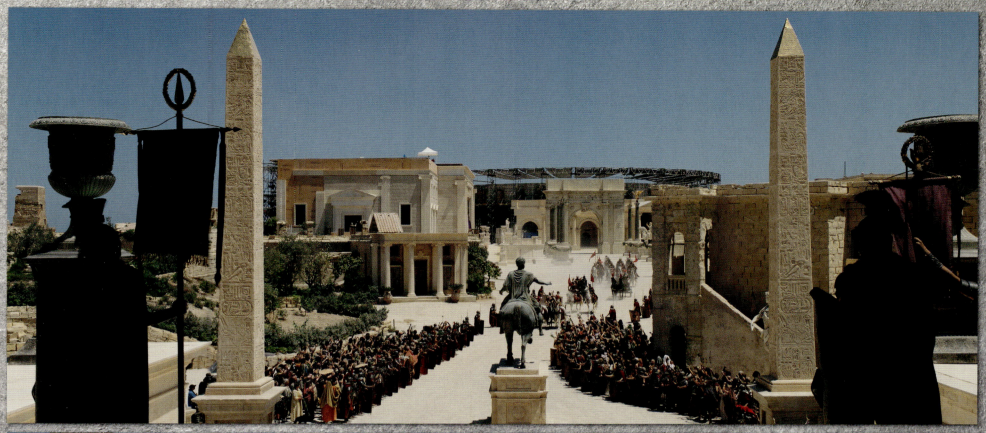
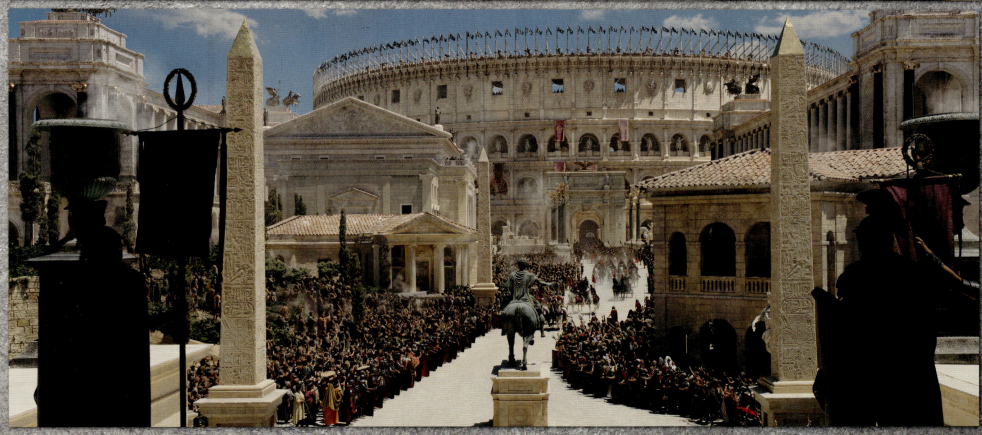

CHAPTER IV: SPECIAL AND VISUAL EFFECTS 229

A LONG TIME AGO

The preparation work for VFX on a film of this grand a scale happened before any actors stepped foot in front of a camera. "I had my first conversation around October of 2022. A world and a half away," said Bakowski. "Then, over the intervening period, the production team members joined, the on-set team, and finally, the post teams at the various facilities with which we would be collaborating."

Even though ILM and Framestore were not involved in the first film, there were some strong personnel tethers. "Ben Morris, the creative director of ILM's London studio, worked on the original along with several other members of our current staff. Along with them was Nikki Penny, VFX producer on *Gladiator II* and VFX producer at the Oscar-winning facility that worked on the original film. So there was a fair bit of historical knowledge to build on. That, coupled with the fact that Ridley was shooting in the same locations as he had previously and that Arthur Max was re-creating the same sets in those locations, meant many questions were pre-answered. The scale of the Colosseum's practical build, the orientation to the sun—the sun shades used (the Valerium)—all those were (virtually) the same as in the original. This meant we knew in advance some of the challenges this would bring."

UNSEEN MAGIC

In real-world scenarios involving ancient Rome or familiar historical periods, ILM and Framestore's seamless work often goes unnoticed by an audience caught up in the film's drama and narrative. But how satisfying or frustrating is this for Bakowski and his team? "A bit of both! Generally, having the audience not notice it means it's supporting the film's narrative flow, and it's well done, so it doesn't take you out of the movie. Now and then, you get a showstopper, which is pure wow factor, in which case it feels more okay to be noticed. But in general, it's a bad thing if the audience is thinking about VFX (or anything else, like the acting, music, etc.). Once it's all done, it can be frustrating not to be able to show off all your work—some studios like to pretend more of what's on the screen is real than it is."

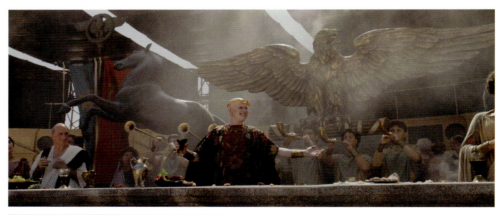

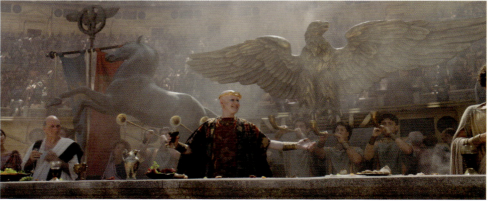

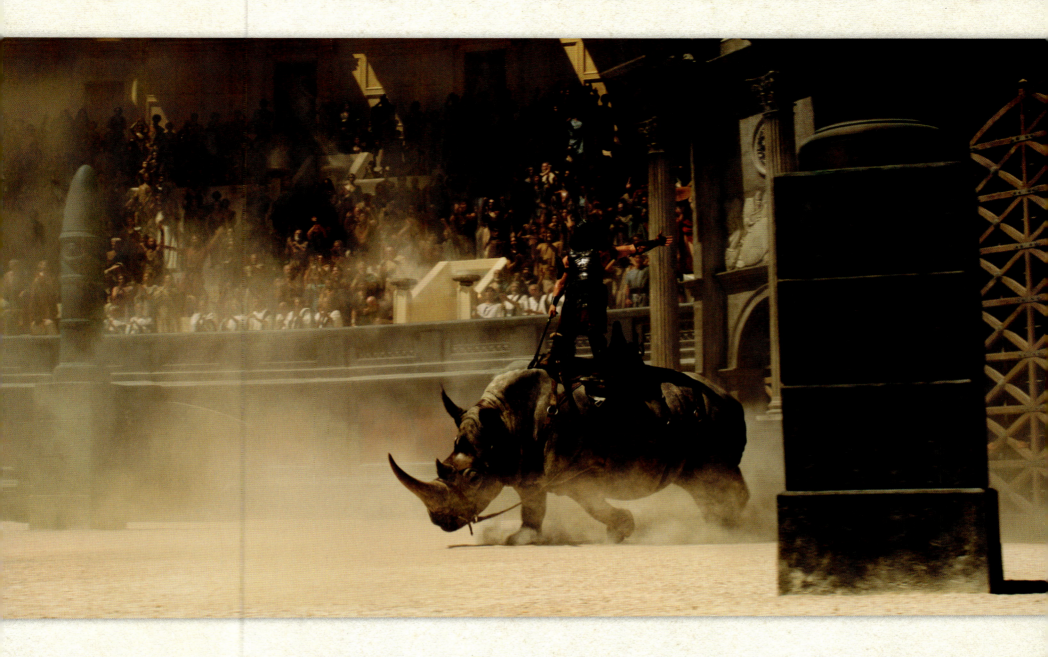

CHARGING RHINO

There were plans to include the rhino in the first film, but Bakowski speculates several reasons it may have been pulled, in addition to limitations of VFX technology at the time. "Perhaps budgetary constraints. *Jumanji* (1995) came out a few years before *Gladiator*. I remember that as having some rhinos running about, but it's a different challenge having a man ride one and sustain it for a whole scene." In *Gladiator II*, the VFX team added legs to the live mechanical rhino, making it more complicated than if this was a 100 percent CGI sequence. "In the end, we only kept the saddle; there may be one shot left where we kept the mechanical rhino; for the rest, the beast is replaced. Then there are a few where he (and the rider) are now fully CG. It was the right way to go with the mechanical rhino. It gave us great references: Ridley something to cut with and the actors something to react to. We replaced it with CG to bring it to life and make it consistent and matching. You need to own it. We were forced to go full CG sometimes because the turning circle was too mechanical, or the cadence of the riding rig didn't feel right for the speed at which the rhino was going. That forced our hand. But in general, it worked well."

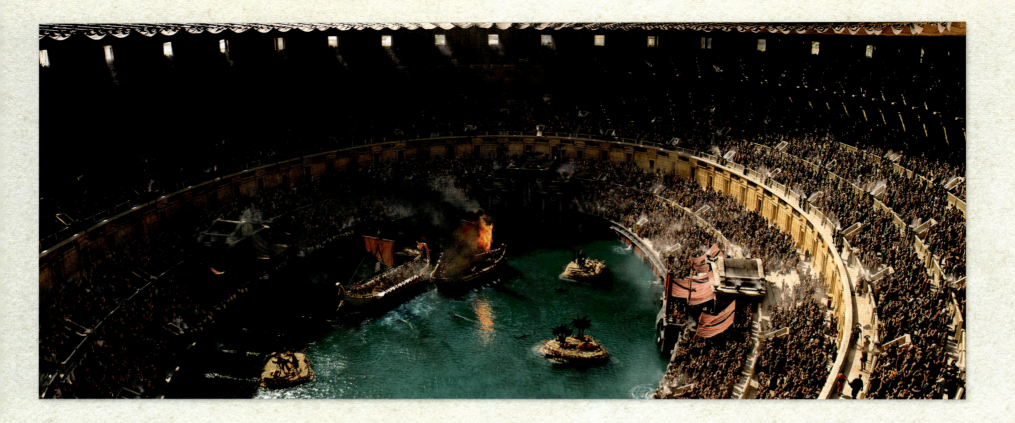

CLASSIC HOLLYWOOD VFX

Classic sword-and-sandal films had some of the best matte painting and model work committed to film, and those pictures still hold up well today. When thinking about the creative approach here, did Bakowski consider the style of classic cinema visual effects, or did Ridley Scott not want a romantic view of Hollywood to intrude? "Visual effects have moved on. In those days, moving the camera, for example, was nontrivial. These days, it's expected. I think it helps sell big visual effects shots to see the parallax of different layers against each other. At the other end of the scale, with some of our full digital shots, you could move the camera however you wish. We were careful to keep it realistic and limit the movement to what a physical camera could do. Let's obey the laws of physics, just like in older movies. The closest shots we have to the camera that break the laws of physics are our drone shots, but because a drone has such precise control and pace, sometimes they result in a shot that feels a bit artificial even if it's not."

Bakowski is fond of the visual effects landmarks from classic Hollywood and names his all-time favorite sword-and-sandal visual effects sequence. "It's got to be the skeleton fight from *Jason and the Argonauts* (1963). It doesn't get much better than that!"

FLOODING THE COLOSSEUM

One of *Gladiator II*'s standout sequences is the flooding of the Colosseum with digitally added water. Bakowski worked closely with the physical effects team. "Neil Courbold did a bit of previz, too, to try and nail down the action. There were plenty of discussions on the best way to shoot it. How much 'dry for wet,' i.e., adding CGI water, versus 'wet for wet,' shooting it in a tank. Both have pros and cons about the practical build, on the shoot day and then into postproduction. The logical way to do it is to split it between the dry and the wet, pending the shot. It never goes down how you think it will. What's in the edit isn't necessarily the purely logical way, but it is the footage that Ridley and the editors want to use—and that, ultimately, is the most important thing. Our job is to make it work. We had to keep an eye on it, though—the split between two locations to shoot, then worrying about the water level matching, the look of the water, and then trying to keep some logic to the islands in there. It's made more complicated because it's not a full practical Colosseum. Sometimes, you shoot into the emperor's box, and it's playing as the other side (the senator's box), which means all the islands are mirrored. Not rocket science, but it's easy to mess up on a busy shoot day!"

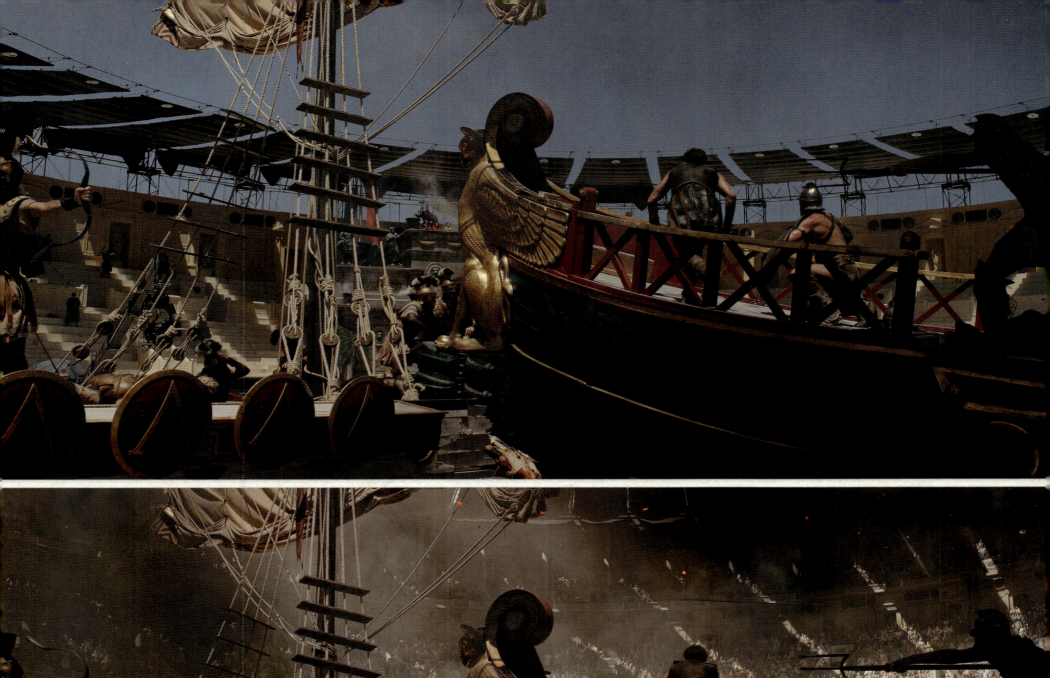
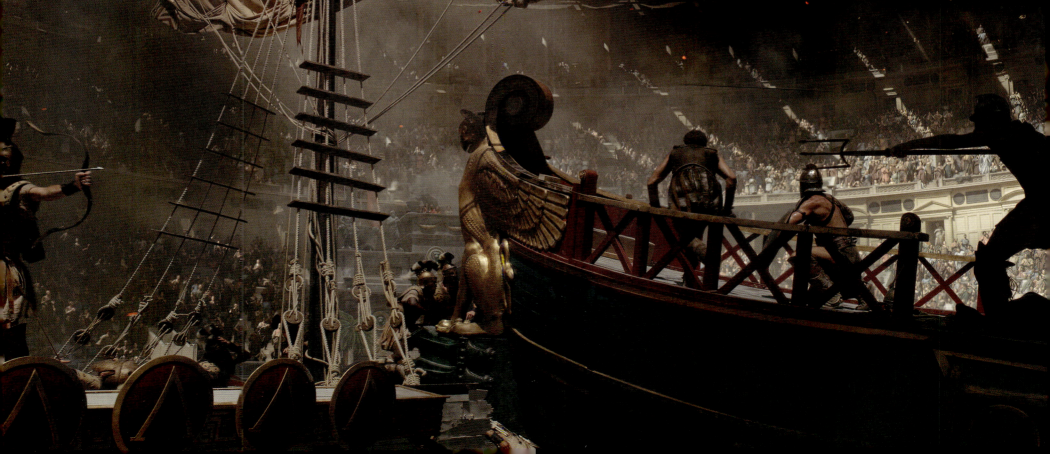

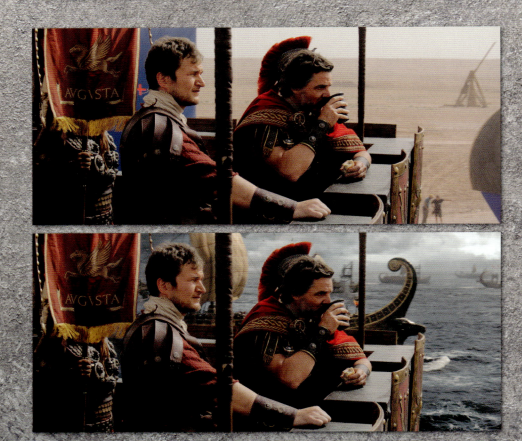
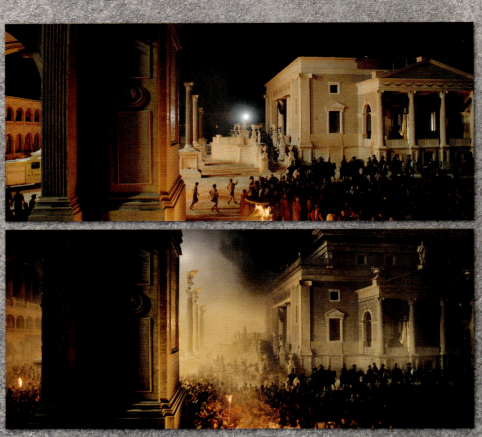

STAGECRAFTING

ILM still employs many traditional techniques and in-camera effects from the photochemical era of moviemaking, such as miniatures and motion control, traditional matte paintings, and even today's ILM StageCraft, an evolution of rear projection. Bakowski had a vast arsenal of techniques to bring ancient Rome to life. "In the case of this film, we leaned heavily into the practical approach to filmmaking. We'd shoot our ships driving about the dry Colosseum in a wide shot, knowing full well it'd be replaced by computer graphics, but that fact it could be shot embedded t in a core reality."

THE RIDLEY EFFECT

Ridley Scott has been a master of VFX from *Alien* (1979) onward. Bakowski enjoyed working closely with him on the film, as Scott's eye closely observes all aspects of the shoot. "He's hugely involved. It's his vision that we're executing. He doesn't worry himself with the day-to-day practicalities but deals with the big picture. In prep and shoot, it's my job to say to him now and then, 'Have you considered this?' or 'If you do that rather than this, we can do it more economically.' He'll then make his call based on that information. Some you win, some you lose, but of course, he's got a lot more on his mind than just VFX. I find it amusing when we all watch a playback of a certain setup on Ridley's monitors. Everyone is looking but obsessing about different things. I'll be stressing about the position of a blue screen, hair and makeup will be looking at some random curl of hair, the art directors at a background wall they think looks too modern, and Ridley needs to look at all of that . . . on twelve or fourteen cameras at once. Amazing!"

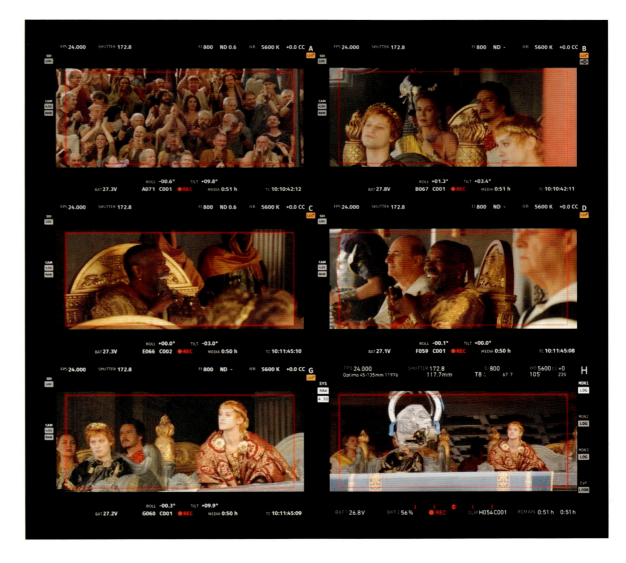

CHAPTER IV: SPECIAL AND VISUAL EFFECTS 235

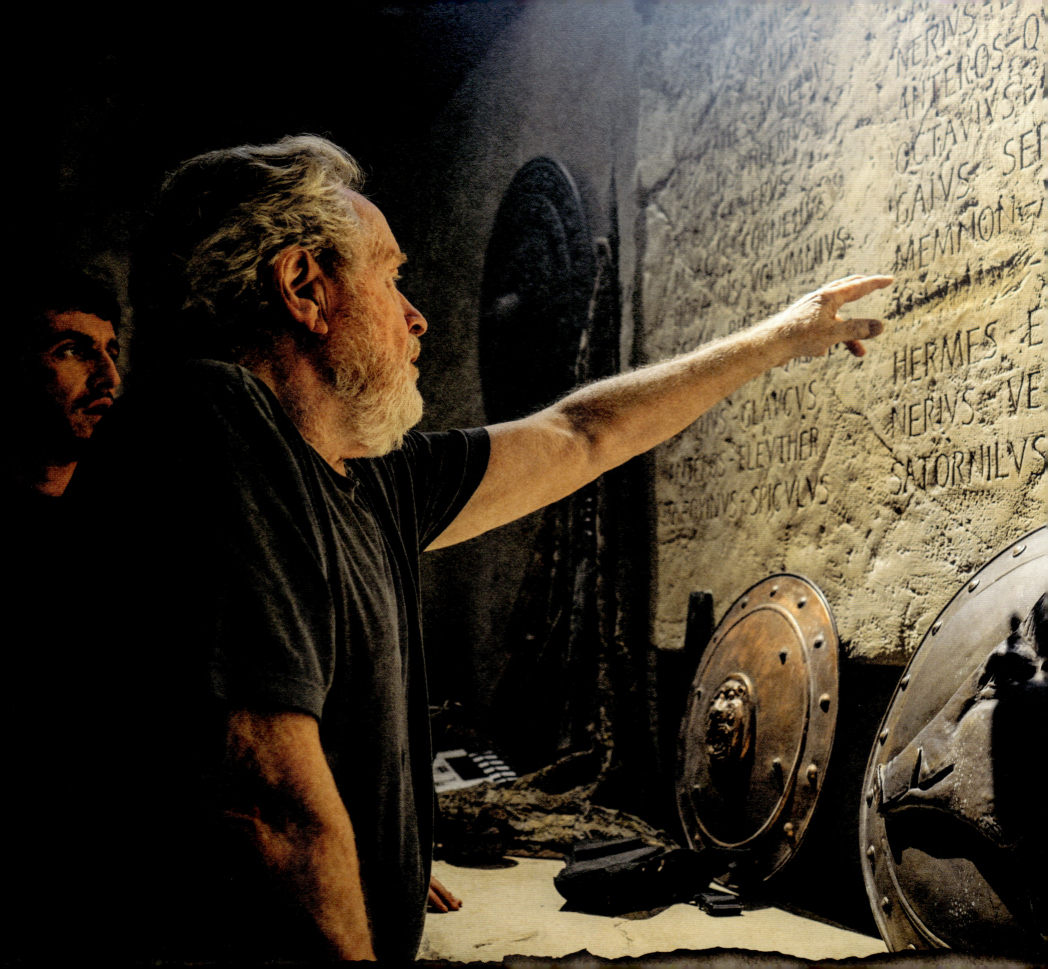

LEAVING ROME

IN 2000, WITH THE RELEASE OF GLADIATOR, DIRECTOR RIDLEY SCOTT PRESENTED AUDIENCES WITH A BOLD NEW VISION. "I LOVE TO CREATE WORLDS, AND EVERY FACET OF THAT WORLD HAS TO WORK WITHIN THE RULES OF THE STORY.

You must smell the battleground and experience the beauty and light of the golden city. The film must take you into this world so that you become part of 175 AD."[5]

A quarter of a century later, Scott is more reflective about the world of ancient Rome and its parallels with our world today. When discussing the corrupt twin emperors from *Gladiator II*, Scott says, "The brother will decapitate the other brother within two seasons. Caracalla murdered his brother in front of their mother in history. So we are bending history a little bit. We still have the brothers in front of Macrinus."

Scott also draws parallels between the father complex seen in the first film between Commodus and his absent father, Emperor Marcus Aurelius. "The fact that a delinquent father neglected him—the father being never there for seventeen years—I think it's a chronic betrayal of leaving Rome behind and not hoping it looked after itself. How can anything look after itself? You can't.

"The emperors are already potty. I don't know how or why they were slightly dysfunctional mentally. It may have been a birth thing, but it also asks how the Roman empires were so dysfunctionally brutal. What made them happy? Because what they were doing would compete even with Adolf Hitler or what Putin is doing now, or it would put Hitler and Putin in the shade. Monstrous behavior. No other word for it. Yet [the Romans] did such beautiful things. But everyone was racially substandard regardless. Put those people in our arena to die for a game, for entertainment. It's beyond sickness. That's sick."

Scott is often referred to by his crew in military terms, "leading from the front" and being the "general" of the production. His clear focus and pursuit of excellence have enabled him to be a cinematic world-builder. "Every film has its difficulties built into it. The thing is not to let them get through the door and start to control you. Again, it has to do with creating a team, choosing the people doing things for you, delegating, and making decisions. This wasn't difficult; it was enjoyable. How often do you get to build the Colosseum, a North African Roman town, and the Forum, or stage the German front on the Danube with thousands of Roman troops fighting the German barbarians? Not very often, today particularly. And I enjoyed the magnitude of it."

Walking in the footsteps of other cinematic giants does not faze the director of twenty-nine feature films, with others in the works. "*Spartacus* was sixty-five years ago, and *Ben-Hur* was even before that. These movies were part of my cinemagoing youth. I thought this might be the ideal time to revisit what may have been the most important period of the last two thousand years, if not all of recorded history, the apex and beginning of the decline of the greatest military and political power the world has ever known."[5]

AUTHOR ACKNOWLEDGMENTS

Connor Leonard, Abrams Books
Ian Kintzle, ILM
Mark Bakowski, ILM
Neil Corbould
Simon Ward

STUDIO ACKNOWLEDGMENTS

The Filmmakers: Ridley Scott, Doug Wick, Lucy Fisher, Michael Pruss, Raymond Kirk, and Aidan Elliott
Art Department: Arthur Max, Tamara Marini, Ty Teiger, and David Ingram
Costumes: Janty Yates and David Crossman
Special Effects: Neil Corbould
VFX: Nikki Penny and Mark Bakowski
ILM: Greg Grusby and Pami Yamzon
At Paramount: Daria Cercek, Ralph Bertelle, Shari Hanson, Vanessa Joyce, Lourdes Arocho, Amy Jarashow, Denise Cubbins, Ali Sandler, Alana Rincella, Risa Kessler, and Sabi Lofgren

NOTES

1. WFAA-TV: "Ridley Scott explains what was most daunting about making Gladiator (2000)," https://www.youtube.com/watch?v=_Sl5QE_WRqQ.
2. Oscars: Director Ridley Scott discussing "Gladiator," https://www.youtube.com/watch?v=x2jDbgQ57ZM.
3. Mike Fleming Jr., "Ridley Scott Won't Let Age or Pandemic Slow a Storytelling Appetite That Brought 'House of Gucci' & 'The Last Duel;' Napoleon & More 'Gladiator' Up Next," Deadline, November 12, 2021, https://deadline.com/2021/11/ridley-scott-house-of-gucci-lady-gaga-adam-driver-the-last-duel-oscar-season-1234872529/.
4. John Anderson and Guy Lodge, "Ridley Scott Honed His Craft in Commercials for Apple and More," *Variety*, November 5, 2015, https://variety.com/2015/film/features/ridley-scott-apple-commercial-1201633811/.
5. Diana Landau, *Gladiator: The Making of the Ridley Scott Epic* (New York: Newmarket Press, 2000).
6. Jamie Graham, with contributions from Megan Garside, TOTAL FILM: "Ridley Scott Teases Denzel Washington's Role in *Gladiator 2*: 'He's a rich guy carrying a grudge,'" *Total Film*, October 7, 2023, https://www.gamesradar.com/ridley-scott-teases-gladiator-2-denzel-washington-exclusive/.

BIBLIOGRAPHY

Anderson, John, and Guy Lodge. "Ridley Scott Honed His Craft in Commercials for Apple and More." *Variety*, November 5, 2015. https://variety.com/2015/film/features/ridley-scott-apple-commercial-1201633811.

Fleming Jr., Mike. "Ridley Scott Won't Let Age Or Pandemic Slow A Storytelling Appetite That Brought 'House of Gucci' & 'The Last Duel;' Napoleon & More 'Gladiator' Up Next." *Deadline*, November 12, 2021. https://deadline.com/2021/11/ridley-scott-house-of-gucci-lady-gaga-adam-driver-the-last-duel-oscar-season-1234872529.

Graham, Jamie. "Ridley Scott Teases Denzel Washington's Role in *Gladiator 2*: 'He's a rich guy carrying a grudge.'" *Total Film*, October 7, 2023. https://www.gamesradar.com/ridley-scott-teases-gladiator-2-denzel-washington-exclusive.

Landau, Diana. *Gladiator: The Making of the Ridley Scott Epic*. New York: Newmarket, 2000.

Editor: Connor Leonard
Designer: Liam Flanagan
Design Manager: Iain Morris
Managing Editor: Lisa Silverman
Production Manager: Larry Pekarek

A Library of Congress Control Number has been applied for.

ISBN: 978-1-4197-8016-5
eISBN: 979-8-88707-593-8

Copyright © 2025 Paramount Pictures. All rights reserved.

Jacket and cover © 2025 Paramount Pictures. All rights reserved.

Published in 2025 by Abrams, an imprint of ABRAMS. All rights reserved. No portion of this book may be reproduced, stored in a retrieval system, or transmitted in any form or by any means, mechanical, electronic, photocopying, recording, or otherwise, without written permission from the publisher.

Printed and bound in China
10 9 8 7 6 5 4 3 2 1

Abrams books are available at special discounts when purchased in quantity for premiums and promotions as well as fundraising or educational use. Special editions can also be created to specification. For details, contact specialsales@abramsbooks.com or the address below.

Abrams® is a registered trademark of Harry N. Abrams, Inc.

ABRAMS The Art of Books
195 Broadway, New York, NY 10007
abramsbooks.com

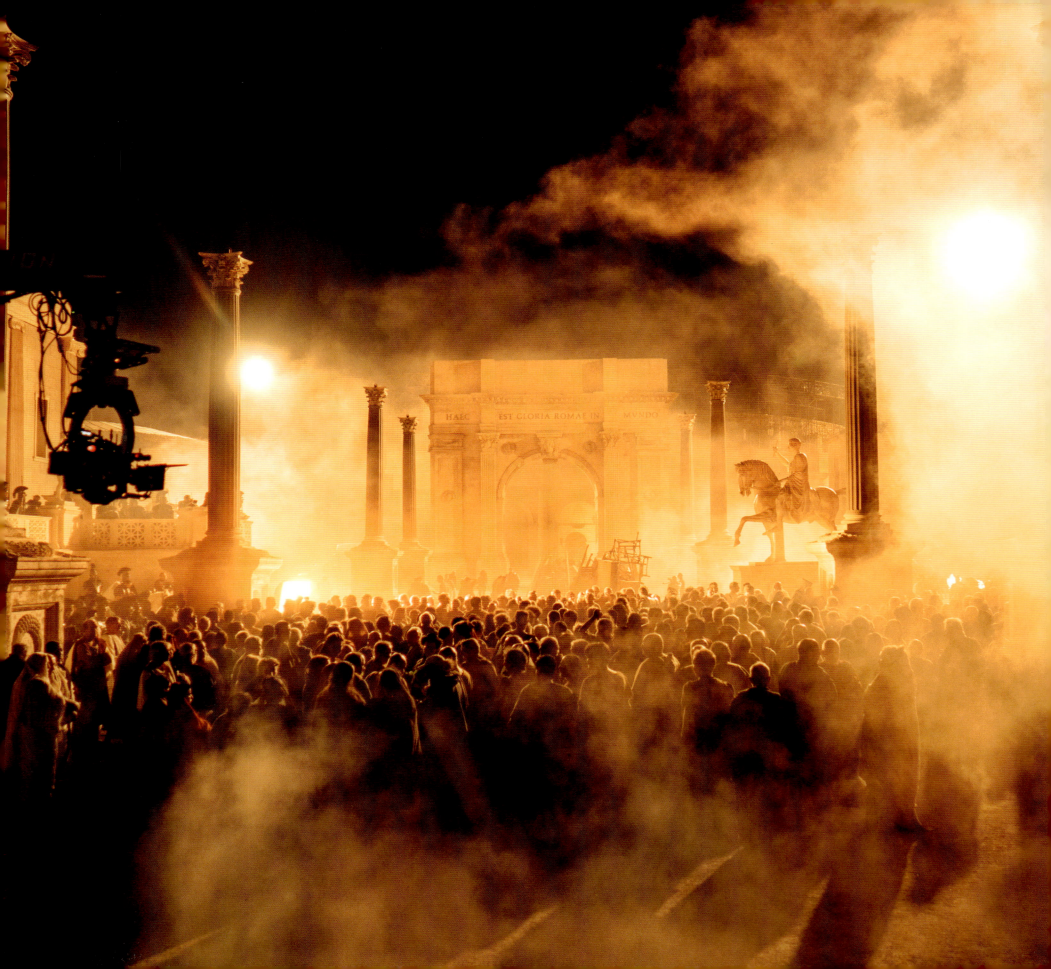